Communicate

Communicate:
Independent
British Graphic Design
since the Sixties

Edited by Rick Poynor

Essays by
David Crowley
Nico Macdonald
John O'Reilly
Rick Poynor

Yale University Press

Published in North America by
Yale University Press
P.O. Box 209040
New Haven, CT 06520-9040

First published in Great Britain in 2004 by
Laurence King Publishing Ltd, London
In association with
Barbican Art Gallery, London
www.barbican.co.uk

Library of Congress Control Number:
2004109196

ISBN 0-300-10684-X

Published on the occasion of the exhibition
'Communicate: Independent British Graphic
Design since the Sixties'
16 September 2004 – 23 January 2005

Guest Curator and Editor: Rick Poynor
Curator, Barbican Art Gallery: Jane Alison
Assistant Curator: Alona Pardo
The Barbican is owned, funded and managed by
the Corporation of London.

Designed by Nick Bell,
Una (London) designers
Index by Drusilla Calvert

The cover features work by the following:
Jonathan Barnbrook; Neville Brody; Margaret
Calvert; The Designers Republic and Kleber;
Simon Esterson and Stephen Coates; Robin Fior;
Foundation 33 (Daniel Eatock and Sam
Solhaug); Graphic Thought Facility; Julian House;
Siobhan Keaney; David King; Alan Kitching;
Michael McInnerney; Jamie Reid. For full credits,
see captions inside the book.

Printed in Spain

Contents

Foreword

It has been our privilege to work with many talented graphic designers in the course of Barbican Art Gallery business. Collaborating with designers is indeed one of the most genuinely satisfying and enjoyable aspects of our work. The list of designers with whom we have been associated is a long and impressive one: Tony Arefin, Jonathan Barnbrook, Nick Bell, Derek Birdsall, Vince Frost, Richard Hollis, Morag Myerscough, Kate Stephens and, most recently, North are just some of those who readily come to mind. All feature in the exhibition 'Communicate'. Collectively, their unique skills and vision have enriched all that Barbican Art Gallery has achieved. We are not alone in enjoying this creative exchange. Many of the exhibits in 'Communicate' are testament to the mutually rewarding partnerships that exist between designers and cultural institutions across London and beyond. Think, for instance, of Richard Hollis's development of the Whitechapel Art Gallery identity when Nicholas Serota was still holding the reins, or Mike Dempsey's enormously successful identity for English National Opera, which graces all its publicity a decade after its inception.

Barbican Art Gallery has a history of exploring and celebrating innovative design and interactive new media in parallel with fine art practices. Indeed, the seeds for this exhibition were sown back in 1996 with an exhibition at Barbican Art Gallery entitled 'Jam'. An account of the crossover between new media, music, graphics, photography and fashion, 'Jam' was inspired by the excitement and energy of a no-boundaries culture that was flourishing in clubs, on catwalks and in style magazine publishing. Fuel, Tomato, Blue Source, Terry Jones and Scott King all featured. A few other notable graphics exhibitions have preceeded this one: the influential solo exhibition of Neville Brody's work at the V&A in 1988; the admirable 'Sublime', shown at the Cornerhouse gallery in Manchester in 1992; and Peter Saville's retrospective at the Design Museum in 2003. The gallery world has been slow, or perhaps just plain unwilling, to recognize the sheer diversity and ambition of graphic design in this country since it emerged as an independent art form in the early 1960s.

What amounts to a hierarchical disdain is mirrored elsewhere in broadsheet journalism and academic education, something that John O'Reilly, writing here, attributes to a cult of the word in British culture at large. The fact that graphic design communication can be so prominent in our lives – an increasingly popular career choice, a point of interest and argument within every workplace seeking to express identity or convey a message – and yet still be so little understood or appreciated continues to rankle with designers and design historians alike. It was certainly one of the motivating factors for this exhibition.

The shelves of London bookstores are today groaning with graphic design titles. It has unquestionably been *the* growth area in art and design publishing over the last ten years or so, though these books often exult in surface qualities at the expense of understanding. It became clear during our initial thinking about this exhibition that no single book attempted the long overdue account of British graphic design as it has emerged in this country since the late 50s. *Communicate* charts this history for the first time, juxtaposing the most influential bodies of work by nearly one hundred designers.

Rick Poynor's essential thesis, which underpins everything in both exhibition and book, is that the emergence of graphic design in the UK in the 1960s as a self-aware practice, a coherent way of working and a credible art form arose from the early efforts of those individuals included here – Derek Birdsall, Robert Brownjohn, Robin Fior, Alan Fletcher, Ken Garland and Richard Hollis among others – who sought independence and remained true to a vision of graphic design as meaningful communication with an artistic legacy and integrity all of its own. Britain's thriving publishing, music, arts and underground scenes have been instrumental in creating an environment in which these designers, their colleagues and later generations have been free to develop individual work undiluted by a corporate agenda.

In selecting works for the exhibition 'Communicate', it became clear that what we were dealing with, for the most part, was print, and that its accumulation in an exhibition would begin to map a social and cultural history of Britain. This aspect of 'Communicate' will provide much of its enjoyment to the visitor, or to the reader of this book. Take, for instance, Ken Garland's Aldermaston CND poster designed in 1963; or Richard Hollis's influential design for John Berger's *Ways of Seeing*, a book that has been essential reading for every art student since it was first published in 1972; or David Hillman's, Simon Esterson's and Mark Porter's redesign of *The Guardian*, beginning in 1988; or Derek Birdsall's *Common Worship* prayer book for the Church of England in 2000. Such examples can justly make us feel optimistic about British culture and the designers who have had the ability and wit to flourish here.

This book documents all that the exhibition is and more. An undertaking of this scale was never going to be anything other than a major challenge. Rick Poynor had the task of editing this thorough and thought-provoking account, and also of writing the lead text. In it, he painstakingly charts a history of contested ideas within graphic design. His essay investigates the fundamental role of graphic design; is it principally a tool for impersonal, problem-solving communication or is it best served by those who follow a more personally committed and questioning path? Three essayists tackle different but highly pertinent aspects of graphic design culture. John O'Reilly explores the relationship of graphic

design to popular culture, David Crowley charts the history and development of graphic design journalism in this country and Nico Macdonald unpicks the complex threads that link interactive media design with traditional print graphics. Each essay brings new insights to this under-researched field and will prove to be an invaluable source of reference for those with a serious interest in graphic design. As will the 15 interviews with designers who kindly agreed to be interviewed for the book.

When it came to the question of who might design the book, we asked ourselves the critical question: who could do justice to the subject, not overpower it and yet lend the required sensitivity and design intelligence that would make it stand out and exemplify everything that was being championed inside? With *Communicate*, Nick Bell has made a distinctive and care-fully crafted addition to his many successes in this most sophisticated discipline within graphic design practice.

We are indebted to Rick Poynor for the enthusiasm and collaborative spirit with which he embraced the ambitious nature of this project. He has worked tirelessly and with professionalism to realize both the exhibition and this book that accompanies it. Bringing together the best of British graphic design has been a formidable challenge, and needless to say would not have been possible without the co-operation and encouragement of the many designers whom we have pestered, probed and chivvied along the way.

As we write this, Fehran Azman of Azman Associates is in the process of

bringing an architectural coherence to the installation. We have every confidence that her innovative design will enhance the display of each and every exhibit. PlayStation have kindly supported the exhibition and we are extremely grateful to them for that.

It is our hope that *Communicate* will, with its rich pools of enquiry, offer a focus for discussion, be an inspiration to those coming new to the profession and the starting point for a renewed confidence and sense of community. Poynor holds the belief that graphic design has a significant role to play in making the world a more just place through its simple power to communicate. It is an imperative that he urges designers to follow, championing those designers who confidently claim parity with their artist contemporaries and defending those practitioners who adopt a more humble role in the service of the client's brief. *Communicate* celebrates the work of graphic designers, whether super-stylists of the visual or visionaries with a distinct message or critique. John O'Reilly writing here concludes that what is significant, and for the most part overlooked, about graphic design is that its practitioners are at the forefront of interacting with, and indeed processing, our fast-changing society and presenting it back to us in a way that helps us understand who we are. It seems then that artists and designers inhabit an increasingly inter-related orbit of cultural intervention. They invite our participation in a sphere that offers us endless scope for reflection and enjoyment.

Jane Alison, Curator
Carol Brown, Head of Art Galleries
Barbican Art Gallery

Introduction

This book and the exhibition it accompanies do not attempt to cover every aspect of British graphic design since the 1960s. By the early 2000s, design had grown too broad for a single exhibition or volume to address its entire range adequately. Instead, *Communicate* concentrates on designers and design activity best summarized as independent.

The word is fitting in two senses. First, because these designers have chosen, often with great deliberation, to preserve their independence. Some of them work alone, perhaps with the help of just one or two assistants. Some of the teams were founded by two or three partners, but have never grown bigger than a handful of designers and some administrative help. Some started small and have expanded, with the pressure of work, to the point where they may employ as many as 20 people. In all cases, though, the enterprise is owned by its founders and answers only to itself. It is not part of some larger, acquisitions-hungry group of communications companies with offices around the world. It does not have a Stock Exchange listing or shareholders who may have little interest in design pressing for a return on their investment. Most of the companies featured in *Communicate* are too small for this ever to have been an issue. In some cases, their size and level of income made it a possibility, but they chose to avoid this path. The largest company included here, Pentagram, devised a plan to have it both ways. Its partners gave up some of their independence by joining, but the company's unusual structure allowed them to continue to manage their own small teams under its wing. Pentagram, too, has elected not to surrender its organizational independence by allowing itself to be absorbed by a larger group.

The second meaning of independence is indivisible from the first. Designers featured in *Communicate* wanted to stay independent because they had an independent point of view. It was important to them to take on projects to which they could bring a strong sense of commitment and personal involvement. Many would also stress the need to retain as much creative freedom as possible. In the 40-year period spanned by *Communicate*, attitudes have certainly evolved. In the 1960s, designers routinely proclaimed that it was their mission to solve clients' problems, but behind this display of modesty there was often a fierce desire to do the best work they could, and this did not always square with a client's expectations or tastes. Clients do not necessarily want trail-blazing design; sometimes they simply want to fit in. The designer's goal then became to try to 'educate' the client in the ways of design. Later, designers became much more open about their personal motivations for undertaking the work. There were times, listening to their rhetoric, when it seemed as though the client – the commissioner and bill-payer – was almost an afterthought in

the process. Yet, however much some designers might push against the inherent constraints of their situation, graphic design is in most cases a commercial activity. Even the most idealistic cultural and charitable projects are undertaken to earn money and some kind of balance of interests must always be struck. Nevertheless, independent designers are in a much better position to keep their options open and concentrate only on things that they care about than those who give up their autonomy to work for big, overhead-burdened agencies, whose overriding concern must, of necessity, be generating income.

By the 1990s, Britain's highly diverse band of independent designers had helped to bring about one of the most energetic, inventive and varied design scenes anywhere in the world. Since the 1960s, when even the most ambitious visual communicators were still finding their footing, many of the significant new ideas, styles and directions have emerged from their studios. The rapidity with which these developments were sometimes taken up by less independent sectors of design was the clearest sign of their relevance and viability, though widespread diffusion often hastened their demise. Independent graphic designers have a complicated relationship with the mainstream. Either implicitly or explicitly, their work may embody a criticism of the broader currents of design and visual communication. Their motivation might in many cases be apolitical, their guiding assumptions largely unstated, but they still prefer to do things differently from the norm. Designers as varied as Vaughan Oliver, Why Not Associates, Mark Farrow, North, Intro and Kerr Noble fall into this category. Other figures, such as Robin Fior and Ken Garland in the 1960s, David King in the 1970s, Neville Brody in the 1980s and Jonathan Barnbrook and Lucienne Roberts in the 1990s, were overtly political in their allegiances and in their use of design as a medium of critique.

Today, the independent spirit is more vital than ever. We live in an era of vast media organizations which gobble up independent publishing houses, newspapers, magazines, film studios and record labels in a process of seemingly unstoppable expansion. The aim of these global enterprises is to capture mass audiences and the techniques they bring to bear are often as patronizingly formulaic as their messages are unadventurous and trite. The independent publishers, publications, film-makers and record labels that remain attempt to challenge the narrowing of options by offering unpredictable alternatives. In an increasingly visual society, independent graphic designers also play a crucial role in keeping the channels of communication open. Imagine a visual culture which had no place for such inter-mediaries, a design landscape in which there were no independent designers at all. Where would its richness, vitality and new critical thinking come from? How would it question and renew itself?

It goes without saying that over the last four decades many more British graphic designers have pursued an independent path than can be shown in *Communicate*. The designers included here are representative and many are leading lights, but there are hundreds of others. Their essential contribution to British cultural life deserves to be recognized and celebrated.

Rick Poynor

'To design is to create images which communicate specific ideas in purely visual terms and to utter statements whose form graphically embodies and enhances the essential nature of the notions to be communicated.' John Commander, 1960

'Designers should not quietly sit in the wings waiting to be asked to take the stage.' Herbert Spencer, 1964

com
municat
ate

Spirit of independence
by Rick Poynor

It may seem surprising now, but graphic design, as we understand it today, was slower to develop in 20th-century Britain than it was in European countries such as Germany, Switzerland and the Netherlands, or in the United States, where several significant European designers fled at the time of the Second World War. Yet by the 1980s, it was common to hear British design's tireless champions boasting that the country produced the best graphic design in the world. Such claims are always dubious, but they certainly revealed the pride and confidence that the design business – for that was what it had become – felt in its achievements. Nor would it be exaggerating to say that by the 1990s, Britain really had established itself as a leading producer of graphic design. It promoted its services abroad more aggressively and with more success than many other countries and its designers were known overseas, profiled in magazines and invited abroad to give lectures and take part in exhibitions. Business success and creative success were not, however, necessarily the same thing. The British graphic designers most likely to be celebrated abroad tended to come from small, independent studios where creativity, rather than the bottom line, was still paramount. This book focuses on their contribution. If Britain had, by the end of the 20th century, become a country where first-rate graphic communication was so tightly woven into the fabric of everyday experience that the public often took it for granted, it was thanks in no small measure to their efforts.

The term 'graphic design' was already in use in Britain in the mid-1950s, but it was not used widely and there was no substantial group of individuals describing their activities in this way. Design Research Unit, one of the first design companies, was founded in 1943, but it was an exception. The typographic design of books and other printed materials tended to be handled by printers. Designers were also employed by advertising agencies such as W. S. Crawford, where Ashley Havinden had been a notable figure since before the war. In the 1950s, a new generation of designers trained in the art schools was beginning to offer its services to business, but at this point ambitious freelances such as Herbert Spencer, author of *Design in Business Printing* (1952), were more likely to think of themselves as typographical designers than as graphic designers.[1] In 1954, two tutors in the Royal College of Art's School of Graphic Design published *Graphic Design*, a textbook aimed at young designers.[2] Revisited today, this sedate, unhurried volume contains little that a contemporary viewer and consumer would recognize as energetic modern graphic design. The authors, John Lewis and John Brinkley, present page after page of book plates, wood engravings

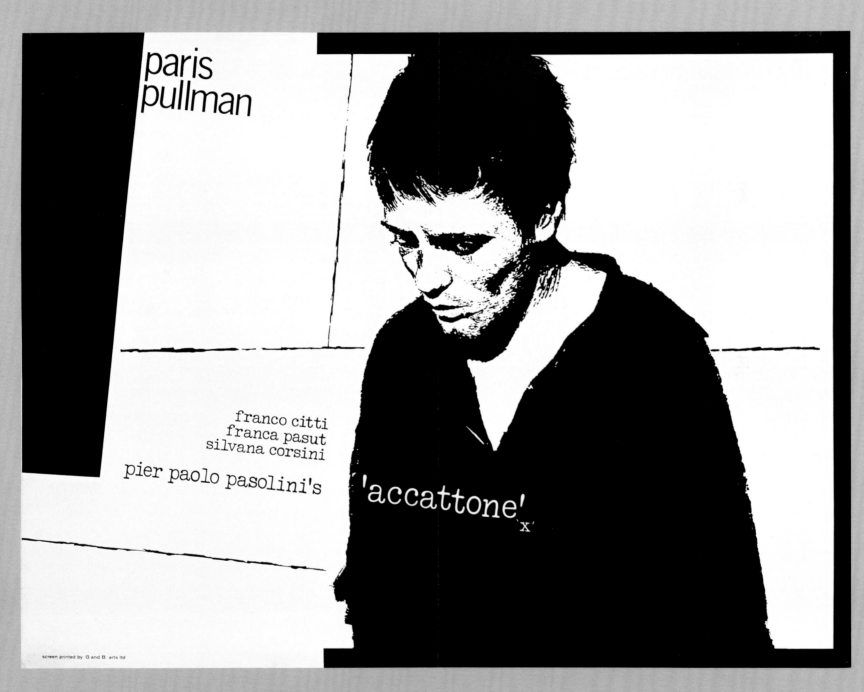

George Mayhew,
Accattone by Pier Paolo
Pasolini, poster for Paris
Pullman cinema, 1962

and genteel illustrations by graphic artists such as Barnett Freedman, Edward Bawden and Lynton Lamb, but Lewis and Brinkley found no space to show or discuss the vigorous modernist work created in Europe in the previous 30 years, and even the Bauhaus is passed over quickly. Nor did they feel it necessary to mention British poster-makers and designers such as Abram Games, designer of the Festival of Britain emblem in 1951, Tom Eckersley, Hans Schleger and F. H. K. Henrion, founder of Henrion Design Associates, also in 1951. Much of the work created by this generation in the 1940s and 1950s, using a paintbrush or airbrush to produce imagery and lettering, has its roots in commercial art, the usual term for visual communication in the pre-war period.[3]

By the end of the 1950s, change was underway in both society and design. In *The Neophiliacs* (1969), a study of the revolution in English life in the 1950s and 1960s, Christopher Booker identifies 1958–59 as a critical moment. It was then, he writes, that 'In a way in which it had never been used before, the word "image" began to pass into journalistic and conversational currency.'[4] In *The Image*, published in 1961, cultural critic Daniel Boorstin notes how in American society the new use of 'image' revealed a readiness to accept a distinction between what was seen and what was really there. People seemed to prefer these images, even though they might be concealing or doctoring the truth.[5] As Booker suggests, the British public's growing concern with something's image, with the subconscious impression it made and the need to be contemporary and 'with it', could be seen in the attention-grabbing images of television and advertising, in the omnipresent beat of pop music and the impact of eye-catching clothes, as well as in the bright lights of the new supermarkets and the seductive packaging of food. In the late 1950s, Booker concludes, the perception that Britain was 'moving into the future on a tidal wave of change' was to a great extent stimulated and sustained by the continuous flow of exciting images of one kind or another.[6] Graphic designers would emerge in the years ahead as increasingly assertive, significant and sometimes ambivalent providers of this imagery.

In 1959, a group of designers ambitious for change formed the Association of Graphic Designers, London (AGDL). They hoped to stimulate, through discussion, exhibitions and publications, an informed interest in the best graphic design work being done in Britain and abroad. The first outcome was the exhibition 'Graphic Design: London', shown at the Time & Life Building in Bond Street from 18 May to 1 June 1960. The display included work by Dennis Bailey, Derek Birdsall, George Daulby, Alan Fletcher,

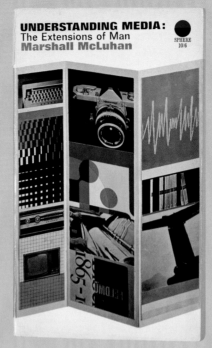

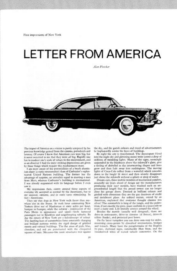

Top: **Jack Larkin**, *Understanding Media* by Marshall McLuhan, book cover, Sphere, 1967

Gordon Moore, *Ark* no. 19, magazine spread showing an article by Alan Fletcher, Journal of the Royal College of Art, spring 1957

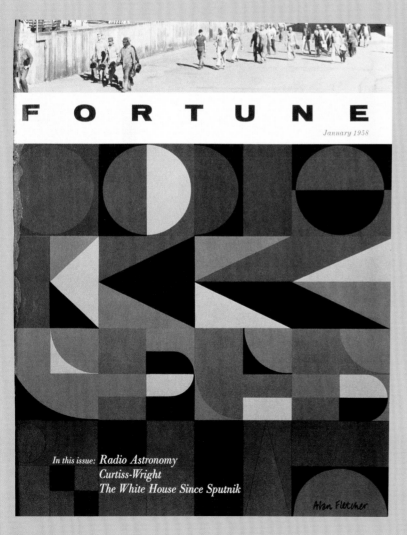

Alan Fletcher,
Fortune vol. LVII no. 1,
magazine cover,
January 1958

Colin Forbes, George Mayhew, Peter Wildbur, Raymond Hawkey and Tom Wolsey. Daulby expressed the group's sense of frustration at the limitations of design in 1950s Britain: 'When judged by international standards, post-war graphic design in England has not got anywhere near the achievement of some designers in America and on the continent.'[7] John Commander, the group's spokesman, an Oxford-educated art director for the printer Balding & Mansell, insisted that graphic design was a 'serious, legitimate, and meaningful discipline', but concluded that, although the problems of visual communication in Britain were now acute, in the main they were being ignored. 'The members of AGDL are not in revolt against the existing order of society,' he explained, 'nor, I think, is it their primary concern that their activity should contribute idealistically to the betterment of the human lot. But if it is accepted that work, in whatever medium of expression, which contains elements of imagination, invention and liveliness is preferable to that which is staid and lifeless, then their activity may be thought to add something of interest to life.'[8] Questions about graphic design's social purpose and value would continue to surface as the decade progressed.

That Britain lagged behind other countries when it came to graphic design was a general view as the 1960s began. One writer went so far as to describe British graphics and illustration as 'extraordinarily prim and gutless', suggesting that the problem lay not in the scarcity of good designers, but in the timidity and tastelessness of clients.[9] Reviewing the state of graphic design in 1962, Henrion felt that while the practice had become more competent, it had also become 'conformist and duller'.[10] Many looked enviously overseas for examples of what could be achieved. Ken Garland, art editor of *Design* magazine, argued that there were lessons to be learned from both the confident exuberance of American commercial design and the asymmetrical, orderly sanserif typography of the Swiss, which British designers were starting to encounter in the austere, white pages of *Neue Grafik* magazine, launched in 1958 by four Zurich designers, Richard Lohse, Josef Müller-Brockmann, Hans Neuburg and Carlo Vivarelli.[11] In 1956, Bailey had worked for a year in Zurich as an assistant editor at *Graphis* and, after he returned to Britain, his poster and publication designs revealed clear signs of Swiss typographic influence. In 1960, Garland spent two months in Switzerland, visiting the studios of many designers, and, in an article published in *Typographica*, he showed examples of Swiss design by Armin Hofmann, Siegfried Odermatt, and Karl Gerstner and Markus Kutter.[12]

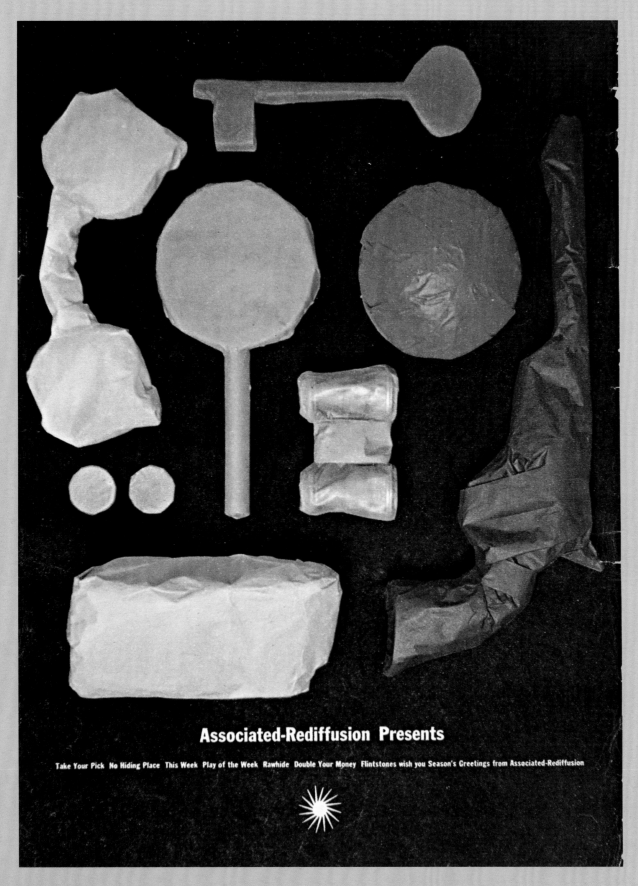

The 'Graphic Design: London' designers were mostly still young. Birdsall was 25 at the time of the exhibition; others were in their late 20s or early 30s. Fletcher, Forbes, Daulby and Birdsall had studied at the Central School of Arts and Crafts, where they had encountered teachers such as Anthony Froshaug, Edward Wright and Herbert Spencer, who encouraged an asymmetrical modernist typography derived from the European innovators Jan Tschichold and Max Bill.[13] Bailey and Fletcher pursued their studies at the Royal College of Art, where Fletcher was awarded a fellowship to study design at Yale University. In an article titled 'Letter from America', published in *Ark*, the RCA magazine, Fletcher gave a bedazzled account of the country's 'dream-cars', supermarket plazas, and chrome and plastic drugstores.[14] While in the US, he gained experience working for Container Corporation, IBM and *Fortune*, and his experience of American culture and approaches to design, still unusual at that time, had a decisive influence on his own ambitions when he returned to Britain. American designers were also travelling in the direction of London to work in advertising agencies that were giving opportunities to graphic designers. In 1960, Robert Brownjohn left Brownjohn, Chermayeff & Geismar in New York and moved to J. Walter Thompson's London office, while Bob Gill joined Charles Hobson, where Yale graduate Lou Klein also put in stints. Another American, Robert Brookes, took a position at the Benton & Bowles agency. They brought a strong sense of the commanding graphic idea, which had been central to the so-called 'creative revolution' on Madison Avenue in the mid-1950s. American magazine layouts and print ads, such as the famous Volkswagen Beetle campaign, combined witty, well-honed copywriting with straight-to-the-point design and photography. The conceptual wit in Brownjohn's output, in particular, would have a powerful influence on British graphic designers who saw his work and attended his lectures.

BDMW Associates, founded in 1960 by Derek Birdsall, George Daulby, George Mayhew and Peter Wildbur, can lay claim to being the first of the 1960s design groups, but it was to be Fletcher/Forbes/Gill, founded in April 1962, which had the greatest long-term impact and has come to represent the paradigm of an independent design team. Gill's presence in the line-up confirmed and strengthened the American influence. (In the late 1970s, Forbes relocated to the US for good.) If there was a central concern in the new British graphic design it was the idea that the graphic designer should be a highly focused solver of problems. Henrion described the need for individuals with 'clear, analytical, and methodical

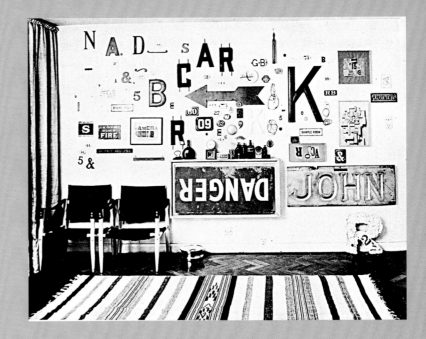

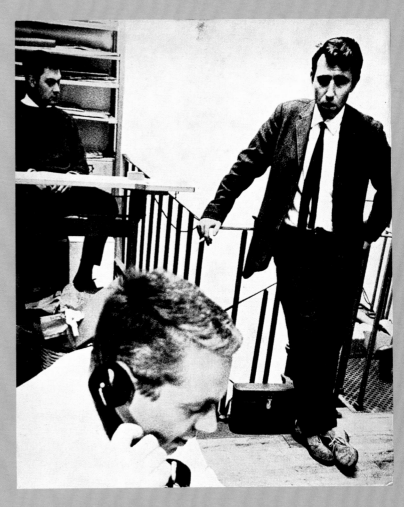

Top: Robert Brownjohn's living room in Campden Hill Towers, Notting Hill Gate, London, 1961. Photograph: Brownjohn

Alan Fletcher (back left), Colin Forbes (front left) and Bob Gill (right) in their London studio, 1963

**Design & Art Direction '63 The first annual
exhibition of the Designers & Art Directors
Association of London at the London Hilton Hotel
Park Lane W1 Open daily 10 am to 7pm from
Tuesday 11th June until 1pm Saturday 15th June
Admission free**

Fletcher/Forbes/Gill,
*Design & Art Direction
'63*, poster for the
Designers & Art
Directors Association of
London, 1963

minds'.[15] While the designer would be at home with all forms of visual expression – drawing, painting, photography, montage and typography – the aim was not self-expression, in the manner of an artist, but the efficient transmission of messages. Garland proposed that, to be properly rigorous, graphic designers must acquire a sense of scientific method and 'be prepared to test their subjective concepts against observable facts'.[16] In 1963, Fletcher/Forbes/Gill published the book *Graphic Design: Visual Comparisons*, showing examples of work they admired, most of them by Americans such as Paul Rand, Saul Bass, Herb Lubalin, and Brownjohn, Chermayeff & Geismar, and by Europeans such as Karl Gerstner and Markus Kutter, Josef Müller-Brockmann, Bruno Munari and Total Design. A brief introduction explains F/F/G's way of working: 'Our thesis is that any one visual problem has an infinite number of solutions; that many of them are valid; that solutions ought to derive from the subject matter; that the designer should therefore have no preconceived graphic style.'[17] A book published to record the first year's work by the studio shows projects for ICI, the BBC, Reed Paper Group, Pirelli, Braun, El Al Airlines and the *Evening Standard*.[18] The work is striking for its clarity. Everything in any way personal to the designers has been eliminated. All that remains is the message elegantly reduced to its essential parts.

The flurry of promotional activity in 1963 was a sign of graphic design's growing confidence and momentum. In April, 'Graphics RCA', an exhibition celebrating student work and later achievements by figures such as Alan Fletcher, John Sewell, Raymond Hawkey and Romek Marber opened at the Royal College of Art.[19] In May, publisher Lund Humphries, in association with *Typographica* editor Herbert Spencer, mounted the exhibition 'Typography in Britain Today', featuring work by 37 designers, including those involved in the founding of AGDL.[20] The same group's work was illustrated as a series of portfolios in the book *17 Graphic Designers London*, with a brief introduction by John Commander, who made the now routine point that the graphic designer's work 'will be effective in inverse relation to the extent to which he regards it as a means of self-expression'.[21] AGDL had been superseded by the Designers & Art Directors Association, formed in 1962, with Commander as its first elected chairman. In June 1963, the first D&AD exhibition, showing some 450 items selected by a jury of 24 (including Forbes, Birdsall, Brownjohn, Wolsey and Marber) from *c*. 4,000 entries, took place at the Hilton Hotel. It was staged again in July at the IPEX show in Earl's Court. The D&AD symbol and promotional materials, showing a stylish black portfolio, were designed by Fletcher/Forbes/Gill.

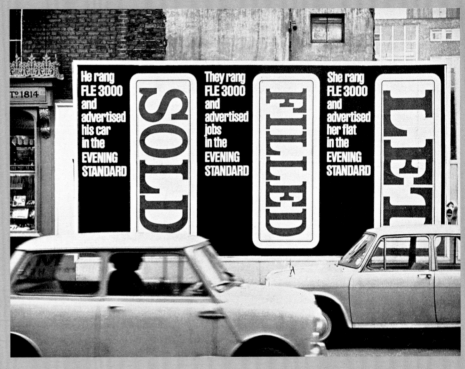

He rang
FLE 3000
and
advertised
his car
in the
EVENING
STANDARD

SOLD

They rang
FLE 3000
and
advertised
jobs
in the
EVENING
STANDARD

FILLED

She rang
FLE 3000
and
advertised
her flat
in the
EVENING
STANDARD

LET

PIRELLI CINTURA
SAFETY IN CORNERING

Alan Fletcher,
poster for Pirelli for
display on a double-
decker bus, 1961

Top: **Fletcher/Forbes/
Gill**, billboard advertise-
ment for the *Evening
Standard*, 1963

COMEDY THEATRE
Panton Street Haymarket SW1 WHItehall 2578
Sole proprietors: Wingate Productions Ltd

William Donaldson and Michael Codron present

An Evening of
BRITISH RUBBISH

Professor BRUCE LACEY
THE ALBERTS JOYCE GRANT
AND IVOR CUTLER
directed by GORDON FLEMYNG

Evenings at 8.30 Wednesdays & Saturdays 5.30 & 8.30
Telephone: WHItehall 2578

Printed by Compton Printing Works Ltd London N1

John Sewell

John Sewell, *An Evening
of British Rubbish*,
poster for the Comedy
Theatre, 1963

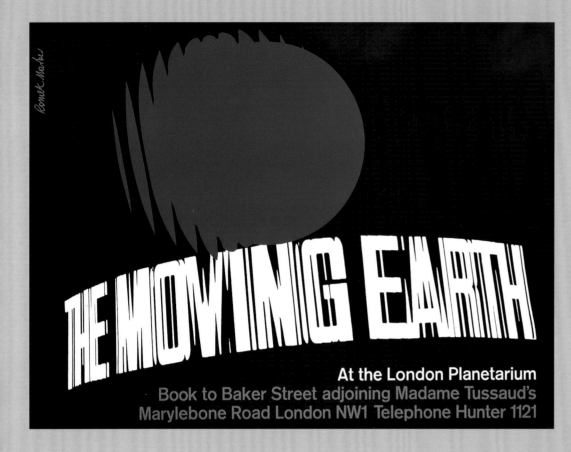

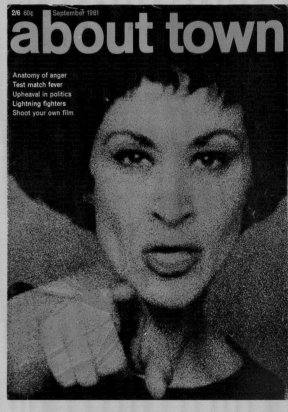

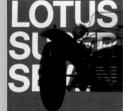

Top: **Romek Marber**,
The Moving Earth,
poster for the London
Planetarium, 1966

Derek Birdsall,
leaflets for Lotus Super
Seven and Lotus Seven,
*c.*1961

Top: **Thomas Wolsey**,
About Town vol. 2 no. 9,
magazine cover,
September 1961.
Photograph: Terence
Donovan

'Design & Art Direction '63', opened by the Earl of Snowdon, was a triumph, with more than 25,000 visitors. Commander wrote in *Graphis* that it had prompted three large British organizations, which had previously paid little attention to design, to accept the need for 'a positive and up-to-date design policy in connection with their public image' (he did not name them).[22] The exhibition established D&AD at a stroke as the most significant British design competition, a position it continues to occupy. D&AD united design and advertising under a single banner, showing the work of advertising agencies alongside work by design firms and freelance designers. This was expedient and it made sense at a time when some graphic designers were employed full-time in advertising, while others, such as F/F/G, worked on advertising as part of a more general mix of projects, but it overlooked and even served to mask some crucial differences of outlook and intention that emerged almost immediately.

Commander had noted in 1960 that designers did not see it as their 'primary concern that their activity should contribute idealistically to the betterment of the human lot'. Others took a different view. One observer, responding to the appearance of *17 Graphic Designers London* and a book about design in Chicago, saw them both as evidence of the same malaise: 'Can the graphic designers of Britain and America really have so little to offer beyond what is superficial and transient? These books read like a Soviet propagandist's loaded indictment of Western capitalism.'[23] On 29 November 1963, at a packed meeting of the Society of Industrial Artists, held at the Institute of Contemporary Arts, London, Ken Garland improvised a short text, which he asked to read out at the end. This personal manifesto, titled *First Things First*, was signed by Garland and 21 colleagues, among them Edward Wright, Anthony Froshaug, Germano Facetti, Geoffrey White, Ken Briggs and Robin Fior. Garland published 400 copies at his own expense in January 1964 and it was reprinted in *Design*, *Ark*, *SIA Journal* and other publications. Anthony Wedgwood Benn MP (now Tony Benn) ran the text in his regular column in *The Guardian*.[24] Garland's much-summarized contention was that a disproportionate amount of designers' effort was devoted to promoting frivolities while more important tasks – signs, books, catalogues, manuals, educational aids, scientific and industrial publications – lost out. 'We hope that our society will tire of gimmick merchants, status salesmen and hidden persuaders, and that the prior call on our skills will be for worthwhile purposes,' he concludes.[25]

Other designers also voiced their concerns. Spencer, responding to designers' growing taste for self-promotion, complained that there

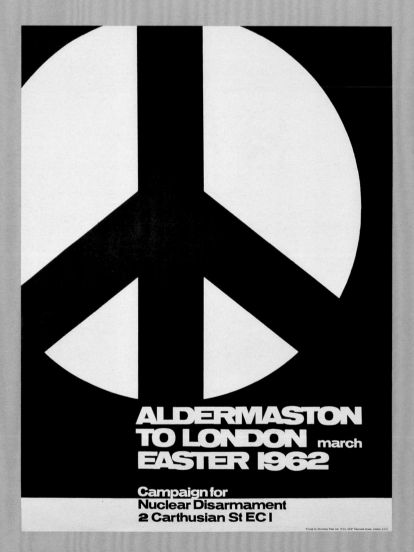

Top: **Ken Garland**, *First Things First*, self-published design manifesto with 22 signatories, 1964

Ken Garland, *Aldermaston to London*, poster for Campaign for Nuclear Disarmament, 1962

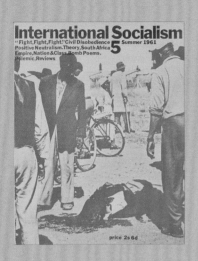

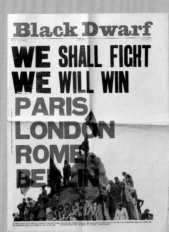

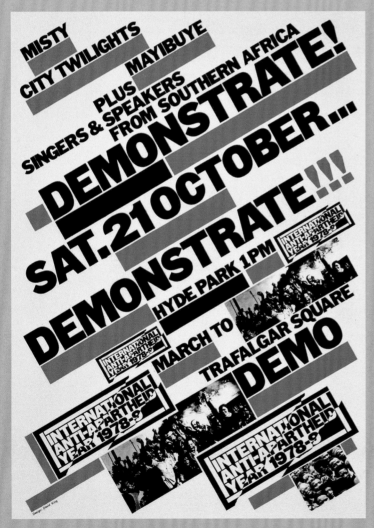

were too many 'designers' designers' creating work not to solve real problems, but to gain the approval of their colleagues. 'They are motivated by fashion rather than conviction and they are rapidly undermining the basis and principles of twentieth-century design.'[26] In 1965, in the third D&AD competition, the rarely given gold award went to Brownjohn's film titles for *Goldfinger* (1964) and *Design* magazine's two reviewers noted the high standards routinely achieved by then in this kind of 'new wave' design. Despite this, they felt that the 1965 exhibition, like the previous year's, revealed 'an appalling lack of straightforward solutions to straightforward problems'.[27] They would prefer, they noted, to see more material displaying some relevance to society as a whole. Instead, the exhibition once again left 'a prevailing impression of froth and emptiness of spirit'.[28]

Criticisms of this kind have echoed down the years, but while some designers have always struggled with issues of social relevance and responsibility and personal commitment, these preoccupations had limited effect on the mainstream of graphic design. The British economy was booming, London was starting to swing and design was being borne along on a wave of national affluence and a rapidly growing awareness, as image-consciousness took hold, of the central role that design could play. Designers were becoming steadily more business-minded and colleagues were banding together to start companies, some of which, in the years ahead, would form the backbone of the British design business: Main Wolff (1963, later Wolff Olins), Minale Tattersfield (1964), Negus & Negus (1968). Richard Negus, responding to *First Things First* in *SIA Journal*, expressed a reductive view of the designer's obligations that many of his colleagues would have found it easy to share. 'The designer, as a designer, has responsibility to clients for good design but no responsibility for the social ramifications or the effect of an advertisement or promotion.'[29]

Politically motivated designers whose careers began in the 1950s, such as Ken Garland, Richard Hollis and Robin Fior, and slightly later David King, always stood to the side of what most graphic design was about. In the 1960s, Fior and Garland created bold, largely typographic posters to announce demonstrations and rallies organized by the Campaign for Nuclear Disarmament and the Committee of 100 that forced these issues to the centre of public attention. King's later anti-apartheid posters cross-fertilized this hard-hitting, politically-driven aesthetic with a more elaborate Constructivist approach to composition to create probably the most powerful and graphically distinctive body of protest posters ever

to be produced in Britain. Such work involves a passionate degree of personal commitment and, as a consequence, it has tended to be marginalized by a view of design that prioritizes the needs of business and celebrates, through publicity and awards, the work of practitioners who produce the most effective design within these limits. Little of the dissident current in independent graphic design has been registered by D&AD (though Fior was a member in the 1960s) because little of it has been entered into the competition or sought this kind of official approval in the first place.

There has always been a question, in any case, of what exactly constitutes graphic design. The view of design as a problem-solving activity does not adequately account for work which takes a looser, more personal, more emotional and expressive tack. The more strictly design is defined in terms that support and help to delimit an emerging professional practice, the more likely it is that less tractable kinds of design expression will fail to register as 'proper' design (at least on the professional radar). By the mid-1960s, London was at the heart of an energetic international counter-culture that influenced almost every aspect of young people's lives: clothing, hairstyles, music, sexual behaviour and the consumption of drugs. Psychedelic rock bands such as Pink Floyd and the Crazy World of Arthur Brown played at new venues such as UFO and the Roundhouse. *International Times*, *Oz* magazine and other subversive 'underground' publications could be picked up at the Indica bookshop and gallery, and at similar hip establishments.[30] The new graphic styles that emerged from this scene owed little if anything to the concerns and prescriptions of professional design. A telling example is the series of 40 or so psychedelic posters produced in 1967 by Michael English and Nigel Waymouth, working as Hapshash and the Coloured Coat, to announce rock concerts and other events. Jazz musician and journalist George Melly, writing in a newspaper about this short-lived explosion of graphic activity, as it unfolded, made three telling observations. First, that the under-ground was the first of the pop movements to have evolved a specifically graphic means of expression. As Melly was not in a position to know at the time, this made it hugely prescient. Second, that the psychedelic poster was 'not so much a means of broad-casting information as a way of advertising a trip to an artificial paradise'.[31] Another way of putting this is to say that its manner of communication was experiential rather than literal and if the viewer was not tuned into the experience it offered, then it would not make much sense. Third, that psychedelic posters now attained a standard that made 'most contemporary commercial advertising look both

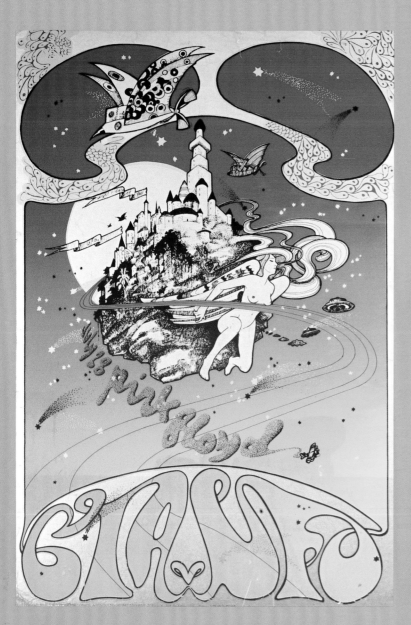

Hapshash and the Coloured Coat (Michael English and Nigel Waymouth), *CIA-UFO*, screenprint poster for Osiris, 1967

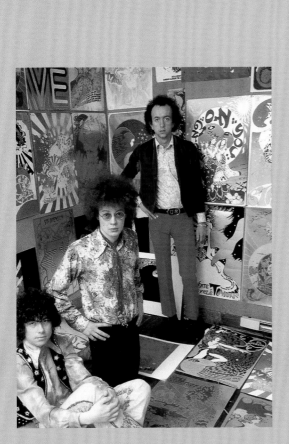

Michael English (left)
and Nigel Waymouth
(middle) with a
display of posters by
Hapshash and the
Coloured Coat, 1967

Martin Sharp,
Roundhouse UFO,
screenprint poster for
Osiris, 1967

uninventive and sloppy'.[32] This, again, is a pointed conclusion by someone with no professional axe to grind, looking at graphic communication from the outside. While much of the 1960s design that was adventurous in its day, at least for Britain, now looks unexceptional, because these approaches soon became the norm, the most inventive graphic artefacts of the counter-culture have retained their power. Early issues of *Oz* (1967-73) designed by Jon Goodchild, with artwork by Martin Sharp, an Australian artist and image-maker then resident in London, cast aside the Swiss tidiness that had become *de rigueur* for stylish designers in favour of a much more layered and chaotic approach to typography, layout, use of vibrant colour, and the fusion of text and images, often overlapping to the point of near illegibility. Sharp's imagery, seen in his *Roundhouse* UFO and Dylan posters – the latter was adapted for an *Oz* cover – has an electrifying graphic intensity that few products of the design business could match. Sharp does not advertise a lifestyle; he exhibits a state of mind.

By the end of the 1960s, after a decade of concerted promotion, British graphic design had established itself as a significant force in international design. The D&AD show became a regular feature at Board of Trade-sponsored export promotions, such as trade fairs, and, with the help of the British Council, D&AD exhibitions were shown in France, Germany, the Netherlands, Switzerland, Italy, Czechoslovakia, Indonesia and even the US. In 1969 *Print*, the American graphic design magazine, ran a special issue on British graphics, with the cover-line 'Bold Britain'. 'The fact is that British design today is uncommonly exciting and warrants examination in depth,' write the editors. 'To those who recall English graphic expression as being an uneasy mixture of Swiss and American tendencies, it may come as a surprise to learn that it has lately developed its own unique personality – one that is full of vitality, assertive and bold.'[33] What was odd, the editors felt, was that this upsurge should come at a time when Britain, as a nation, was experiencing confusion about its identity and role in the world. In the examples illustrated, most of the emphasis fell on the output of commercially astute design groups, specializing in packaging and corporate identity projects: Keith Murgatroyd (the issue's guest editor), Wolff Olins, Minale Tattersfield, Kinneir Calvert (Jock Kinneir and Margaret Calvert) and Klein Peters (formed by Lou Klein and Michael Peters). The most unlikely figure in this cast of 'new professionals', Alan Aldridge, flamboyantly attired former art director of Penguin Books and creator of an iconic 1960s film poster for Warhol's *Chelsea Girls*, had become something of a star

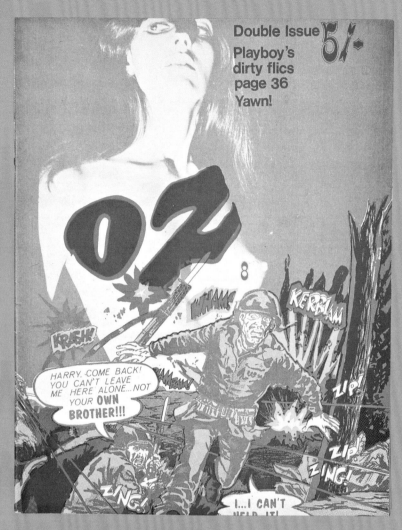

Top: **Jon Goodchild with Virginia Clive-Smith**, *Oz* no. 8, magazine cover, January 1968

Jon Goodchild with Virginia Clive-Smith, *Oz* no. 11, magazine spread, April 1968. Art: Martin Sharp

and his airbrush illustrations were the height of fashion. In an article titled 'Design today: "the new professionals"', D&AD chairman Edward Booth-Clibborn (who would occupy the role for the next two decades) acknowledged that British graphic design had been hesitant and derivative. He felt that the younger generation was shaping a new national identity and that the result for design was 'a new, native British style – uninhibited, witty, international in outlook, and exciting.'[34]

More tellingly, Booth-Clibborn suggested that the situation was now so fluid in the communication field that the term 'designer' was perhaps no longer meaningful. In any event, the designer should be free, he argued, to use film or music, or to move into any area that the task of communication required. 'The old labels have become unstuck – and we do not need new ones. A new type of creative man is wanted, one whose training gives him fluency in many skills and who knows no barriers.'[35] In truth, such figures had always been at work in European design. In the 1920s, modernists such as Rodchenko, El Lissitzky and Moholy-Nagy had moved freely across the boundaries that later, more professionally-minded generations attempted to cement in place between one medium and another, between art and design. In 1960, RCA graduate John Sewell, one of the most original British designers of his generation, wrote, directed and narrated an 18-minute film satire, *Everybody's Nobody*, in which his friend, the artist Bruce Lacey, played an automaton. Robert Brownjohn, who had been taught by Moholy-Nagy in Chicago, moved fluently from design for print into film-making. Many designers, including Brownjohn, took photographs, seeing the camera as a modern tool as vital as the pen. Pop artist Peter Blake readily produced illustrations for magazines and book covers, along-side his paintings, regarding them as more or less interchangeable, and created, in *Sgt. Pepper* (1967), one of the most famous designs of the decade. Richard Hamilton's pure white album cover for the Beatles (1968) was another audacious design concept.

In 1972, a book appeared that treated the blurring of definitions as an operational principle. In *Art without Boundaries: 1950–70* by Gerald Woods, Philip Thompson and John Williams, no hierarchical distinction is made between painting, film-making, photography, cartooning, concrete poetry and graphic design. Thompson himself was a designer and D&AD member, and in the book fellow designers such as Bailey, Birdsall, Brownjohn, Crosby/Fletcher/Forbes (architect Theo Crosby had replaced Gill), Froshaug and Marber rub shoulders with Antonioni, Christo, Fellini, Godard and Hamilton. 'At one time it was easy to distinguish between the "fine"

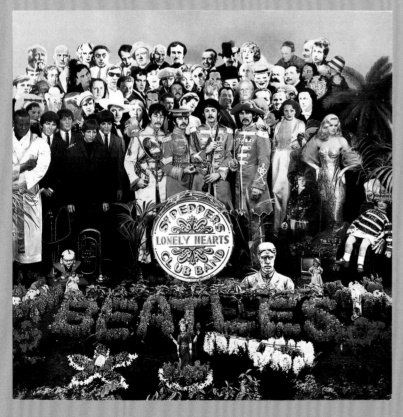

Peter Blake and Jann Haworth, *Sgt. Pepper's Lonely Hearts Club Band* by the Beatles, album cover, EMI, 1967. Photograph: Michael Cooper

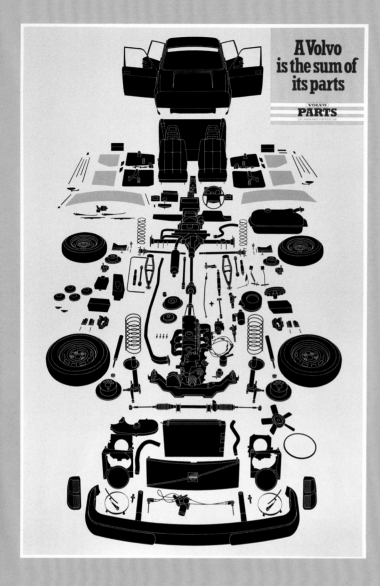

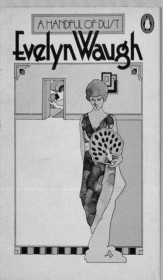

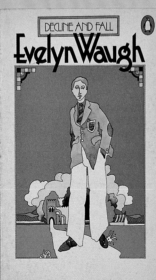

Top: **Trickett & Webb**, *A Volvo is the Sum of its Parts*, poster for Volvo, 1979. Illustration: Joe Parker

Bentley/Farrell/Burnett, *A Handful of Dust* by Evelyn Waugh, book cover, Penguin, 1972

Bentley/Farrell/Burnett, *Decline and Fall* by Evelyn Waugh, book cover, Penguin, 1972

artist and the commercial artist,' write the authors. 'It is now less easy. The qualities which differentiated the one from the other are now often common to both. … During the last twenty years or so, barriers have been broken down; and they are still being broken down.'[36] In the entry on Fletcher and Forbes, the authors suggest that their impact on the identity of British graphic design was similar to the Beatles' impact on pop music and that there is an analogy between pop music and the design groups of the 1960s. The comparison would be made many more times in the years ahead, often as a criticism.

Art without Boundaries was a highly suggestive summation of a hugely fertile period in international culture, but in local terms, the situation was, if not more restricted, then certainly more focused than the book's optimistic boundary-blurring implied. In the early 1970s, graphic design was continuing its growth as a business. Companies started at that time had a deep influence on the course of British design over the next two decades. In 1970, Michael Peters founded Michael Peters & Partners and, in 1971, Lynn Trickett and Brian Webb opened their studio Trickett & Webb. In 1972, Crosby/Fletcher/Forbes acquired another partner, product designer Kenneth Grange, and with Mervyn Kurlansky, who had joined them in the late 1960s, became Pentagram. It was already clear that the path of independent design posed some problems. If a studio stayed small, then it ran the risk of losing large corporate clients that required more intensive forms of support. However, to expand would require them to become more businesslike, and perhaps cause them to lose touch with the pleasurable aspects of being a designer. Pentagram's solution was to structure itself as a collection of small teams operating under a single roof. Each partner would control his own jobs and employ his own assistants, but the company would enjoy the benefits of shared resources and, to potential clients, its size would appear impressive. The sharing of experience might also facilitate the interdisciplinary connections described in *Art without Boundaries*. In Pentagram's first book, the partners record their ambitious desire 'to be universal men, to grasp at opportunities outside their speciality, and to use them to explode the bounds of that speciality'.[37]

For the most part, though, the first half of the 1970s was not a strong period in British design. The impact of the recession that began when the Arab oil producers cut supplies in 1973 could be traced in the rapidly diminishing page sizes of once expansive news-stand magazines and colour supplements. *Nova*, one of the most graphically exuberant titles in the 1960s, went into decline and

ceased publication in 1975. Graphic design lacked the vitality, wit and sense of discovery that marked the most effective 1960s work. The simple graphic idea, which had not long ago seemed the key to efficient contemporary communication, had become an overly deterministic formula. Illustration flourished in these years, perhaps to compensate, and the decorative Art Nouveau and Art Deco revivalism that had been a feature of late 1960s counter-cultural design continued to define the visual mood, suggesting a loss of faith in the aesthetic possibilities of the present.

Bentley/Farrell/Burnett's series of covers for Evelyn Waugh novels published by Penguin unite well-observed typographic pastiche with delicately drawn and exquisitely coloured scenes – like the 1930s revisited on LSD. Such perfectly integrated designs were the exception, since in this case, the designers were also the image-makers. More usually, the designer acted as a commissioner of images and, as a result, British graphic design was becoming much less graphic. In the 1940s, a poster designer such as Abram Games created complex pictorial spaces in which lettering and imagery were part of the same seamlessly dramatic expression of a graphic idea. By contrast, the emphasis in the 1970s on commissioned illustration led to an inevitable segregation of type and image, and something similar had also occurred in advertising, where text and image occupied strictly defined positions and roles. A cover design by Richard Hollis for the journal *Modern Poetry in Translation*, created in 1975, provides a telling reminder of the path that most British graphic design had not taken at this point. Its subject is Polish poetry and it looks, in both conception and graphic style, much more European than British, owing nothing to the decorative flourishes and directionless whimsy of fashionable taste. Hollis' design is a dynamic graphic construction based on a carefully controlled relationship between type, image and colour, between positive and negative space, and between four repeated details derived from a photograph of a man walking his dog. This is clearly a graphic idea in the purest sense, but not one that offers up an immediate, obvious meaning. Instead, Hollis uses atmosphere, suggestion and the pleasure of unravelling the cover design's intricate geometry to pull the viewer in.

Something new was needed to re-energize British design and, once again, it was supplied by youth culture and pop music. Some of the most intriguing and memorable graphic images of the early 1970s were created for record sleeves. Hipgnosis, founded in 1968 by Storm Thorgerson and Aubrey Powell, crossed visionary psychedelia with classic Surrealism in photography-based covers for

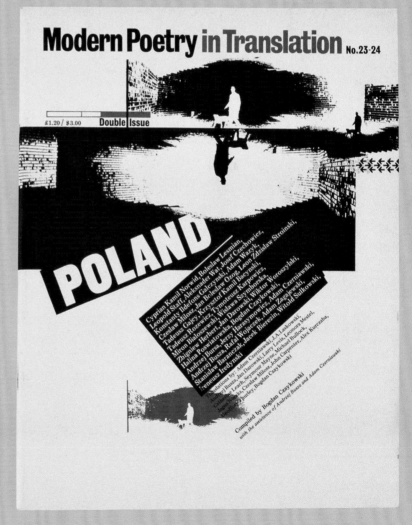

Richard Hollis,
Modern Poetry in Translation no. 23/24, magazine cover, spring 1975. Photograph: Stefan Witkowski

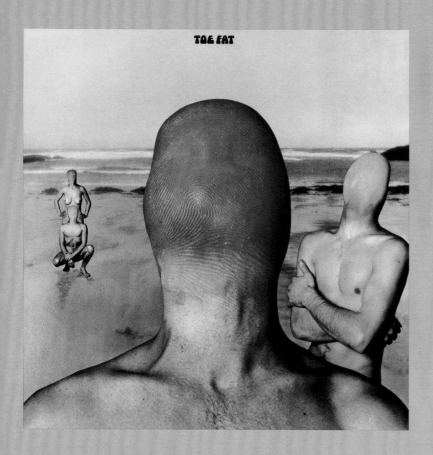

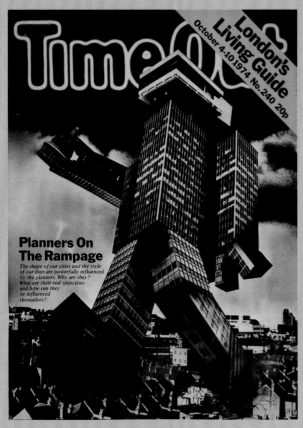

Top: **Hipgnosis**, *Toe Fat*
by Toe Fat, album cover,
Parlophone, 1970

Pearce Marchbank,
Time Out, magazine
cover, 4 October 1974.
Montage: Trevor Sutton

Toe Fat (1970), Nice (*Elegy*, 1971) and Led Zeppelin (*Houses of the Holy*, 1973) that achieved an hallucinatory presence.[38] In 1972, Nicholas de Ville, working with singer Bryan Ferry, art directed the first of a series of sleeves for Roxy Music that expressed the band's identity with an unvarying repertoire of devices. Each cover featured a photograph of a glamorous model (with two on the fourth album) and the band's name rendered in a different typeface – the album title was never given on the front. Anyone could see that a theme was unfolding. This kind of visual consistency became more familiar later, but in the early 1970s it was novel and it gave the band an air of artistic seriousness. Ferry had been taught by Richard Hamilton at the University of Newcastle upon Tyne and he brought a semiotic understanding to the use of imagery from which the next generation of designers would learn.

The story of 1970s punk and the new wave has been told many times, but its importance for the development of British design cannot be overstated.[39] Punk's anarchic spirit of self-empowerment, like that of the 1960s underground, embraced music, fashion, design, retailing, social attitudes and lifestyle. Once again, it demonstrated that culture was not simply something dished out by standard-defining 'professionals' for an audience of passive consumers, but that it could be created by young people in their own way for themselves. While established independent designers such as Hollis, King and Pearce Marchbank produced estimable work throughout this period, and Marchbank in particular enjoyed high visibility as cover designer for London's listings magazine *Time Out*, they were not in a position to exert much influence on the course of graphic design. The music designers who emerged in the late 1970s, starting with Jamie Reid, supplier of cut-and-paste graphic mayhem for the Sex Pistols, the most notorious of all the punk bands, enjoyed the best of both worlds. They were given considerable freedom, their work was immediately perceived as being at the leading edge of visual pop culture, yet they distanced themselves from the mundane design business. One of the most original British designers of the 1970s, Barney Bubbles, belonged to the same generation as Marchbank and shared his experience of working for the underground press. Bubbles's first job in the mid-1960s was with Terence Conran's Conran Design Group, where he worked on publicity materials for Habitat, Conran's fashionable homewares stores. However, he soon gave it up, preferring to go his own way and even declining to sign his work, though he did once say, 'I think commercial design is the highest art form.'[40] His projects for the hippie rock group Hawkwind in the early 1970s made a deep

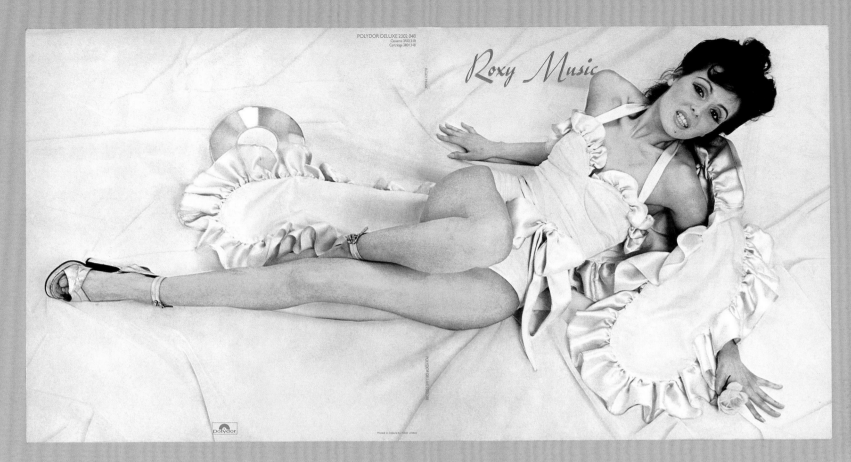

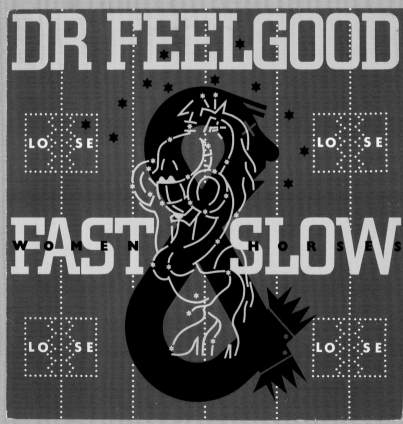

**Bryan Ferry and
Nicholas de Ville**, *Roxy
Music* by Roxy Music,
album cover, Island
Records, 1972.
Photograph: Karl
Stoecker

Barney Bubbles, *Fast
Women & Slow Horses*
by Dr Feelgood, album
cover, Chiswick, 1982

impression on designer-in-the-making Malcolm Garrett, and Neville Brody acknowledged the influence of his new wave work.[41] Bubbles was a consummate graphic thinker able to work fluently in a variety of styles and an accomplished image-maker, unlike many designers, who produced sleeves for musicians such as Ian Dury, Elvis Costello and Dr Feelgood with a playful spontaneity uniquely his own.

At the end of the 1970s, graphic design began to divide even more clearly into separate genres of work – a fragmentation that has consequences to this day. Sleeve designers such as Garrett, Brody, Peter Saville and Vaughan Oliver had all studied design at college (as had Bubbles) and they might have followed the well-worn path of becoming junior designers at established design companies before perhaps, in time, starting companies of their own. Oliver came closest to pursuing this route, working for two years at Michael Peters & Partners, where he gained experience of typography for packaging that he would shortly turn to his own ends.[42] The others worked for record labels: Garrett for Radar Records and Virgin; Saville for Factory and Dindisc; Brody for Stiff and Fetish. Slightly later, in 1983, Oliver hitched his wagon to 4AD Records as full-time designer. For these designers, the primary motivation was not to become detached, professional problem-solvers, of the kind proposed by Fletcher/Forbes/Gill, but to become fully involved in a milieu and subculture – the music scene – which they were passionate about. They were also concerned to break with the increasingly trite and, to them, meaningless visual formulas of 'idea-based' commercial design. For Garrett and Saville, who had studied together at school and college, as well as for Brody, inspiration came not from the previous generation of designers, or from that generation's heroes such as Rand and Bass, but from Pop Art and from the modernist typographers of the 1920s. Herbert Spencer's *Pioneers of Modern Typography* (1969) became their set text.[43] As a student, Garrett took a close interest in Dada and Surrealism; Brody looked to Dada, Oliver to Surrealism. In the mid-1970s, while living in Ireland, Bubbles, too, had belatedly put himself through a crash course in Cubism, Dada, Constructivism and other 20th-century art movements.

The most carefully thought-out and detailed statement of purpose came from Brody. No other young British designer of this period made such a publicly outspoken and sustained attack on the direction that design had taken. If this has tended to be overlooked in accounts of these years, it is because Brody's work made so much impact on his contemporaries as style, which inevitably went out of fashion, that it obscured his underlying aims. Brody showed

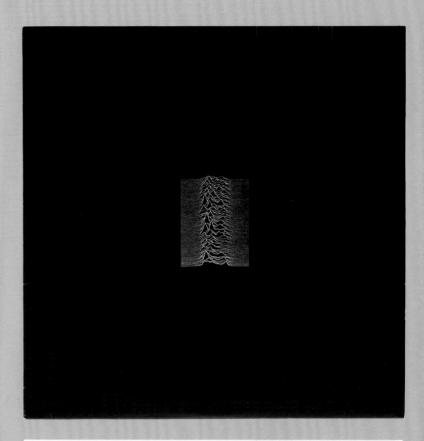

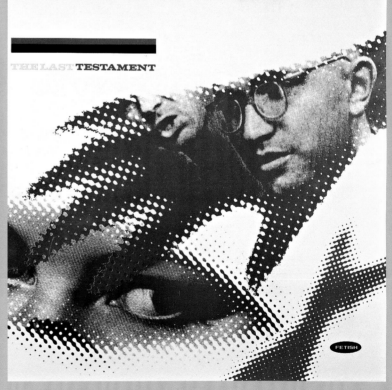

Top: **Peter Saville and Joy Division**, *Unknown Pleasures* by Joy Division, album cover, Factory, 1979

Neville Brody, *The Last Testament* by various artists, album cover, Fetish, 1983

talent as a painter and came close to studying fine art, but decided on graphic design because he felt that art was elitist and he wanted an audience beyond the galleries. 'Why can't you take a painterly approach within the printed medium?' he asked.[44] He wanted to reintroduce a sense of humanity and individual identity that he believed had been lost in contemporary communication, and the visibly hand-made marks and textures seen in many of his projects in the early 1980s were one way to do this. Brody criticized the misery caused by the 'false representations' of advertising, rejected the problem-solving approach that he had been taught as a student at the London College of Printing and challenged the idea of design as neutral communication. 'Communication exists on far more levels than the simple communication of an idea, but I can't see it as problem-solving,' he explained. 'You become a scientist, a technician, performing a service. What that does is destroy the emotion of communication, which is the thing that is most lacking in the first place. Painting is not seen as problem-solving. If you approach design from the point of view of problem-solving, then essentially it is the problem that you are communicating.'[45] Brody chose to work in the music business because he thought that it was the only field that would offer opportunities for experimentation. Other graphic designers of his generation shared some of his assumptions, but no one else conveyed the idea so persistently, through every utterance, that design could be a vehicle for a personal point of view. This simply was not the way that most graphic designers thought or talked at this time. Brody's position as art director of *The Face* magazine, from 1982 to 1986, gave him greater visibility as a designer than any of his contemporaries or elders, and his impact was confirmed by his 1988 retrospective at London's Victoria & Albert Museum. Ultimately, his example as a new kind of international design star – a role that he did not much relish – was probably at least as significant as his work.

In the 1980s, everything that the 'new professionals' had longed for in the 1960s had come to pass. Designers had always argued that good design would sell and by the 1980s, many manufacturers and retailers were convinced. The obsession with design was so pervasive, if not neurotic, that before they were over, these years had been christened the 'design decade'. 'Designer taste dominates middle-class print media – and especially magazines,' wrote marketing man Peter York in 1984. 'The look of almost everything you buy, read, or watch, reflects not so much the world it was made in, but Design Land.'[46] In the mid-1980s, design consultancies of all kinds had a combined turnover of £1.1bn and accounted for

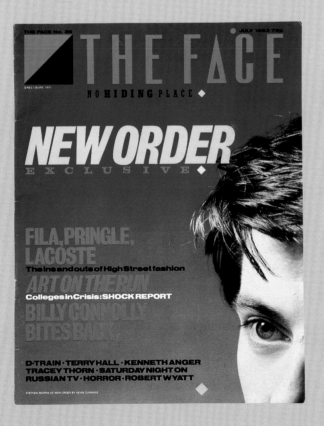

Neville Brody, *The Face*
no. 39, magazine cover,
July 1983. Photograph:
Kevin Cummins

GUERILLAGRAPHICS

THE TACTICS OF AGIT POP ART

◆ Provocative, scandalous, full of exhilarating mischief, JAMIE REID's graphic work for the Sex Pistols was as much a cause of the group's notoriety as anything they said or did. JON SAVAGE traces the style back to its origins in the era of the Underground Press and talks to Reid about the subtle art of agitation.

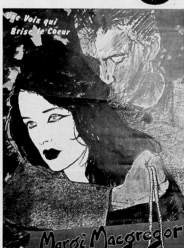

◆ Left: Jamie Reid at work on a poster for *Chaos In Cancerland*.
◆ Opposite: Jamie's sleeve for Sex Pistols' "God Save The Queen". Below: Poster for a recent single by Margi MacGregor. Centre: "Lies" sticker — "Fun things we printed at the Suburban Press on leftover bits. We printed thousands of them. You'd sit on the train and stick one on the front of some guy's *Daily Telegraph*, or on someone's TV screen or on a newsstand . . ."

For someone whose work has graced millions of record sleeves and influenced a whole generation, Jamie Reid's personal profile is not the highest. This is partly due to personal inclination and partly to the troubling nature of the work he did for the Sex Pistols — hardly likely to be appreciated in this conservative age — but is just as much the result of a stubborn refusal to abandon his preoccupations as one of that rare breed, a political artist.

His graphics for the Sex Pistols defined this perfectly: images that were apparently simple but which, when examined or lived with, revealed complexities and linkages at once disturbing and liberating — art that was political but didn't shout it. As he puts it himself: "The combination of naivete and sophistication, cruelty or discipline and compassion."

Or, as his slogan said: *Keep Warm This Winter: Make Trouble.*

After a few years of false starts — he walked out of BowWowWow and his partnership with Malcolm McLaren after the failure of "C30 C60 C90 GO!" — and what might be described as picaresque adventures, these preoccupations have a fresh focus. They're embodied in the person of Margi MacGregor, who, as Margox, had a brief but exciting career on television in the Granada region four years ago. A chance meeting — with this writer as kibitzer — in her native Liverpool took them to Paris where they've stayed, on and off, for the last three years. The result is a project that even in its current, unfinished state goes a long way to justifying Jamie's claim that it's the best work he's ever been involved with: a "novel cum exhibition cum musical" called *Chaos In Cancerland.*

After various excitements in Paris, where they went through "six companies in six months" with only one single (on French Polydor), "Beauty And The Thief", to show for their pains, both Jamie and Margi have returned to England for a breather. "It was too intense, too incestuous. You're walking a tightrope and I think we needed a respite. Of all the things I've been involved with in my life, Margi is the most stimulating person I've met besides McLaren. Personally and as a tremendous performer. Really in that Marie Lloyd tradition. She's got it. And that's one of the things that depresses me now about music, that it's used technology to become as boring as technology is in its own sake. What pop star has any charisma whatever? Just to walk on stage or appear on TV, you've got to grab people, you've got to make a tremendous effort.

"The title *Chaos In Cancerland* isn't mine; it comes from an obscure Twenties pamphlet written by a homeopath which was a spoof on *Alice In Wonderland.* I find it a very apt title for the present situation in this country. And other countries. And it relates to a lot of things that I've been trying to do with my work for the last 20 or so years. It's just the process of finding yourself and some of the obstacles that are there to stop you doing that."

Born in 1947, son of the City Editor of the *Daily Sketch,* Jack MacGregor Reid, Jamie was brought up in the Thirties dreamland of Shirley, a suburb of Croydon not too far from Selsdon, the district immortalised in the Fifties phrase "Selsdon Man" as the average ideal of the good life. He's lived there, on and off, for much of his life, and the theme of Suburbia crops up in much of his work, particularly the vicious graphic for "Satellite".

"Funnily enough suburbia was a very interesting, exciting place in the Twenties and the Thirties when it was conceived because it gave everybody a bit of garden, gave everyone a bit of space and a bit of their own time. And I think after that first generation went it became a bit of a monster unto itself. It reversed itself. You've only got to walk around the suburbs now and see the new post-war working class Thatcher voters there, the new generation of suburbia."

Educated at John Ruskin Grammar, he went to Croydon Art School in 1964; it was there that he met Malcolm McLaren. When the sit-in that they'd organised at the art-school collapsed — "when it came to the holidays nobody wanted to occupy buildings and they all went home" — he went to Paris just after the bulk of the student riots in June 1968. These were the riots that had sparked from the tiny flame lit by an obscure group called the Situationists in Nanterre University late in 1966; by May 1968 they had captured headlines around the world and the imagination of a generation. Jamie remembers the feeling of the riots as:

"Very positive. They were about people taking control of their own →

26 THE FACE

THE FACE 27

Neville Brody,
The Face no. 42,
magazine spread from
a profile of Jamie Reid,
October 1983

£175m in exports. (By 1995, exports had risen to £350m and an estimated £12bn was spent on design services.)[47] Design Land was a shiny realm of Rolodexes and Filofaxes, Mont Blanc pens and Zippo lighters, matt black Tizio lamps and Marcel Breuer tubular steel chairs. Design watchers delivered the seemingly unarguable verdict that a person's choice of artefact was an infallible guide to who they were. The preoccupation with labels such as Levi's and Dr Martens, Armani and Comme des Garçons, was an indicator of a growing brand awareness that would, by the 1990s, have mushroomed into a global phenomenon. Style magazines such as *i-D* and *The Face* celebrated the tastes of design-aware young people, and articles about graphic designers such as Bubbles, Garrett, Saville and Jamie Reid were all part of the mix.[48]

By the middle of the decade, design's bifurcation was starkly apparent. While some designers still preferred to work alone or in teams of two or three, like their predecessors 30 or 40 years earlier, the big design consultancies, such as Michael Peters & Partners, Conran and Fitch, could now employ as many as 100 or 150 people. In 1983, Peters went public and floated his company on the London Stock Exchange. By the end of the decade, shortly before the Michael Peters Group fatally over-extended itself and went into receivership, he employed more than 700 worldwide. Ken Garland reflected in 1985 on the dilemmas facing a line of work which, since its origins in the late 19th century, 'has been poised awkwardly between the poles of craftsmanship and salesmanship, the individual activity and the corporate activity'.[49] For Garland, the key terms in this comparison were clearly craftsmanship and individual activity. He found it more satisfying to deal face to face with an organization's leaders, and if this meant his small company working for small and medium-sized clients, this was fine. Garland feared that the design consultancies that would struggle most in the new, polarized design landscape of the 1980s would be medium-sized. The disappearance of many of their natural clients, medium-sized businesses, through mergers and takeovers, would oblige them to compete against the big consultancies for larger clients less sympathetic to their values and ways of working.

For a few designers, the overwhelming triumph of design provoked a desire to purge and purify the practice and this led in the perhaps unlikely direction of modernism. This was the decade, after all, when postmodernism became a ubiquitous buzzword and the old certainties and verities of modernism were constantly under attack.[50] Brody, recoiling from the way that his designs had been taken up as fashionable style, particularly by advertising, opted for plain

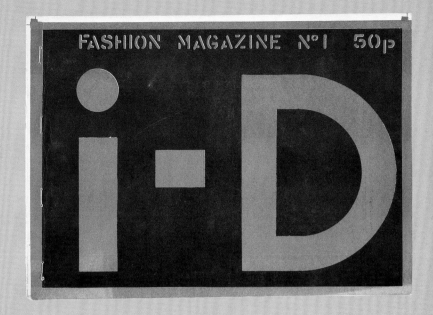

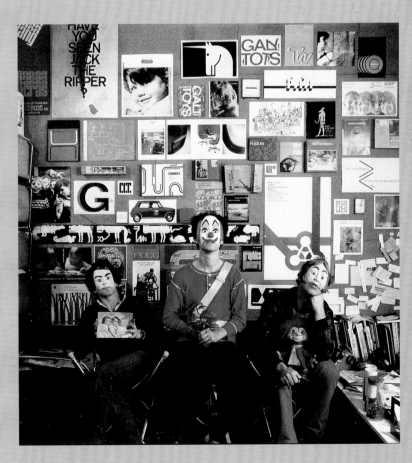

Top: **Terry Jones**,
i-D no. 1, magazine
cover, 1980

Colin Bailey (left),
Peter Cole (middle)
and Ken Garland (right)
in the studio at Ken
Garland & Associates,
London, 1982

the emperor holds court
giorgio armani is at the
leading edge of the most
important business in the
post-industrial world – the
creation and manipulation
of identity. *deyan sudjic*
unravels a business that
also happens to turn over
£150 million a year

Helvetica in the pages of *Arena* magazine, launched in 1986. It was a repudiation – though, as it turned out, only temporary – of everything that was personal, painterly, expressive and overtly postmodern about his work. In the same year, the four-man team 8vo launched the first edition of *Octavo*, which they planned to publish for eight issues. Two of them, Hamish Muir and Simon Johnston, had studied at the Kunstgewerbeschule (School of Applied Arts) in Basle, learning from Wolfgang Weingart, one of the most influential typographers of the last 40 years. 8vo's demand for typographic purity and rigour, expressed in such an uncompromisingly manifesto-like manner, was unheard of in contemporary British graphic design. 'Our work deals solely with the formal relationships between visual components, rather than being simply a service mechanism for "clever ideas". Idea-based design relegates visual/aesthetic considerations to a secondary role,' said Johnston.[51] The exacting precision and beauty of *Octavo*'s typography and layout instantly related it to the Swiss International Style of the 1950s and to the work of Anthony Froshaug, who was reassessed in an article in the first issue.[52] In an editorial parenthesis, 8vo made a point of distancing themselves from what they saw as the failings of English culture and design: '(it would be difficult to complete eight issues of a publication with examples of good English typography. As a nation our respect for tradition, nostalgia, fashion, and our love affair with symmetry make such a proposition unthinkable.) As editors we take an international, modernist stance. This is necessary in England.'[53] *Octavo* had arrived out of nowhere, but its quality and sense of purpose gave it immediate authority. 8vo were filmed by a BBC2 arts programme throwing paint on Brody's work, an emblem for them of everything that had supposedly gone wrong in British graphic design.[54]

The new wave designers had broken the stasis in British design, opening the way for evolution and a wider variety of aesthetic approaches. Now European tendencies, largely ignored for more than a decade by the mainstream, were once again exerting an influence. While some designers were beginning to reassess modernism, others were taking their cue from Dutch graphic design, in particular from Gert Dumbar's work. Dumbar had studied at the RCA from 1964 to 1967 and, in the 1980s, his company Studio Dumbar often entered and won the D&AD awards, giving his way of working unusually high visibility in Britain. From 1985 to 1987, Dumbar was professor of graphic design at the RCA, further extending his influence. His studio's designs combined modernist typographic rationality with unpredictable elements that were

Neville Brody,
Arena no. 6, magazine
spread from a profile
of Giorgio Armani,
December 1987.
Photograph:
Tony Meneguzzo

8vo (Simon Johnston,
**Mark Holt, Michael
Burke, Hamish Muir)**,
Octavo no. 1, cover of
self-published
magazine, 1986

8vo, *Circuses and
Bread* by the Durutti
Column, album cover,
Factory, 1986

Top: **Why Not Associates (David Ellis, Andrew Altmann)**, folder for the Arts Council's visual arts department, 1991

Neville Brody, *F Code* poster for *Fuse* no. 6, FontShop International, 1993

emotional, arbitrary and strange, particularly in the use of photography. What was especially surprising to British designers was that he achieved these freedoms with even the most apparently cautious of clients. His portfolio included work for small arts organizations alongside public projects for the institutional and corporate sectors.

The independent designers who emerged at the end of 1980s sought to emulate this range of clients. In this sense, design had turned full circle – teams such as Fletcher/Forbes/Gill took a broad client-base for granted. Where Garrett, Saville and Brody had grasped, correctly, that the music business could give them the most freedom, ten years later, with design awareness greater than ever, it seemed possible to produce challenging design for a much broader range of clients. The new generation also recognized the dangers of type-casting. They had seen how designers such as Saville and Garrett had struggled to convince clients outside the music scene that their skills were transferable. What the late 1980s designers shared with the 1970s new wavers was a belief that design could be personal, that it could be aesthetically adventurous, and that it need not conform to the dated simplicities of the graphic idea, which they regarded as patronizing and dull. For this generation, too, *Pioneers of Modern Typography* was a significant influence. They responded to the work's formal daring, its dynamism and plasticity. Whether the immediate inspiration came from Weingart or Dumbar, the lineage was modernist, with its sources in the 1920s. This was different, however, from the questioning of design by Garland or Brody, which came from political convictions and a particular way of looking at society. The late 1980s designers insisted on their right to free aesthetic expression, as did Dumbar, but other than this most of them were not trying to 'say' anything through their work. They tended to explain their methods in much the same terms of client effectiveness that designers had always used, except that their sense of what would be effective was different now.

By the end of the 1980s, an even more fundamental change was driving graphic design: the computer. British graphic designers had not been especially quick to engage with the Apple Macintosh. Americans such as April Greiman and Rudy VanderLans acquired Macs in 1984, when the computer was first launched, and immediately set about developing a computer-based graphic aesthetic. In Britain, even Brody, a vocal advocate of digital aesthetics and founder, in 1991, of the type publication *Fuse*, did not start experimenting with the Macintosh until 1988. Although people assumed that his angular typefaces for *The Face* were digital productions, they were originally hand-drawn. 8vo's early designs

were also assembled using galleys supplied by a typesetting
company, which were pasted up manually as artwork, as was the
typographically intricate early work by Why Not Associates, formed
by David Ellis and Andrew Altmann in 1987, after graduating
from the RCA, where they had studied under Dumbar. Yet in all
three cases, the visual processing capabilities of the computer, once
embraced, drove the development of much more complex graphic
and typographic constructions than would have been possible
without extraordinary efforts using manual means alone. Brody's
work returned to its painterly origins and he became fascinated by
the idea of a font as a collection of abstract marks. 8vo's typography
became denser, more compacted, super-charged with expressive
energy and the exhilaration of form. Why Not's creations were
wild assemblages of wandering letterforms, irregular shapes and
stray rules colliding together and rushing apart. This flew in the face
of everything that a designer was instructed to do to reduce
complexity, eliminate redundancy and clarify the message, but it was
by no means as uncontrolled as it might appear at first glance.
Designs such as Why Not's folder for the Arts Council's visual
arts department, created in 1991, are meticulously balanced visual
structures. The designers take it for granted that the viewer
will share their delight in irreverently playful form and that this
exuberance will reflect the client's values and goals.[55]

New developments in British graphic design had caused
controversy since the early 1980s. Older designers, educated in the
1950s and 1960s, often viewed new wave work with bafflement,
claiming that it lacked substance and was purely a matter of style.
This was neither correct nor fair in many cases, but it made a
certain amount of cultural sense. The magazines that had nurtured
this approach were commonly known as style magazines and
publications such as *The Face* were in thrall to the idea of style as a
medium of individualistic expression. Style had become a public
issue and even the Left had started to wonder whether it needed
to dress up its political messages more stylishly. It was also true
that the work of Saville, Brody, Oliver and others depended for its
impact on its aesthetic qualities. If Oliver used a piece of
Japanese rag paper to create an area of visual texture in a record
sleeve design, then that was clearly a stylistic decision and effect.
Moreover, if he did it more than once and used other similar
textural devices as part of his visual repertoire, then this could be
regarded as an aspect of his personal style. According to the rhetoric
of problem-solving, though, a personal style was at best a distraction
from the communication task at hand and at worst completely

Vaughan Oliver,
23 Envelope, *L'Esclave
Endormi* by Richenel,
12-inch single cover,
4AD, 1986. Photograph:
Nigel Grierson

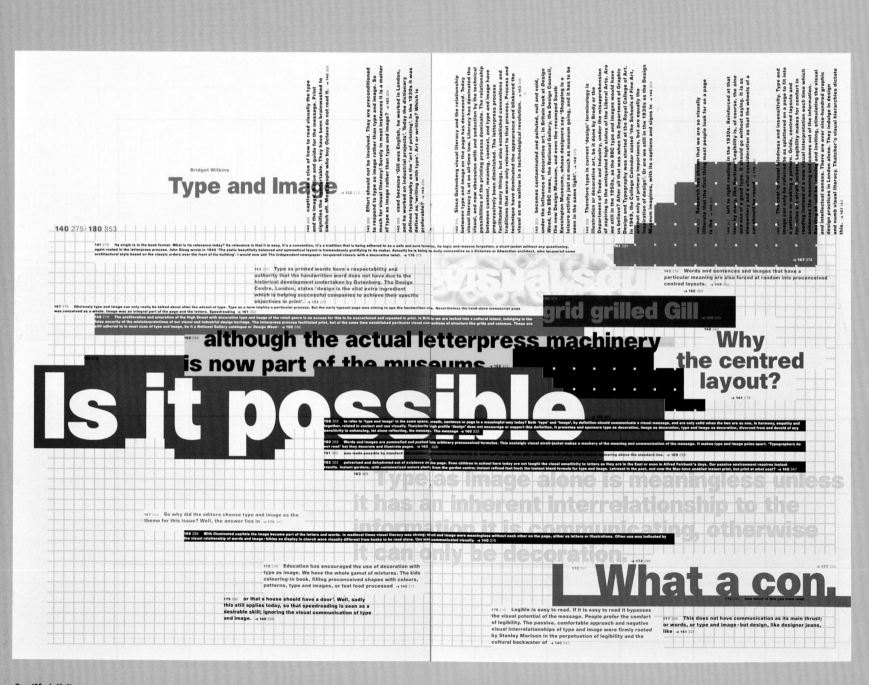

Bridget Wilkins

Type and Image

Is it possible

although the actual letterpress machinery
is now part of the museums

Why
the centred
layout?

What a con.

**8vo (Mark Holt,
Michael Burke,
Hamish Muir)**, *Octavo*
no. 7, spread from
self-published
magazine, 1990

unnecessary. In 1962, Henrion had sounded a warning against 'designers who suffer from an over-preoccupation with self-expression and impose their personal solutions on problems which they have not even tried to understand'.[56] A generation of visual communicators had taken such sentiments to heart and, after all these years of selfless problem-solving, the eruption of visually expressive work that could be instantly identified as a 'Brody' or a 'Saville' caused resentment and dismay. (It was a significant moment when Saville joined Pentagram in 1990 because it suggested that the partners at one of the bastions of 1960s problem-solving had decided that his work was not, after all, about the unthinking manipulation of style, but that it was based on rationales and ideas.)

To those who were already suspicious of the excesses of style, the labyrinthine, computer-generated designs of the early 1990s appeared to exemplify all the worst tendencies. Once again it was Garland, one of graphic design's most persistent and trenchant observers over four decades, who went on the attack. In *Design*, he singled out two recent magazine projects as examples of 'typographic footling' (silliness or triviality). One was an issue of *Issue*, designed by Cartlidge Levene and published by the Design Museum, in which a matrix of decorative rules criss-crosses the pages, lancing everything in its path. The other was *Octavo*, which Garland had initially supported, though evidently with reservations, as he now revealed: 'all the incipient mannerisms that had been present from the very first issue in 1986 had now burgeoned into monstrosities. Whatever respect there had been for the text had now all but disappeared.'[57] In one notorious spread from issue 7, shown in *Design*, an essay titled 'Type and image' is crumbled into fragments and scrambled in a riot of brightly coloured type.[58] Yet a reading of Bridget Wilkins' article, which is reprinted in full at the back as a linear text, suggests that this was always intended by the editor-designers as a provocation (perhaps rather despairing) aimed at all those who bought *Octavo* not to read it but to admire its lavish design and print quality. 'Grids, centred layouts and formulas are straitjackets,' writes Wilkins. 'Legibility makes for comfort in reading instead of a new visual interpretation each time which enhances the meaning and comes out of the communication. Reading should be enticing and inviting, stimulating the visual and intellectual senses. There are over nine hundred graphic design practices in London alone. They indulge in design and numb visual literacy.'[59]

Wilkins' words summarized the feeling among many young graphic designers that design had an even larger role to play in

Cartlidge Levine, *Issue* no. 6, magazine cover, Design Museum, spring 1991. Photograph by Richard J. Burbridge

Autumn 1990
Musical Vision
at the Queen Elizabeth Hall
This LCO concert series is sponsored by Technics hi-fi

LCO

London
Chamber
Orchestra

Venue
Four
concerts at
the Queen
Elizabeth Hall

Dates
Friday
7 September
All American

Thursday
20 September
All Mozart

Friday
9 November
All Bach

Friday
30 November
All Minimalist

Time
7.45pm

Bookings and
Information

South Bank
box office:
071 928 8800
10.00am–9.00pm

All branches of
Keith Prowse
and First Call

Technics

communication than conventional hierarchies allowed. Others had their doubts. 'All this fire-breathing polemic seems to lead merely to a plea for graphic designers to be allowed to make their presence known,' writes design historian and critic Robin Kinross.[60] Yet even if this were all that was happening – and this requires us to ignore completely design's potential for positive communication – the 'plea' was an inevitable response to the evolving role of design. If Christopher Booker had been right about the importance of image as an expression of social change at the end of the 1950s, then this was even more the case now. Such concerns were more pervasive, more all-consuming, more intense in every way. Designers did not need to read McLuhan, Barthes or Baudrillard to grasp the immense power of the image world and the centrality of design – magazines, books, television, advertising, shops, restaurants and travel confirmed it at every turn. It was hardly surprising in a consumer society that stressed the importance of individual fulfilment and rated design so highly that designers would also wish to have a voice.

Young designers increasingly took it for granted that their work would be, wherever possible, a form of personal expression. Staying small and independent, whatever difficulties this might entail, was the only reliable way of achieving some degree of creative autonomy. After working for successful 1980s design groups such as Smith & Milton, and Robinson Lambie-Nairn, creators of the Channel 4 ident, Siobhan Keaney set up on her own. 'I knew that no matter what happened, even if it was a disaster, I could not go back and work for a design group,' she explained. 'I'm not good working in a team. Also I didn't want to bend to decisions that I didn't think were right, because I have strong ideas about my work.'[61] It also became more common, though it was still unusual in terms of the profession as a whole, for highly motivated independents to express a clearly articulated studio ethos or philosophy so that, as with Brody or Oliver, their output was perceived as an *oeuvre*. One of the most influential was The Designers Republic, founded in Sheffield in 1986 by self-taught designer Ian Anderson. Working at first for clients in the music business, then in the entertainment industry, Anderson and his collaborators originated a studio style grounded in the drawing, layering and replicating possibilities of the computer – their designs often resembled a technical illustrator having a brainstorm. No British designer emerged in the 1990s to equal Brody's international impact in the 1980s, or the American David Carson's in the 1990s, but TDR came close and their 'techno' style was imitated from Germany to the US.[62] Tomato, formed by a

Top: **Mark Porter**, *Direction*, magazine cover, December 1991/January 1992. Photograph: Steve Speller

Siobhan Keaney, spread from a brochure for Browns Retail, 1986. Photograph: Robert Shackleton

Top: **The Designers Republic**, *Familus Horribilus* by Pop Will Eat Itself, album cover, Infectious Records, 1993

group of friends in 1991, offered another highly influential example of the freedom, publicity and rewards that might follow the decision to start your own studio. The eight initial members configured themselves loosely as a collective, with a couple of musicians in the line-up, making the old comparison between the pop group and the design group even plainer. This was perhaps the closest that any design team had come to achieving the flexibility of self-definition and manoeuvre suggested 20 years earlier by *Art without Boundaries*.

Another characteristic of several 1990s studios was that they initiated their own projects. Some designers have always taken this path. David King had rapidly evolved from magazine art editor into an author of visual books about Soviet history, drawing on his own massive archive of photographs. Garland published *Graphics Handbook*, the first of several books, in 1966. Hollis's *A Concise History of Graphic Design* (1994) is a standard reference on the subject. Fletcher's career-long commitment to producing his own work culminated, after years of research, in the appearance of *The Art of Looking Sideways* (2001), a massive compendium of reflections about visual thinking. The tradition of professional reflection has continued with books about design matters by Lucienne Roberts, Quentin Newark, Michael Johnson and David Crow.[63] These are illustrated texts about particular topics, with the designer in the role of author, as well as acting as his or her own designer. In the 1990s, however, some designers began to treat graphic design itself as a medium of authorship.[64] Books and short films by Tomato and Fuel (founded in 1991), banners and posters by TDR, unorthodox typeface designs by Jonathan Barnbrook and Paul Elliman, and self-initiated publications and wall-mounted texts for gallery display by Scott King became the means for exploring personal ideas, concerns and obsessions.[65] Some fellow designers inevitably criticized such work as 'art', seeing it as a misguided attempt to elevate the designer and a slur on graphic design's vital role as a medium of everyday public communication. It was certainly the case that completely autonomous work, created as the expression of a personal vision, required different yardsticks to assess its quality, effectiveness and value. It seems unarguable, though, that this kind of activity has created new possibilities for visual communicators, and that designers with a strong point of view will continue to devise their own forms of graphic authorship. There is a growing audience and market and, if the work is good enough, it is likely to develop.

The formal explosions and legibility debates of the first half of the 1990s were so intense that it was probably inevitable that the period that followed would be less certain. By the middle of the decade,

Top: **Paul Elliman**, advertisement for The Cornflake Shop hi-fi consultants, 1991

Fuel (Peter Miles, Damon Murray, Stephen Sorrell), *Fuel* no. 1, 'Girl', spread from self-published magazine, spring 1991

CRASH!
CREATING RESISTANCE AGAINST SOCIETY'S HAEMORRHOIDS

ISSUE No.1 SPRING 1997 PRICE £3

DEATH TO THE NEW

Scott King, *Crash!*
no. 1, cover of self-
published magazine,
spring 1997. Words:
Matthew Worley. Design
assistance and
production: Nick Booth

after the huge outpouring of energy in British graphic design, there was a feeling almost of exhaustion. All the rules had been broken, anything was now possible; designers were fully in command of the tools of production and their creations were more complex, spectacular and overloaded with visual content than ever before. They had gorged themselves, like exuberant children turned loose in a cake shop, on the pleasures of formalism, and now a certain queasiness had set in.

The problem that faced designers arriving on the scene in the second half of the 1990s lay in knowing what to do next. The last 30 years of graphic design had seen a remarkable amount of formal innovation, especially when design was viewed in international terms. Designers usually made their mark and built their reputations by inventing new kinds of form, but it was hard to believe that, in formal terms, there was much left to do. Modernism, given a generous push by Brody and 8vo, provided one answer. It offered the possibility of jumping backwards to a tried and tested way of working with an impeccable pedigree that still looked rigorous and fresh: dynamic asymmetry, sans serif type in small sizes, photography rather than illustration (later, illustration would return) and copious amounts of white space. Retooled modernism was attractive to larger independents such as Carroll, Dempsey & Thirkell (founded in 1979), which applied it with vigour to album covers for the London Chamber Orchestra and an identity for English National Opera, as well as to smaller, more self-conscious experimentalists such as Mark Farrow, Cartlidge Levene and North (founded by former Cartlidge Levene designers Sean Perkins and Simon Browning).

An ironic, mutant, postmodern 'modernism' was also the basis of TDR's work, though it could be argued that modernism's return as a form of vernacular, one style among many in a pluralistic design landscape, was a postmodern phenomenon. This was not real modernism – it was neo-modernism. Corporate identities for First Direct phone banking, on which Perkins had worked at Wolff Olins, and for the Orange mobile phone network confirmed the style's mass appeal: it was clean, tasteful and contemporary, corporate, predictable and unthreatening. By the late 1990s, neo-modernism had become the default mode not only of British design and advertising, but of design the world over.

There had always been abstainers, though, designers who managed to say more with less, in a new way, without resorting to dependable modernism or falling back into the kinds of retina-denying cliché that had caused design's new wave rebellion in the

first place. From the late 1980s, Elliman's work was fastidiously restrained and, at a time when many were spinning tangled webs of type, Fuel applied an almost brutal directness. Both showed a liking for the ordinary, the everyday and the otherwise overlooked. Elliman's 'Bits' type project discovered an ever-growing family of letterforms in the rubbish gathering in the gutters at his feet. The more questioning designers who emerged in the late 1990s tended, like Elliman and Fuel, to make a little go a long way. There was something almost ecological about their reluctance to disfigure and pollute the page or screen with self-indulgent typographic effusions and superfluous marks. In 1998, *Blueprint* dubbed this tendency the 'new graphic realism'. 'The aim is to get away from the slick and sanitised, the constructed and self-conscious, and replace it with something smeared with the fingerprints of its time,' writes Claire Catterall, curator of 'Stealing Beauty', an exhibition at the ICA, London, which explored these approaches.[66] 'There's a lot of seductive imagery and colour around these days, without much attention to content and concept – design that is solely about the way something appears,' explained Daniel Eatock and Sam Solhaug of Foundation 33.[67] Their typography was so bureaucratic-looking, with forms, templates and boxes for people to fill in, that it took on a deadpan humour. Another designer, John Morgan, who collaborated with Derek Birdsall on the *Common Worship* prayer book, produced a 'Vow of Chastity' based on the Dogme manifesto issued by Danish film director Lars von Trier and others in 1995 to prohibit needless excesses in film-making.[68] Among other things, Morgan's document bans the use of pastiche, superficial elements, graphic wit, images that do not relate to the text, Photoshop and Illustrator filters and design credits (unless everyone is credited), 'I swear as a designer to refrain from personal taste!' he concludes. 'I am no longer an artist.'[69] Other young British designers, such as Åbäke, and Frith Kerr and Amelia Noble, used a wider range of typefaces, sometimes creating their own eccentric fonts. But they shared the distaste for unnecessary clamour and obvious computer effects, preferring to entice the viewer by speaking softly and allowing space in the designs for moments of delicacy and oddness.

British graphic design in the early 2000s was as confident as it had ever been. There was more of it around, there were thousands more designers doing it and, if the quantity of lavishly produced magazines and books devoted to the topic was anything to go by, there was more interest in it than ever. It had become the fabric of everyday life, a living tissue of messages that permeated and helped to structure and to direct almost every aspect of

communication and commerce. It was also, despite an in-built tendency to reproduce popular styles to the point of exhaustion, more varied and open to alternative approaches and new ways of thinking than it had perhaps ever been. The differences of emphasis and the debates of the last four decades had generated a climate of discovery in which 'graphic design' – if that was still the right term – could be almost anything, so long as imagination was given free rein. It could be used for highly focused social purposes, or as an exploratory form of personal expression, or for any number of possibilities in between. As developments over the last 40 years have shown, any attempt to be prescriptive is ultimately pointless because graphic communication is a visual language as adaptable and protean as speech and it cannot be constrained. Whatever directions it might take in the future, independent designers following their own enthusiasms, passions and hunches are the researchers and field-testers most likely to ensure its development.

Kerr Noble,
*User_Mode = Emotion +
Intuition in Art + Design,*
poster for a symposium
at Tate Modern, 2003.
Photograph:
Amber Rowlands

Does the Pill confuse women? In G2

The Guardian

guardian.co.uk

Tracking the Runningman
Hot on the heels of the missing miles

In G2

Space—property, design and interiors

space

In G2

Juliette Binoche
'Tragedy is a treasure in disguise'

In G2

Safety team vetoes leading air traffic bid

Israel stun
by bus carn

TO

CITY

SEAN KENNY
FRANCIS NEWTO

views

Publishing

Britain has often been described as a literary culture, rather than a visual culture, but by the 1960s the balance was starting to alter. Magazines such as *Town* and *Nova* delivered well-written journalism in consummately art-directed pages. Penguin continued to innovate with paperback covers that combined attractive graphic variety with a consistent visual identity. For the rebellious underground press, epitomized by *Oz*, visual imagery and uninhibited page layouts became a crucial part of the message. From then on youth culture would be a launch pad for graphic experimentation and, in the 1980s, self-consciously designed style magazines such as *i-D* and *The Face* exerted great influence on the direction of British visual culture. Newspapers, too, were becoming aware of design's power to engage and inform readers, but it was not until the 1980s, with the arrival of *The Independent* and David Hillman's redesign of *The Guardian*, that newsprint finally accepted the imperative to look good. *The Guardian*'s evolving design was a model of its kind, and its website reflected its identity. By the 1990s, design was regarded as a necessity for every kind of publishing project and books were increasingly created and consumed as beautiful objects.

Top: Designer unknown, *Penguin Modern Poets 2* by Kingsley Amis, Dom Moraes, Peter Porter, book cover, Penguin, 1962

Romek Marber, *Boiled Alive* by Bruce Buckingham, book cover, Penguin, 1961

Top: **Peter Barrett**, *Penguin Modern Poets 3* by George Barker, Martin Bell, Charles Causley, book cover, Penguin, 1962

Romek Marber, *The Case of the Perjured Parrot* by Eric Stanley Gardner, book cover, Penguin, 1961

Romek Marber, *The Innocence of Father Brown* by G. K. Chesterton, book cover, Penguin, 1962

Top: **Romek Marber**, drawing of cover grid for Penguin Crime series, 1961

Romek Marber, *Lord Peter Views the Body* by Dorothy L. Sayers, book cover, Penguin, 1962

Sewell

visit The CITY Bookshop
look for the Post Office sign in Gracechurch Street and turn in there
7 Ship Tavern Passage

John Sewell,
poster for The City
Bookshop, early 1960s

Top: **Keith Cunningham**,
Quartet by de Sade,
book cover, Peter Owen,
1963

Keith Cunningham,
Summer Storm
by Cesare Pavese,
book cover,
Peter Owen, 1966

Top: **Keith Cunningham**,
Gertrude by Hermann
Hesse, book cover,
Peter Owen and Vision
Press, *c.* 1965

Keith Cunningham,
Mr Three by William
Butler, book cover,
Peter Owen, 1964

An About Town enquires out to explain the phenomenal ten-year success of the party in power

Why are the Tories in power? What secrets lie behind the popular image?

This exclusive interview with the Prime Minister begins ABOUT TOWN'S investigation

'As Disraeli said, "the easiest thing to live down is being young." That might refer to my past, but things have changed a lot. The party is much stronger. It is only when the Conservatives are a national party that they have grasped and held the affection of the country. The party has always been a coalition. It has grabbed in, clawed in, great numbers who are not, perhaps, Conservatives. At other times, in the bad times, it has turned in on itself... Parties of the left break up. It is their doctrinaire character, their vociferous elements. When they break, we attract the moderate elements... Today the opposition behaves as though chasing heretics in the middle ages. But why do they worry? The great advantage of not being in office is that you don't have to make decisions on these issues. The position in the country is so much changed - wealth more distributed, power more distributed. I was amazed to see an opponent in a recent by-election criticise our candidate because he was non-U and non-Public-school... The 1914 war was terrible, far worse than the last war. I couldn't go back to Oxford afterwards. Walking round the colleges, all those memorials. In my college that year were three exhibitioners and three scholars - I was the only one left alive... The Tory Party produces nothing for the welfare state - it is the productive effort of the country, the ratepayer and the taxpayer. There is no pool of endless funds, as some people seem to think... Suez! It was a great shock to take over from a man like Sir Anthony Eden, with whom one had worked so long. A man so respected, loved, struck down on a battlefield, like taking over a battalion when the commanding officer is cut down. There were three factors that made it possible - the loyalty of our own troops, whatever skill one might possess, and the inefficiency of the enemy... It is said that a strong opposition is necessary to stop the government being complacent. It's not true. We go on working just the same. There are too many worries, the problems are too big - armaments, China, Russia, all these mean we can work harder. There is no holiday...'

Len Deighton Date of Birth: 18.2.29 | National Status: Anglo-Irish | Maiden Name of Mother: Fitzgerald | Place of Birth: Marylebone, London, U.K. | Description: height six feet. Weight fourteen stone. Complexion dark. Hair black, worn short. Eyes blue. Clean shaven. Medium build. | Special peculiarities: bayonet scar, three inch diagonal, palm right hand. Large hands, short thick fingers. | Habits: talks rapidly and tends to gesticulate. Punctuates speech with nervous laughter. Cruel, sardonic sense of humour. Vicious temper which he controls with difficulty. Is prone to exaggerate accomplishments. Dresses impeccably or slovenly. Trained to comprehend control systems; he controlled a London railway marshalling yard for a prolonged period. Smokes Gauloises occasionally. Drinks warily. | Skills: encyclopedic knowledge of military history tactics and weapons. Expert rifle and pistol shot. Experienced frogman. Known to have worked for RAF Special Investigation Branch. Widely travelled with special knowledge of, and contacts in: Havana, Darwin, Macao, Casablanca, Tokyo and Anchorage.

DOWNGRADED TO UNCLASSIFIED

The IPCRESS File / A NOVEL BY Len Deighton

Secret File No. 1

Top: **Thomas Wolsey**, *Town* vol. 4 no. 5, magazine cover, May 1963. Illustration: Barry Fantoni

Raymond Hawkey, *The Ipcress File* by Len Deighton, book cover (front and back), Hodder & Stoughton, 1962. Photograph: Ken Denyer

Top: **Thomas Wolsey**, *About Town* vol. 2 no. 3, spread, May 1961. Photograph: Terence Donovan

Raymond Hawkey, *Only When I Larf* by Len Deighton, book cover, Sphere, 1968. Photograph: Brian Duffy

Top: **Harri Peccinotti**,
Nova, magazine cover,
May 1966

David Hillman,
Nova, magazine spread,
February 1972.
Illustration: Michael
McInnerney

Top: **David Hillman**,
Nova, magazine cover,
February 1972.
Photograph: Hans
Seurer

Richard Hollis,
Ways of Seeing by
John Berger, book
cover, Penguin, 1972

Derek Birdsall

You studied book production at the Central School of Arts and Crafts.

The course was called 'Book Production', but I do not think anybody studied book design as such. In those days, 1952–55, you were not allowed anywhere near the composing rooms. That was the printing industry. There was an iron door, quite literally, between you and it. We used to steal in at night and set type. I was nearly expelled once for being caught setting type.

I had a printing press when I was fifteen at Wakefield College of Art. I bought a little flatbed Adana, a simply horrible machine. But it was printing – and printing was magic. I did things for local shops. When I came to the Central, I made part of a living from making letterheads and so on for people. My show at the Central School final diploma exhibition was six letterheadings and three business cards, and Edward Bawden, the famours illustrator, who was the outside assessor, failed me. He said, 'Not enough work and the type's too small,' and walked out.

Do you have a particular approach to book design?

I realize in retrospect that I have never regarded magazine design and book design as anything different. Quite a lot of my approach to book design is magaziney, and vice versa. I have always thought that magazines should be very readable and enjoyable to read, and not too buzzy. So I never felt there was a dichotomy between the two. I began to enjoy the process. I began enormously to enjoy – I still do – a huge pile of transparencies and prints and a big manuscript. That is my element. I know that I can make good sense of that.

It is all pragmatism. It has got to be. There are certain givens. One of the most important givens for me is leading – seven out of ten books have not got enough space between the lines! It is surprising how often a smaller size of type with more leading is just as readable, if not more readable, than a bigger size of type with less leading. That is arithmetic, almost.

What are the other givens?

The relationship between the illustrations and the text – the congruency, as I have learned to call it. The balance of illustrations on a page. My *bête noire* is illustrations, of works of art in particular, where the largest picture is shown smaller than the smallest picture. That should be a capital offence! It is utterly false information. I cannot see any reason that justifies false scale, except for details. But with details I am rather obsessed with actual-size details. If you are going to show a detail, show it the real size of the painting, so you are getting double information.

You did a lot of work with Pelican and Penguin in the 1960s, often with Harri Peccinotti – on the Somerset Maugham series, for example.

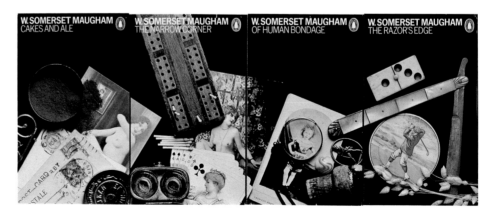

Top: **Derek Birdsall**, spines of Penguin Education series, Penguin, 1971

Middle: **Derek Birdsall**, book covers for Penguin Education series, 1971

Derek Birdsall and Harri Peccinotti, book covers for series of W. Somerset Maugham titles, Penguin, 1971

I worked with Penguin for about ten years, on and off. I probably did about a hundred jackets or so for them over the period. Harri was a designer first and foremost. He taught himself to be a photographer when he was art editor of *Nova*. His eye for a picture story is unbelievable. The idea of the continuous image [for the covers] was mine, because I had the slightly superficial idea that all Maugham's books were about the same thing, the same milieu. So I had the idea that a collection of Edwardian bric-a-brac would be not only delicious, but would also solve the problem of 24 individual designs. Harri had a fantastic collection of stuff. He is a real jackdaw. So he had a wonderful time doing it. He did most of the compositions.

You have said that the best layouts appear to have designed themselves.

How could they be different? Of course, you could do it in a million ways, but it should have a look of conviction. The conviction in my case comes about from knowing how right it is, because I have been through the mill. I have been through it all. There is a reason for everything.

There is not a right and wrong way, but there are better ways and worse ways, and they are almost always findable in the text. There is often a recurring word in the text that might give you an idea for the right typeface. Let us suppose there was a book about Herman Melville. His name will appear quite often in the book. Sometimes even there there is a clue to a nice typeface that has a lovely 'M'. One of the reasons I like justified setting is because I use Poliphilus a lot, which has the most deliciously surreptitious angled hyphen. It is worth breaking words for.

The suitability of the type to the subject of the book is less important than to the nature of its text. Not the politics of the text – which, of course, is something that obsesses kids today because they think they can get an idea out of it – but the actual words. Even things like ampersands and brackets – if you have stuff with a lot of brackets, Bell has the most delicious square brackets. It is a good enough reason to use that typeface.

Does book design still give you the same pleasure?

Oh, yes. I cannot help thinking that books, and now perhaps websites – information – are really the proper stuff of design. All the rest is *Blue Peter*, playtime. It is about real text which real people have spent half their life trying to get right.

Interview: Jane Lamacraft

Derek Birdsall,
Common Worship,
book covers and
spread, Church House
Publishing, 2000

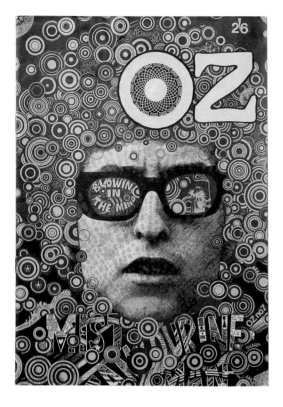

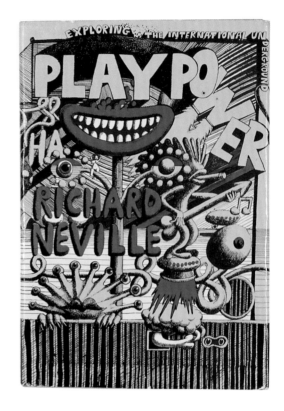

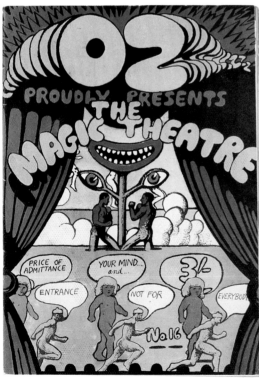

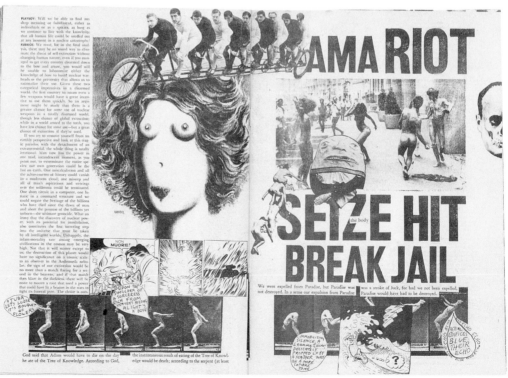

Top: **Martin Sharp**,
Oz no. 7, magazine
cover, November 1967

Martin Sharp,
Oz no. 16, magazine
cover and spread, 1969

Top: **Martin Sharp**,
Play Power by Richard
Neville, book cover,
Jonathan Cape, 1970

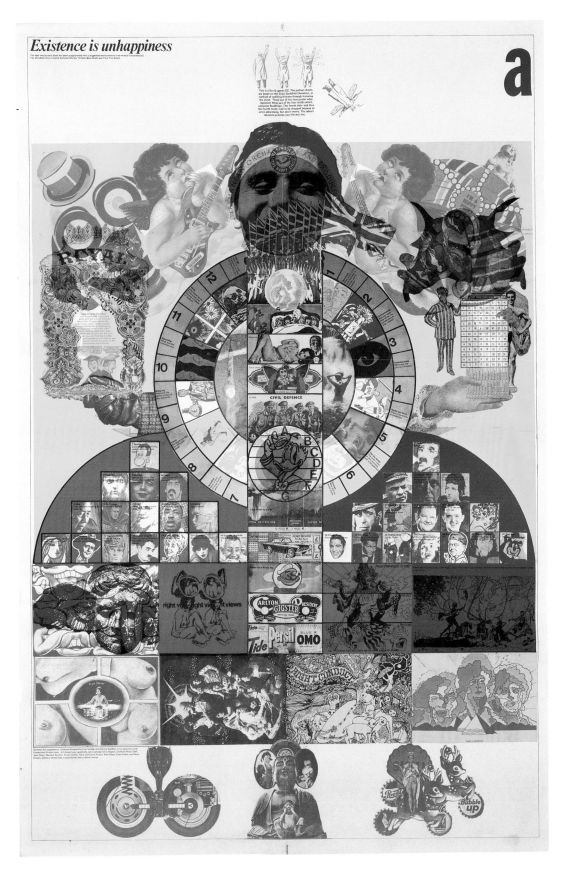

Barney Bubbles,
Oz no. 12, 'Existence is
Unhappiness', fold-out
poster, 1968

Pearce Marchbank,
Oz no. 37, cover,
September 1971

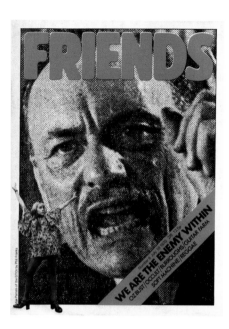

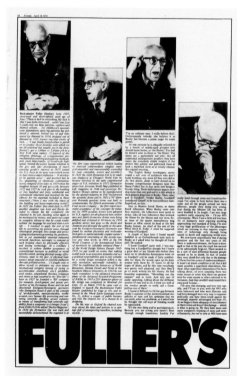

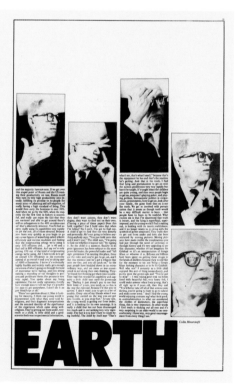

Top: **Pearce Marchbank**,
Architectural Design,
magazine cover,
October 1969

Pearce Marchbank,
Friends, magazine
spread, 14 April 1970

Top: **Pearce Marchbank**,
Friends no. 9, magazine
cover, 10 July 1970

Pearce Marchbank

How did you come to design *Time Out*, the London listings magazine? Was it via the underground press?

I was made art editor of *Architectural Design* while I was actually still in my last year at the Central School of Art and Design in 1969. After a few months I was asked to join the short-lived English edition of *Rolling Stone* magazine, which was funded by Mick Jagger. The day I got there everyone had been fired. Jagger had pulled out. It turned into *Friends of Rolling Stone* and, after some legal pressure, became plain *Friends* – I hated the name. After about a year at *Friends*, which had become roughly the underground's version of *The Guardian*, I was asked to join *Time Out*, which I never regarded as an underground magazine really.

In the early 1970s, you designed *Oz*.

I co-edited and designed a number of issues of *Oz*, firstly in 1971 when the original editors, Richard Neville, Felix Dennis and Jim Anderson, were on trial under the Obscene Publications Act – and were ridiculously jailed. It was very exciting, but also slightly frightening. We were told our phones were tapped and there were strange men in cars parked outside the office for hours.

Oz was produced on a shoestring, as was *Friends*, which was often literally artworked on a kitchen table. Everything was Letraset, text set on one IBM golfball machine. There were no camera prints, you had to write headlines to fit. But *Friends* must have been the first 'direct-input' newspaper in the world. The writers would come in and type their pieces direct on to repro paper on the IBM setter to the exact lengths I gave them, then it was straight to pasted-up artwork. We had total control, yet how it ever looked any good I do not know. I was then heavily influenced by *Twen*, the German monthly magazine designed by Willy Fleckhaus. Years later I discovered that *Friends* had had this cult-like following among some art directors and ad agencies.

Friends was completely different from all the other underground papers. It did not have flowers all over it, no colour overlays preventing you reading the type. If you look at *Friends*, and the later *Oz* magazines that I did, they are much more about communicating – direct photographs, type as clear as possible.

I always assume people do not want to read what you are putting in front of them. You have to stop them in their tracks. Hence the *Time Out* covers were conceived as, in effect, posters – not contents lists.

Did you have free rein at *Time Out*?

Almost totally. The covers were left very much to me. I deliberately avoided obvious subjects, which you get now so much. Nicole Kidman has a new film out, so she is on the cover of every consumer magazine – and on the news-stand there are 99 Nicole Kidmans. My approach was to make all the other magazines on the shelves act as our background. I would

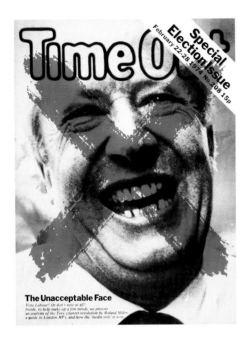

deliberately spotlight obscure or quirky features on the covers. As simple as possible, sometimes completely white covers, very rare at the time and hated by the booksellers. The totally bare, green 'Jealousy' cover was probably the most minimalist, slated by everyone on the business side, but not after it became an instant sell-out. *Time Out* now tries to put everything on the cover – the *Cosmopolitan* disease: the contents page on the cover. Too much information. Design by committee.

Another thing I have always liked doing is trying to make covers work three-dimensionally, using *trompe l'oeil* tricks, so that the type, the logo, etc, work with the image and become part of it – not just an overlaid layer on top of it. One of the most complex *Time Out* covers was the 'Their art belongs to Dada' cover. The contents page, which was shown behind the 'burnt' portion at the bottom of the cover, could not be artworked until ten days after the cover deadline, so I had to force them to do just the bottom two inches days ahead. We shot the flames 20 or 30 times to get it right as retouching or montage was out of the question. The origination was very complicated, years before Photoshop – it would have taken minutes today.

I always make a point to editors that the words and pictures must work together, be created together. For example, 'the unacceptable face of capitalism' was one of Prime Minister Ted Heath's catch lines, so I used it as the headline with his 'unacceptable face' crossed out with a red election cross, turning the words against him. That is the sort of idea that can only work when words and image are created together, very similar to their relationship in advertising.

How did the *Time Out* logo come about?

It was Letraset Franklin Gothic, shot out of focus so that it had a glowing fuzziness to it. I put a negative over a positive and the gap between the two made the glowing 'neon' outline, which I then shot in line, then again out of focus. It was deliberately 'transparent' so the cover images could read through it, as if it were on the glass of a window.

What do you feel about your work at *Time Out* when you look back at it now?

It is now a very small proportion of my career, but it was certainly a time of some of my best work. I could make as much, and sometimes even more, comment than newspaper editorials. *Time Out* was on the streets every week, all over London – and even those who did not buy it could see the covers. It was the most wonderful job to do and we gave tremendous exposure to the subjects we spotlit on the covers. It is sad to see that this radicalism has been lost now.

Interview: Jane Lamacraft

Top: **Pearce Marchbank**,
Time Out, cover,
22 February 1974

Pearce Marchbank,
Time Out, cover,
13 January 1978

Top: **Pearce Marchbank**,
Time Out, cover,
12 October 1973

Pearce Marchbank,
Time Out, cover,
18 July 1980

Katy Hepburn

You worked on the first Monty Python book with Derek Birdsall. How did that come about?

I was already working on animations for *Monty Python's Flying Circus* with Terry Gilliam. I was still at the Royal College of Art when I was approached by Methuen to design the first book. Eric Idle [member of the Monty Python team] knew and got in contact with Derek Birdsall, whom I had met through design circles. We all got together and the project was set up. I worked on the book at Omnific [Birdsall's studio]. I had a huge great pinboard, which was Derek's favourite way of designing books – all the designed pages could be seen in sequence. He gave me a lot of latitude, but he was teaching me at the same time. I was testing the water with how to do it, although it was great fun. If we could not use the right sort of paper, we would make the pastiche of the typography even more exact.

Had you encountered this kind of typographic pastiche anywhere else?

I worked on pastiche ideas of my own at the Royal College. I was influenced by very different sorts of typography, so turning my typographic skills into a joke for Monty Python came quite naturally to me. Working with Terry Gilliam, I was already having to Letraset things or mock them up so they could be used in the animation. The Pythons emulated particular situations. It could be someone from the ministry who had a badly fitting suit and rather short trousers. The costume and everything was carefully done to achieve the right awkward effect. I was trying to do that with the typography. I was trying to get it so right that it would make the joke stronger.

With the second book, *The Brand New Monty Python Bok*, you had full control of the design.

I knew them all much better and by that point they trusted me. We were given some rooms in Methuen's office in New Fetter Lane. We had a fantastic editor, Geoffrey Strachan. He was immaculate, careful, witty, brilliant at editing all the Pythons' material, and he groomed it and edited it down to a tee with the Pythons in order that it could come to me and be typeset. He kept the ball of humour bouncing between Eric and me, and Eric and Terry. Eric was the editor, but Terry was around a lot and did specific illustrations. Some of these ideas came about through discussion and throwing so many ideas between us at such a speed that these things just came out. There is more detail in the second book and the jokes became immensely intricate.

What sort of research did you do for items such as the spoof ad for *The Hackenthorpe Book of Lies*?

This was taken from the weekend newspaper supplements and it is partly influenced by the *Reader's Digest*, or something like that,

Katy Hepburn,
Monty Python's Big Red Book, cover and spread, Methuen, 1971. Art direction: Derek Birdsall

Katy Hepburn,
Another Monty Python Record by Monty Python, album cover, Charisma, 1971. Art direction: Terry Gilliam

Katy Hepburn,
The Brand New Monty Python Bok, cover and spreads, Methuen, 1973

where you get these appalling photographs of a whole row of encyclopedias photographed rather badly. You cannot even read any of the titles, so you wonder why they used the picture in the first place. And cramming in so much text in boxes with rounded corners next to square corners – just badly done design. So it was rather a delight to emulate this, but with a very dry, sarcastic and anarchic humour buried in it. The combination is extremely powerful – the trashiness of it, but done in an excellent way. It gives it a surrealism and such an edge.

As you can imagine, the typesetting bills were pretty high. A lot of it was set in metal. You would do justified setting with no indents and you would have some really good rivers and patterns happening which made it look bad. Bullet points, four different typefaces, caps mixed with lowercase – all these 'don'ts' of typography. There is a flight chart which is terribly accurately done. It almost looks dull. There is a Penguin book which is actually bound within the book – a Penguin is being sick at the top. This is a particular style of Penguin cover. Inside, it is set in Linotype Juliana. I was looking all of this up in Penguin books. From beginning to end, it is a plagiarism of all the different type styles, for different gags. It is all pasted down. It was a time of real artwork, which meant that it was more radical in its look. It didn't have to be hammered through some sort of production process where it was tamed. This was straight from the horse's mouth – or the designer's Cow-gummed spatula.

What was the thinking behind the cover, with the obscene photograph concealed under the plain typographic wrapper smeared with dirty fingerprints?

I think there was an element in the programme's humour of the old man in his raincoat – the flasher. This was a book version of the flasher. You take off the dirty exterior and there are rude bits underneath. It had that kind of perverseness to it. Some of the more sexy aspects of the Pythons I was never quite sure about. It was poking fun at the lack of liberation, but there is also an old-fashioned, dirty old man element from the 1950s. After 1968, the Rolling Stones, *Sgt. Pepper*, *Oz*, everything else, there was a sexual revolution going on. With the jump that I made from working with the Pythons into the feminist magazine *Spare Rib* – they were going on in parallel – I was against the idea of *Spare Rib* being separatist. It should be discussing how women feel in relation to men, but it should not be an exclusion zone.

I was becoming quite politicized. Everyone was. I went on to do quite a lot of political work with Pluto Press, so it was a great mix-up of this fantastic surrealism – anarchy – and politics. I saw the Python book as being as radical as it could be, therefore there were no boundaries in the layout. Ideas were just bursting out.

Interview: Rick Poynor

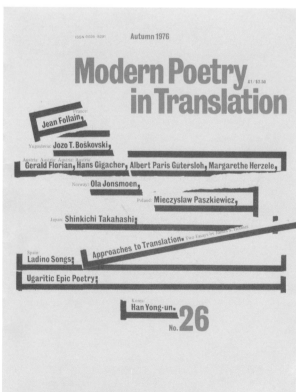

Top: **Katy Hepburn and Sally Doust**,
Spare Rib no. 1, magazine cover, July 1972

Richard Hollis,
Modern Poetry in Translation no. 26, magazine cover, autumn 1976

Geoff White,
The Architectural Review vol. CLXIII no. 976, magazine cover, June 1978

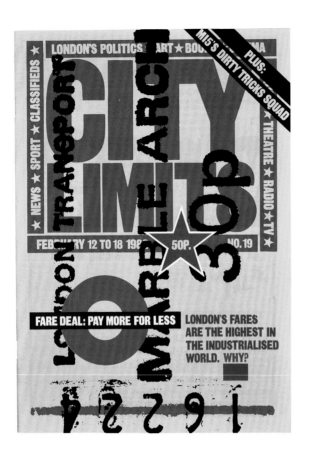

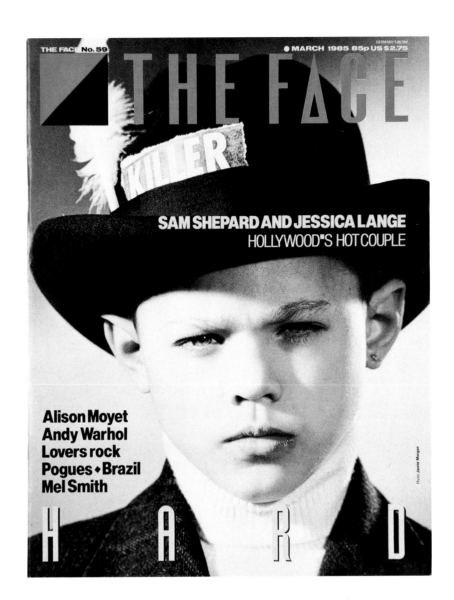

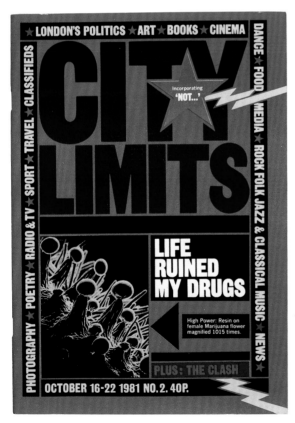

Top: **David King**, *City Limits* no. 19, magazine cover, 12 February 1982

David King, *City Limits* no. 2, magazine cover, 16 October 1981

Top: **Neville Brody**, *The Face* no. 59, magazine cover, March 1985. Photograph: Jamie Morgan

Neville Brody, *The Face* no. 61, magazine spread, May 1985. Photograph: Nick Knight

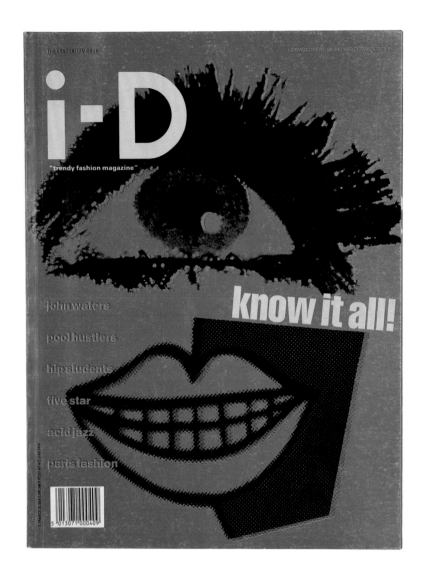

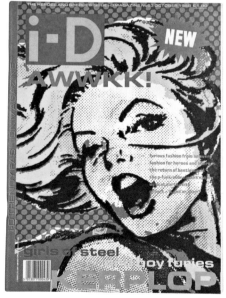

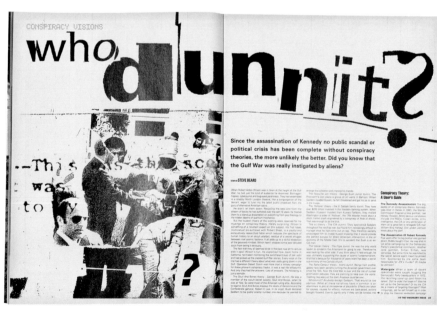

Stephen Male,
i-D no. 60, magazine
cover, July 1988. Art
direction: Terry Jones

Stephen Male,
i-D no. 63, magazine
cover, October 1988

Top: **Moira Bogue,**
i-D no. 41, magazine
spread, October
1986. Photograph:
Bogue and Tim
Hopgood. Art direction:
Terry Jones

Stephen Male,
i-D no. 92, magazine
spread, May 1991

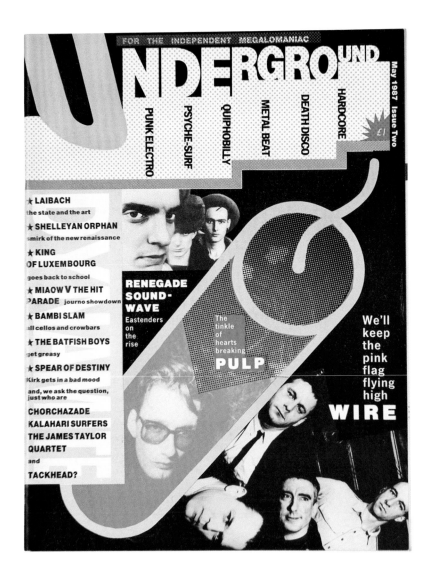

Top: **Rod Clark**, *Underground* no. 2, magazine cover, May 1987

John McConnell, Pentagram, *Kid* by Simon Armitage, book cover, Faber and Faber, 1992

John McConnell, Pentagram, *Skevington's Daughter* by Oliver Reynolds, book cover, Faber and Faber, 1985

John McConnell, Pentagram, *Station Island* by Seamus Heaney, book cover, Faber and Faber, 1984

Top: **Angus Hyland**, *The Trial* by Franz Kafka, book cover, Minerva, 1992

Angus Hyland, *The Castle* by Franz Kafka, book cover, Minerva, 1992

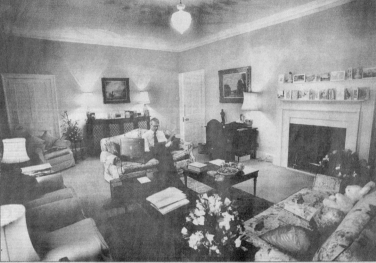

Top: **Mike Dempsey and Ken Carroll, Carroll & Dempsey**, *The Farewell Party* by Milan Kundera, book cover, Penguin, 1984. Illustration: Andrzej Klimowski

Mike Dempsey and Ken Carroll, Carroll & Dempsey, *The Book of Laughter and Forgetting* by Milan Kundera, book cover, Penguin, 1983. Illustration: Andrzej Klimowski

Nick Thirkell, CDT, *The Independent*, front page, 9 April 1992

THE
INDEPENDENT
MAGAZINE

28 JANUARY 1989

MARK LAWSON
SUFFERS WITH THE
DOCTORS

MAUREEN CLEAVE
ON THE
CREATOR OF ADAM

LORD LONGFORD
AS HERO

THE FEUD
THAT OUTLIVED
DALI

Top: **Derek Birdsall**,
*The Independent
Magazine*, cover,
1 March 1989

Derek Birdsall,
*The Independent
Magazine*, cover,
28 January 1989. Art
editor: Derek Copsey

Top: **Vince Frost**,
*The Independent
Magazine*, cover,
4 November 1995.
Photograph: Matthew
Donaldson

Vince Frost,
*The Independent
Magazine*, cover,
16 September 1995.
Photograph: Matthew
Donaldson

The Guardian, detail of front page before redesign, 11 February 1988

Top: *The Guardian*,
detail of front page
before redesign,
11 February 1988

**David Hillman,
Pentagram**, *The
Guardian*, front page,
12 February 1988

**Mark Porter and
Simon Esterson**,
The Guardian, front
page, 15 February 2001

All the President's gays

As the American homosexual community comes out for Clinton, Martin Walker explains why Bush should be worried

Top: **David Hillman,
Pentagram**,
The Guardian G2, cover,
15 October 1992

**Mark Porter and
John Henry-Barac**,
*The Guardian,
Big Brother* special
supplement, cover and
spread, 7 September
2002

Top: **Simon Esterson
and Roger Browning**,
The Guardian G2, cover,
19 September 1995

Top: **Alan Kitching**,
The Guardian Weekend,
magazine cover, 17
March 2001. Art
direction: Maggie
Murphy

Mark Porter,
The Guardian Weekend,
magazine cover, 9
September 2000

Neville Brody

You took to digital media relatively early. What was the impetus behind that?

I have been using a Macintosh computer since 1988. There was a guy called Ian McKinnell working as a photographer on the floor above us in our studio on Tottenham Court Road. It was a fantastic 1930s building that used to house all the underground movements from the 1960s. Ian had a Mac and one day he was watching me hand-draw fonts and he said, 'You can do that on the computer.' He drew one of my fonts in Fontographer, which was the first ever PostScript drawing program. Adobe had invented PostScript, but no one could use it because there were no tools available – Fontographer and Freehand were the first. He drew one of my fonts, put it into Freehand, started moving it around and I was just blown away.

How did you get involved in designing *The Guardian* website and what was your brief?

We were brought in by a guy called Tony Ageh, who worked on *City Limits* magazine just after I was there, who went on to *The Guardian* where he developed *The Guide*. He brought us in to work on redesigning *The Observer* and subsequently worked with us to develop the online section of *The Guardian*. Through that relationship, Ian Katz, who now runs the G2 section, contacted me to work on the website. He came to us with a vision for a different kind of approach to the web, based on societies and communities. Everything was something 'Unlimited': *Guardian Unlimited*, *Work Unlimited*. Sadly, they later dropped the word 'Unlimited' from half of the site.

Essentially, they approached us to do something which was not a newspaper website. They knew that they did not want to reproduce the newspaper online, which had been the standard approach. They did not want a portal. They did not want to create a hub. So the challenge was to create a 'third space'. We came up with the Brion Gysin idea, the cut-up technique, the idea that by putting disparate things together we would come up with a new possibility that was unexpected. We wanted something that was extraordinarily modular. Within each page you could not only have an infinite amount of meaning and message from any given combination, but you could actually construct your whole web experience. It was very molecular. The heart of it was the idea that, by its very fluid nature, information on the web is organic, so we stripped it right down to a really cellular approach – to its core DNA.

We weren't going to be conventional, for a start. We were not going to be left-hand of the page-led. It was going to be centre of the page – or screen – and that was quite unusual at the time. The top of the page was going to be full of blocks that could be combined in any way to form any kind of meaning without the use of heavy images. People in the office used to tell me that they

Top: **Neville Brody**,
Guardian Unlimited
website, 1998–99

Jane Glentworth,
Guardian Unlimited
website, 1 June 2004

enjoyed writing the headlines that went in the blocks. I have been told that they call them 'Brody blocks'. The website is very classical, actually. We tried to strip all decoration away. We wanted to keep a really strict grid, bring modernist, humanist references to it and then make it lively.

How has *The Guardian* site changed or evolved since your original design?

We designed *The Guardian* at a time when people used to redesign things every few weeks or months to maintain user interest. A year with one design felt like ancient history. *The Guardian* five years on is essentially the same, although it has been tweaked. Talking to the people there now, they yearn to go back to its original design, where the blocks were larger, for instance. They reduced the size of all the blocks because they thought it was taking too long to download. But the thing that took ages to download was the HTML language that was so over-written, which meant that the mark-up language for each page was too heavy. They reduced the size just as bandwidth increased. The logo also changed. Originally we had the '@' symbol sliced off, which became the 'U' of Unlimited. That was the logo they used in the newspaper as well. They dropped that – maybe it looked like an email address.

How did editorial design for print influence your approach to the web?

The difference, of course, is that with a magazine you flick through and you can refer to previous pages, but with a website you can enter at any point. That is a problem they are facing now. In the late 1990s, people generally went in through the homepage and expected that always to happen. You would go to the *Football Unlimited* site, then you would go to a story and then you could go to some links. But now, with search engines, people come in through the back door, straight to one story, and that is proving to be quite problematic, because how do you tell someone who has never been to your site before about the other stuff that is available, without having everything on every page all of the time? You don't want to drown in information.

Portals do that: they put everything there all the time, so you have this constant list of contents down the left-hand side. It just gets in the way of the experience. We wanted to leave the stories and columns as clutter-free as possible, so very early on we used the pull-down idea, which was unfashionable at the time, but we thought it was a practical solution. We wanted the simplest navigation possible and the simplest way to understand the site was to have less on the page. I pointed out that digital white space was infinite. White space is a lack of information and it does not cost anything.

Interview: Alona Pardo

Top: **Alan Kitching**,
Dazed & Confused,
magazine cover,
July 2000. Art direction:
Martin Bell

William Webb,
Soft by Rupert
Thomson, book cover,
Bloomsbury, 1998

William Webb,
Bear v Shark by
Chris Bachelder, book
cover, Bloomsbury,
2003. Illustration:
Mark Thomas

Top: **Julian House**,
Intro, *Beautiful Losers*
by Leonard Cohen, book
cover, Penguin, 2001

Julian House, Intro,
Hell's Angels by
Hunter S. Thompson,
book cover, Penguin,
2000

Top: **Julian House**,
Intro, *The Favourite
Game* by Leonard
Cohen, book cover,
Penguin, 2001

William Webb,
*Easy Riders, Raging
Bulls* by Peter Biskind,
book cover,
Bloomsbury, 1998.
Photographs: Retna

Scott King,
Sleazenation vol. 4
no. 8, magazine cover,
September 2001.
Photograph: Kent Baker

Top: **Scott King**,
Sleazenation vol. 4
no. 2, magazine cover,
March 2001.

Scott King,
Sleazenation vol. 4
no. 1, magazine spread,
February 2001.
Photograph: Daniel Stier

Top: **Scott King**,
Sleazenation vol. 4
no. 4, magazine cover,
May 2001. Photograph:
Jonathan de Villiers

Atelier Works,
*Different: Contemporary
Photographers and
Black Identity* by
Stuart Hall and Mark
Sealy, book cover (front
and back) and spread,
Phaidon, 2001

Alex Rich, *Design
Noir: The Secret Life
of Electronic Objects* by
Anthony Dunne and
Fiona Raby, book cover,
August/Birkhäuser,
2001. Photograph:
Jason Evans

The *informal* is opportunistic, an approach to design that seizes a local moment and makes something of it.

Ignoring preconception or formal layering and repetitive rhythm, the *informal* keeps one guessing. Ideas are not based on principles of rigid hierarchy but on an intense exploration of the immediate.

SPIRAL

The Spiral challenges the concept of a museum: does space have to be container-like and neutered to house works of art? When there is much invention and fantasy in porcelain or jewellery or the lines of a fashion garment, should the space around the exhibits be inanimate; is not the real invention to present art, not as lost object in a static box container, but as vital trigger in a spatial dynamic?

Question: is art treasure to be hoarded, or fresh thought to be continually transformed?

With a shape that is formless and a façade that motivates geometry as a mathematical mosaic, the V&A Spiral designed by Daniel Libeskind opens the debate: Norm and Form would have new definitions from the year 2000 onwards.

A cherished symmetry and insistence of right-angled forms rejected, and the old paradigm of fixed centre left behind, the V&A Spiral vaults into new space. Inside is outside. Floors are denied columns, and walls offer no vertical short cuts for gravity. Structure and architecture become one immediacy.

Jannuzzi Smith, *Informal* by Cecil Balmond, book cover and spreads, Prestel, 2002

Why Not Associates, *Guide to Ecstacity* by Nigel Coates, book cover and spread, Laurence King, 2003

Identity

The expression of identity is one of the central tasks of design. As the 1960s began, organizational identities were often described as 'house styles', but this term was soon replaced by the concept of corporate identity. Fletcher/ Forbes/Gill's work for Pirelli in the 1960s worked many permutations around the company's basic logo in posters, print ads and brochures. Questions of identity were equally important to retailers. John McConnell's Art Nouveau-inspired livery for the Biba clothing store was applied to all its packaging and labelling, making a crucial contribution to its fashionable image. By the 1990s, approaches to identity had become more flexible, though the term 'branding' was increasingly preferred. Paul Smith's graphic identity by Aboud Sodano was dispersed across hundreds of disparate pieces. There was no one style: the diversity was the point. Siobhan Keaney's identity for The Mill, a TV post-production company, showed this tendency at its most ornamental. As competition between TV channels developed in the 1990s, it became vital to stamp a strong graphic identity on a channel's output. Lambie-Nairn's BBC2 ident was subjected to many witty transmutations, setting a new standard.

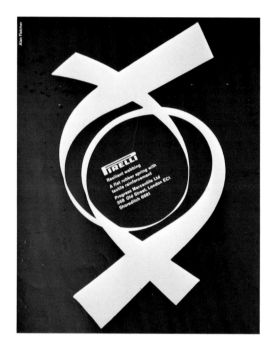

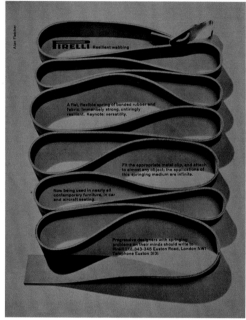

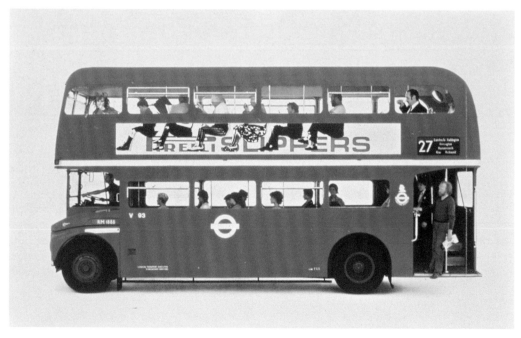

Top: **Fletcher/Forbes/ Gill,** magazine advertisement for Pirelli, early 1960s

Fletcher/Forbes/Gill, advertisement for Pirelli slippers, 1962

Fletcher/Forbes/Gill, magazine advertisement for Pirelli, early 1960s

Top: **Crosby/Fletcher/ Forbes,** magazine advertisement for Pirelli, *c.* 1966

Top: **Crosby/Fletcher/ Forbes,** magazine advertisement for Pirelli, *c.* 1966

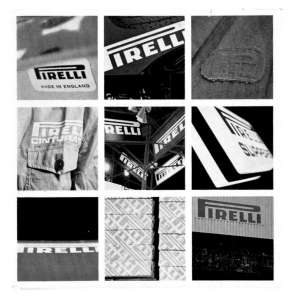

In the tyre division, the dark rubber compounds emerge from huge mixers into rolling and sheeting mills. Woven nylon or rayon cord is impregnated, stretched and dried to give a perfect bond with the rubber compounds. When the fabric has been coated with rubber it is then ready for use in the reinforcement of tyres or resilient webbing.
The rubberised fabric now passes to the tyre builder, one of the key men in process of tyre-making. Around him are racks of cut tread bands and flipped gromets which form the beads to anchor the tyre to the wheel, all of which he brings together to create the 'green carcass' of the tyre.
Under heat and pressure they are transformed into the finished article, emerging from the presses jet black and precise in their dimensions. For many, many thousands of miles they are going to provide their impeccable service over the roads of Britain.

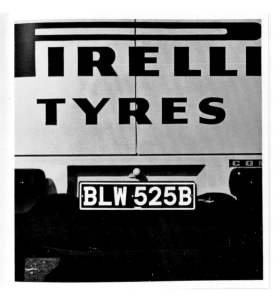

Crosby/Fletcher/ Forbes, *The Pirelli Factory at Burton-on-Trent*, brochure cover and spreads, late 1960s. Photograph: Crosby/Fletcher/Forbes

Derek Birdsall, Pirelli
calendar, 1968.
Photographs: Harri
Peccinotti

Top: British road sign,
1933 design, in early
1960s

Above: **Jock Kinneir and
Margaret Calvert**,
Transport alphabet
(middle); motorway sign
numbers in Commercial
Grotesque (Haas, 1946)
with redrawn 4, 6 and 9
(below), early 1960s

**Jock Kinneir and
Margaret Calvert**, road
sign pictograms, 1963.
Drawings: Margaret
Calvert and John
Jamieson

Margaret Calvert

Had work on the road signs started when Jock Kinneir asked you to join him?

No, what had started was the signs for Gatwick Airport. The first thing was to write a report and it was at that stage that I came in because Jock wanted me to help him with doing all the presentation artwork, macquettes and drawings. A job like Gatwick meant something then. It was really pioneering. You really believed in it and you wanted to be part of it – not in the sense of glory. It was just simply thrilling to be building. Colin Anderson [chairman of P&O-Orient Line] read about Gatwick in one of the design magazines, and he asked Jock to do a baggage labelling scheme for P&O. That was our first big job in terms of what you might call information design. I would like to call it no-frills design because you absolutely cut down to the essence of making it work.

The Anderson committee started [reviewing British road signs] and he was the chairman. Knowing Jock, he recommended him to be the designer for that committee and that then moved on to the Worboys committee. I was already entrenched, learning the business. There were just the two of us. Lots of designers liked to have women as their devoted assistants and they took all the glory. That was a fact. But it was different with Jock because we loved the debate about everything. I always felt that he treated me totally as though we were in the team together.

What are your recollections of working on the road signs project?

The Anderson committee went touring. I tended not to register all that. I was interested in mixing paints, drawing letters and doing tests. They were paid by the Ministry of Transport to visit the Continent, the autobahns and all that, to see what they were doing. The signs were all in upper and lowercase letters. Very aggressive and fairly ugly and uncompromising because they were designed by engineers. There was a lot of debate about legibility.

The Preston by-pass trials came first, then the motorways, and then it was decided by this fantastic civil servant, T. G. Usborne [chairman of the working party for the Worboys committee], to extend it to all roads. Then the pictograms came in. Jock worked out the system. He had that clarity of thinking in terms of rationalizing the various codings, the colours and the layout of the signs. The design evolved from the information that is required on a particular sign. Everything related to the stroke width of the capital 'I': all the borders, the interrelationship between the lowercase letters, one place name to the next place name, groups of place names, when to drop a place name when leaving the motorway, the sequencing, and his brilliant contribution of '1 mile', '½ mile' – he took the dividing line out. Style never came into it. You were driving towards the absolute essence. How could we reduce the appearance to make the maximum sense and

Top: **Jock Kinneir and Margaret Calvert**, primary route road sign, early 1960s

Jock Kinneir and Margaret Calvert, motorway road sign, early 1960s

minimum cost? The important thing was the weight of the letter and the stroke width in relation to the x-height, about 1 to 5.

With upper and lowercase you get word shape, which relates to book typography. It is also friendlier. If you look at the flow of the letters in terms of the terminals, you will notice that the lowercase 'a' turns out a bit at the stem of the letter. If you analyse all the shapes of Transport, it is full of curves; one curve flows into the other and the 't', 'l' and the 'f' do, too. We never thought of ourselves as designing a typeface. That is so important to say. Designing letterforms for signs is totally different from designing letterforms as a typeface. We always called it lettering.

What did you do to test the design as you went along?
I did all of the drawing, working from Jock's specifications. The lettering was drawn several times. It was then put on glass negatives for prints. Then we took a large-format film positive to a place called UDO (Universal Drawing Office) to produce dyelines. We got large sheets of drawing board. We cut the rectangular tiles up [with the letters on] and pasted them up with Cow gum according to the specification, which took no time at all. The road symbol we would just cut out. We cut the letters out, then you could easily pull off the tile that the letter was in, leaving just the letterform stuck down on the board. So you can imagine a sign with just white on white – very beautiful. Then you rub all the Cow gum off. Then you roll the paint on. It dries and then very carefully you peel the letterform off. That was so satisfying.

We would stand them up in a little mews off Knightsbridge, opposite Hyde Park. We would test them there first, then we would take them into the park, put them up against a tree and walk back to look at them. We established the reading distances and so the letter size and the information would generate the size of the sign.

Did you view the signs as an expression of national identity?
After the whole thing settled down, when I went abroad and came back to England, I felt that, yes, there was something quite different about it. We were conscious of the look in terms of the colours and also, with the motorway, of how the signs would sit in the landscape. We never thought of it as a corporate identity because a corporate identity is not just signs, but if you see it everywhere, then it is part of the look of Britain. For me, and this is speaking of London, it goes with red buses and black cabs.

Interview: Rick Poynor

Jock Kinneir and
Margaret Calvert, sign
layout diagram, early
1960s

Fletcher/Forbes/Gill,
Plastics Today no. 23,
magazine cover for ICI,
1965

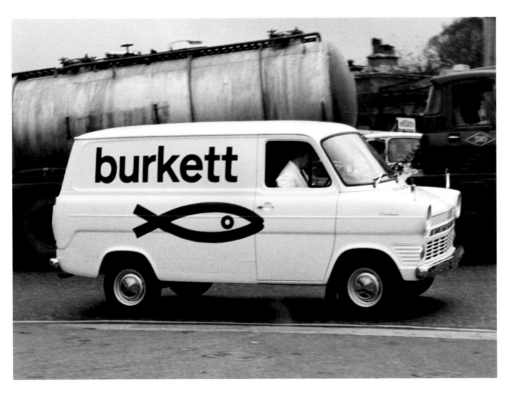

James Galt and Company Limited 30/31 Great Marlborough St London W1 Brookfield Rd Cheadle Cheshire

never mind; we guess you'll know it's Galt Toys

Top: **Margaret Calvert**, corporate identity for Burkett/Rudman fishmongers, 1962

Margaret Calvert, corporate identity for Burkett/Rudman fishmongers, 1962

Top: **Ken Garland**, brochure cover for Galt Toys, 1962/63

Ken Garland, brochure cover for Galt Toys, 1969

**Robert Brownjohn,
Cammell, Hudson and
Brownjohn,** *Money
Walks, Money Talks,*
commercial for Midland
Bank, *c.* 1966. Agency:
Charles Barker

Robert Brownjohn,
promotional poster for
Nagata and Brownjohn,
1960s

John McConnell,
Biba cosmetics
packaging, late 1960s

Top: **John McConnell,**
Biba catalogue cover
and spread, late
1960s. Photographs:
Donald Silverstein

John McConnell, Biba
catalogue spread, late
1960s. Photographs:
Harri Peccinotti

Why Not Associates,
Next Directory no. 5,
mail order catalogue
cover and spread,
1989. Photograph:
Rocco Redondo

Why Not Associates,
Next Directory no. 7,
mail order catalogue
cover (front and back),
1990. Photograph:
Rocco Redondo

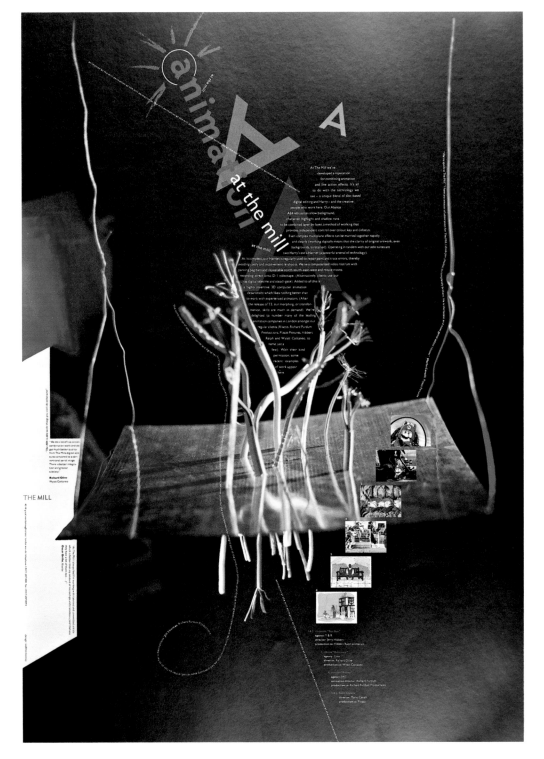

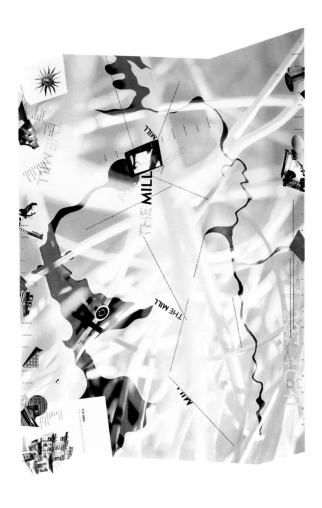

Siobhan Keaney,
brochure with loose
sheets for The Mill,
1990. Photograph:
Robert Shackleton

Siobhan Keaney,
promotional poster for
The Mill, 1992.
Photograph:
Robert Shackleton

Lambie-Nairn, television idents for BBC2, updated versions of original 1993 design. Creative director: Martin Lambie-Nairn

Top: **Aboud Sodano**, catalogue cover for Paul Smith, 1999. Photograph: Mario Testino

Aboud Sodano, catalogue spreads for R. Newbold (Paul Smith), 1995. Photographs: Julian Broad. Typography: Tim Spencer

Top: **Aboud Sodano**, promotional postcards for Paul Smith, 1994 (top and middle), 2003 (bottom)

Graphic Thought Facility, corporate identity for Habitat, 2002

Graphic Thought Facility, brochure spreads for Habitat, Christmas 2001. Computer illustration: François Lefranc

North, corporate identity
for British motoring
organization RAC,
1995–97

Frith Kerr Kerr Noble

Your identity work is quite low-key, mysterious even. Are you reacting against the slickness of many corporate identities?

Quite often we think about what we *do not* want to do, and what other people do. That is often a starting-point. We definitely revel in the restraints in some of our work, playing with this idea that we could have really gone to town, but in fact we have just chosen to use two colours but on a beautiful material. Certainly we like to build up the complexities of things and play on people's expectations.

With Liberty's food range, we created a family of products. They had different personalities but they all basically belonged to one place, and within that we really liked this idea of what we call 'in-built imperfections'. We chose not to use Liberty's logo and instead used this really beautiful escutcheon from one of their silk scarves made in the 1930s – we felt that this connected the food range to the rest of the store whilst giving it its own feeling. We explored different hand finishing techniques like wax seals and rubber-stamping. We made the decision not to print the escutcheon – it is hand-stamped on every product. Sometimes the stamp has not come out properly – and that is brilliant, that is part of it. There was also something quite delightful about James Lambert's illustrations for the range, but they were not sweet.

Paul Davis's illustrations for your work for the research company TWResearch are quite surreal.

It is quite dark – people holding their heads and looking into their stomachs or blindfolded with aerials on their heads. There is quite a knowing, self-effacing humour in there, but it is from a very smart position. There is this whole world we have built up with Paul. Each person at TWResearch gets a set of twelve business cards with different characters – and what we enjoy is that they then can create a bespoke relationship with whoever they are giving their cards to. Also, within that we use different colours – there is no corporate colour for the company. Amelia [Noble] and I think that the identity work we do is like a person – I wore different clothes yesterday from those I am wearing today, but I am still the same person. So TWResearch can have pink and green and blue and yellow on their business cards, but it is still identifiably the same company.

We think people enjoy variety, and that they can make these connections between things. What we tend to do is build a system and then break that system. There is nothing worse than making work that is predictable.

You use typefaces in a very particular way. They are almost the logos.

We rarely get in typographic ruts because each time we try and look for solutions that are appropriate, to make connections. With Konstam, a café, we did a lot of type research. The owner was

Kerr Noble, set of twelve business cards for TWResearch (fronts and one back), 2001. Illustrations: Paul Davis

making good quality food, but he was in King's Cross and so it was not going to be a posh gastro café. Intrinsic to this was the idea of family cooking. In building up our approach to Konstam we chose a font that enables the client to change his menu every day, typesetting it himself, and for it to still look good. We found this lovely font called Elementa, which is a redesigned typewriter font, and we set it in italics. That worked really well against the typographic playfulness in the name Konstam, which we set in stars. Quite often it is making the contrast between typefaces that we really relish.

For us, the 'logo' is not something that we conceive as a primary thing. We create an identity whereby the name, which is usually what becomes the kind of logo for our client, is just part of a complex visual language. Though for all I have said about complexity, we enjoy a certain simplicity. Maybe that comes through for us in restraint.

How do you and Amelia Noble work together?

We met at the Royal College of Art. I had been at Camberwell College of Art and Amelia went to Central Saint Martins. Camberwell and Saint Martins are very different, and in fact how we work is very different, but we approach things in the same way. We are interested in learning and we are fascinated by things that we can get to grips with and investigate. Everyone does research into projects, but I think that a lot of what we do is really weighted towards what we discover in that research. We do not approach things like designers. We approach things almost like detectives.

That makes it sound very factual. Isn't there something intuitive as well?

Absolutely. We like to work from a solid base, which then allows us to be intuitive. You do all that research, you do all that legwork, and then from that platform you can be intuitive with confidence. We do work on everything together, and that slows us down. But working together gets us a unique result that is very different from one of us working on something separately, and that is what we enjoy. In the old days we used to laugh because we would end up sitting in two chairs at one Mac, and some of the time it is still like that. To make that work we have to stay small. But what we have done is set up this nucleus whereby we can have artists or photographers or programmers come in and work with us on different projects, and clients love that. It creates a whole new palette. It is exciting for us, the client feels it is an entirely bespoke team for them and it gets results that sometimes perhaps we do not expect.

Interview: Jane Lamacraft

Kerr Noble, set of twelve business cards for TWResearch (fronts only), 2001. Illustrations: Paul Davis

TWResearch

5 Cowcross Street
London EC1M 6DW

T. 020 7324 9999
F. 020 7324 9980
terry@twresearch.com
www.twresearch.com

TWResearch

5 Cowcross Street
London EC1M 6DW

T. 020 7324 9999
F. 020 7324 9980
terry@twresearch.com
www.twresearch.com

TWResearch

5 Cowcross Street
London EC1M 6DW

T. 020 7324 9999
F. 020 7324 9980
terry@twresearch.com
www.twresearch.com

Spin, television ident
for Five, 2002–3.
Director of photography:
Alvin Kuschler

Top: **Foundation 33 (Daniel Eatock and Sam Solhaug)**, advertisement for *Big Brother* television programme, Channel 4, 2002

Foundation 33 (Daniel Eatock and Sam Solhaug), *Big Brother* television programme ident, Channel 4, 2003

Peter Miles, Damon Murray and Stephen Sorrell, Fuel, television idents for Sci-fi Channel, 2002. Words: Miles, Murray and Sorrell

ssitzky 1890-1941

AN ORBITAL NCE: 9
AN ORBITAL ITY: R
AN ORBITAL D: 1
BITAL ECCEN Y: 0

TY OF THE ECLIPTIC 2
RIAL DIAMETER
DIAMETER 8

Arts

As a sector to work in, the arts has an obvious attraction for graphic designers. Clients such as film-makers, theatre companies, art galleries and museums often share the same outlook and visual tastes. This is one area in which street posters retain their importance. More than 30 years separate George Mayhew's designs for the Royal Shakespeare Company and Graphic Thought Facility's for Shakespeare's Globe Theatre, but the promotional goal remains the same. Richard Hollis's relationship with the Whitechapel Art Gallery, beginning in the 1960s, was one of the longer running and most productive designer-gallery partnerships, uniting a careful regard for economic and practical considerations with a tightly defined identity that made the gallery appear both accessible and serious. In the early 1990s, CDT's influential sanserif identity for English National Opera underlined how crucial the visual presentation of arts organizations had become. State's evolving identity for the Onedotzero film festival showed that a high degree of impact could be achieved by interconnected imagery used for both moving-image and print. Experimental film websites by Hi-Res! elaborated cinematic narratives into a new dimension.

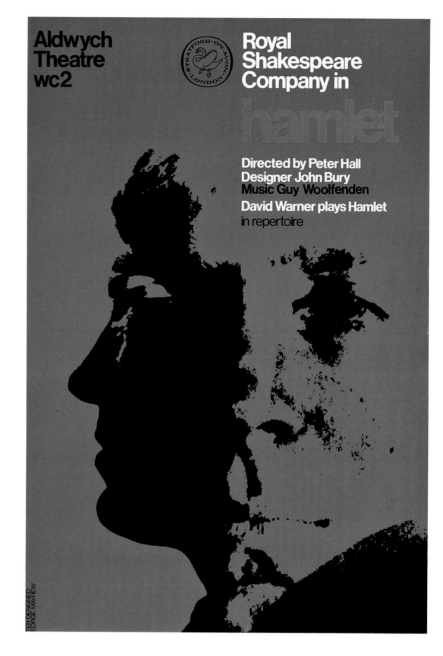

George Mayhew,
The Revenger's Tragedy,
poster for Aldwych
Theatre, London, 1969

George Mayhew,
Hamlet, poster for
Aldwych Theatre,
London, 1965

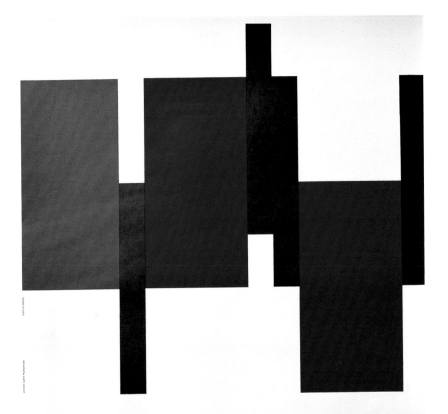

A Painter's Use of Sound
Peter Schmidt
ICA 8pm Tuesday 11 April 1967

architecture
today

an exhibition arranged jointly by
the Arts Council and the
Royal Institute of British Architects

Arts Council Gallery 28 June - 29 July 1961
4 St James's Square London SW1 Mondays, Wednesdays, Fridays,
 Saturdays: 10 am - 6 pm
 Tuesdays, Thursdays: 10 am - 8 pm

 admission 1s 6d

Dennis Bailey,
Architecture Today,
poster for Arts Council
Gallery, London, 1961

Alan Kitching,
*A Painter's Use of
Sound*, poster for
Institute of
Contemporary Arts,
London, 1967

AND FANTASY

We, the undersigned,
deplore and oppose
the Government's intention
to introduce admission charges
to national museums
and galleries

Write in protest to your MP
and send for the petition forms to
Campaign Against Museum Admission Charges
221 Camden High Street
London NW1 7BU

Robert Brownjohn,
Obsession and Fantasy,
poster for Robert Fraser
Gallery, London, 1967

**Colin Forbes, Crosby/
Fletcher/Forbes**, *We,
the Undersigned*, poster
for Campaign Against
Museum Admission
Charges, 1970

 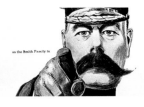

 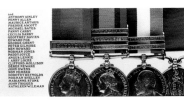

 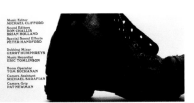

 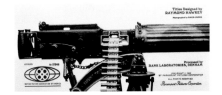

Raymond Hawkey,
Oh! What A Lovely War
directed by
Richard Attenborough,
film titles, 1969

Richard Hollis

As a designer you are deeply immersed in the visual arts. How did this commitment begin?

It is probably because I have always known artists. At art school, I wanted to be a painter and I slowly drifted from representation to being interested in art that was based on mathematics. An American painter, Charles Biederman, wrote a book called *Art as the Evolution of Visual Knowledge* [1948], which suggested that art gradually developed away from representation: art had a completely logical development because it was to do with the way we saw. I got interested in that kind of thing because of a book by Lawrence Alloway, *Nine Abstract Artists* [1954], which became a bible for me and one or two friends. I started making constructions as well as painting mathematically. I went to see various artists. I met Georges Vantongerloo, a member of the DeStijl group in the 1920s, and spoke to people like Vasarely – on the telephone! Eventually I came to meet some of the Swiss Concrete artists who were also graphic designers. So I realized that one could combine painting with being a graphic designer.

I started design as a silkscreen printer in a small room in Holborn. The first silkscreen job was a poster for Zwemmer Gallery for an exhibition of John Piper and Michael Rothenstein. The style of the poster was nothing like their work. It was my idea of what design was about. Just what I deplore now: the imposition of a designer's idea on the material. I suppose I now think that design is a kind of social service – and a cultural service. The designer's personality is not important. The designer should be invisible in the graphics, which should be talking about the subject. That is why some of us did not have the designer's name on, say, a poster.

How did you first start working for the Whitechapel Art Gallery?

I met the person who had just taken over, a splendid man called Mark Glazebrook [director 1964–73]. He said, 'We want someone to design a letterhead. Maybe we could set up a competition.' I said, 'If you like, I'll do something and you can use it or not.' I did something pretty eccentric. He was one of those people who thought anything you did was terrific, if you liked it – as a designer. It was a really un-English attitude. One of the first jobs for him was a catalogue for three Israeli artists. I did a poster which was blue and orange lettering on yellow ochre. I said to him, not seriously, 'The blue is obviously the Mediterranean, the orange is jaffa oranges and the yellow ochre is the desert.' He said, 'Richard, I so admire your research!' He was absolutely serious.

Were you given any kind of brief by the director or curators with these Whitechapel posters, catalogues and leaflets?

Not really. That was also true of Nicholas Serota [director 1976–88]. They did not interfere at all. They just let you get on

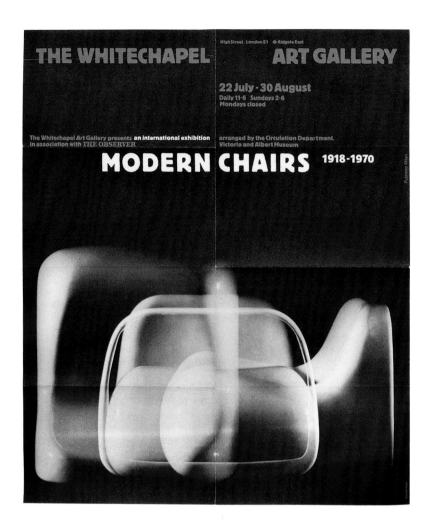

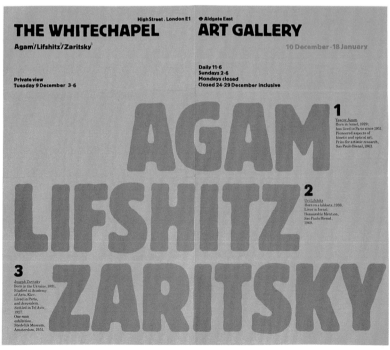

Top: **Richard Hollis**, *Modern Chairs 1918–1970*, poster for Whitechapel Art Gallery, London, 1970

Richard Hollis, *Agam, Lifshitz, Zaritsky*, poster for Whitechapel Art Gallery, London, 1970

Richard Hollis,
El Lissitzky, poster for
Museum of Modern Art,
Oxford, 1977

with it. They were terrific to work for. Everything was done very cheaply. I knew about printing. I spent a lot of time with printers. I love the smell of ink. When it came to doing things practically, I could suggest ways of folding paper. Art galleries communicate with their possible audience partly through advertising, but mainly through the things they send out. They normally send out a newsletter that shows what the programme is. They may send out other things. Gradually at the Whitechapel I found that it was possible to send out a poster folded together with the news sheet and an invitation to the private view, where it was appropriate – all in a DL envelope. One could then build up an interested public. They received all this stuff, but it was not costing the gallery any more to do that.

The use of the Block typeface was partly a practical decision. You could enlarge it and reduce it and nobody could see if it was not sharp. There was no type involved. Eventually I had it put on one of these hand photo-setting machines, but, generally speaking, it was all done from photoprints cut up letter by letter and pasted down.

With your knowledge of the visual arts, did you feel a mission to explain art to the public?

This is the extraordinary thing about the visual arts. If you suddenly have this material dumped in front of you, it is terribly confusing because, since the 19th century, art is not like what you see any more. I think it takes tremendous effort and experience. It is all very well for those of us who went to art school because you have been subjected to it and you have done it. I felt people needed more help, particularly with more contemporary things. Of course, now the big galleries tell the public how to respond. They have staff in charge of 'interpretation', and marketing men and branding experts who have displaced the designer.

Design is not a big deal. You are just having fun with a technology and, with any luck, you are putting across the message. Froshaug was important in teaching us to categorize the message and give hierarchies to it, so at least you knew you were putting across the important things first and the person looking at it could find things. With a poster you could see where an exhibition was, give some idea of its character, when it was open and whether it was admission-free. You would take those things for granted, then have fun. Also, the fun is in relating to the people you are working with because they are usually very decent people. Being an artist is a nightmare. In a way, to be an artist is to be a heroic figure. It is a hard life. Not like a designer's.

Interview: Rick Poynor

Alan Fletcher,
Pentagram, *How to Play*
the Environment Game,
poster for Hayward
Gallery, London, 1973

Dennis Bailey,
Dada and Surrealism
Reviewed, catalogue
cover and spread, Arts
Council, 1978

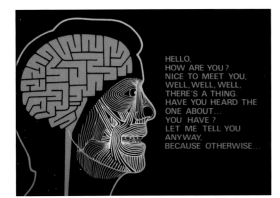

HELLO,
HOW ARE YOU?
NICE TO MEET YOU,
WELL, WELL, WELL,
THERE'S A THING.
HAVE YOU HEARD THE
ONE ABOUT...
YOU HAVE?
LET ME TELL YOU
ANYWAY,
BECAUSE OTHERWISE...

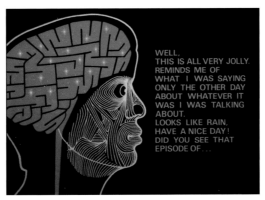

WELL,
THIS IS ALL VERY JOLLY.
REMINDS ME OF
WHAT I WAS SAYING
ONLY THE OTHER DAY
ABOUT WHATEVER IT
WAS I WAS TALKING
ABOUT.
LOOKS LIKE RAIN,
HAVE A NICE DAY!
DID YOU SEE THAT
EPISODE OF...

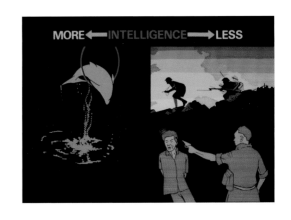

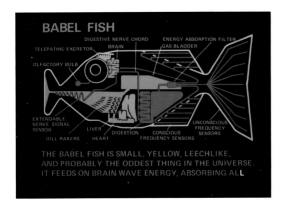

**Rod Lord, Pearce
Studios**, *The
Hitchhiker's Guide to
the Galaxy*, programme
graphics for BBC tele-
vision, 1981. Direction:
Alan J. W. Bell at BBC.
Animation: Lord

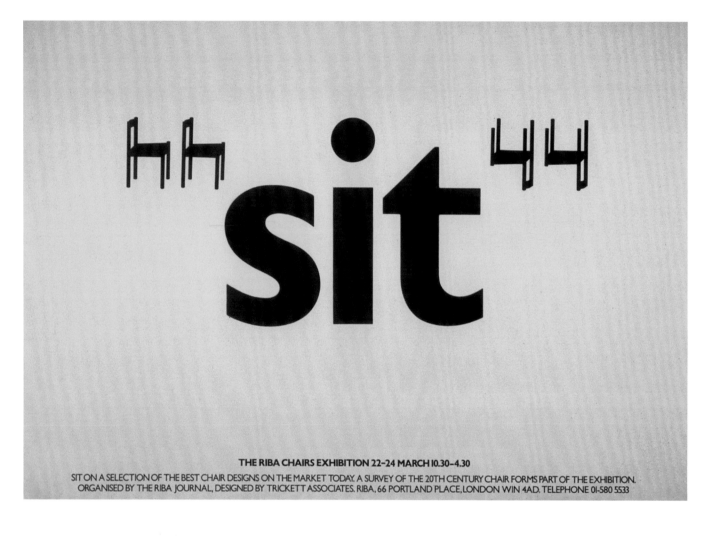

THE RIBA CHAIRS EXHIBITION 22–24 MARCH I0.30–4.30

SIT ON A SELECTION OF THE BEST CHAIR DESIGNS ON THE MARKET TODAY. A SURVEY OF THE 20TH CENTURY CHAIR FORMS PART OF THE EXHIBITION. ORGANISED BY THE RIBA JOURNAL, DESIGNED BY TRICKETT ASSOCIATES. RIBA, 66 PORTLAND PLACE, LONDON WIN 4AD. TELEPHONE 0I-580 5533

Top: **Trickett & Webb**, *Sit*, poster and catalogue cover for Royal Institute of British Architects, 1983

Kate Stephens, *Effluvia*, Helen Chadwick catalogue cover and spread for Serpentine Gallery, 1994. Photographs: Edward Woodman

Kate Stephens, *Anish Kapoor*, catalogue cover for the British Pavilion of the XLIV Venice Biennale, British Council, 1990

Top: **Tony Arefin and Stephen Coates**, *Like Nothing Else in Tennessee*, poster for Serpentine Gallery, 1992

Kate Stephens, *Something the Matter*, catalogue cover for British Council, 1995

Tony Arefin, *Acts of Faith*, poster for Institute of Contemporary Arts, 1992. Photograph: Anthony Oliver

Tony Arefin, *Decoy*, catalogue cover for Serpentine Gallery, 1990. Image: Elizabeth Magill

Mike Dempsey, CDT,
*The Duel of Tancredi
and Clorinda*, poster for
English National Opera,
1992. Photograph:
Michael Hoppen

Iain Crockart, CDT,
Xerxes, poster
for English National
Opera, 1991

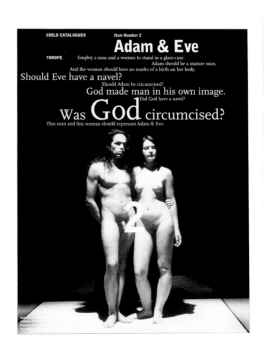

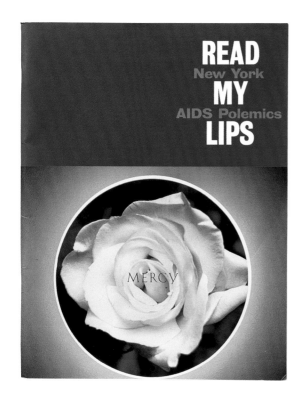

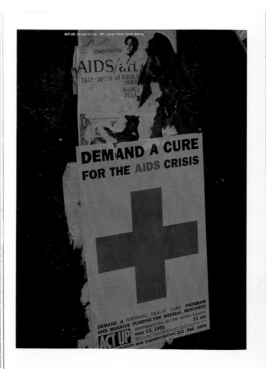

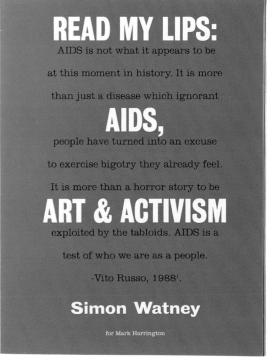

Top: **Stephen Coates**, *100 Objects to Represent the World: A Prop Opera* by Peter Greenway, libretto cover and spread, Change Performing Arts, 1997

Tony Arefin and Stephen Coates, *Read My Lips*, catalogue cover and spread for Tramway, Glasgow, 1992. Cover image: Donald Moffett

Why Not Associates,
Sensation, poster for
Royal Academy of Arts,
1997. Photographs:
Rocco Redondo and
Photodisc

Why Not Associates,
Apocalypse, poster for
Royal Academy of Arts,
2000. Photograph:
Photodisc and
Powerstock Zefa

Jonathan Barnbrook,
*I Want to Spend the
Rest of My Life Every-
where, with Everyone,
One to One, Always,
Forever, Now* by Damien
Hirst, cover, Booth-
Clibborn Editions, 1997

BRITAIN

Comedians

Johnson Banks,
Britain: Comedians,
poster for British
Council, 1998. Photo-
graphs: Rex Features

Paul Neale Graphic Thought Facility

In 1990, after leaving the Royal College of Art, you set up Graphic Thought Facility with Andy Stevens and Nigel Robinson, who has since left. Why did you decide to band together?
We had been sharing a studio at the RCA, working sometimes together and sometimes not. It was a healthy creative atmosphere and we were having fun. We just wanted to keep that going. We were a bit green but in terms of what we were interested in, I think now it is pretty consistent with that – we used to spend a lot of time there working ideas and concepts through materials, as well as two-dimensional possibilities.

Your work shows a fascination with materials. Sometimes it seems more like product design than graphic design.
It seems irrational to think of graphic design as a purely two-dimensional thing. It is a physical thing. People respond to the physicality of graphic design as strongly as they respond to use of colour in graphic design.

You have done everything from neon logos to printing on pets' headstones. Is your aim to push at the limits of what is possible?
We are trying to change things in different ways. A lot of the exhibition work we have done follows a similar pattern of finding an appropriate medium and working out of the process. You have to find out enough about the process so that you are not trying to do something that the process is not particularly good at. It can be a very mundane process but applied to something less familiar.

When you find something that you like, do you tend to reuse it or do you always look for something new?
It has to feel right. We want to push things forward – to keep them interesting for ourselves. A lot of it is finding a manufacturer or a supplier that you can have an intelligent dialogue with. That makes all the difference for us, finding someone who may be up for doing things that are not quite what they normally do. We are not trying to make things overcomplicated for the sake of it. The likelihood is, if we go back and use something again, the context will be different. An example of that is 'Stealing Beauty', an exhibition we did at the ICA in 1999: we used a very basic, old-fashioned method of mechanically engraved laminated plastics. We reused the same process very quickly after that, for Café Gandolfi in Glasgow. Because it was a different problem it felt totally appropriate yet in a completely different way.

The Digitopolis project at the Science Museum with Casson Mann started with Andy and Huw [Morgan, GTF's third director] visiting a big electronics components trade fair so we could get up to speed on light-emitting devices. The gallery had been designed as a dark space; we had to find ways of delivering texts that would provide their own light source. We finally used vacuum fluorescent displays, LCD messaging and electro-luminescent messaging.

Graphic Thought Facility, poster for fashion designers Antoni & Alison, 1994. Photograph: Andrew Penketh

Usually on these jobs it is quite a steep learning curve, but one thing that excites us about a lot of projects – and it certainly applies to exhibition work – is being able to affect the physicality, to play with materials and process. That is often a more appropriate way of making a difference than over-designing the flat graphic elements, especially when you are dealing with a strict hierarchy of information.

It is quite frustrating when we get to use a process like electro-luminescent messaging. When we got the chance to use EL at the Science Museum we thought we might not get the opportunity again, so we wanted to push it as far as we could. But unlike an artist who gets to push the medium and express himself, we always have to balance everything up with the requirements of the client and the delivery of information.

When you are working in the arts, how much are you affected by the demands of marketing?

Usually the curators are the people we are dealing with directly when we are designing exhibition spaces. Sometimes we get involved in designing the catalogue. Other times we get asked to design the publicity material. I cannot think of one exhibition, apart from possibly 'Stealing Beauty', where we have been able to bridge all those platforms with one idea. It is frustrating because the potential synergy between those things is lost. Having to make things work equally successfully across all those formats is a challenge that we would be more than happy to take on.

Has the earlier era of ideas-based solutions influenced your approach?

It is hard to work without ideas. I think we are graphic designers in quite a traditional sense. We start with the client's needs – and obviously it helps if we have some sympathy with what they are involved in, hence we end up working with the likes of Habitat and Shakespeare's Globe Theatre. Most of our work is commercial and it feels commercial. Most of our solutions, hopefully, are accessible.

What about the future? Do you expect GTF to keep growing?

It probably will not get bigger. We are a studio of seven permanent members – one studio manager and six designers, including the directors. If you get bigger you end up designing less, spending too much time in meetings. But I said that when we were four. Like many designers, we are in business because we like designing rather than because we like being business people and trying to optimize business opportunities. We want a balance of financial stability and fun.

Interview: Jane Lamacraft

**Graphic Thought
Facility**,
*Shakespeare's Globe
Theatre*, poster,
2003. Photograph:
Nigel Shafran

**Angus Hyland,
Pentagram**, *Fabric
of Fashion*, poster
for British Council,
2000. Photograph:
Michael Danner

Wolfgang Tillmans

6 June –
14 September 2003

if one thing
matters, everything
matters

BRITAIN
TATE

**James Goggin,
Practise**, *If One Thing
Matters, Everything
Matters*, poster for Tate
Britain, 2003

Kerr Noble, fold-out
souvenir for riverboat
trip on the Thames for
Channel 4, 1999

**Hi-Res! (Florian Schmitt
and Alexandra Jugovic)**,
Requiem for a Dream,
film promotion
website for Artisan
Entertainment, 2000

Florian Schmitt Hi-Res!

**Given your background in industrial design, film and television,
why did the web attract you so much and how has that affected
your approach to web design?**

For us the web was a chance to combine all these disciplines that
Alexandra Jugovic and I were working on separately into one
cohesive thing: music, graphic design, moving image and make it
interactive and accessible to everyone. It was just a big challenge.

When you work on a film, you work with the narrative and you
want to be true to that, but we always try to create pockets of
something else. The same with the visuals. We just take an image
and begin to unravel it, find new meaning in it, shift things
around and combine stuff. We like the idea of something growing
on top, not just replicating something, which is such a senseless
approach. You cannot replicate a film on the web.

These websites require visitors to invest a lot of time.

Yes, things are so incredibly difficult to find, aren't they? There is
always a sense of discovery. With *Requiem for a Dream*, for
example, we wanted to challenge people. We did not want to
design something that could be measured against web standards
or usability tests, because frankly we were not very interested in
that side of the work. I can see the point of it now. The whole
website was pretty much rebelling against everything that was the
status quo at the time, at least for film promotion websites. We
just did what we felt would work.

**Requiem for a Dream was your first commissioned website.
What was the concept behind it?**

Darren Aronofsky, the director, came across the *Soulbath* website,
a self-initiated project we did in 1999, and he really identified with
the idea of decay. There is a bit in the site menu where words
become distorted or things fall apart and it is a lot about losing
control. I think that really resonated with him. The film is about
addiction, compulsive behaviour and about losing control – things
getting progressively worse. While we were designing or discussing
the concept of the website with Darren Aronofsky, we never
actually saw the film and a lot of our discussions were very
abstract: based around the American Dream, how things can all
go wrong, addictions in various disguises.

**Your websites all seem to have a fractured, futuristic aesthetic.
Do you subscribe to a particular style?**

We went through a whole phase of thinking about what our style
is, and then we went through a whole phase when we did not
want a style, and then when we compiled our showreel and
reviewed it we noticed there was an underlying style. Creating
depth has always really interested us as a possibility on the web.
For me, it was important given my background is in 3D, and I
could never understand why web design had to be flat, why it

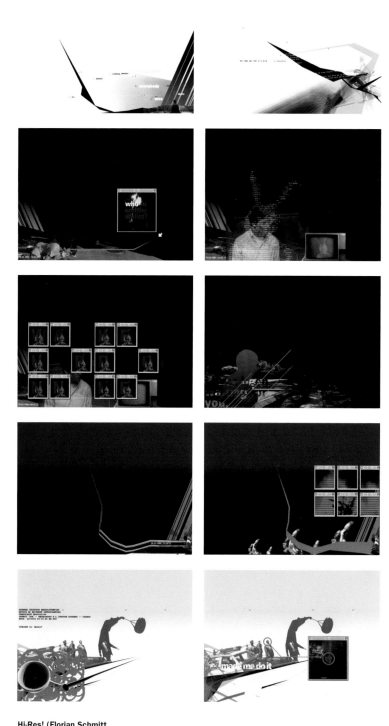

**Hi-Res! (Florian Schmitt
and Alexandra Jugovic)**,
Donnie Darko, film
promotion website for
New Market Films, 2001

could not have depth. Also, the whole layering thing: it is like making music; like taking five different loops, mixing them together and all of a sudden you have something completely new. It is like dense information all compressed together.

A lot of the early design we did was definitely influenced by architecture, especially by Zaha Hadid. But it was also a lot about malfunction and things not working properly.

How did you come to design the *Donnie Darko* website and what was the thinking behind it?

It is a bit like what we were trying to do with the *Requiem* or *Centre of the World* sites, to create something that can exist alongside the film, but that could also exist on its own and still somehow make sense and be a valid piece.

For the film, we thought it would be good not to talk about the film at all. As it is set over a period of 28 days, which is integral to the narrative, we thought it would be interesting to cover things that happened before and after. So when you go to the site without having seen the film, it is a bit of a mystery and if you have seen the film and you visit the site, you think, 'Oh, now it all makes sense' – except that of course it still does not make sense. But in a nutshell, that was the concept.

We worked with the director, Richard Kelly, who was very keen on writing the copy. Then we had this idea of creating different levels within the site, partly because the site was launched over a 28-day period. We wanted to spread it out rather than launch the site in one go. So that is where the whole game-like structure, where you have to finish one element to go on to the next, comes from. There were lots of elements that we launched in between. Every two or three days there was something new. You cannot see it any more, but there used to be these counters that told the browser to return in 3 hours 25 minutes and 16 seconds. We were always replicating the idea of 28 days on the site, and people began to expect things to happen.

It was such an interesting site on so many levels, some of them completely unexpected. I really liked the fact that people started interacting with the site in an organic and different way. We had this email response component, where people would email us and we would reply pretending to be Donnie and they would say, 'I thought you were dead?' We had all these surreal conversations with people over the course of five or six emails. Then people began to expand bits of the website. When you click on a link you are directed somewhere completely different. To me, that was totally unexpected and unprecedented. That someone would take an official website, co-opt bits of it and make them their own, continue it somewhere else and create a new strain, like a beautiful virus.

Interview: Alona Pardo

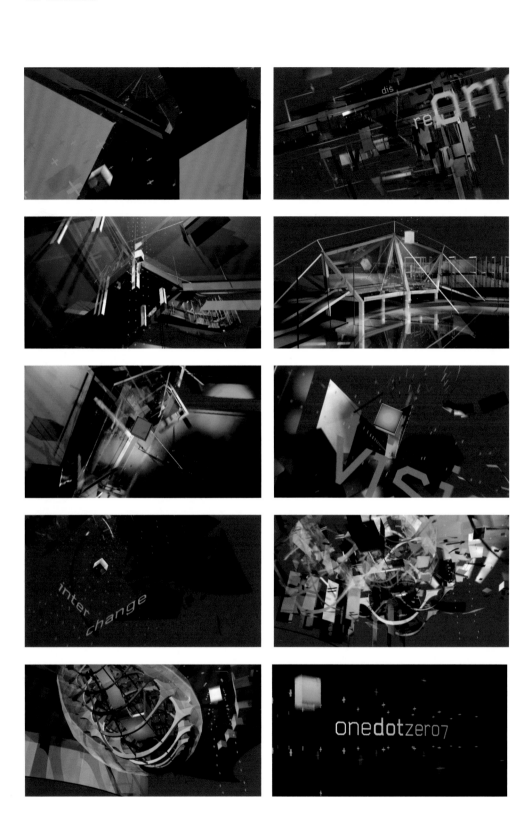

Mark Hough, State,
Onedotzero 7, title
sequence for annual
moving image festival
at Institute of
Contemporary Arts,
London, 2003

Studio Myerscough,
UK State of Play,
exhibition stand
promoting computer
games, E3 Electronic
Entertainment Expo,
Los Angeles, 2003.
Architects: Hût
Architecture

Top: **North**, Student
Expo poster for D&AD,
1999

Music

British pop music was second only to that of the US in its impact on listeners around the world. Such a high level of creativity demanded an equally sophisticated visual response. By the mid-1960s, bands were starting to view albums as works of art, and they wanted covers to match. The Beatles set the pace, with a series of classic sleeves for *Revolver, Sgt. Pepper* and other albums. While a few design generalists, such as Robert Brownjohn, made distinctive contributions, most sleeve designers, from Hipgnosis on, were specialists fully in tune with the music scene. The new wave that followed punk in the late 1970s saw an explosion of visual energy. British music graphics now led the way, and designers such as Barney Bubbles, Malcolm Garrett, Peter Saville and Vaughan Oliver produced some of the most striking designs of the period. The sector's strength was its stylistic flexibility. It could accommodate the rigorous typography of 8vo or the riffs and improvisations of Tomato. In 2000, despite some concerns that possibilities were narrowing, music design was still a place for bold invention. The work of Julian House of Intro represented a synthesis of influences, from Pop Art to new wave, spliced with an aggressive new digital aesthetic.

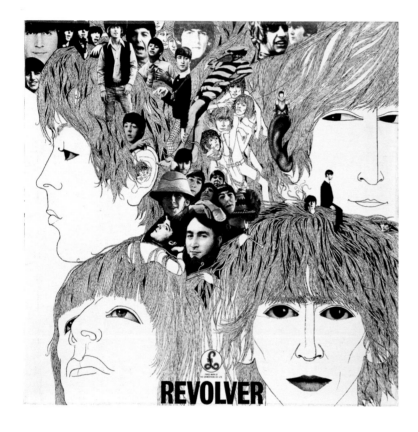

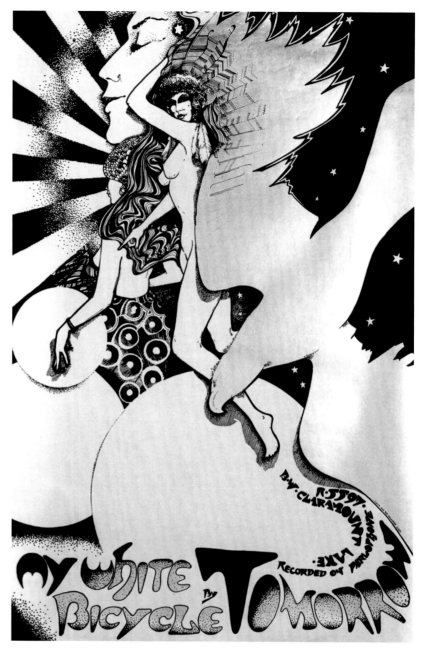

Klaus Voorman,
Revolver by the
Beatles, album cover,
EMI/Gramophone
Company, 1966

**Hapshash and the
Coloured Coat
(Michael English and
Nigel Waymouth)**,
My White Bicycle,
silkscreen poster for
Parlophone, 1967

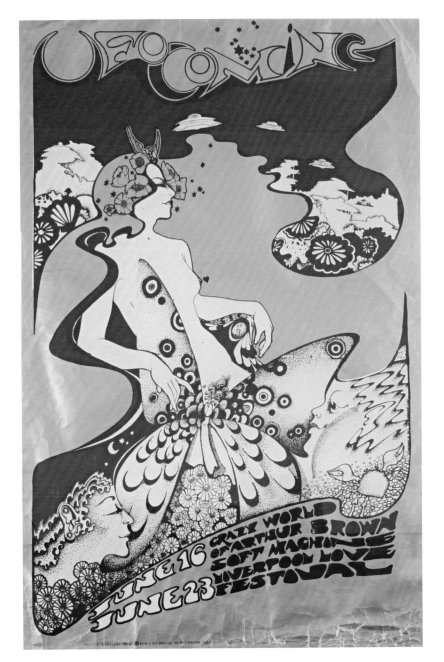

Hapshash and the
Coloured Coat
(Michael English and
Nigel Waymouth), *UFO
Coming*, silkscreen
poster for Osiris, 1967

Michael McInnerney,
UFO Dawn to Dusk,
silkscreen poster for
Osiris, 1967

Robert Brownjohn, *Let
It Bleed* by the Rolling
Stones, album cover
(front and back), Decca,
1969. Photographs:
Don McAllester

**Hipgnosis
(Storm Thorgerson and
Aubrey Powell)**,
Ummagumma by Pink
Floyd, album cover,
Harvest/EMI, 1969

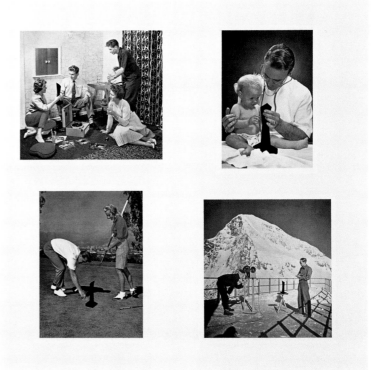

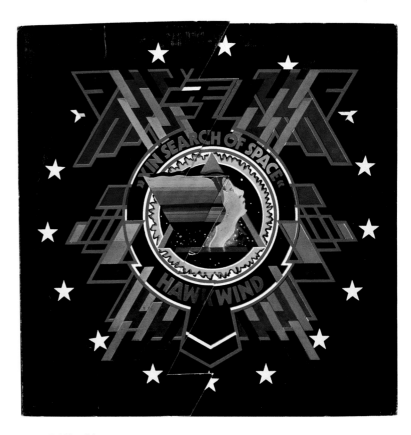

Hipgnosis
(Storm Thorgerson and
Aubrey Powell) and
George Hardie,
Presence by Led
Zeppelin, album cover
and detail of inside
cover, Swan Song, 1976

Barney Bubbles, *X in
Search of Space* by
Hawkwind, album cover,
United Artists, 1971

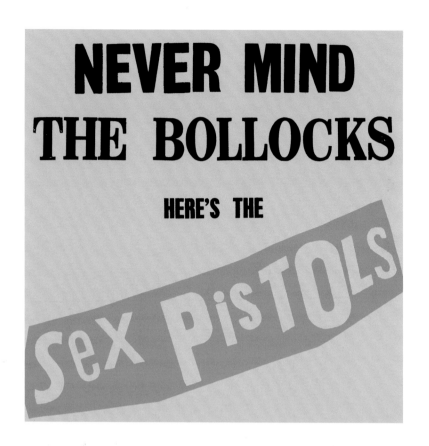

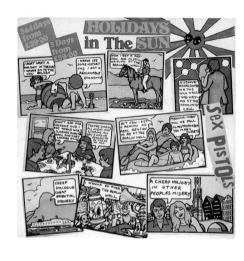

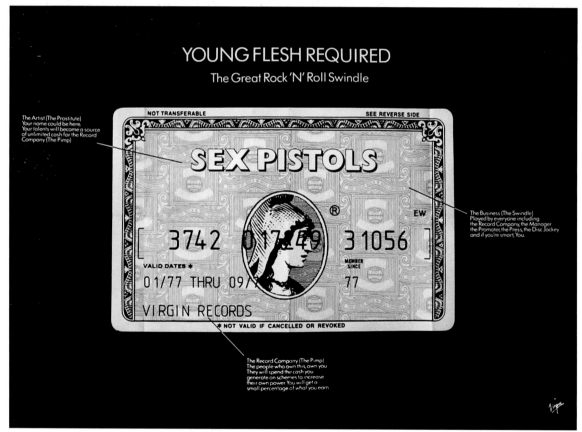

Top: **Jamie Reid**,
*Never Mind the
Bollocks Here's the Sex
Pistols* by the Sex
Pistols, album cover,
Virgin, 1977

Jamie Reid, *Young
Flesh Required*, poster
for the Sex Pistols,
Virgin, 1979

Top: **Jamie Reid**,
Holidays in the Sun
by the Sex Pistols,
7-inch single cover,
Virgin, 1977

Nicholas de Ville, *Gary
Gilmore's Eyes* by the
Adverts, 7-inch single
cover, Anchor, 1977

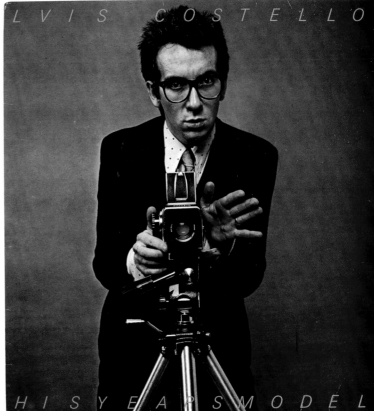

Barney Bubbles, *Armed Forces* by Elvis Costello and the Attractions, detail from inside folding album cover, Radar/WEA, 1979

Barney Bubbles, *This Year's Model* by Elvis Costello and the Attractions, album cover, Radar/WEA, 1978

Top: **Barney Bubbles**, *I Love the Sound of Breaking Glass* by Nick Lowe, 7-inch single cover, Radar/WEA, 1978

BUZZCOCKS · NEW PRODUCT · SINGLE ITEM · UP 36348 · WHAT DO I GET?

Malcolm Garrett,
What Do I Get?, poster
for Buzzcocks single,
United Artists, 1978

Malcolm Garrett

Why design for the music business rather than any other area of design? What led you in that direction?

I do not know whether it was so much a decision as a natural opportunity that opened up. I have always been somebody who follows his instinct. I was 16 or 17 and about to go to university and, like many people of that age, then and now, I was obsessed by a music-led lifestyle. I was into music of all kinds – rock, glam, electronic, Krautrock, various avant-garde things – and picking up on culture in the post-psychedelic era. I was seven in 1963, when the Beatles exploded, and so my earliest musical memories are of buying *Can't Buy Me Love*, *Help!* and *A Hard Day's Night*. By the time I hit 13 or 14, it was Deep Purple, Black Sabbath – who even in the post-hippie era still had chart hits – but more importantly I bought 'progressive' albums by the likes of King Crimson and Van der Graaf Generator.

When I went to Manchester Polytechnic to study graphic design, which appealed to me as fine art with a purpose, I was very interested in the way music was packaged. The kind of thing that had really caught my attention was the packaging for Hawkwind, which played with what you could do with the cardboard, rather than just putting it in a simple 12-inch square with a picture. There were fold-outs and cut-outs, and they were playing with metallic inks and fluorescents. There were always inserts and posters and booklets.

What part did punk play in pulling you towards design for the music scene?

On a trip to London at the end of 1976, after hearing a friend of a friend saying how brilliant the Sex Pistols were, I bought *Anarchy in the UK* to see what it was all about. I went into a branch of Virgin Records and there above the counter was a video of them playing. I walked away with that single a re-oriented man. I was still in the middle of my second year at college, but I had suddenly found a focus for all the graphic energy that up until that point was in research mode, but from that point went into development mode. All the things I did for my own amusement were now centred on, or driven by, ideas generated by punk, whether it was representing a feeling or an attitude, or taking words that summed up that attitude and playing with the typography.

How did you come to design for the Buzzcocks?

In the year above me at Manchester there was a girl called Linder, an illustrator. In January 1977, I met Howard Devoto [Buzzcocks' first singer] and Richard Boon [their manager] through Linder. Richard had gone to Reading University to do fine art, which was where I had spent a year doing typography. We were both in the fine art club and had been to lots of the same events, but had never met, so we had a lot to talk about. They asked me if I

Malcolm Garrett,
*Love You More/Noise
Annoys* by Buzzcocks,
7-inch single cover,
(front and back),
United Artists, 1978

wanted to design a poster for their gigs. So I set about designing this poster and a piece of type that would say say 'Buzzcocks', which I printed up as a screen print in March 1977. I met Peter Shelley [Buzzcocks' singer] and saw them at a place called The Band on the Wall and it all rollercoasted from there.

What was the graphic thinking behind the Buzzcocks sleeves?
I was trying to do something that represented who I thought the Buzzcocks were and what their music was about, and produce something that was as different from any other sleeve that I had liked or disliked as I could. There was a surreal, homely aggression to the Buzzcocks' lyrics that I wanted to capture.

I was interested in the record sleeve as a package. I wasn't a photographer or an illustrator – or even a logotype designer. I wasn't interested in the sleeve as something you might display on the wall. I saw it merely as a piece of cardboard which was an expression of the mood that is Buzzcocks. I did not want it to be like a punk sleeve. Handwritten stuff and torn paper was already a cliché. Out of economic necessity we developed the idea that each single sleeve should be done in two colours. With my first sleeve (for the single, *Orgasm Addict*) I thought that if you use the colours of hazard warning signs, industrial colours, then that would also be quite punk. Yellow was really bright, both happy and aggressive – it is the most visible colour there is. I contrasted it with blue, a solid, dark colour that you can also print images in.

What kind of feedback and input did you get from Richard Boon and the band?
Richard was always the person I had the most dialogue with. Almost all of the work I did with the Buzzcocks was through or with Richard, who had a huge hand in developing ideas. We loved playing word games. I called them word games in pictures. Richard was very literary. He knew his contemporary art from a curatorial standpoint. We loved making oblique art references, such as a sleeve that was black on black in homage to Ad Reinhardt. There were all sorts of little games and jokes and details that Richard and I discussed and put in. I'm sure the band didn't always get it. Peter Shelley certainly did, but as the main lyricist he came up with a lot of the ideas that we picked up on.

We just had lots of fun. We sort of knew what we were doing and treated it as an identity, but more as a way of controlling our disparate ideas. One of the challenges is that you don't know what song Peter Shelley is going to write next week, or what direction the music will take, so we tried to set up a framework with many starting-points that would allow the design to go in lots of different directions. When you look at it in retrospect, it looks like it was planned in some detail, but of course it was not.

Interview: Rick Poynor

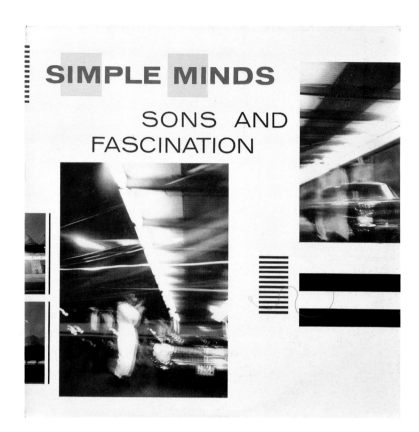

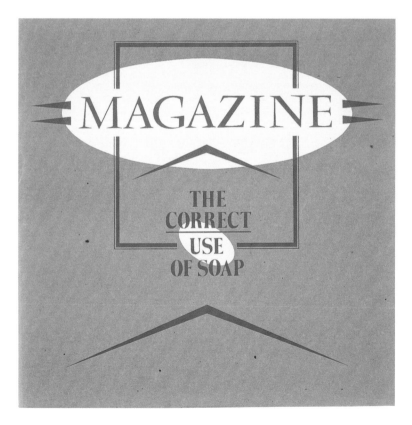

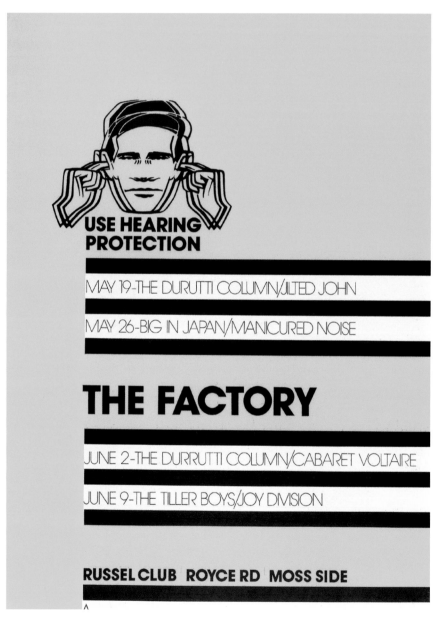

Top: **Malcolm Garrett, Assorted Images**, *Sons and Fascination* by Simple Minds, album cover, Virgin, 1981. Photographs: Sheila Rock

Malcolm Garrett, *The Correct Use of Soap* by Magazine, album cover, Virgin, 1980

Peter Saville, *The Factory*, poster, 1978

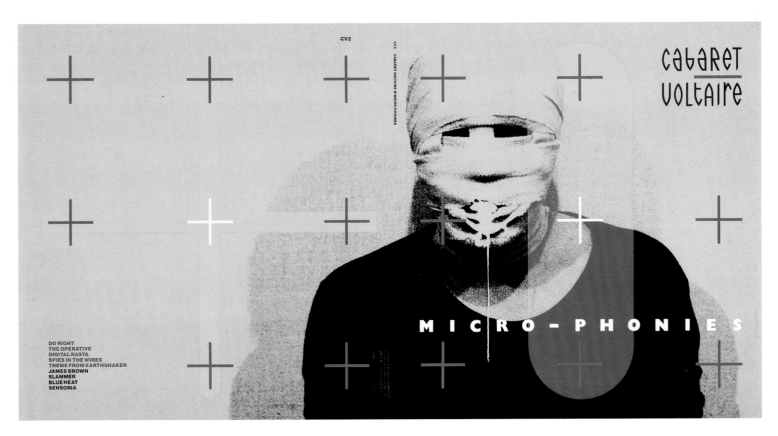

Neville Brody, *Micro-Phonies* by Cabaret Voltaire, album cover (front and back), Some Bizarre/Virgin, 1984. Photograph: Phil Barnes

Vaughan Oliver, 23 Envelope, *Clan of Xymox* by Clan of Xymox, album cover, 4AD, 1985. Dolls screenprint: Terry Dowling

Vaughan Oliver,
23 Envelope, *Aikea-Guinea*, poster for
Cocteau Twins, 4AD,
1985

Top**: Vaughan Oliver,**
v23, *Doolittle* by Pixies,
album cover, 4AD,
1989. Photograph:
Simon Larbalestier

Vaughan Oliver, v23,
Sweetness and Light,
by Lush, 12-inch
single cover, 4AD,
1990. Photograph:
Jim Friedman

8vo, *Haçienda Seven*,
club anniversary poster,
Factory, 1989

Top: **Peter Saville**,
Low-life by New Order,
album cover, Factory,
1985. Photograph:
Trevor Key

**Mark Farrow and Pet
Shop Boys**, *Yesterday,
When I Was Mad* by
Pet Shop Boys, 12-inch
single cover, EMI,
1994. Photograph:
Richard J. Burbridge

Top: **Peter Saville**,
Blue Monday by New
Order, 12-inch single
cover, Factory, 1983

**Peter Saville,
Pentagram**, *Regret* by
New Order, 12-inch
single cover, London,
1993. Image manip-
ulation: Brett Wickens

Central Station Design,
Bummed by Happy
Mondays, album cover,
Factory, 1988

Stylorouge, *Modern
Life is Rubbish* by Blur,
album cover, Food
Records/EMI, 1993.
Illustration: Michael
Woodward Licensing

Top: **Mike Dempsey, CDT**, *LCO 8: Minimalist* by London Chamber Orchestra, album cover, Virgin, 1990. Photograph: Andy Seymour

Top (right): **Mike Dempsey, CDT**, *LCO 10: Power* by London Chamber Orchestra, album cover, Virgin, 1990. Photograph: Lewis Mulatero

Nick Bell, *The Ice Break* by Michael Tippett, CD booklet cover (front and back), Virgin Classics, 1991. Art director: Jeremy Hall

Top: **Me Company**, *Bang up to Date with the Popinjays* by Popinjays, album cover, One Little Indian, 1991

Me Company, *Make it Mine* by the Shamen, 12-inch single cover, One Little Indian, 1990

Top: **Tomato**,
*Dubnobasswithmyhead
man* by Underworld,
album cover (front and
back), Junior Boy's
Own, 1993

**Tomato and Robert
Shackleton**, *Cowgirl* by
Underworld, music
video, 1994

underworld : second toughest in the infants

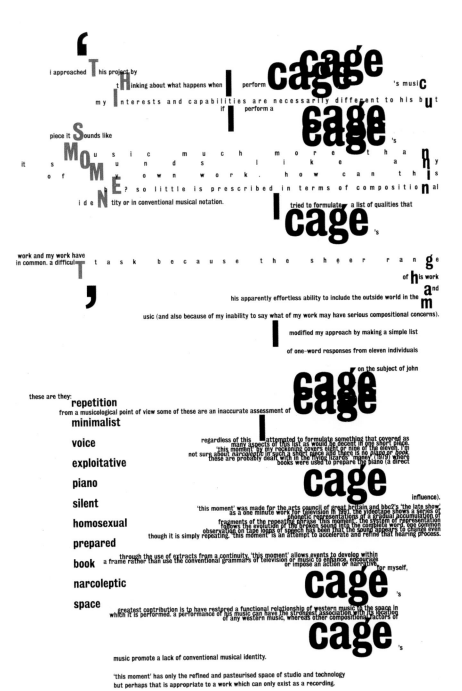

'This project by i approached T thinking about what happens when I perform cage cage 's music
my Interests and capabilities are necessarily different to his but
if I perform a cage cage 's
piece it Sounds like
it s MOMENT music much more than y
of y own work. how can this
? so little is prescribed in terms of compositional
identity or in conventional musical notation.
tried to formulate a list of qualities that I cage 's

work and my work have
in common. a difficult T task because the sheer range
of his work
his apparently effortless ability to include the outside world in the and
am

I usic (and also because of my inability to say what of my work may have serious compositional concerns).

I modified my approach by making a simple list
of one-word responses from eleven individuals
on the subject of john

these are they:
repetition
from a musicological point of view some of these are an inaccurate assessment of cage
minimalist
regardless of this I attempted to formulate something that covered as
voice many aspects of this list as would be decent in one short piece.
'this moment' by my reckoning covers eight or nine of the eleven. I'm
not sure about narcoleptic in such a short piece and there is no piano or book.
exploitative these are probably dealt with in the flying lizards' money (1979) where
piano books were used to prepare the piano (a direct
cage
silent influence).
'this moment' was made for the arts council of great britain and bbc2's 'the late show'
homosexual as a one minute work for television in 1991. the videotape shows a series of
phonetic representations of a gradual accumulation of
fragments of the repeating phrase 'this moment'. the system of representation
prepared follows the evolution of the broken sound into the complete work. one common
observation on tape loops of speech has been that the sound appears to change even
book though it is simply repeating. 'this moment' is an attempt to accelerate and refine that hearing process.
through the use of extracts from a continuity. 'this moment' allows events to develop within
narcoleptic a frame rather than use the conventional grammars of television or music to enhance, encourage
or impose an action or narrative. for myself,
space cage 's
greatest contribution is to have restored a functional relationship of western music to the space in
which it is performed. a performance of his music can have the strongest association with its location
of any western music, whereas other compositional factors of cage 's
music promote a lack of conventional musical identity.

'this moment' has only the refined and pasteurised space of studio and technology
but perhaps that is appropriate to a work which can only exist as a recording.

Tomato, *Unknown Public* no. 1, 'A Page for Cage', looseleaf page for a boxed audio journal, 1992. Editor: John L. Walters

Dylan Kendle, Tomato, *Second Toughest in the Infants* by Underworld, album cover, Junior Boy's Own, 1996

Ben Drury, *Psyence
Fiction* by Unkle, album
cover and inside cover,
Mowax/A&M, 1998.
Cover illustration:
Futura. Photographs:
Will Bankhead

Ben Drury, *Push the
Button* by Money Mark,
album cover,
Mowax/A&M, 1998.
Photographs: Drury

Julian House Intro

An interest in art history is very apparent in your approach to design.

As a student I was really into Surrealism and Pop Art and people like Rauschenberg. It still crops up as a reference point. Primal Scream's *Xtrmntr* is a case in point. The starting-point is James Rosenquist or Richard Hamilton, but then what comes into it is PlayStation games and CNN. I tend to flick through *Frieze* and *Art Forum* more than I do contemporary design magazines. Then there are also peripheral elements of design, Polish poster art and things that you have to search out. The Broadcast covers come from that sort of aesthetic – quite dark and surreal, but visually bold at the same time.

What is the process of development with an album cover project such as *Xtrmntr*?

It usually starts with just chatting to the band. That might give an idea of where their heads are at, what the album's themes are, and what is interesting them at the time. The two things on *Xtrmntr* were an obsession with the military-industrial complex and, for the time, their quite political statements. The sound itself was really heavy and industrial and fractured.

So the Rosenquist, Pop Art idea was at the forefront of my mind, coupled with the subject matter of the lyrics. I'm sure it is an unconscious thing that led me to make it so angular and aggressive. It was done in QuarkXpress rather than Photoshop and it is quite a limited, clumsy tool to cut things out with. You are not going to get nice shaped picture boxes. Sometimes it is the fact that you cannot do something very well with a program that gives the design its feel. There is quite a lot of drug paranoia in these tracks. The lyrics have a J. G. Ballard and William Burroughs influence. There is a slightly dark, 1970s sci-fi feel to it, together with the military-industrial side. The earlier stages of the design were a lot more coherent. The shape of things made a lot more sense. What happened was that I was creating a new document and copying and pasting elements from the old document into the new one. I pasted a lot of stuff down and it was all over the place. The scale was wrong and there were pieces missing where I had not grabbed the whole image.

Collage is central to everything I do. Even if the end result is not necessarily a collage, that process of letting things emerge from the elements you push together is a fundamental part of it. I do not see it as an illustrative style. As a student I was interested in Kurt Schwitters, as well as William Burroughs and Brion Gysin and his ideas about cut-up theory. He gave it an almost magical significance. Strange meanings would emerge if you followed a certain process, putting two things together to produce a third meaning that was not there before. That is what keeps me excited about doing this sort of work.

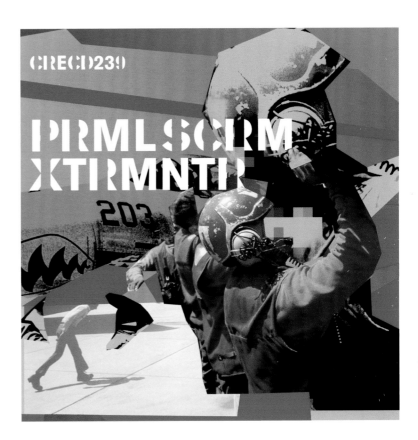

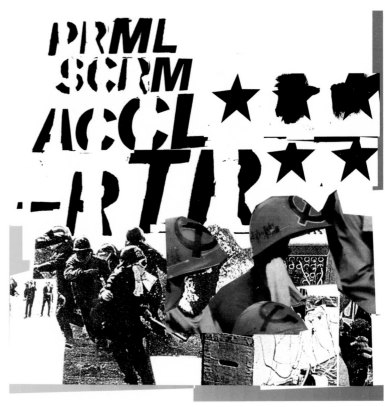

Top: **Julian House, Intro**, *Xtrmntr* by Primal Scream, album cover, Creation, 2000

Julian House, Intro, *Acclrtr* by Primal Scream, 12-inch single cover, Creation, 2000

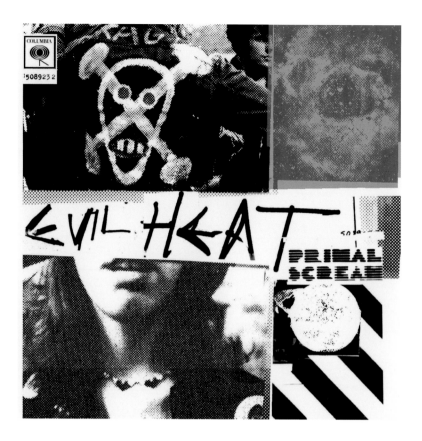

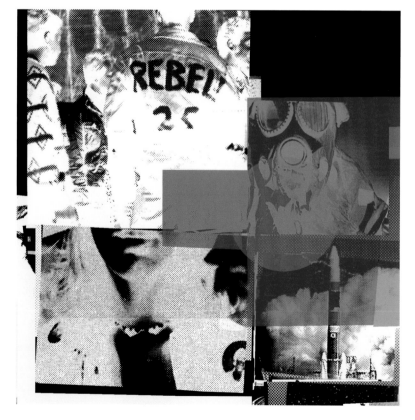

Julian House, Intro, *Evil Heat* by Primal Scream, album cover (front and back), Sony (UK), 2002

How did you arrive at the decision to eliminate the vowels on the Primal Scream covers?

The eventual result looks quite militaristic. With price stickers in record shops, there are systems of abbreviation that you can still read. The first sleeve was for *Swastika Eyes*, which worked quite well as typography. It had a clandestine feel to it. I like the way that Primal Scream project this rebel gang personality and this sleeve with the vowel-less name had an anti-establishment feel. Everybody who was in on it knew that it was Primal Scream. For the record label, it also defused the fact that *Swastika Eyes* was quite a contentious title. It was codified and that helped them get away with it. The posters really stood out. The typeface was Akzidenz, which has been turned into a stencil.

Do you see this kind of record industry work as a form of self-expression?

The fundamental aim is to advertise the band. I like working within those constraints. If you can bring something to it, then it can do two jobs at once. It is a personal position that you take, but it is still there to sell records. I would never say, 'This is my vision that I'm bringing to the band.' It is a two-way process, a collaboration. Their response to some of my ideas often focuses it in a way that maybe I would not have done. They might see something that would not have been my first choice, but that steers it along. I suppose I am at a stage where I have got used to all the things that you have to do to fulfil the requirements of a record sleeve, and I know how much of me I can put in and not overtake their identity. I would like to think that everything comes together looking like an individual's take on things, but each cover has to work in its own right for that particular band and their music or statement. I am lucky that these bands are all different, but they complement the sort of things that I am into.

It is often observed that marketing is more in control now in the music business and there are fewer opportunities for creative expression. What is your own experience?

Everyone I have worked with in the record industry has come to Intro because they want an interesting sleeve and they understand the importance of that. There might sometimes be disagreements or restrictions about the size of type, or legibility, or the market sector they are speaking to, but we are lucky enough to know a group of individuals who still care. As long as there is an enlightened project manager who likes design it can still work. You cannot just say no to everything that is asked of you because you will not get anywhere. If you can get what you see as good design through according to their rules, they might not realize it. It is a game of diplomacy in a way.

Interview: Rick Poynor

Top: **Julian House, Intro**, *Sound-Dust* by Stereolab, album cover, Duophonic, 2002

Julian House, Intro, *Haha Sound* by Broadcast, album cover, Warp, 2003

Top: **Farrow Design and Don Brown**, *Let It Come Down* by Spiritualized, CD cover, Arista, 2001. Packaging design: Farrow and Spaceman. Sculpture: Don Brown

Farrow Design, *Ladies and Gentlemen We are Floating in Space* by Spiritualized, set of CDs, Dedicated/ Arista, 1997. Packaging design: Farrow and Spaceman

Top: **Tom Hingston and Robert Del Naja**, *Mezzanine* by Massive Attack, album cover, Virgin, 1998. Photograph: Nick Knight

The Designers Republic, *Incunabula* by Autechre, album cover (inside), Warp, 1993

Top: **Tom Hingston and Robert Del Naja**, *100th Window* by Massive Attack, CD cover, Virgin, 2003. Photograph: Nick Knight

8vo, *Flux: The Edinburgh New Music Festival*, poster, 1997

Top: **Blue Source**, *Hey Boy Hey Girl* by the Chemical Brothers, 12-inch single cover, Virgin, 2000. Screenprint: Kate Gibb

Blue Source, *A Rush of Blood to the Head* by Coldplay, CD cover, Parlophone, 2002. Photograph: Sølve Sundsbø

ept

AL LONDO

17 Septer

res

aga

Resistance

Wethersfiel

December

also Bristol

Yor

dwin St N4 Arch

f 10

SANC

APARTHEID MASSACRES

CORPORATION

and visibility

Politics and society

British graphic designers actively committed to political and social issues have always been in the minority. Such interventions tend to arise at times of public tension, as a cause ignites, and they always stem from firmly held beliefs. The demonstrations against nuclear weapons, which began in the 1950s, were one such episode in national life. Robin Fior and Ken Garland produced posters of lasting graphic power for the Committee of 100 and the Campaign for Nuclear Disarmament. In the 1970s and 1980s, David King, who had worked at *The Sunday Times Magazine*, created incisive posters protesting about South African apartheid and the rise of the ultra right-wing National Front. Effective partnerships with charitable organizations were occasionally possible, as in Sans+Baum's work for Breakthrough Breast Cancer, but ambitious designers sometimes struggled to reconcile their desire to create graphically innovative work with more prosaic marketing needs. Bodies of work such as Jonathan Barnbrook's, which used aesthetically challenging design as the vehicle for personal political convictions, were unusual. Without affiliation to a particular cause, there were bound to be limits to what such designs could achieve.

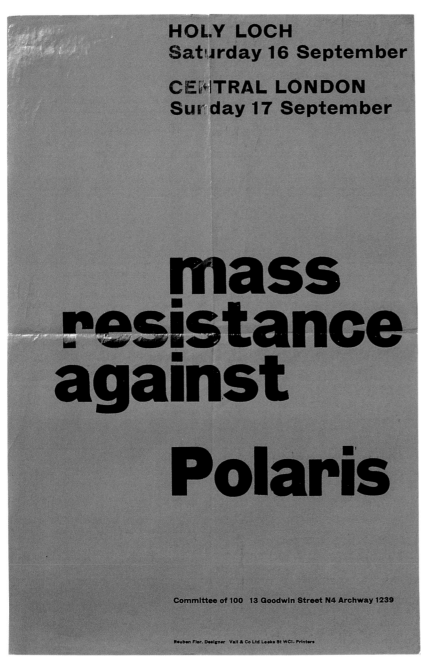

Robin Fior,
*Mass Resistance
Against Polaris,*
poster for Committee
of 100, 1961

Robin Fior,
Call to Action!,
poster for Committee
of 100, 1961

Trafalgar Square
Rally. Sat. 18 Feb. 2pm

Polaris
'NO'

Earl Russell OM FRS
Sir Herbert Read
Rev Michael Scott
Hugh MacDiarmid

CONTACT the Secretary. Committee of 100. 13 Goodwin Street. N4. ARChway 1239

Robin Fior,
Polaris 'NO', silkscreen
poster for Committee of
100, 1961

legal proposals

will be presented to the public
meeting to launch the Campaign
against Racial Discrimination
Friends House Euston Road NW1
Saturday 20th February at 5 pm
Hamsa Alavi K. Amoo-Gottfried
Walter Birmingham Aucar Deshi
Cy Grant Dr David Pitt chairman

Robin Fior, *Legal
Proposals,* poster for
Campaign Against
Racial Discrimination,
c. 1965

Robin Fior, billboard for
Amnesty International
(bottom left), 1970

Ken Garland

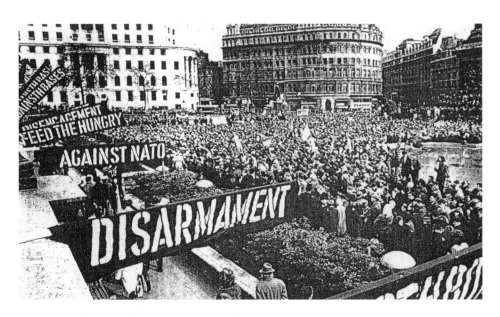

There has always been a strong social – and socialist – commitment in your work. Where did that come from?

By the time I finished over two years' National Service in the army in 1950, I had met and talked with many fellow soldiers from Glasgow, South Wales, Liverpool, Newcastle and Birmingham, and knew a lot more about the condition of the working class in Britain than I had before. Also, I had seen enough of the pretensions of the officer class. Within a year of being in London as a student, there was a crisis in the Labour government: Aneurin Bevan, Harold Wilson and John Freeman resigned their ministerial posts over what they thought to be the dilution of socialist principles, and we students were for them, almost to a man and woman. I suppose I can date my active social/political stance from that time.

What were the key influences on your approach to design?

I do not have heroes as such. I have great respect for the work of some people, and quite often they are people who would be very impatient of politics. They are people like, say, Paul Rand and like Hans Schleger, a much-neglected designer who, being a refugee from Nazism, certainly had a political attitude. But he did not brandish it. And Jan Tschichold.

My greatest influences are probably Futurism, Dadaism and Surrealism, which is intriguing because the Futurists were crypto-fascists, after all. Also photography. Bill Brandt's greatest work was his social commentary for *Picture Post*. My upbringing was punctuated by the weekly arrival of *Picture Post*, a hugely important magazine. That and *Lilliput* were the two things that influenced me most before I even thought about being a graphic designer. Wonderful. Anyone of my generation would say the same, I think.

How did your involvement with the Campaign for Nuclear Disarmament come about?

I went on the first CND march, in 1958, the one that went from London to Aldermaston. CND already had their symbol. It arrived in 1958, designed by a textile designer called Gerald Holtom. There was a black-and-white style already, because it was cheapest. It was a simple, you could say almost crude, printing technique – silkscreen – for the posters.

I did not do graphics for them until 1962. Robin Fior came to see me and said, 'I have been asked by the Committee of 100, a splinter group of CND, to put together a group of designers who might help with publicity material, and would you like to do a poster to put on the Underground?' After seeing my poster for the Committee of 100, the general secretary of CND, Peggy Duff, came to see me and said, 'I want you to work for us, and I would like you also to get some other designers together to work for us.' She became a very dear friend. Everything she asked me to do I

Top: **Ken Garland**, *Committee of 100*, poster, 1962

Banners by Ken Garland for a Campaign for Nuclear Disarmament demonstration in Trafalgar Square, London, 1963

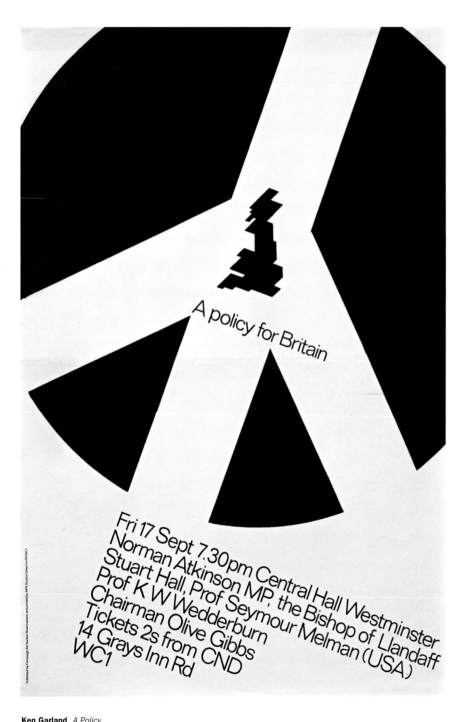

A policy for Britain

Fri 17 Sept 7.30pm Central Hall Westminster
Norman Atkinson MP, the Bishop of Llandaff
Stuart Hall, Prof Seymour Melman (USA)
Prof K W Wedderburn
Chairman Olive Gibbs
Tickets 2s from CND
14 Grays Inn Rd
WC1

Ken Garland, *A Policy for Britain*, poster for Campaign for Nuclear Disarmament, 1965

did. If she wanted me to do it overnight, I did it overnight. Peggy turned up one Sunday morning and said, 'We need a poster for showing in the Tube next week.' So I took the existing poster and gradually laid one poster on top of another and felt it said something about a march – like the dawn of something, like when the moon comes to full size from being a small crescent.

The tall banners were designed for the 1963 Easter march. We had issued each CND branch with stencils and cheap black cloth so that they could make their own banners containing slogans such as 'Against H Bases'. When the banners came together on the day, they looked as though they had all been done by one hand. On the march, I could not believe it. There were so many hundreds of them and when we marched along Whitehall it looked like an invading army. I got a letter from the chairman of CND, Canon Collins, saying that the banners were 'quite the most efficient and attractive we have ever had'. Some time later, though, I felt a little queasy about them – they reminded me of the long banners used so effectively at Nazi rallies.

I am still a member of CND and I still feel it is a hugely important crusade, more than ever now.

What prompted your *First Things First* manifesto?
By the end of 1963, I had been running my own business for a year and a half and I knew the kind of clients that I enjoyed. I found that the older generation of designers, who included many of my friends – I do not want to suggest that there was anything hostile in our relationship – had missed a few pointers. The graphic design business was prepared to be a servant for whatever clients came along, and designers did not perhaps think too much about what they were working for, what influence it was having environmentally, politically, socially. I thought it was not a bad idea that we should think a bit more about this because, after all, in those days we all had an affiliation to a left-wing party. We wanted social change and we felt we ought to be part of it.

Students keep wanting me to talk about *First Things First* [updated in 1999]. They ask, 'Should we do more pro bono work?' Good God, no! How are you going to earn a living? How are you going to survive? They think they should have more social awareness in their teaching, and I say, 'No, I think you should have social awareness in your life and then bring that back into your work. Your teaching would be best occupied with giving you skills, because if you don't have skills you are nowhere.' All the time, over the years, I have been bothered by this fact, that people think that once you start talking about an ethical stance you are entitled to put aside all other interests and talk about that as if it were all that matters. It is not.

Interview: Jane Lamacraft

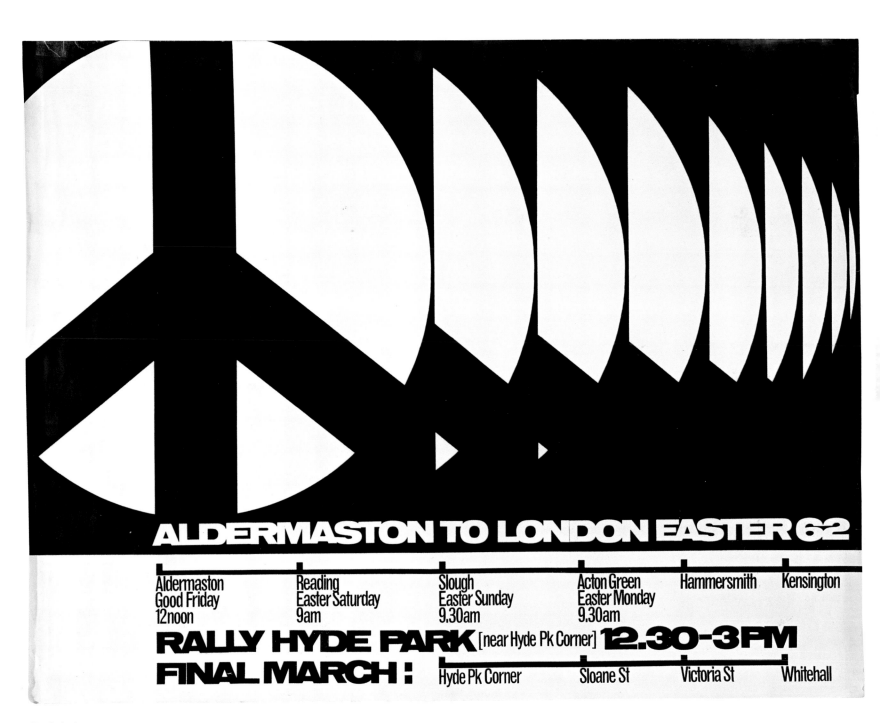

Ken Garland,
Aldermaston to London,
poster for Campaign
for Nuclear
Disarmament, 1962

At **Guildford** 40 part-time **staff** have been dismissed, 7 full-time staff suspended, 5 full-time staff threatened, some **students** are in danger of being refused readmission. **Hornsey** is to stay closed for six weeks; Haringey has asked local authorities to pay **grants** monthly.

This is all negative

Movement for Rethinking Art & Design Education

MoRADE
seeks **positive** action

†

Vali & Co.Ltd Leake Street London WC1 · Printers

Michael McInnerney,
Legalise Pot Rally,
silkscreen poster, 1968

Richard Hollis,
*Movement for
Rethinking Art & Design
Education (MoRADE),*
poster, 1968

Derek Birdsall,
*Sharpeville Massacre
Tenth Anniversary*,
poster, 1970

Richard Hollis,
*International Year of
the Child*, poster for
African National
Congress of South
Africa, 1979

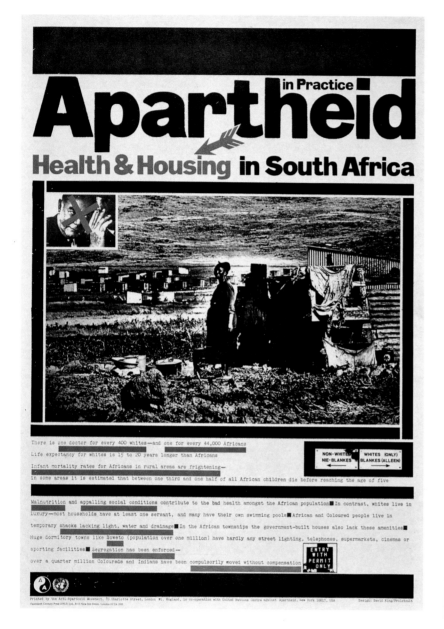

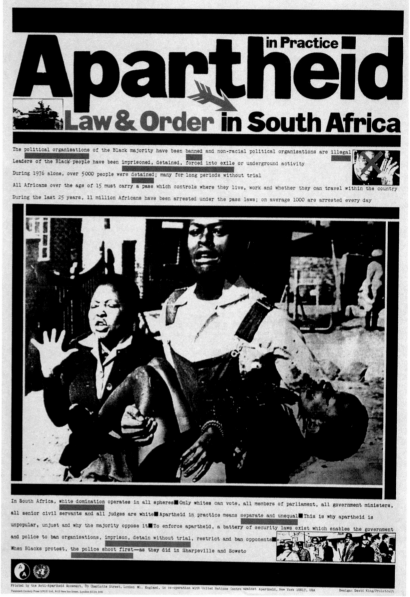

David King, *Apartheid in Practice: Health & Housing in South Africa*, poster from a series of five for Anti-Apartheid Movement, 1978

David King, *Apartheid in Practice: Law & Order in South Africa*, poster from a series of five for Anti-Apartheid Movement, 1978

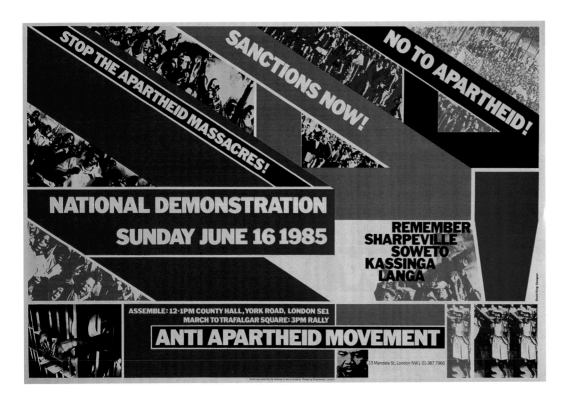

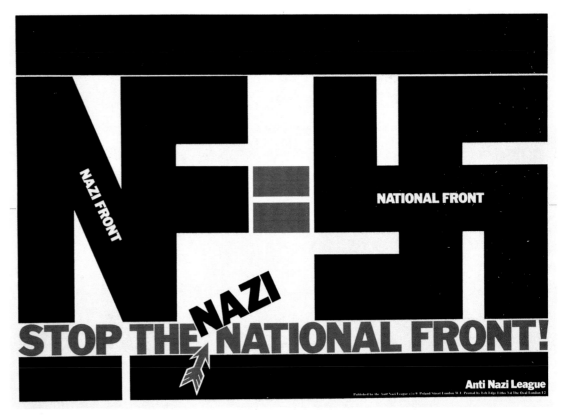

David King, *National Demonstration*, poster for Anti-Apartheid Movement, 1985

David King, *Stop the Nazi National Front!*, poster for Anti-Nazi League, 1978

Lucienne Roberts Sans+Baum

What factors and influences led to your sense of social engagement as a designer?

My parents have been an important influence. My mother trained as an illustrator and my father as a typographer. He campaigned for the Labour party in 1945 and, although he is very disillusioned now, he was part of the post-war generation that thought they could really make the world a better place.

Also, I think I am very much a product of the period in which I grew up – I left the Central School in 1986. It was a very politically engaging time. I allied myself with feminism, discussed the bomb, felt enlivened and frightened by the riots in Brixton and Tottenham. We knew exactly what we were fighting about and so it was all very clear. It felt absolutely possible to change things for the better.

I cannot see the point of doing anything unless you can change something or make it better. In terms of graphic design I was looking for some way to apply these skills to something that seemed bigger and more important.

Is that present in your work now?

It is present in that it is how I look at the world. There are very obvious things – like people you would not want to work for. As graphic designers we have choices to make: are we happy to endorse our client's message, to give it more power? But then there is how you actually work. I am not interested in using design just as a vehicle to express me. I am much more interested in the job. If it is a message worth conveying, then our job is helping to convey that message.

I have never had a problem with the idea that design is a service industry. Ultimately, I do not think graphics exists in a pure sense. It only becomes graphics because somebody is paying us to do it, and that is interesting, that makes it potentially useful, which to me makes sense of it. I think most graphic designers would be absolutely horrified to have somebody who is a graphic designer saying that. But most people do not go into galleries; most people get on buses, look at leaflets. We have a visual impact on everyone's life. It is our job to make the world potentially a more beautiful place and also to convey the message in the best way that we can. It is still the case that most public sector information is really badly laid out. In the end, because the designers who have any sort of status are generally not interested in doing that sort of work, it will always be below par. It seems such a wasted opportunity. The National Health Service is absolutely crying out for it.

You have worked with clients such as the charities Breakthrough Breast Cancer, Unicef and Save the Children. Is there a tension between your pure modernist approach and what is obviously also a very humane stance?

Lucienne Roberts and
Bob Wilkinson,
Sans+Baum,
*Breakthrough Breast
Cancer Review
1996–97*, cover, 1997.
Photographs: Jonathan
Worth

Top: **Lucienne Roberts,
Sans+Baum**, *Break-
through Breast Cancer
Review 1995–96*, cover,
1996

I do not see it as a tension. Modernism made sense to me because I am quite logical. It seemed to me that modernism had sorted design out, really. You did not have to decide which typeface every time – obviously it is Helvetica or Univers, obviously ranged left. So you can get on to some other questions. I am interested in clarity and access, so the fewer excrescences to clutter the page the better. I get endless pleasure in refining this approach and applying it in different configurations to be appropriate for every job. I am also fascinated by numbers and grid structures, and coming up with schemes that have flexibility and playfulness built in. My colleague Bob Wilkinson is not a hardline modernist in the way that I am. He is more interested in the power of images and is probably more playful. Colour is a device we use to bring warmth to what otherwise might be considered an austere design aesthetic. The more I work with Bob, the more I can see that he applies logic to colour in the way that I do to typography.

How did you apply that approach on your work for Breakthrough Breast Cancer?

For one of the first annual reviews we did for them we asked twelve photographers to take images of anything they wanted around the subject. At the time, one in twelve women in this country would develop breast cancer at some point during her life. We had some fantastic responses: Fleur Olby, for example, took a photograph of a loaf of bread which one Breakthrough supporter had frozen for her family before she died. It is a beautiful image and quite hard hitting, but it does not immediately tell you what it is about. The second annual report we did for them was a sticker book – that was Bob's idea – which was a very upbeat but again quite lateral way of doing it. I am certainly not saying that everything has to be worthy just because it is for a charity.

Interview: Jane Lamacraft

Top: **Lucienne Roberts, Sans+Baum**, *Breakthrough Breast Cancer Review 1995–96*, spread, 1996

Middle: **Lucienne Roberts and Bob Wilkinson, Sans+Baum**, *Breakthrough Breast Cancer Review 1996–97*, spread, 1997. Photographs: Jonathan Worth

Lucienne Roberts and Bob Wilkinson, Sans+Baum, *Breakthrough Breast Cancer Annual Review 1997–98*, spread, 1998. Photographs: Tim Simmons

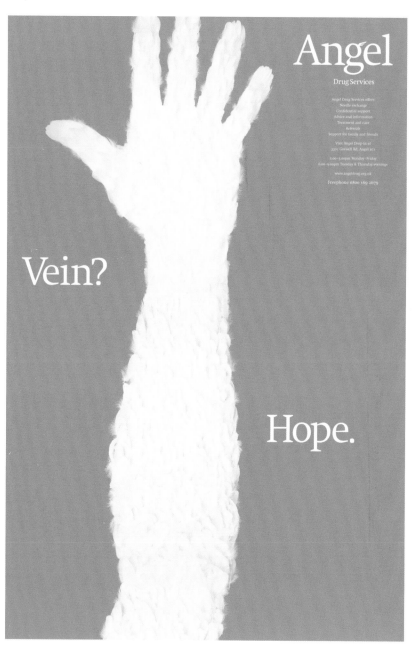

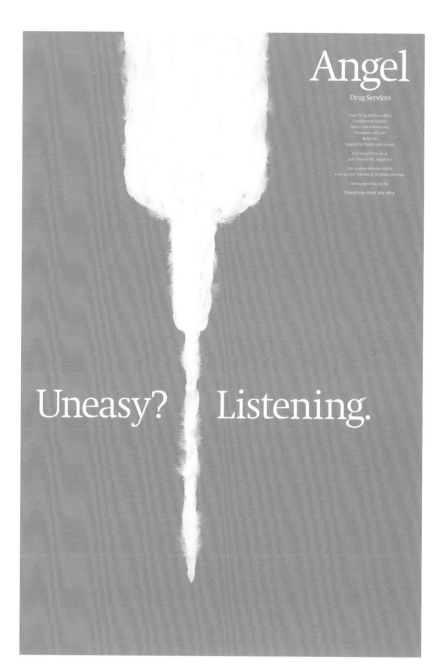

Johnson Banks, *Vein?
Hope*, poster for Angel
Drug Services, 2003

Johnson Banks,
Uneasy? Listening,
poster for Angel Drug
Services, 2003

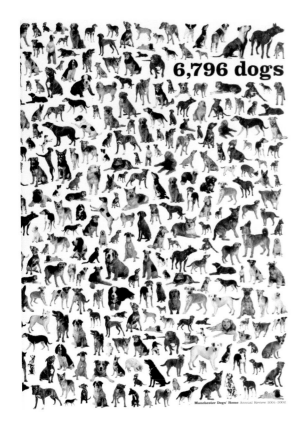

6,796 dogs

Manchester Dogs' Home Annual Review 2001-2002

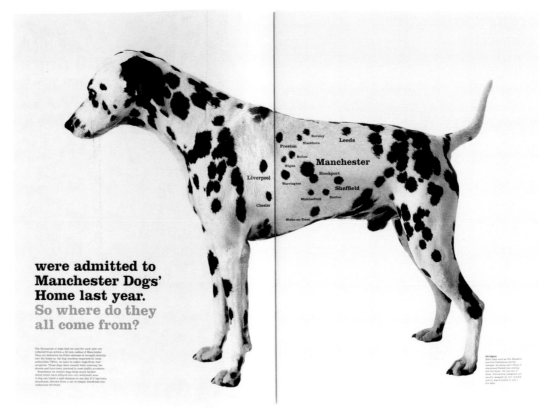

were admitted to
Manchester Dogs'
Home last year.
So where do they
all come from?

The thousands of dogs that we care for each year are collected from within a 50 mile radius of Manchester. They are delivered via Police stations or brought directly into the home by the dog wardens employed by local authorities. Often, we have to collect dogs from very surprising places. These dogs have usually been running the streets and have been involved in road traffic accidents.

Sometimes we receive dogs from much further afield which have strayed into our catchment area. A dog can travel a vast distance in one day if it has been abandoned. Strays from a car or simply wandered into unfamiliar territory.

Leeds — Burnley — Blackburn — Preston — Bolton — Wigan — Manchester — Stockport — Liverpool — Warrington — Sheffield — Chester — Macclesfield — Buxton — Stoke-on-Trent

Every dog counts.

Harriet Devoy and Steve Royle, The Chase, Manchester Dogs' Home annual review, cover and spreads, 2001–02. Photographs: Matt Wright

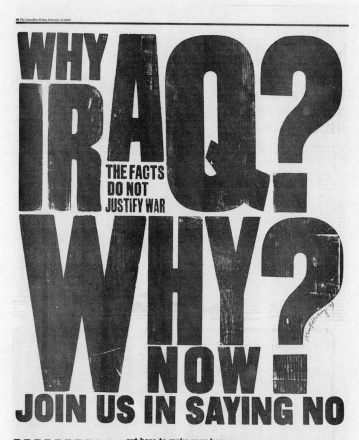

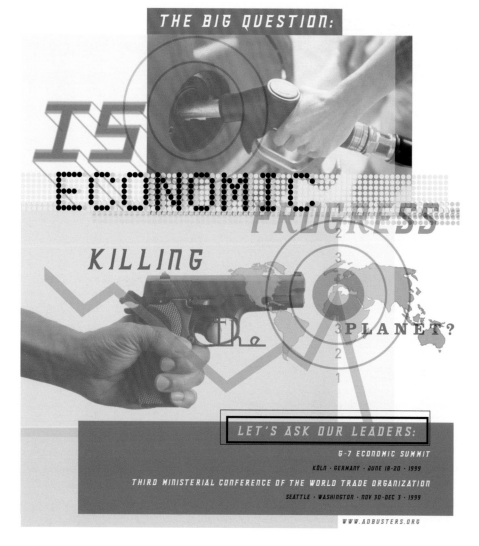

Alan Kitching,
Why Iraq? Why Now?,
newspaper advertise-
ment protesting about
the US invasion of
Iraq, 2003

Jonathan Barnbrook,
*Is Economic Progress
Killing the Planet?*,
poster/advertisement
for *Adbusters*, 1999

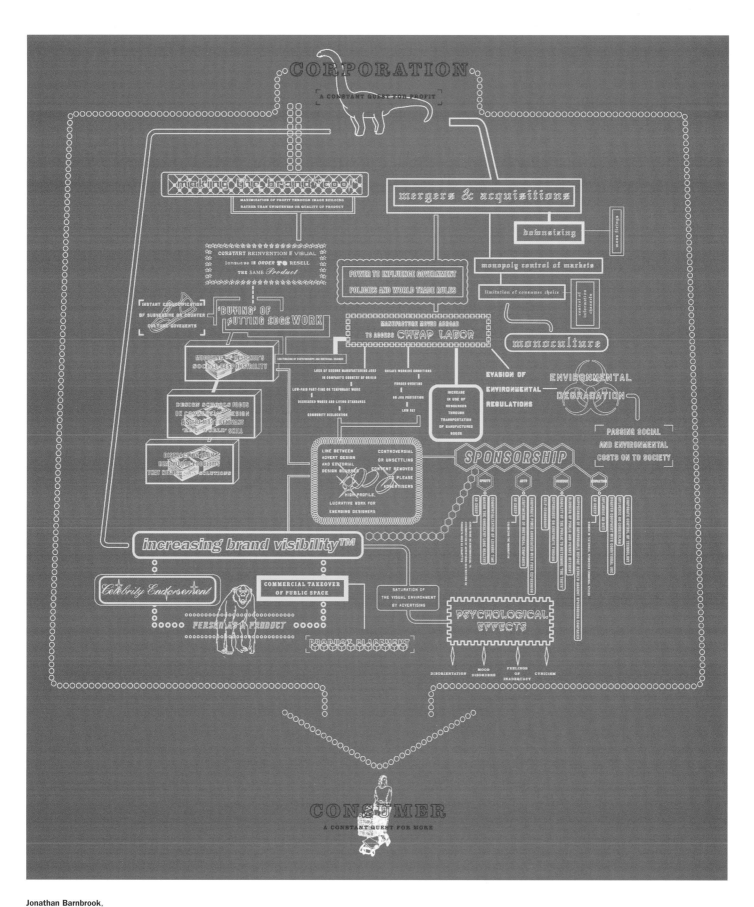

Jonathan Barnbrook,
First Things First 2001,
manifesto poster for
Adbusters (reverse
side), 2001

Self-initiated projects

Graphic designers have always originated projects of their own. Visual communication exists at the meeting point of different disciplines and this encourages some to range beyond the conventional borders. In 1960, John Sewell, a pioneer of television graphics at the BBC, wrote, directed and narrated a satirical film about an automaton. The designer's eye is apparent in the film's typography, production design and playfulness. In the 1970s and 1980s, design companies such as Pentagram and Trickett & Webb found time for extracurricular publishing initiatives, but it was not until the 1990s that significant numbers of British graphic designers began to invest in ambitious personal projects. Neville Brody's experimental typeface venture *Fuse*, launched in 1991, made a notable contribution to typographic debate. Graphic designers were increasingly visible protagonists in contemporary culture and design teams such as Tomato and Fuel took it for granted that their personal print and moving-image projects could be viewed as a form of 'graphic authorship'. These assumptions have helped to bring about many changes in the appearance and application of graphic design, and are transforming perceptions of what it can be.

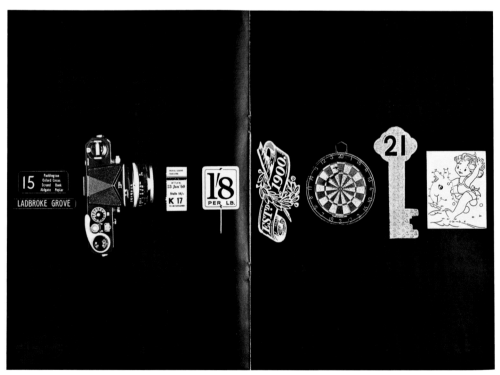

Top: **Crosby/Fletcher/
Forbes**, *A Book of
Matches*, spread from
self-published booklet,
1966

**Crosby/Fletcher/
Forbes**, *Objects Count*,
spread from self-
published booklet,
1967

 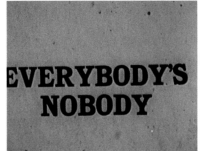

John Sewell and Bruce Lacey, *Everybody's Nobody*, opening sequence from 16mm black-and-white film, 1960. Writer, director and narrator: Sewell. 'Mobile Absurd Nonentity' (MAN) played by Lacey

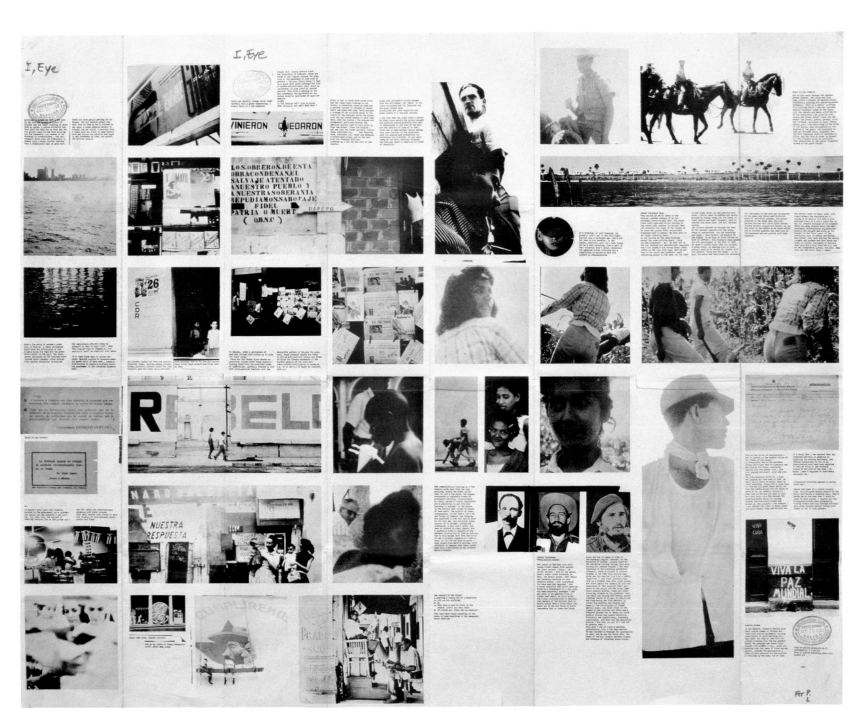

Richard Hollis,
Albion Broadsheet no.3,
'I, Eye', self-published
travel journal about visit
to Cuba, 1962.
Text, design and
photographs: Hollis

Pearce Marchbank,
The Wall Sheet Journal,
looseleaf publication
in a plastic bag (front
and back), 1969.
Contributions by
Richard Hollis, Alan
Kitching and others

Top: **Trickett & Webb**,
'I am a Doughnut',
screenprinted calendar
cover and spreads for
Augustus Martin, 1992.
Assistant designer:
Steve Edwards.
'Washing Up' collage:
Peter Blake

Pentagram,
Pentagram Papers
no. 1, 'ABC: A
Dictionary of Graphic
Clichés', booklet
cover, 1975

Pentagram,
Pentagram Papers
no. 4, 'Face to Face',
booklet cover, 1977

Pentagram,
Pentagram Papers
no. 27, 'Nifty Places:
The Australian Rural
Mailbox', booklet cover
and spread, 1998.
Photographs: Cal Swann

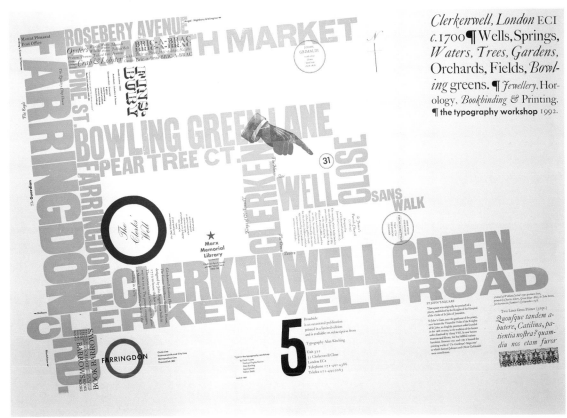

Alan Kitching,
Broadside no. 5, self-
published folding sheet
printed by letterpress at
Kitching's Typography
Workshop, 1992

Alan Kitching,
Broadside no. 7, self-
published folding sheet
printed by letterpress at
Kitching's Typography
Workshop, 1993

June 16 1991 Royal College of Art, London. Photocopy paper in windows

Top: **Fuel (Peter Miles, Damon Murray, Stephen Sorrell)**, *Hype*, cover and spread from self-published magazine, 1991

Neville Brody, *Fuse* no. 1, 'Invention', experimental typography publication with floppy disk and posters for FontShop, summer 1991. Editor: Jon Wozencroft

Paul Elliman, *Bits*, font
based on found objects
first published in *Fuse*
no. 15, 'Cities', 1995

Ian Anderson The Designers Republic

Why do self-initiated work? What are these projects for within the larger body of your studio's work?

In many respects, within a design context, the way we approach our work is probably closer to being artists. There are a lot of things that we feel we want to say and do; some can be achieved through client work, to mutual benefit, and some cannot, due to clients not wanting us to explore that territory. Or maybe it is a question of timing, and sometimes it is more about producing a raw message. Also, a lot of the personal work effectively becomes a way of keeping in training for client work. Clients benefit from us being able to flex our creativity untethered, if you like.

The way we perceive working with clients is that what they provide is the puzzle that needs to be solved. We are happier without too much creative input from the client because, for us, it is a little like someone leaning over your shoulder and doing the crossword for you. We want them to set us the challenge and then, as artists, we want to go back to them and for them to say 'That is fantastic. That is more than we could ever have imagined.' It is all about us, but that is to the benefit of everybody really. Because I never trained as a designer, that whole idea of being there purely to action the ideas of others seems completely alien. We always feel that we can offer more in the commercial sector because we spend so much time in the mind gym, as it were.

Does The Designers Republic represent your personal vision or more of a studio vision?

If you think of The Designers Republic as a filter, then that filter is our approach to work, our attitude, our aesthetic and cultural sensibilities, our sense of humour and all the things that make The Designers Republic. This has been fine-tuned and has evolved, but it has remained fairly constant through eighteen years of work. Anyone who is at The Designers Republic has a bearing on The Designers Republic, though I get two votes because I started it. As people come in, they are absorbed, but once they are in, I feed off them as well. All the people at The Designers Republic create this filter and everybody adds extra little facets to it, but I moulded the filter.

Did your 'techno' aesthetic emerge collectively and evolve from this mix of people?

It definitely emerged from the mix. We very rarely sit down and talk about design. The techno label is something that we do not really get. We understand why people think that, but we have never really been into all that. We have always been much more interested in information graphics and instruction manuals and all those things where the communication of information is key. We have expanded that into the communication of ideas, but still using that language. This has evolved into something people see as being quite techno, but it is technical rather than techno.

ADVERTISEMENT

The Designers
Republic, *Work Buy
Consume Die*, self-
published poster, 1993

What effect or meaning are you trying to achieve in this multi-layered work?

At the core of things, I just do not believe that there is ever one truth. It is always, to me, about options. Someone said our work was quite like Cubism in the sense of trying to present something from every perspective at once. Traditionally, design is about trying to find the most important thing about a product or project and then dismissing other ideas. Whereas we have always been interested in the opposite. In any one project there might be ten alternatives, all equally valid. Some people may be able to reduce that down, but I want to leave those options hanging and pull it into a cohesive design that can be experienced by viewers. They are free to filter through the layers that we present, to look deeper if they want. That is something that works well for personal work, but it also works for client-based work. We are saying that your product can be all of these things. You can present something that is immediate and has impact, but also has layers of meaning.

In the posters and banners in your own exhibitions there is an ambiguous but at times almost satirical commentary on consumer culture. Is that something you intend?

It is more than just a commentary or an observation. It is a desire to inspire or provoke people to think for themselves. Our interest in consumerism is not so much about imperialistic capitalism, though that is a fascinating subject, and it is not about people spending money or being duped into believing that they need things they never knew they wanted. It is more about control. When we did the 'Customised Terror' exhibition, there was a poster with the word 'Flesh'. It is not saying you should not eat meat. It is saying there is an issue here. If you eat a burger, you can mince it up and put dill pickle on it, but you are eating flesh. It is just playing around with issues that are on people's minds, without trying to go for easy targets. It is about being aware of the ramifications of your actions.

The whole consumerist thing is pretty evil – the fact that before Christmas there is nothing but toy ads on at the time kids are watching TV. It is brutal and distasteful and, to some degree, it is disgusting, but that is the world we live in. I was born in England into a consumer society. I can moan about it or I can go with the flow and enjoy it. If there is a game to be played, then I will play it and try to win. In that respect, what our work says is that this is the situation, your life is this, you work, buy, consume, die, so accept the basic scenario, play with it and enjoy playing the game.

Interview: Rick Poynor

The Designers
Republic, *We Sell, You Buy*, self-published poster, 2000

**Fuel (Peter Miles,
Damon Murray,
Stephen Sorrell)**,
Original Copies, three
digital films, 1998

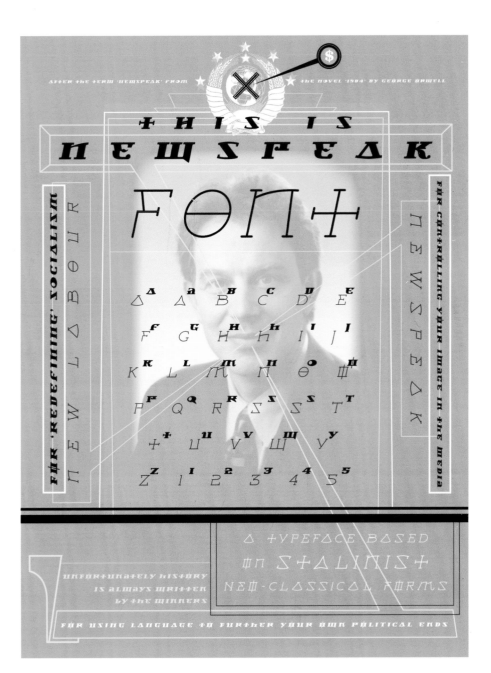

Jonathan Barnbrook,
This is Newspeak, self-
published poster for
Barnbrook's Newspeak
typeface, 1999

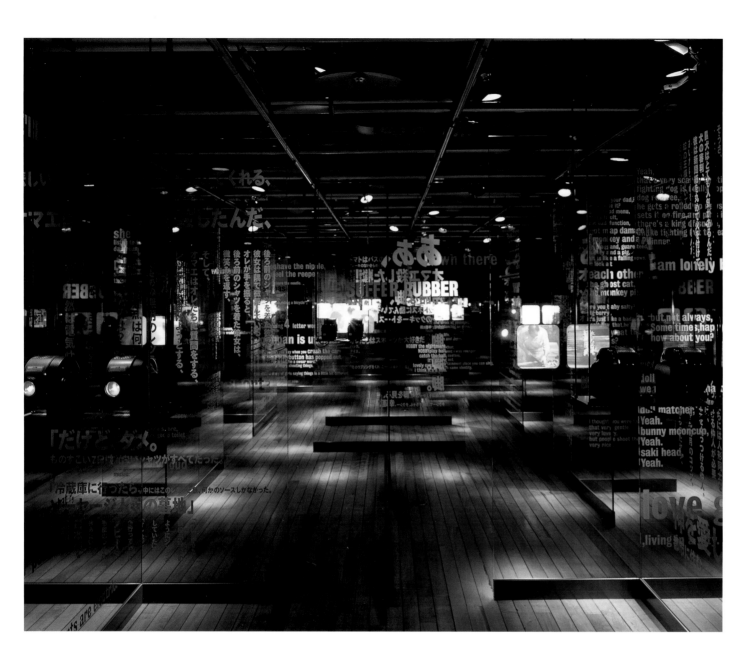

Top: **Tomato**, *Tomato Makes London<>Tokyo*, exhibition in Ginza Art Space, Tokyo, Japan, 1998

Rebecca and Mike (Rebecca Brown and Mike Heath), *Communicating in Micro-Gravity*, interactive digital project about the problem of communicating in space for ShowStudio website, 2001. Programming: Tracey Matthieson

Top (left): **Åbäke**,
Sexymachinery no. 1,
self-published magazine,
summer 2000. Edited
and designed by
Shumon Basar, Dominik
Kermerskothen, Dagmar
Radmacher and Åbäke

**Graphic Thought
Facility**, *MeBox*, display
of customizable storage
boxes, 2002

Top (right): **Åbäke**,
Sexymachinery no. 5,
self-published magazine,
summer 2002. Edited
and designed by
Shumon Basar, Dominik
Kermerskothen, Dagmar
Radmacher and Åbäke

Scott King

Was it your *Crash!* project that provided a way into creating more personal work after being art director of *i-D* magazine?

I do not know whether I got sacked or whether I left *i-D* of my own accord. It was a blurred week of mutual loathing and I left. I was doing freelance jobs and trying to make a living, but within four or five months I decided to do *Crash!*. I wanted it to be very much aimed at the *i-D* crowd and those kinds of people. Because it was political in a loose sense, I did not want it to be right-on and earnest and *New Left Review*-ish. I wanted it to be pop politics. I never considered myself politicized at all. I considered it to be a throw-a-spanner-in-the-works kind of thing. Matt Worley, the writer, very much believes in it and is politicized in that way. To me the excitement was just to introduce that kind of language into pop culture at the time. Style mags are incredibly apolitical. It was meant to be a critique of that kind of culture. Ultimately, it is very much the combination of the two of us. Matt was so perfect for what I wanted to do and we got on so well that I decided to carry on doing it with him.

What were some of the influences on your way of thinking?

The whole lineage: Jamie Reid, the Situationists, the Surrealists, Dada and Wyndham Lewis's *Blast*. We modelled *Crash!* on that and on Situationist stuff as well. Punk music was very important. Also, a love of magazines like *Nova* and *Avant-Garde* and those beautifully designed magazines of the 1960s. I was very conscious of wanting it to be classic. Because there is such an obvious punk influence in what I think and do, I really did not want it to be a pastiche of that style. I decided to do the opposite, which is clean, bold and very much made on the computer now.

How did you develop *Crash!*'s content with Worley?

I had a studio in King's Cross at the time. There was a pub across the road and we would just sit there all day talking and he would write things down. The first *Crash!* [spring 1997] was very much at the peak of *Loaded* and lad mags and Matt wanted to write something against that whole thing of middle-class graduates adopting a football hooligan stance and the nonsense of that. He would come up with an idea for an essay, then together we would make up headlines like 'Carnaby Street Preachers', 'Pol Pot Noodle' and 'Prada Meinhof' – stupid things that we thought were funny. He exaggerated everything to try and make it provocative, but intelligently provocative, not moronically provocative, hopefully. I would do the reverse side, like the football pitch diagram or whatever.

The first one we just distributed ourselves. We took it to the ICA, the Whitechapel Art Gallery and all the usual places. The second one we did as a giveaway in *Dazed & Confused*. I rang up some distributors and no one was interested, so we just went round the shops ourselves, like teenagers.

Scott King, *Crash!*
no. 12, cover of self-
published magazine,
autumn/winter 1999.
Words: Matthew Worley

I could've been a Sex Pistol if I hadn't tried so hard at school, I could've been a Sex Pistol if I hadn't worried about getting a job when I was 18, I could've been a Sex Pistol if I hadn't listened to Mr Buckton, I could've been a Sex Pistol if I hadn't cared about other people's opinions so much, I could've been a Sex Pistol if I hadn't been more interested in Lucy Campbell than anarchy, I could've been a Sex Pistol if I hadn't dismissed Tom Casey's idea of starting a band at college, I could've been a Sex Pistol if I hadn't cared what my mum and dad thought, I could've been a Sex Pistol if I hadn't stopped my organ lessons with Mrs Barker, I could've been a Sex Pistol if I hadn't been such a coward, I could've been a Sex Pistol if I hadn't preferred The Jam when I was 12, I could've been a Sex Pistol if I hadn't been brought up in the middle of a field, I could've been a Sex Pistol if I hadn't listened to anyone and everyone who said it was impossible, I could've been a Sex Pistol if I hadn't wanted to be a graphic designer when I was 22, I could've been a Sex Pistol if I hadn't started to get fat when I was 24, I could've been a Sex Pistol if I hadn't spent so much time talking about it to Jamie Fry, I could've been a Sex Pistol if I hadn't gone to work at that magazine, I could've been a Sex Pistol if I hadn't liked Simple Minds so much when I was 16, I could've been a Sex Pistol if I hadn't listened to Simon Hislop's opinions about musical ability, I could've been a Sex Pistol if I hadn't differentiated between expressive outlets for so long, I could've been a Sex Pistol if I hadn't believed it might be better to be an architect when I was 14.

I'm not a Sex Pistol because I'm a graphic designer, I'm not a Sex Pistol because I'm too old now, I'm not a Sex Pistol because I didn't have the guts when I was younger, I'm not a Sex Pistol because I've got a gut now, I'm not a Sex Pistol because I've got a bald patch, I'm not a Sex Pistol because I've been too busy worrying, I'm not a Sex Pistol because nobody wants me to be, I'm not a Sex Pistol because I've always been too conscientious, I'm not a Sex Pistol because I've never really had the chance, I'm not a Sex Pistol because I was even scared to be a mod in Goole when I was 12, I'm not a Sex Pistol because all the people who had groups where I grew up were hippies, I'm not a Sex Pistol because I never dared try and make my dreams a reality, I'm not a Sex Pistol because I'm too scared to get on stage, I'm not a Sex Pistol because I didn't realise I really wanted to be one until it was too late, I'm not a Sex Pistol because I've always worried about failing publicly, I'm not a Sex Pistol because I think I prefer to rebel in safety zones, I'm not a Sex Pistol because I've never let go of my water-wings, I'm not a Sex Pistol because I'm ultimately a voyeur, I'm not a Sex Pistol because I'm not as self destructive as I like to think I am, I'm not a Sex Pistol because I used to have a recurring nightmare about replacing Pete Townshend in The Who.

The Sex Pistols weren't that good because they were only an exciting way to sell T shirts and vinyl, The Sex Pistols weren't that good because only an idiot would think it was anything other than vaudeville, The Sex Pistols weren't that good because Kath Wood saw them in Doncaster and said they were crap, The Sex Pistols weren't that good because they wrote Submission, The Sex Pistols weren't that good because they nicked loads of ideas from crap american groups, The Sex Pistols weren't that good because all the punks where I grew up liked The Exploited and cider as well, The Sex Pistols weren't that good because they didn't cause a revolution, The Sex Pistols weren't that good because they signed to Virgin Records, The Sex Pistols weren't that good because Johnny Rotten daren't say the word shit outloud on Bill Grundy, The Sex Pistols weren't that good because they reformed and proved they were only a pop group.

The Sex Pistols were good.'

I'm not a Sex Pistol.'

Scott King's text for *I'm Not a Sex Pistol.*

Scott King, *I'm Not a Sex Pistol*, four chromalin prints, 2000

How did the experience of doing *Crash!* lead to the more recent gallery pieces?

Really, it was like starting again for me. It is not that *Crash!* is over because we have not stopped it. It is just quiet. I consciously wanted to start doing my own work and I did not want to be bound to these political ideas, or to a magazine format. By the end of 1999, just before the 'Crash!' show at the ICA, I was in a group show at the gallery that became Magnani, which was called Robert Prime. That was my first serious attempt at doing a piece of artwork in a public gallery. It is something I struggle with, to be honest. The main problem for me is the shift in context. As an art director and designer I come up with solutions that are absolutely refined. They are reductive and they try to make a solution that is very clear. That does not seem to work very well in the art world. You have got to leave a gap for people to read something into it.

What concerns are you dealing with in these wall pieces?

Pop music and self-pity, I think. Rightly or wrongly, I have no great plan with these things. I have an idea and I do it. I am retreating more and more into words. I do not have a scanner. I do not have a studio. I do not make things in my hands. Everything I have ever done is word-related and a lot of that, inevitably, is autobiographical. It is cathartic, I suppose. When it is true, it sometimes works very well. They are quite comic, but they are melancholic as well. The other aspect of it is reductive: trying to contain visually these grand emotions. That is where the pie-charts came from, figuring out a view of the whole.

Could there be a middle ground – a kind of work that exists somewhere between design and art as we have traditionally understood them as different kinds of activity?

I think of it in terms of a 'critical product'. It might be a shower curtain, but a shower curtain with a message. It might be wallpaper, but wallpaper with a point. It would be utilizing a medium as something to think on to. I have a lot of ideas for things like that. If it does not exist now, it could exist. It is something I have been talking about with my gallery in Italy. They are doing a line of critical products. That is the area that I would be more comfortable in. I am having ideas that I would not want to present as some kind of art, in that context, but that are too good to give away as graphic design.

Interview: Rick Poynor

Essays

Design magazines and design culture by David Crowley

The history of journalism about graphic design in Britain is, in large part, the history of specialist design journals. Unlike other spheres of contemporary art and design, graphic design rarely receives a mention in the culture or business pages of newspapers or on television arts programmes. Whilst the media regularly discusses new products as objects of desire, and public architecture attracts both controversy and acclaim, only the publicity-seeking fringes of graphic design draw attention. In recent years, shock advertising and earlier, in the late 1980s, the expensive rebranding of privatized industries in Britain ('BT blows millions on trumpet', *The Sun*) have been put under the spotlight. Like language itself, graphic design seems so deeply ingrained in the texture of daily life that it is taken for granted. While this might be seen as graphic design's achievement, it has been a cause of concern for those who wish to promote the pecuniary and professional interests of designers, as well as for those who want to put the social and moral effects of their work under close scrutiny.

Magazines are commodities and, with some notable exceptions, most are produced for profit. Since the 1950s, the news-stands of Britain have had to grow to accommodate the new titles that have burgeoned year on year. Seizing the economic benefits produced by new printing technologies (not least the desktop publishing revolution of the 1980s), magazine publishing is increasingly characterized by specialist titles serving particular and often narrow interests. The fact that British readers today can purchase half a dozen home-grown graphic design titles when none existed a generation ago might seem to be a simple reflection of the same unerring commercial 'logic' that has produced a dozen different gossip magazines over the same period. As *Blueprint* (1983–) stressed in an early editorial, 'once upon a time people started magazines because they believed that people would want to read what they had to say; today it is more likely that a magazine is launched because the advertisement sales manager can see a "gap in the market"'[1]. *Blueprint* was itself, however, initiated by volunteers prepared to write pro bono, moonlighting from careers elsewhere. The motives behind the launch of this and, in fact, many other design titles cannot be reduced to commercial opportunism (even if some of these magazines have espoused an out-and-out commercial philosophy).

As this essay sets out to show, in launching new graphic design magazines like *Creative Review* (1980–) or *DotDotDot* (2000–), editors and publishers sought to change the world in which their readers lived and, more specifically, in which they worked. In great

Herbert Spencer,
Typographica no. 7,
front and back cover,
May 1963

part, the readers of these titles have tended to be designers and others working in closely aligned fields. Although few titles have been explicitly ideological or doctrinaire in the manner of the avant-garde in the 1920s, most have sought to create an imagined 'community' of readers; to raise the status of the professions they report; and to influence the quality of design. This is ideological work that extends beyond mere commercialism (and sometimes pitches publisher against editor, and advertising against editorial). It has never been a surprise to designers that representation is ideological, even if this is a term that they might not use: to portray and frame one's activities and those of others is to assert power and is, ultimately, an attempt to shape the world.

Graphic design and typography were framed in very particular and sometimes unexpected ways by *Typographica*, one of the few British journals discussing (if not strictly reporting) graphic design in the 1950s and 1960s. Founded in 1949 by Herbert Spencer, designer, teacher and critic, it appeared in two series of sixteen issues each and ceased publishing in 1967. The first series, with reviews of the work of continental modernist designers past and present, such as H.N. Werkman and Max Bill, and debates about standardization, economy and legibility in print, did much to make Spencer 'the most prominent exponent of the new typography in Britain' by the mid-1950s.[2] Although never a rigidly didactic publication, the articles in the first series of *Typographica* were underscored with a proselytizing attitude that sought to modernize British taste. The second series, gaining in confidence, was shaped by a more experimental and avant-garde sensibility. Spencer sought to frame typography within a wider visual culture populated by concrete poets like Dieter Rot and Ian Hamilton Finlay, word artists such as Josua Reichert as well as film-makers and photographers. The growing pluralism of the magazine in its second phase led Spencer, as Rick Poynor notes in his historical account of *Typographica*, to produce interesting and sometimes unexpected visual contrasts that unsettled any claim on tendentiousness. The magazine's interest in presenting graphic design as a highly aesthetic practice with rich resources in the form of images and letters, ink and paper was an eschewal of the commercial and narrowly practical ends to which it was typically put. Compared to *Ark*, a small though influential magazine published by the Royal College of Art, it displayed relatively little interest in the contemporary taste for Pop then shaping much British art and design.[3] Similarly, *Typographica*'s remarkable investment in the history of modern design and printing (developed further in Spencer's landmark 1969 book, *Pioneers of*

Top: **Herbert Spencer and Robert Brownjohn**, *Typographica* no. 4, spread from 'Street Level' photo-essay by Brownjohn, December 1961

Herbert Spencer, *Typographica* no. 10, spread showing newspaper seals, December 1964

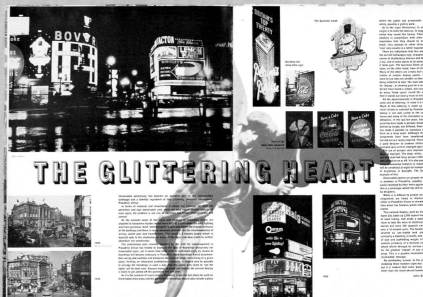

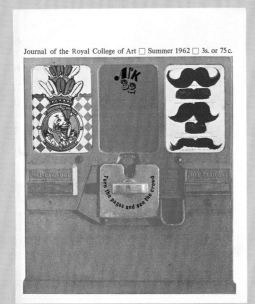

Top: **Margaret Calvert**, *Motif* no. 13, cover, 1967

Brian Haynes, *Ark* no. 32, cover, Journal of the Royal College of Art, summer 1962

Top: **Ruari McLean**, *Motif* no. 4, spread about Piccadilly Circus, March 1960

Roy Giles and Stephen Hiett, *Ark* no. 36, spread about surfing, Journal of the Royal College of Art, summer 1964

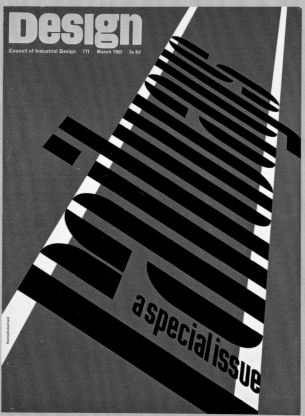

Top: **George Daulby**,
Design no. 152,
August 1961.
Art editor: Ken Garland

Ken Garland, *Design
no.* 171, March 1963

Modern Typography) was a refusal to see graphic design in the urgent and distracted terms of fashion and novelty.

If *Typographica* pursued an increasingly eclectic course during the 1960s, *Design* magazine (1949–99) the official mouthpiece of the Council of Industrial Design (COID; re-designated as the Design Council in 1972) was much more self-consciously ideological. A monthly reporting the design of consumer and capital goods as well as some aspects of graphic design such as packaging, *Design* proselytized for 'good design', a concept never adequately defined and closely connected to a taste for modernism. An official and bureaucratic organization funded by grant-in-aid from government, the COID saw itself as both a servant and a critic of industry. If the design standards of manufacturers and the level of taste of consumers could be raised, Britain's dire post-war economic situation and the quality of ordinary lives would be improved. Design expounded a techno-cratic view of progress: designers were technical experts who, working alongside engineers and other specialists, were best able to make rational judgements about the appropriate form of the material world. In the Manichean world of the COID, design could be 'good' (modest, functional, transparent, rational and enduring) or 'bad' (gauche, ambiguous, emotional and ephemeral). The failures and successes of British industry – measured on technical, aesthetic and moral indices – were regularly called to task on the pages of its magazine.

Graphic design, a practice thoroughly implicated in the spectacle of the emerging consumer society, posed a problem for *Design*. 'The image' – the aspect of design least susceptible to the COID's quasi-scientific and civic-minded approach – was increasingly the immaterial basis of marketing, advertising and Pop design (as well as politics and other 'serious' aspects of modern life).[4] Despite occasional forays into the record shops and boutiques of London's fashionable Carnaby Street to report the taste for Pop, *Design*'s writers were ill-equipped to deal with the ephemeral and fast-changing world they found there.[5] They returned to form which, in the case of graphic design, meant reports on the systematic techniques behind successful corporate images, road signage or the practical failings of public information campaigns.[6]

If *Design* was ideologically inhibited from embracing the ephemeral world of fashion and marketing, it was also unable to provide a platform for the ideas of the consumer society's most vocal critics. The writings of philosophers like Herbert Marcuse provided the counter-culture of the late 1960s with a pugnacious critique of the alienating effects of affluence. When the march of

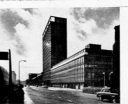

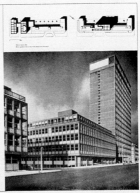

Top: **Ken Garland**,
Design no. 134,
spread from an article
about design as a
'sales weapon' by
Richard Hamilton,
February 1960

Ken Garland, *Design*
no. 135, spread from
an article about British
magazine design by
Garland, March 1960

progress was measured by the launch of new, 'improved' products performing old functions, humanity, it was argued, was reduced to one dimension. Deprived of their imaginations by advertising, men and women were apparently becoming unable to imagine other ways of living, except as consumers. Feeling the pressure of the counter-culture, *Design*'s editor responded by invoking the irresistible force of progress ('the clock cannot be turned back'): designers had to reform rather than reject the world in which they worked.[7]

Design froze in the bright lights of consumerism. Unable to endorse the fast-changing image world or to sign up to the more radical utopianism of the counter-culture, it withdrew into its tried and tested world of engineering.[8] Graphic design, which had never been at the centre of *Design*'s interests, was treated as a peripheral phenomenon, of greatest interest when it corresponded to the magazine's world-view. In fact, the only publication published in Britain exclusively covering graphic design during this period was Icographic (1971–79). The official organ of ICOGRADA (International Council of Graphic Design Associations) and under the editorship of Patrick Wallis Burke, this quarterly took a disciplined approach to communication, publishing long and often scholarly articles on the 'efficiency' of new alphabets, 'rational' classification systems in publishing or the need to 'move [graphic design] from the applied arts to the applied sciences.'[9] Graphic design was discussed not in terms of events or products, but as a project to improve the world through the exchange of knowledge.

Icographic was an unambiguously modernist publication that claimed roots in the design and social idealism of the 1920s. It was ideological in ways that virtually no graphic design writing has been since. The explicit internationalism of Otto Neurath's ISOTYPE (International System of Typographic Pictorial Education, introduced in 1936), a lingua franca of graphic symbols that aspired to transcend national and linguistic boundaries, was shared by *Icographic*, albeit in changed political circumstances. Neurath's invention has been understood in terms of its opposition to the xenophobia and belligerent nationalism in inter-war Europe: *Icographic* rejected the long Cold War divisions that separated East and West, publishing the research findings of Polish and East German designers. Underdevelopment and global inequalities came under attack, too. In 'New ways to view world problems', a co-authored article, an electronic engineer from India, a geographer and a graphic designer from the US and a technologist from Iran argued for information systems able to display 'only the stark reality of facts, concepts and the significance of global interdependencies.'[10]

Top: **Patrick Wallis Burke**, *Icographic* no. 2, cover, 1971

Patrick Wallis Burke, *Icographic* no. 3, spread from an article about Penguin Books by Germano Facetti, 1972

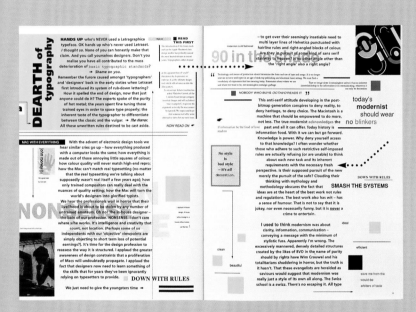

Top: **Malcolm Garrett**, *Baseline* no. 13, spread from a personal manifesto, 1990. Art direction: Newell & Sorrell

Newell & Sorrell, *Baseline* no. 13, showing work by Vaughan Oliver, 1990

Icographic's writers turned their backs on the steady growth of business-minded graphic design consultancies in Britain and elsewhere in the 1970s. The reproduction of paintings on the paperback covers of the Penguin Classics series was, according to its designer, Italian-born and London-based art director Germano Facetti, less a manipulation of desire than a cultural service: art on the jacket, he suggested, would find its way to those 'without immediate access to art galleries or museums.'[11] *Icographic* could not, however, escape the gravitational pull of economics. From 1972, Letraset International provided sponsorship in return for space to promote its new typeface designs, available under licence to typesetting system manufacturers, and its dry-transfer lettering. Expressive faces like Shatter and Good Vibrations struck a colourful and discordant note, out of tune with the journal's collective and earnest voice. By the same measure, *Icographic*'s quasi-scientific rhetoric did little to support Letraset's interest in fashion or the passage of its dry-transfer lettering into the hands of the non-professional designers. In fact, in 1979 Letraset issued its own occasional magazine, *Baseline*, to showcase its products. Under the art direction of Mike Daines, prominent commercially-minded designers, including Erik Spiekermann and Milton Glaser, were given space to experiment with the company's products and to reflect on the impact of new technologies like laser printing.[12] Although *Baseline* was not firmly established as a magazine until 1995 (when it was bought by Daines and art director Hans Dieter Reichert), its appearance at the end of the 1970s anticipated a wave of new design titles that engaged directly, and often enthusiastically, with promotion and marketing.

Creative Review, a monthly magazine launched by Marketing Week Communications in 1980, was the first onto the blocks. A sister publication to *Marketing Week*, it provided glossy, colour pages in which the output of the 'creative industries' could be surveyed. Framed alongside unequivocally commercial products like pop music promos and television advertising, graphic design was presented as a tool that would give an edge to those businesses which made use of its most skilled practitioners. After early issues in which the great and the good lamented the state of creativity, *Creative Review* established a successful, up-beat formula (still followed today). Unlike its predecessors, it dedicated space to the portfolios of designers working in the commercial sector. Images of the output of individuals and consultancies would be accompanied by a glowing commentary that emphasized the 'originality', 'innovation' and 'vision' of the designer under the spotlight, as well at his or her ability to solve 'problems'. Technique was discussed,

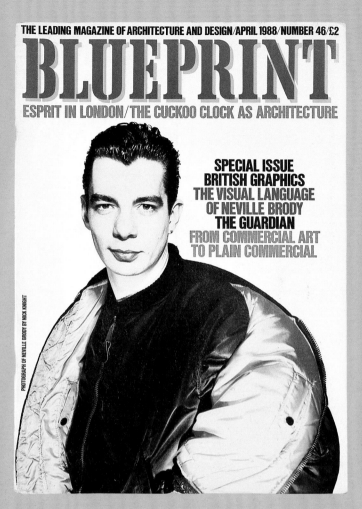

THE LEADING MAGAZINE OF ARCHITECTURE AND DESIGN/APRIL 1988/NUMBER 46/£2

BLUEPRINT

ESPRIT IN LONDON/THE CUCKOO CLOCK AS ARCHITECTURE

SPECIAL ISSUE
BRITISH GRAPHICS
THE VISUAL LANGUAGE
OF NEVILLE BRODY
THE GUARDIAN
FROM COMMERCIAL ART
TO PLAIN COMMERCIAL

PHOTOGRAPH OF NEVILLE BRODY BY NICK KNIGHT

THE AWARD WINNING MAGAZINE OF ARCHITECTURE AND DESIGN DECEMBER–JANUARY 1987/NUMBER 33/£2.00

BLUEPRINT

LE CORBUSIER: THE GOD OF MODERNISM

MONTAGE BY ANDRZEJ KLIMOWSKI

CREATIVE REVIEW

September 1985 £1.75
A Centaur Publication

CREATIVE REVIEW

March 1996 £3.45
A Centaur Publication

Top: **Simon Esterson and Stephen Coates**, *Blueprint* no. 46, cover, April 1988. Photograph: Nick Knight

Clare White, *Creative Review* vol. 5 no. 9, cover showing portrait of David King, September 1985. Main photograph: Ben Rice

Top: **Simon Esterson and Stephen Coates**, *Blueprint* no. 33, December 1986/ January 1987. Illustration: Andrzej Klimowski

Chris Ashworth and Neil Fletcher, Substance, *Creative Review* vol. 16 no. 3, cover, March 1996. Art director: Gary Cook

Deyan Sudjic talks to Carroll, Dempsey and Thirkell, the designers who left their mark on *The Independent*, about their progress from books to newspapers. Photograph by Phil Sayer

A SENSE OF INDEPENDENCE

24 Blueprint November 1986

Blueprint November 1986 25

DESIGN

DESIGN

At a time when many graphic design groups are expanding through the roof, Trickett & Webb has prospered by staying small and producing stylish work. In particular, its partners enjoy designing for other creative groups, especially architects and agencies, and reworking classics of graphics history. By Jeremy Myerson

INSPIRED BY CLASSICS

Marriage to an architect

CREATIVE REVIEW JANUARY 1986

CREATIVE REVIEW JANUARY 1986

Top: **Simon Esterson and Stephen Coates**, *Blueprint* no. 32, spread from a profile about Carroll, Dempsey & Thirkell, November 1986. Photograph: Phil Sayer

Clare White, *Creative Review* vol. 6 no. 1, spread from a profile about Trickett & Webb, January 1986

although not necessarily in the familiar terms of materials and tools: readers were as likely to be presented with a discussion of 'how to master the creative pitch' as with an article on 'the art of retouching a photograph.'[13] In an unconscious echo of postmodern rhetoric associated with thinkers like Jean Baudrillard, *Creative Review*'s journalists were happy to claim the all-conquering importance of the image at a time, in the words of one, 'when style is everything'.[14] In promoting a picture of creativity in market conditions, *Creative Review* flattered designers and reassured those who commissioned them.

Representing those professions that usually operated in conditions of anonymity, the names of designers (alongside animators and illustrators) were carefully reinstated on the pages of *Creative Review*. As if to illustrate this point, Edward Booth-Clibborn, then chairman of D&AD, argued in an early issue that illustrators ought to enjoy the same kind of critical attention as painters.[15] This was not simply a way of generating commissions in the manner of a trade directory: it was a strategy that sought to raise the 'cultural capital' of the professional readers of the magazine. Graphic designers, illustrators and other image-makers were represented as masters of creativity rather than as servants to business. *Blueprint*, a title reporting widely across the fields of design, took this trend to its logical conclusion by presenting a 'star' designer, rather than his or her work, on each of its covers in theatrically-lit portraits. Although not strictly 'celebrity profiles' in the sense of exposing private lives to public attention, such a treatment of graphic designers, for example Neville Brody appearing on the April 1988 cover with an extensive profile and interview inside, marked a new stage in the way in which graphic design was reported.[16] *Blueprint*'s starry portraits had a unmistakable influence on other magazines of the day: the fortunes of young graphic designers Why Not Associates were given a boost when they appeared on the March 1990 cover of *Direction* not long after graduating from the Royal College of Art.

While *Blueprint* made stars amongst designers, *DesignWeek*, a weekly launched in 1986 by the publisher of *Creative Review*, sought to make their names better known to business. Presenting itself as a no-nonsense 'newsmagazine written specifically for the British design industry', it launched straight into the business of reporting design as news in September 1996. With very little editorializing in the early issues, *DesignWeek* made few attempts to judge design on ethical or aesthetic grounds. Significance was understood largely in terms shared by business: competitions, briefs and fees, stocks and

Top: **Lucy Pidduck**, *DesignWeek* vol. 3 no. 43, cover, 28 October 1988. Illustration: Chesc Riera

Mark Porter, *Direction*, cover, March 1990. Photograph: Mark Harrison

Top: **Lucy Pidduck**,
DesignWeek vol. 3
no. 43, news spread,
28 October 1988

**Jayne Alexander and
Violetta Boxill**, *Design*,
cover, Design Council,
spring 1999. Computer
animation: Core Design

shares, relocations, new appointments and redundancies determined the content of the news pages that opened each weekly issue. Fields that might seem to lack glamour from the perspective of *Creative Review* or *Blueprint* were its staples. During the late 1980s its pages were filled with 'aspirational' corporate identity schemes and food packaging with 'dynamic presence on supermarket shelves'. Although *DesignWeek*'s editorials regularly used the phrase 'the design cause', what this meant in practice was the 'interests of design consultancies'. Whilst Brody might appear on its pages as a newsworthy designer in the 1980s, it was his art direction of *Arena* and Italian fashion advertising rather than his logos for socialist groups like Red Wedge and his covers of *City Limits*, a left-leaning London listings magazine, which made good copy.[17]

The appearance of new titles in the 1980s represents the growth *and* the hubris of British graphic design in this period. In retrospect, this boom seems to have been scripted by a number of authors, including professional bodies like D&AD, new institutions like London's Design Museum launched with great publicity in 1989 and, of course, the design press. The label 'the design decade' was used without irony to brand the era even before it was over. Repackaging, rebranding and other forms of design sophistry were presented as a panacea for industry; public utilities were 'remade' into efficient private companies by new corporate identity schemes; graphic design, it was even claimed, could win elections.[18] Firmly located within the sphere of what cultural theorist and academic Andrew Wernick called at the time 'promotional culture', graphic designers reaped the benefits of this neo-commercial rhetoric.[19] Graphic design (and often design journalism, too) had become almost indistinguishable from advertising.[20]

The speed at which *DesignWeek* insinuated itself with graphic, product, vehicle and interior designers and, of course, their clients, was a sign of incontrovertible success: it was and remains, at the time of writing, the mostly widely read design magazine in Britain. A self-consciously unglamorous title, it worked hard to give amorphous professions (each ultimately defined by competition rather than consensus) a shared sense of community. The response to the collapse of the Michael Peters Group in 1990 is a case in point. Peters, a specialist in packaging design, had developed an enormous and over-extended design business offering diverse services, from management consultancy to letter headings, by acquiring British and American design companies with funds generated on the stock market. When the Group went into receivership – an event widely interpreted as 'the end of the goldrush' in

Top: **Stephen Coates**,
Eye vol. 4 no. 15, cover,
winter 1994

Nick Bell, **UNA**,
Eye vol. 11 no. 42,
cover, winter 2001.
Illustration:
Jasper Goodall

Britain – *DesignWeek* led the mourning with headlines like 'Tributes pour in from a stunned design community'.[21] The newsmagazine also emphasized consensus by dampening down controversy. Speaking for this 'community' and reliant on the revenue brought in by the adverts placed on its pages, controversy risked opening up divisive differences. While *Creative Review* invited disagreement in the form of stage-managed conversations between prominent figures holding different views and *DesignWeek* took a campaigning stance on the issue of 'green design' in the early 1990s, any doubts about graphic design's commercial 'cause' or concerns about its social effects remained unspoken.[22]

Eye, a quarterly magazine launched under the editorship of Rick Poynor in 1990 by Wordsearch, the publisher of *Blueprint*, set itself against the grain of current graphic design journalism in Britain. Perfect-bound, beautifully printed and expensive, it was launched at what seemed an inauspicious moment, one of economic recession. *Eye* established a wider platform for thinking about graphic design than its predecessors had. Whereas Europe and North America had featured in *DesignWeek* largely as territories for British design groups to 'penetrate', *Eye* made a self-conscious statement about internationalism by publishing in English, French and German (an undertaking that proved too costly and was abandoned after six issues) and by featuring profiles of prominent designers abroad, including politically uncompromising groups like Grapus in France and socially-minded designers and clients in Germany and the Netherlands. *Eye*'s deliberate internationalism created a space for 'unfashionable' voices to question the social purposes and effects of design. An early issue, for instance, explored Dutch designer Jan van Toorn's combative approach to graphic design, rooted in the politics of the counter-culture of the 1960s and in Brechtian aesthetics.[23] The different varieties of design humanism and radicalism found on the continent still needed, *Eye* seemed to argue, to 'penetrate' into Thatcher-era Britain.

Whilst the format and high production values of *Eye* make it a desirable commodity in its own right, it has regularly featured opinion expressing anxiety about the seductive powers of graphic design in the marketplace. In 1995 American critic and historian Steven Heller stressed that graphic design repressed its historical relations with advertising in order to emphasize its status as 'an aesthetic and philosophical pursuit'.[24] Three years later Poynor compressed the point into three blunt words, 'Design is advertising'.[25] This had, of course, been implicit on virtually every page of *Creative Review* for almost two decades. But in a new

Top: **Stephen Coates**,
Eye vol. 5 no. 17, spread
from an article about
early American adver-
tising, summer 1995

Nick Bell, UNA,
Eye vol. 11 no. 41,
spread from an article
about the role of
accidents in design,
autumn 2001

political climate shaped by global protest, anti-consumerist movements and 'culture jamming', this assertion was now an accusation designed to shake graphic designers' deeply-held self-image as agents of culture and progress.

The growing critique of consumerism on the pages of *Eye* made the need for self-reflexivity all the more important (i.e., that contributors, including those on the magazine's small staff, made their own critical positions explicit). With this in mind, Poynor wrote in 1995: 'What we hope to achieve with *Eye* is not so much a "journalistic criticism"... as a "critical journalism"... informed, thoughtful, sceptical, literate, prepared to take up a position and argue a case.'[26] This sometimes meant publishing polemical articles designed to generate controversy. When, for instance, *Eye* was absorbed with the fashionable question of the limits of typographic legibility, it published a forceful piece by Paul Stiff that argued that such designers, in ignoring the findings of cognitive psychology and ergonomics, misunderstood the embodied experience of reading.[27] Stiff, teaching at Reading University, represented an intellectual tradition (expressed in *Icographic* in the 1970s and *Information Design Journal* [1979–]) with a deep investment in the morality of clear delivery of information. At its best, *Eye* has acted as a clearing house for diverse and sometimes competing ideas about graphic design from different constituencies.

Eye has also regularly featured articles on the history of graphic design. Designers had engaged with the past in the 1980s, albeit only in the limited modes of pastiche and what was then called 'retrostyling' (lent an intellectual gloss by limp postmodernist theory). Many of the most prominent repackaging and branding exercises during the boom years reworked sentimental and popular visual languages such as Victorian ornament and Art Deco styling. *Eye* took a more Whiggish line, arguing that knowledge of history would encourage designers to 'recapture the sense of self-inquiry and rigour' that had characterized the profession in its infancy and was, by implication, now lost.[28] This was, in effect, a modernist view that understood history as a set of ideas and ideological conflicts. The mode of these history lessons was predominantly biographical, with *Eye*'s writers exploring a canon established by historians like Philip Meggs.[29] A second line of investigation of anonymous or vernacular design was also developed by the magazine, though not with the same consistency. For instance, investigations into the powerful appeal of mass-market women's magazines promised, at one time, to draw *Eye* closer to cultural studies' critical interest in the consumption of popular culture.[30] Ultimately, *Eye*, as a

Paul Stiff, *Information Design Journal* vol. 7 no. 3, cover, 1994

commercial product, has remained wedded to its core readers, graphic designers. This fact continues to limit the extent to which their work can be explored as the anonymous texture of everyday life or tested by moral critique. To have one's work appear on *Eye*'s pages is still regarded as an endorsement.

One of *Eye*'s major achievements (shared, it must be said, with other prominent titles abroad like *Emigré*) has been to gestate new writers, many of whom also practise as designers. Although graphic design has a long tradition of designer-writers, most members of this select group have been wedded to the book. In recent years, however, the design magazine has enjoyed a revival (stubbornly resisting the communicative advantages of the Internet as a medium). Numerous graphic designers have seized this most ephemeral of products to demonstrate their creativity as designers and writers. A celebrated, early example of this phenomenon was *Octavo* (1986–92), an occasional magazine (preceding *Eye* by four years). Produced in eight issues by 8vo, a London-based design group established by Simon Johnston, Mark Holt and Hamish Muir, the rigorously structured design of the magazine was striking (an effect all the more pronounced when viewed alongside 'local' whimsical and pastiche-ridden designs of the 1980s design boom). Style, on the pages of *Octavo*, was not everything: the designers used the magazine as a way of introducing continental design theory and history to its readers. Issue four, for instance, reproduced Wolfgang Weingart's 1972 lecture 'How can one make Swiss typography?', in which he argued that the seemingly objective typographic designs of the Swiss School were ultimately based on intuitive choices and could therefore be used expressively. If the logic of Weingart's lecture seemed controversially radical in the context of late Swiss asceticism, it seemed remarkably principled in the *laissez-faire* design world of Britain.

Well versed in the history of modern typography (demonstrated not least by some of the powerfully argued articles on the subject that appeared on its pages) 8vo's publishing venture invoked the tradition of the pamphlet and the small magazine that characterized avant-gardism in the 1920s. Designer-writers – largely from continental Europe – polemicized in order to communicate the failure of the societies in which they lived or to report the 'discovery' of principles with which to build a new world. It is, however, hard to contend that the recent wave of small magazine publishing by designers in Britain can be characterized as cultural and design activism in anything like these terms. Numerous occasional magazines – from Miles, Murray and Sorrell's *Fuel* (irregularly

8vo (Simon Johnston, Mark Holt, Michael Burke, Hamish Muir), *Octavo* no. 2, cover, winter 1986/87

Theory in Practice

The stonemason's finest work is often so high on a church that almost nobody sees it – and it tells us a good deal about typographer Geoff White that some of his appears in a design manual produced on a photocopier, and is seldom seen outside a county architect's office. After thirty-five years at the drawing board he remains just as committed to quality, experiment and development as any fine artist.

Geoff White gave up his first job as a messenger-boy in the West End of London to become a full-time student at the Central School of Arts and Crafts. The course at the Central closely followed the Bauhaus example, and Geoff White says this was the first true graphic design course in Britain. Victor Pasmore taught basic design, and Jesse Collins, Herbert Spencer and Anthony Froshaug taught typography.

At this time White was interested in the work of Lissitzky and Malevich, but he also admired the Euston Road artists. On leaving college he could only find work in advertising, and was unable to carry on with the asymmetric typography he had done as a student. However, in 1962, White joined Dewar Mills Associates, a design group with many clients in architecture and the building industry. These clients believed in modern design, as did his colleagues, and here White was able to get into his stride. At this time he also discovered the work of Swiss designers in the magazine New Graphic Design, and then, in Graphis, he read Emil Ruder's article 'The Typography of Order'.

After several years of combining freelance work with teaching in London colleges, White was offered a full-time teaching post at Ravensbourne College of Art and Design. The graphic design course there was especially to his liking as it had been modelled on the Hochschule für Gestaltung at Ulm in West Germany.

On both sides of the Channel designers felt that 'functionalism necessarily contradicts the affluent society which is forced to produce and sell relentlessly.' Like many of his contemporaries, White was spiritually dependant on the fundamentalism of Ulm. When, in 1968, following its criticisms of the economic system in Germany, Ulm was closed down, its loss was seen as a catastrophe. In Britain, the art editor of Design, Ken Garland, had produced his manifesto signed by many leading designers and criticising the dubious moral climate in which they now worked as the post-war consumer boom gathered momentum. The failure of these protests, soon to be followed by a loss of faith in modernist architecture, proved to be a watershed. The international style, its reputation tarnished by the sterility of the work done by many third-rate practitioners, became

the philosophy of a minority. Geoff White remained a steadfast advocate.

As the national optimism of the 1960s faded and the British economy flagged, the demand for design also receded. Many of White's friends and contemporaries left Britain for countries where the climate for design was more congenial. Others stayed here but lost their missionary spirit. As the pattern of industrial activity changed, the emphasis was on marketing rather than making, and the expediency of the stylist has now almost ousted the radicalism of the designer. There has always been around Geoff White a small group of individuals who remain faithful to the principles of modernism, where '... a new approach to the making of the human environment in which visual values – space, form, structure, mass, rhythm – served as vehicles of emotion'.

Like Josef Müller-Brockmann, White sees sans-serif type as being expressive of the age. While most designers were still specifying the Victorian faces like Playbill and Figgins Shaded, revived at the time of the Festival of Britain to put a gloss on the modernist architecture, White was using sans-serif types exclusively. And then in 1961, when Adrian Frutiger's Univers range was introduced into Britain, White instantly saw its potential to become integrated as a neutral element of the composition, its anonymous appearance avoiding the connotations of time and place associated with most typefaces.

One of the tangible links between modernist typography and architecture is in the use of a grid. Said to have been inspired by Le Corbusier's Modulor, it came to Britain via Switzerland in the 1950s. White observed its use on the German magazine Twen, and Typographische Monatsblätter. The design and the use of the grid has become a major component in organising and composing his typography.

The 1972 Munich Olympic Games made one or two British designers working with Otl Aicher and Rolf Müller aware of the German approach to using the grid. Although White was not himself on the design team, the freer and more painterly way of using type, and especially the regression and progressive stepping of paragraphs, is very marked in his work from the late 70s.

A major factor in the shaping of Geoff White's graphic work has been his lifelong interest in drawing. He identifies closely with the Basel school, where Armin Hofmann's approach is gentler and more fluid than his colleagues from Zurich, and at Basel it is assumed that designers should be accomplished artists.

Over the years, White has built up his visual vocabulary to include gradations and type/image combinations. By creating his own drawn imagery he avoids the

Highway Order

Neil Parker

Vehicle registration plates are an intriguing example of typographic signs which are a statutory requirement throughout the world. As Neil Parker explains, the codes, systems and letterforms employed are surprisingly varied and can often be indicative of a country's national characteristics and even its political history. The history of registration plates goes back almost one hundred years, following hard on the heels of the motor car itself. The original requirement was simply the registration of the vehicle and/or owner, with evidence of such registration displayed perhaps by means of a windscreen sticker. The display of the registration in the form of a plate prominently displayed on the front or rear of a vehicle is believed to have been required first by the German state

in 1896. Within ten years such plates were the norm in Europe and many of the United States. Almost all countries have had several changes in plate formats and there are few jurisdictions where a 1900s plate would be valid today. The United Kingdom is one such, and although there has only been one design change in 85 years (an 11% reduction in the dimensions of characters in 1963 to allow for the increase from six characters to seven), a 1900s plate looks very different from a 1988 plate.

Enamel plates were common in many places in the early days, but rapidly became too expensive. Cast iron and riveted digits were popular – well into the sixties in the Middle East – and in times of economic crisis even stencilled lettering on cardboard has been used. By the mid-fifties plates were beginning to take on a more familiar look. During this period the current French and German series started, and the North Americans introduced their standardized 12 x 6" plates. The manufacture of plates using pressed aluminium became standard at this time.

Top: 8vo (Simon
Johnston, Mark Holt,
Michael Burke, Hamish
Muir), Octavo no. 2,
spread from an article
about Geoff White,
winter 1986/87

8vo (Simon Johnston,
Mark Holt, Michael
Burke, Hamish Muir),
Octavo no. 6, spread
about car number
plates, winter 1988

published in the mid-1990s) to Åbäke's *Sexymachinery* (2000–) – are so closely defined by a set of personal preoccupations that they are much closer to self-promotion than reportage or cultural intervention.[31] Although there has been much discussion of design authorship and 'no brief' work in the late 1990s as a way of breaking out of the service relationship that designers have with clients, such liberated publications often present their readers with little more than marginalia.[32] Now that designers have grasped the mantle of authorship, it seems as if they often have little to say. Magazines and journals ought to stimulate intellectual exchange. And this is how they should be judged. In this regard, *Dot Dot Dot* is a welcome and provocative rival to *Eye*. Founded by Stuart Bailey, a British designer living in the Netherlands, and Peter Bilak, a Slovak based in The Hague, this biannual title channels the international ebb and flow of the more experimental and undisciplined currents of graphic design today. Positioning design alongside pop music, experimental film and conceptual art, *Dot Dot Dot* eschews the glossy 'show and tell' world of the portfolio or discussion of design as business. Readers are presented with an unpredictable range of articles, from the organization of arcane systems mapping London's postal and telephone districts and ironic profiles of fictitious designers to more familiar discussions of graphic objects venerated by the cognoscenti. In this messy variety, Bailey and Bilak abstain from editorializing in favour of a more pluralist conception of design and design writing.

Pluralism is, of course, ultimately a sign of maturity and confidence, as is the fact that British graphic design is supported today by half a dozen magazines and journals. This is not to say that these titles are comprehensive in their coverage of the profession and its products, or that all issues are addressed on their pages: lacunae persist and challenges still remain (not least that of extending the interest and readership beyond the profession). Nevertheless, a diverse range of journals publishing critical articles and reproducing a broad range of graphic images remains one of the best possible guarantees of the discipline's intellectual health and creative vigour.

Top: **Goodwill, Stuart Bailey and Peter Bilak**, *Dot Dot Dot* no. 4, cover, winter 2001/ 2002

Stuart Bailey, *Dot Dot Dot* no. 5, spread from an article about Richard Hollis, summer 2002

British web design:
a brief history
by Nico Macdonald

In May 2000 in London's Regent Street, just a month after the Internet investment bubble burst, a hyperactive office with a multi-national staff finally closed its doors. Boo.com, the sports and outdoor-fashion online retailer, had been the most talked-up – and would become the most talked-down – dotcom of its era.

The 'start-up' became a byword for dotcom hubris and unchecked expenditure. But it also came to stand for design hubris, for an over-graphical and over-ambitious approach.[1] Among Boo.com's much vaunted, and criticized, features were rotatable product images, a persistent shopping basket that used images of selected items, and a pop-up 'Ms Boo' adviser. At Boo.com's demise, influential web design critic Jakob Nielsen argued that this 'proves that overly fancy design doesn't work'.[2] Although many critics of Boo.com's design had little idea about the nature of design, or were wilfully ignorant of the specifics of its situation, this event, and that period, marked a turning point for web design. 'Boo.com was a victory of concept of form over concept of use,' argues industry veteran Dorian Moore. 'That site killed conceptual design. After that the focus moved to usability and efficiency.'

Most of the discussion around Boo.com caricatured design in general, and graphic design in particular. Many of the same preconceptions about web design exist among graphic designers, serving sometimes to obscure the contribution of their field to the development of web design.

Design for interactive digital media is, however, arguably the most significant development in design in the UK in the last 20 years. It is comparable in scope to the flourishing of three-dimensional design – product, automotive and furniture – and is still in its infancy. Despite this, leading graphic designers in the UK, unlike their American counterparts, have been slow to engage with it and interactive designers, for their part, have been influenced by a diverse field of creative practice that extends well beyond the traditional boundaries of print media. Product design, architecture, gaming, and interface and interaction design have now all been assimilated.[3] The influence of graphic design (including televisual design) is the least understood influence on web design. It deserves particular examination in the context of the UK, where graphic design is in its element.

We can see the influence of graphic design on web design at three levels: aesthetics and typography; conceptual ways of thinking; and processes and methods. Sadly the early years of web design are more thinly documented than those of print – a copy of the Gutenberg Bible is in the British Library in London, but the ground-breaking

Shopboo Zoom it Try

HOME | HELP | CUSTOMER SERVICE | CLUBOO | BOOM MAGAZINE | ABOUT BOO | MISS BOO | KEYWORD SEARCH: | GO | POWER SEARCH

Brand
Activity
Accessories
Bottoms
Footwear
Outerwear ▸ Coats
Tops Fleeces
 Jackets
 Vests (bodywarmers)

boom
global culture style
sports magazine
▸

 boobag Try on an item Remove

Buy now
free shipping free returns

Niclas Sellebråten,
retail website for
Boo.com, 1999. Art
direction: Sellebråten.
Designers: Ida Wessel
and Genevieve
Gauckler. Flash
programming: Farid
Chaouki

1994 World Cup site designed at Sun Microsystems is nowhere to be found on the web – which brings the emphasis of this story's visual references closer to the present.

EARLY ENGAGEMENT WITH DIGITAL MEDIA

Why then has web design taken off so differently in the US? For one, the high-tech companies and global corporations that first exploited the web were US-based and worked with US designers. In the UK, design institutions and the graphic design press have for the most part failed to understand or take seriously design for the web, and good design work in this area has not received the same kudos as graphic or advertising design. Publications such as *New Media Creative* and *Create Online* may have understood the web, but they lacked a deeper appreciation of design thinking and other design disciplines. Consequently they were unable to escape the web ghetto when the bottom fell out of the industry.

The British designers who did engage with web design sooner rather than later included Neville Brody and Research Studios (founded in 1994), Malcolm Garrett and AMX (founded in 1994), Tomato, The Designers Republic, Tim Fendley and Robin Richmond of MetaDesign London, and some corporate design consultancies, such as Wolff Olins. Despite these few admirable in-roads, the wider influence exerted by traditional practices of print media tended to be negative rather than positive. This was evident in the desire for fixity in web interfaces and an over-emphasis on imagery and traditional typography. It was also demonstrated by the treatment of the screen as a metaphorical page (reflected in the sequence and ordering of information as well as shape and size), a perception of the web as a static or linear medium, and a wariness about designing for an intangible medium – especially one in which it was difficult to leave a creative signature. Ignorance of the rules and patterns that laid the foundation for creativity in graphic design produced web design solutions lacking in usability.

There are a number of areas in which the influence of graphic design would have benefited web design had it been brought to bear earlier, perhaps facilitated by the greater engagement of established graphic designers. These include better appreciation of client communication and collaboration; understanding of client needs and constraints; a more dispassionate view of software tools (a product of the previous technical revolution); and effective assessment of and design around complex information and varied assets (encompassing text, database output, images and time-based material).

In 1984, the entanglement of graphic design and interactive digital media began with the New Year launch of the Apple Macintosh – sporting a graphical user interface. The design tool was now digital, but not the medium. In the 1990s, CD-ROM delivered the medium, although its full potential was not immediately grasped by the majority of designers. Nonetheless, CD-ROM inspired a flurry of creativity in the US, and also in the UK with the Multimedia Corporation and others. The eighth issue of 8vo's celebrated *Octavo* journal was an interactive CD-ROM.

Next stop, the Internet. By 1996, the salvos of the 'browser wars' had forced the development of graphical browsers and web coding (in the acronym HTML).[4] It was easy to connect a computer to the Internet, and low-cost access was proliferating. Companies and individuals were taking the web seriously. Designers needed to explore this brave new medium thoroughly.

FIRST STEPS IN WEB DESIGN

The slow pace of adaptation to the web in the UK graphic design and print sectors meant that individuals from other disciplines and backgrounds had plenty of opportunity to influence the field. 'There were a lot of people without formal design backgrounds around that were very influential in those early days of interactive design,' notes American-trained art director David Warner, formerly of Razorfish in New York and now working at Oyster Partners in London. Their backgrounds ranged from the rave or club scene to the arts and television production, and their diverse skills – including programming, architecture and human-computer interaction – reflected this. These first movers came to their new discipline with a less restricted view of its boundaries or possibilities than graphic designers. However, they also had to learn many of the approaches with which graphic designers were familiar, not least managing client relationships and project process. From this adhocracy, a number of pioneering studios emerged: Webmedia, nurtured by entrepreneur Steve Bowbrick and artist Ivan Pope in the basement of London's Cyberia café, used pared-down design work to make the most of bandwidth constraints; Online Magic, whose self-initiated *General Election 97* site was notable for its rich but controlled visual aesthetic and detailed icons; Oyster Partners, which adopted an elegant but minimal style, led by product design-trained art director Hugo Manassei; Clarity Communications, who brought a utilitarian approach to their work for corporate clients; and Obsolete, which created the Backspace gallery and pioneered formats such as the interstitial 'blipvert' – short and often animated adverts that appear as the user moves between site pages.[5]

Top: **Online Magic**, *General Election 97*, political website, 1997. Executive producer: Michael Martin. Producer: Alistair Jeffs. Designer: John Dutton

Sunbather, Spice Girls band website for Virgin, 1998. Creative director: Mike Bennett. Designers: Hilla Neske, Paul Sonley, Jeremy Mac Lynn and Rich Wallet

Ad hoc combinations of skills produced ad hoc activity. Many of these studios initiated their own projects, some – such as Webmedia's *MovieWeb* film database – beyond the realm of design.[6] Bowbrick's company, in particular, grew quickly and hired many graphic designers. Bowbrick characterizes the skills challenge at this time as 'can't spell versus can't draw': designers were not sufficiently focused on detail and quality, and programmers – who often took on a design role – could not draw. In 1998, Webmedia hit the wall, undercut by one-kid-and-a-PC web designers and headed off by established players in the IT and consultancy sectors. Its alumni founded a number of new outfits, including Sunbather, started by Mike Bennett, which was responsible for the original Spice Girls site. It developed a style based on smooth shapes and organic forms and also used blurring and played with type and colour, referencing Neville Brody.

THE INTERNET BOOM

The end of the 1990s was characterized by an exuberant stock market, with hungry venture capitalists having nothing better to do than invest in Internet-related technologies. A boom in design work ensued, and – in larger organizations – designers were propelled into roles in which they had the ears of CEOs. Save for a few of our design heroes, this was a historical anomaly for an often retiring profession.

The upshot was an increase in the scale and ambition of projects. Web designers had to draw on more fundamental elements of British graphic design, and were aided by people with more graphic design experience entering the industry. These approaches were characterized by an independence of thought, where assumptions would be challenged and obvious routes not always taken. Increasingly, designers sought to establish the 'what, why, when, where and who' that informed a project. 'Graphic designers had to become more explicit about this as they engaged more with business, and designed for multiple content formats and the potential users of a service,' observes Giles Rollestone, former research fellow in computer related design at the Royal College of Art. Nykris co-founder Nikki Barton, whose employment encompassed the Multimedia Corporation and Neville Brody's Research Studios, notes that viewing a problem in different ways became increasingly important, as did 'questioning the assumptions behind the project, and getting customers to question them as well'.

Corporate branding and, more surprisingly, municipal design began to exert an influence on web design. Dorian Moore, formerly

at design and development studio Kleber, cites the British Rail signage and identity as an example of the former, with its focus on functionality and adaptability. Architecture-trained designer Matt Jones, who has worked for organizations including Sunbather, the BBC, web integrator Sapient and Nokia, notes that 'we went back to worthy municipal design, that only us, Northern Europeans and the Scandinavians can do well, and found a way to turn that into an aesthetic'. He presents the pre-war schools design of the Hampshire County Council architecture department as evidence. Municipal design he characterizes as low budget and robust, rational and information-focused, and produced for 'low bandwidth of attention'. It was constituted of flat colour, type and line, compared to high-budget, visually rich US design work. 'It was GIF versus JPEG,' he observes, referring to the low- and high-fidelity image formats. He cites the BBC News site, in which he was involved, and online retailing developments at Tesco, Waitrose and Sainsbury's.

The design process beyond the brief began to be considered more holistically and designers started to appreciate that design quality was as much a product of a thorough, multi-tiered approach as it was of individual creativity. 'I came in when there was no process,' says Bill Galloway of the Butterfly Effect, which evolved from Clarity. 'We learned process, and drew some of this from the technical side. Early sites were arty or functional. Now we are able to fuse the two.' Graphic design approaches to developing concepts and presenting solutions were adapted. Traditional graphic designer Frances O'Reilly of Recollective notes that they would typically present clients with two to three design pathways: 'way out, sober, and middle-of the-road', not least to see where the client stood. Adaptation was key. 'Screenshot layouts were ineffective, they didn't give the clients the full picture,' explains art director Timo Arnall, who studied media, film and television. 'So how do you document temporal, hypertextual and spatial concepts?' He drew on his training, and he and others scoped resources beyond design, such as Kevin Mullet and Darrell Sano's 1995 book *Designing Visual Interfaces*, Jakob Nielsen's AlertBox mailings and the ACM SIGCHI (Computer-Human Interaction conferences).[7]

The kinds of information being communicated via the web were becoming more complex. Publishing systems were developed that could manage sites with multiple templates. The traditional concept of the grid in graphic design was revived. However, on the web grids had a third dimension, and templates needed to be designed explicitly with a view to production and publishing. As with trad-itional magazines, and particularly newspapers, they had to support

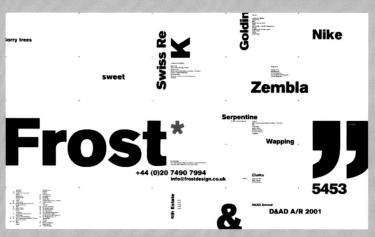

Top: **Deepend**, website for International Society of Typographic Designers, 2001. Design direction (interaction design): Nicky Gibson

Above (middle): **The Designers Republic with Kleber**, website for Warp Records, 2001

De-construct, website for Frost Design, October 2002. Designers: Fred Flade and Vince Frost

Top: **Mook**, website for Glastonbury music festival, 2002, updated 2003

Intro, Chemical Brothers band website for Virgin, 2001

an appropriate variety of material but avoid a templated appearance. Some designers, such as London-based Mook (who 'approach things as a graphic design company') went beyond conventional graphic design use of the grid to incorporate rich illustration. The grid approach informed the need for navigation and location information, and designers looked to book and magazine semantics, as well as to environmental signage.

More detailed analysis of the kind of information to be published was required, taking into consideration the various ways in which information elements could be combined and presented, as well as publishing system constraints – all familiar challenges in catalogue and directory design. Such approaches became known as 'information architecture'. At the BBC and elsewhere designers also focused on the related areas of information graphics and maps. 'We really did go back to the old schools,' comments Matt Jones, then at BBC News Online, who cites as influences 'Nigel Holmes, information design in old magazines, such as *Time*, and the broadsheets, and internal broadcast designers,' as well as the more celebrated information design and visualization gurus Edward Tufte and Richard Saul Wurman.

Editorial design and strong use of photography began to inform web design, although as an information-driven and mass-to-mass communication tool the web had been taken to be a medium in which editorial control was less appropriate or desirable. Designers began to apply approaches that they had followed in print editorial design. David Curless, for example, previously an art director at *The Times*, moved to Interactive Bureau London, where he worked with his former employer to create a more flexible and accessible design for *The Times* site that supported greater editorial differentiation.

Designers also applied typographic styles from editorial design. Simon Esterson's 1997 design for *The Guardian* newspaper's football site used large Bureau Grot and flat bold colours for titling. These were not standard system fonts and had to be presented as images rather than text. Esterson's typographic style produced small file sizes, and did not significantly increase page loading time. Brody's Research Studios led the design of the succeeding Guardian Unlimited site, launched in 1999, and adopted an almost entirely typographic treatment, based on Helvetica and Helvetica Extended, with a modular approach anchored by low bandwidth one- or two-colour story 'sells' and cross-promotions. Again, this suited users' low-bandwidth connections.

In the mid- to late 1990s the browser software companies – primarily Netscape and Microsoft – turned to embedding fonts in

Digit,
retail website for
Habitat, 2001

web pages. These fonts would be downloaded from the server when a page was accessed, and could have transformed web design by making it easy to use any typeface – not just the standard Arial, Times and Courier – in headline or body copy without adding significantly to page download times. As Netscape steadily retreated in the browser wars, both sides lost interest in these initiatives, and Microsoft opted instead to commission Matthew Carter to create fonts – including Verdana and Georgia – suited to screen reading. These were included with Microsoft's Internet Explorer browser and Windows installers, and were thus available on users' computers – along with the other standard fonts – if they were referenced in the mark-up of a web page.

Macromedia's Flash browser plug-in was also gaining a foothold, and its vector-based model proved well suited to screen-based typography.[8] Designers were able to apply typographic styles developed in print, experiment with time- and user-based interaction, and play with sound. Type could be embedded and scaled on-the-fly rather than being presented as images. More elegant approaches to interaction with menus and other navigation elements – including aural feedback – could be applied. These features allowed for the creation of more immersive and richer environments. Digit London's celebrated Habitat site used simple vector images of people in interior environments.

Deepend, founded in 1994 by three Brunel and RCA graduates, pioneered motion-based interfaces, often with a televisual aesthetic. Motion graphics were also pioneered by New York-based Razorfish, which started its London office with the acquisition of the studios CHBi and Sunbather. It developed a signature style around simple oscillating graphical forms based on vertical lines, which also translated into still and print form. This form was reminiscent of film graphics, such as Tomato's contemporary titles for the 1996 film *Trainspotting*. Time-based change and user input in networked media was investigated by Tomato in the context of branding, with its Sony Connected_Identity project. Visitors to the Connected_Identity site could select a word, which was then rendered and mutated over time and presented via the web, mobile phones and on a display in the Sony Building in Tokyo. Selected clips of these animations were also used in Sony television commercials.

Elsewhere, illustration styles drawn from pop culture as well as late 1980s and early 1990s advertising and flyer design – bright, contrasting colours in minimalist or white environments – inspired many web designs, for instance Niclas Sellebråten's design for Boo.com, and worked well with the Flash vector-aesthetic. Some

illustrators, such as Anthony Burrill, found that their style already suited the medium and were then also able to experiment with movement and sound. Art and design also crossed over. British artists such as Damien Hirst, Julian Opie, Gary Hume, and Gilbert and George regularly borrowed from graphic design – though the last have a long established graphic style. This was re-appropriated for Gilbert and George's 1997 CD-ROM 'The Fundamental Pictures' (and for the accompanying website); MetaDesign London used their distinctive style of upper case, sanserif, white-on-black type for the CD-ROM navigation.

British web designers were more esoteric than their American cousins, less focused on functionality. The 2001 site for the Barbican's 'Jam: Tokyo–London' exhibition, for example, by London-based designers Airside, was inspired by early games design and exemplified the wry sense of humour that had long pervaded British graphic and advertising design. An element of fun and self-conscious silliness have characterized the work of many other designers, including Crispin Jones, Burrill and Mook (who talk about a light-hearted tone of interactivity and the intrinsic enjoyment of cause and effect). One iteration of the Nykris website displayed a fig-leafed man and woman logo while loading, with the text 'hold on a minute, we're just getting ourselves decent'. A later application, developed for use on mobile phones, helped people to find public conveniences in London – British toilet humour, but practical with it.

Some designers exploited the related states of intrigue and frustration felt by website users. The Hi-ReS! site for the 2000 film *Requiem for a Dream* offered visitors a selection of obscure paths, using 'reveals' of new paths and narratives to tempt them onward, yet leaving them unsatisfied and wanting to know more about the film. Moving still further away from functionality, some designers and artists developed projects solely to experiment with and investigate the nature of the medium. The most celebrated of these was mediagenic Liverpudlian Danny Brown, who acknowledges the influences of Japanese Manga and photography on his work and describes his projects – which include the much-acclaimed *Mr Noodlebox* (1997–2001) – as entertaining 'interactive music videos'.[9]

AFTER THE FALL

Then, as the new millennium took its first breaths, the Internet investment bubble burst. The 'irrational exuberance' (a phrase associated with Alan Greenspan, chairman of the US Federal Reserve) of speculation in telecom and dotcom stocks lost its

Tomato, corporate ident for Sony Connected_Identity, 2001. Creative direction: Tomato and One Sky Inc.

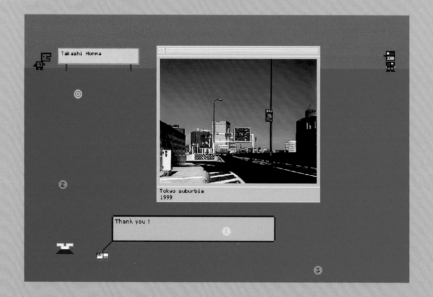

Top: **The Designers
Republic**, websites for
The Designers Republic,
2002

Airside,
Jam: Tokyo–London,
exhibition website for
Barbican Art Gallery,
2001

Friendchip (Anthony Burrill and Kip Parker), website for 13 Amp Records, 2002

Danny Brown, *Mr Noodlebox*, personal website, 1997–2001

bluster. In the web agency sector this led to a further round of mergers and acquisitions, while failures of studios such as Deepend later in 2001 served to produce many 'little acorns' such as Recollective – reminiscent of the fall-out from Webmedia's failure.[10] Some designers who left or were made redundant began working independently or set up other small studios. Many others moved to work for clients in-house.[11]

The charge of hubris was laid at the door of many designers and companies whose ambitions had risen with the stock market. Many engaged in self-flagellation. Some, such as Mark Hurst, evangelist for the importance of the 'user experience', argued that by treating the web as a 'graphic' medium, many designers had created an 'atrocious customer experience' – citing as examples sites such as Boo.com.[12] In their generalizations about design as a whole, and graphic design in particular, many commentators failed to appreciate that design is a process, rather than a thing in itself. To paraphrase one of communication theorist Paul Watzlawick's axioms, 'you cannot not design'.

With this utilitarian turn, web design did begin to diverge from one trend in graphic design at the time, the increasing focus on illustration, and to cleave instead to the historic concept in design thinking of truth to materials and simplicity. This design philosophy went on to characterize the work of many studios, such as Less Rain in London's Hoxton district, who note on their site that 'Less' is a byword for 'making a few design elements work more intelligently, unusually and 'organically' rather then encumbering a project with every off-the-shelf effect available'.[13] The truth to materials approach was epitomized by Friendchip collaborators Anthony Burrill and Kip Parker, whose early site 'Get Jet Set' employed a crude pixel aesthetic and digital sounds, not least because Burrill had no access to a scanner and artwork had to be originated on the computer.

Many designers who had been juniors in agencies during the dotcom boom were coming of age. Many of them had been influenced by designers such as Neville Brody, Peter Saville and Mark Farrow, whose work emphasized simplicity among other characteristics. The concept of truth to materials represented a recognition by designers that on the web – a 'deliver and print' medium – the final appearance of a design could not be fixed. At one level this resulted in a greater focus on the technical aspects of web technologies, at another a drive to map the characteristics of the web – the 'material' – to those of clients or their products and services. This approach can be seen in the design collaboration between Poke (whose partners include Deepend co-founder Simon

Top: **Less Rain**,
website for Less Rain,
2003

Middle: **Less Rain**,
website for Beck's
Futures, 2003

Poke and Fuel,
website for Fuel, 2000.
Design and art
direction: Peter Miles,
Damon Murray and
Stephen Sorrell, Fuel.
Consultancy and
construction: Poke

Waterfall) and Fuel on the Fuel site, in which the qualities of featured items, such as posters, are reflected in their technical implementation on the web.

The use of more traditional approaches to typography has also seen a renaissance, with designers exploiting the potential of Flash for presenting rich typographic compressions in dynamic environments, as seen in De-construct's site for graphic designer Vince Frost. Designs for the Hyphen Press design book website by Eric Kindel, and the Royal Society for the Encouragement of Arts, Manufactures & Commerce (RSA) site by Grundy & Northedge, were based on the elegant typography characteristic of classic editorial design. While there is no set of rules for typography on the web, many web designers have, like their counterparts in print, built on modernist thinking in typography. There is a tendency to use simple sanserif typography, not least because it is more readable on current low-quality screens. Deepend's 2001 site for the Design Museum in London used a recently designed sanserif typeface, adding movement and roll-over states to the site navigation.

A new appreciation for the virtues of simplicity and elegance, as well as attention to detail, could also be seen in website navigation, which revisited the graphic design approach to system design (for instance, the design of signage). When, for example, Nykris designed the interfaces for the MacOS X versions of a number of Microsoft products, including the Office software suite, Internet Explorer, MSN Messenger and Entourage, principal Nikki Barton chose to cite the information design work of Cartlidge Levene as an inspiration – particularly in view of their commitment to 'the tiny details that are so easily overlooked'.

Away from functional and navigation-driven design, a number of trends that had been evident in graphic design for a decade came to the fore. Web design drew on vernacular elements and street-culture aesthetics, and adopted a more 'rough around the edge' feel. The latter phenomenon was in response to the perfection of print and typography brought about by PostScript-based artworking, and a search for authenticity beyond the suspect veneer of corporations and brands. In this spirit, The Butterfly Effect developed a website in 2002 for music TV station VH1 using pastiched elements from the music industry such as a gig ticket and backstage pass. In 2003, Recollective's site design for Virgin Mobile's Virginmobilelouder campaign was based on the club flyer aesthetic, using manipulated photography to create rough two-tone images and visible dithered dots reminiscent of newsprint. Punk graphics, an older British street-culture aesthetic epitomized by Barney Bubbles and Jamie

Top: **Grundy & Northedge**, website for Royal Society for the Encouragement of Arts, Manufactures & Commerce (RSA), 2003

Middle: **Eric Kindel and Matt Patterson**, website for Hyphen Press. Original design: Kindel, 1998. Revised design: Patterson, 2000

Deepend, website for Design Museum, London, 2001

Top: **Nykris**, Microsoft Office v.X for Apple Macintosh, 2000

The Designers Republic, website for Manhattan Loft Corporation, 2004

Reid, influenced the design of music fanzine site Playlouder. In a similar vein, Lateral described the style of its own site as 'a bit simple, amateur, not polished or shiny, and quite illustrative'. It is intended to show what Lateral staff like, and to be a bit of fun, with the only hard guideline being to 'make sure the font, colour and logo match'. This 'ground up' approach is distinctly British, in contrast to the more corporate and market-led approach of US organizations.[14]

Some of the more conceptual approaches of British graphic design, such as humour and story-telling, also reasserted themselves. As clients and agencies recognized that the web was a complementary medium to other media, such as print and television, they began to use it more appropriately and strategically, creating integrated campaigns based on one 'big idea'. Advertising agency Mother, for example, worked with its affiliated interactive studio Poke on the 2003 LiveSexy campaign for radio station Kiss, which was based on a watch that would tell its owner when they were going to die, and was inspired by evangelical teachings and religious websites.

A TWO-WAY STREET

While graphic design has indeed had a substantial, if indirect, influence on web design, there are also many areas in which web design has gone beyond graphic design, and may therefore be able to shed new light on it.

Web designers are typically more involved in client strategy than graphic designers, and in the evaluation of the business benefits and return-on-investment of their work. They are also more likely to work across an organization, considering the specific needs of all those involved in a project. Their design and communication processes tend to be more consciously thought out and they generally think more carefully about the people for whom they are designing, conducting more user research and giving greater consideration to the usability of the final product.

In some respects these traits reflect the degree of professional self-consciousness that is required at the birth of a new discipline. However, we can also gain a better understanding of the graphic design process by examining it through the lens of web design. By adopting some of the processes and techniques made explicit by web design, graphic design could itself benefit.

Improvement or not, there is no doubt that the web and web design have already made a profound impact on graphic design. In the early days of digitally-based publishing, tools designed to

Hi-Res!, Massive Attack
band website for Virgin,
2003

facilitate existing processes, such as page make-up, had an influence in themselves. Designers started to exploit the pixelated nature of digital media, for example, and to investigate the possibilities of layering type and image. The vector-based Flash aesthetic has also been influential, encouraging flatter, more graphical forms in work as diverse as the Monkey Dust cartoons, interstitials for BBC Education, magazine cover illustrations (particularly in design and IT-related publications), the BBC Four identity (which modulates to the announcer's voice) and the Royksopp *Remind Me* video.[15]

The web 'look' can also be seen in the use of web-specific fonts, such as Verdana, in print. Internet and dotcom-style nomenclature (as well as SMS and email) have inspired the use of lowercase typography, concatenated words and new uses of punctuation, seen, for example, in Fibre Design's work on the identity of creative PR company The Fish Can Sing. Web and graphical user interface elements – particularly hypertext links and menus – are also widely used in graphic design.

Some of the influences have, of course, been less direct. While the ease of accessing and sharing information on the web has given graphic designers a rich source of inspiration, it has also forced some designers of books, magazines and other printed design artefacts to adopt a more tactile and idiosyncratic approach. This is evident in the use of dramatic photography and illustration; unconventional formats and finishes; and hand-lettering in place of commercial fonts.

This ease of access has also supported graphic design practice. Design consultant Heath Kane observes that 'designers of all practices are turning to the web as a source of inspiration, as well as utilising it to become content creators to share their ideas and work'. Resources such as *Kaliber10000* (subtitled 'The Designers Lunchbox'), and *Linkdup*, created by Hoxton-based digital media consultants Preloaded, reflect this disposition. In addition, mailing lists and, more recently, weblogs have become popular among designers and design commentators. Matt Jones's original and reflective *Blackbeltjones* journal is a popular example of the latter.

Web design and its related disciplines of interface and interaction design still have a long way to go before they can help us to realize the full potential of digital and networked environments. In many respects these disciplines are in a kind of stasis, an ironic result of the enormous success of the personal computer and the web. It is perhaps surprising that graphic design, founded in systems thinking and focused on the visual communication of ideas, has not had a more profound influence on British web design. However, it is not

too late. Graphic design thinking may be able to give momentum to the next leaps we need to make, particularly as we take the necessary steps of grounding these technologies in the physical and social worlds.

In the longer term, web design practice is likely to be subsumed by interface and interaction design, and we may then no longer distinguish interfaces – web, software, mobile phone – according to the technology behind them.[16] Even these distinct design skills may eventually disappear and become part of every other design discipline, including graphic design. If this happens, graphic design will have evolved as much as web design has needed to evolve.

Rob Corradi, Preloaded, website for *Linkdup*, 1999 (top) and updated version 2004 (bottom)

Thinking with images
by John O'Reilly

Sometimes by design, often by accident, Hollywood manages to capture mysterious, surprising emotions that lie just below the surface. So what are we to make of the fact that the world's most iconic, graphic superhero, the simple, clean-living Superman, has as his nemesis Lex Luthor, an embodiment of corruption, avarice and cheating sleaze but also a fan of graphic design? 'Some people can read *War and Peace*,' explains our villain, 'and come away thinking it's a simple adventure story. Others can read the ingredients on a chewing gum wrapper and unlock the secrets of the universe.'

What esoteric secrets might Lex Luthor find on a chewing-gum packet? According to design writer Thomas Hine, the Wrigley's chewing gum green arrow 'is the perfect symbol for a product that offers the primal comfort of chewing with a stimulating taste. The package doesn't so much sell the product as indicate how to enjoy it. ... And when we say that packages are important cultural expressions, it is not to suggest that the culture is dominated by hucksterism, but rather that packaging provides a way in which people define and understand themselves.'[1]

We live in a design-rich world, where our attention is directed, organized and sculpted according to the craft and skills of the graphic designer. But despite this, and despite the fact that Britain is recognized as a world leader in graphic design, the country's intellectual establishment is resolutely bookish. What is the source of this? Why are graphic designers themselves in thrall to the idea of art? And why is graphic design not a major area of study in universities?

SPELLBOUND BY BOOKISM

The British cultural establishment is spellbound by the culture of words, and bows before the weightiness of the book. Its heroes are writers rather than artists or film-makers or designers. Obsessed with 'readability', it still applies the critical language of literature, its values and its habits to cinema and art. The first decade of the 21st century still has our chattering classes and cultural mandarins looking to *The Spectator* magazine and the *London Review Of Books* rather than *i-D*, *Eye* or *Idea* magazine, let alone advertising or graphic novels, to get a sense of what is happening on the cultural scene.

Take the response of BBC cultural pundit Tom Paulin – poet and lecturer in English literature at Oxford University – to Chris Ware's *Jimmy Corrigan*, a graphic novel which won the American Book Award and *The Guardian* First Book Award in 2001. 'The colours are dreadful, it's like looking at a bottle of Domestos or Harpic or Ajax. Awful bleak colours, revolting to look at; it's on its way to the Oxfam shop. Disgusting look to it. Really horrible.'[2]

TBWA/London,
Dotscreen, billboard for
Sony PlayStation, 2001.
Art direction: Paul
Belford. Copywriting:
Nigel Roberts

Paulin might have commented on the narrative scale of documenting a modern family over three generations; the pathos of Jimmy's life story; or the sheer visual impact of over 3,000 images. He might have mentioned the flattened-out illustration, like an Edward Hopper painting with the creases and shading ironed out, that lends *Jimmy Corrigan* its generic, everyman feel. The issue is not Paulin's lack of critical engagement *per se*, but rather how indicative it is of the way the established media regards graphic media.

CULTURE SHIFT

While the arbiters of social value remain fustily pedantic, there has been a tectonic shift within UK culture as a whole. We live in an image culture and our children already have a far greater grasp of visual culture, through the use of computers in schools, than any previous generation. Emily Campbell, head of design promotion at the British Council, believes that the UK is received enthusiastically abroad partly because of its 'indelible association with youth'. And, moreover, 'Design is the pursuit of change,' Campbell says. 'The prolific state of British design reflects the rate of change in the UK and can help shift the more hackneyed stereotypes of British society and business.'[3]

Although such stereotypes are changing abroad, the UK still lacks a powerful forum in which to respond to the public level of inquiry and curiosity around design. So even though the old-school arbiters of taste still ignore design, the public's design sophistication means that designers have to work harder and be more creative. According to one businessman, consumers 'know when a piece of advertising flatters to deceive, when a pack design dresses up the same old product, when a website promises convenience and just aggravates.'[4]

A new generation has emerged whose headspace has evolved into a multi-tasking instrument, who enjoys the 'me-time' pleasure of reading, but who also craves the speed, excitement and visceral pleasure of visual and graphic language. Anyone born from the 1980s onwards is part of a computer-literate generation, familiar with Graphic User Interfaces and a level of desktop publishing, and whose culture has thrived around DIY club-flyers and websites. It was this generation that invented a whole new graphic vocabulary of text messaging and has found a purpose for camera mobile phones. The graphics revolution happened so quickly that it is invisible to most cultural analysts.

All the anxiety that fuelled debates in the late 1990s as to whether the UK had 'dumbed down' was only possible through a lack of awareness of just how visually and graphically sophisticated

TBWA/London,
Dotscreen, billboard for
Sony PlayStation, 2001.
Art director: Paul
Belford. Copywriter:
Nigel Roberts.

the mainstream had become. And of simply how conceptually the consumers of mainstream design had begun to think.

GRAPHIC THINKING

In 2001, design company Williams Murray Hamm wrapped a beer bottle in tiger stripes for Wild Brew. No logo, no message. This was not about confidence in brand awareness, but rather confidence in the mental versatility of the average customer at a bar or sweaty club. The belief was that these drinkers would connect immediately with the visual and semiotic vocabulary of tiger stripes, that they would, in that split second at the bar, free-associate along the chain of meanings available from the visual stimulus – animal stripes–booze–party animal. There were no words. No windy rationale. Just graphic thinking. It was not groundbreaking design work, but that is not the point. It was about the consumer's ability to think visually and conceptually.

Likewise, the 2003 poster for Quentin Tarantino's *Kill Bill* movie was given a number of executions in the UK, one of which completely removed the film star Uma Thurman, boiling communication down to graphic elements of colour and shape.[5] This may be seen either as a sackable piece of marketing or confidence in the knowledge that the UK cinema public is so graphically aware that it will intuit the visual message immediately.

But more than anything else, graphic design is, as Campbell says, something that 'reflects the rate of change'. It shapes change, and pictures it, most obviously in representing new technology. In 2001, Paul Belford and Nigel Roberts at TBWA London created a huge poster for Sony PlayStation with no words or letters. It appeared as a face from far away, but was constructed entirely out of the symbols on the PlayStation console. It is graphic design in its purest form.

TRANSLATORS OF THE FUTURE

As a piece of communication the PlayStation poster is clear. It locks into the new language and iconography of gameplay. Belford and Roberts's work shows why the best graphic design is our most important discipline for understanding society and reflecting on the impact of social changes. Why? Because graphic design is both instrument and interpreter of commerce. Designers give visual shape and symbolic form to the products and technologies that drive our society. Designers are called in to represent, and make sense of, new technologies in marketing. They provide the deep visual language with which we understand new technologies. Call it conceptual thinking in popular form.

Top: **Williams Murray Hamm**, Wild Brew beer bottle for Interbrew UK, 2000. Design director: Garrick Hamm. Designers: Simon Porteous and Garrick Hamm. Photograph: Phil Hurst

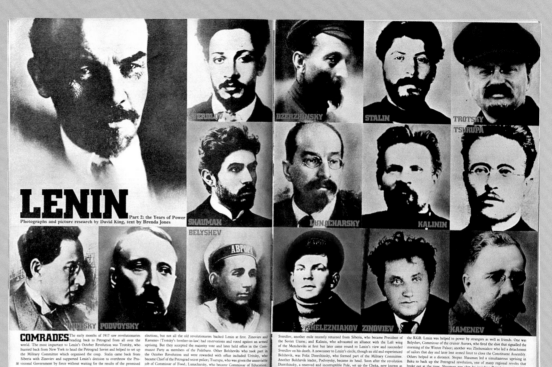

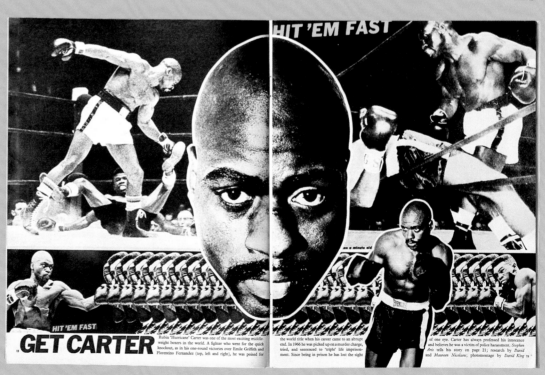

David King, *The Sunday Times Magazine*, cover, 19 April 1970. Art direction: Michael Rand

Top: David King, *The Sunday Times Magazine*, spread with picture research by King, 19 April 1970. Art direction: Michael Rand. Photographs: Novosti Press Agency, Moscow

David King, *The Sunday Times Magazine*, spread, 7 July 1974. Art direction: Michael Rand. Photomontage: King

Like most new technologies of virtual spaces, the PlayStation aims to communicate the fact that it is an immersive experience. And this is the concept behind TBWA's 1999 ad for PlayStation, which shows the console symbols as the nipples of the players. In some ways, the ad's visual message is simpler and more direct. To quote media guru Marshall McLuhan's analysis of television, 'You are the screen. The images wrap around you. You are the vanishing point.'[6] The various graphic devices in many PlayStation campaigns set up this idea that technology uses us. This is fundamental to understanding why the cultural nabobs, and the literary values they are governed by, are of little use in getting a grasp of where we are.

As readers of a commercial brief, graphic designers are the first students and analysts of any new changes. So when did graphic design become a popular, mainstream form of thinking? And what are the roots behind the prejudice that visual and conceptual thinking is frivolous or shallow?

XEROXOGRAPHY

Graphic design in the 1960s and 1970s fed into the culture at large and helped shape it. From the Beatles album sleeves by Peter Blake and Richard Hamilton to the psychedelic poster work of Michael English, from David Pelham's conceptual cover images for Penguin science fiction to Michael Rand and David King's tough, urgent layouts for *The Sunday Times Magazine*, it is not as if graphic design was invisible. But there was a tipping-point in the late 1970s when design became democratized and opened-up. The impulse for this (as ever with design) came from technology.

The photocopy machine had originally been invented by an American law student, Chester Carlson, in 1938 and he named the process 'xeroxography' (Greek for 'dry' and 'writing'). The first commercial automatic photocopier appeared in 1959 and could print seven copies a minute. By the late 1970s the photocopier was part of the office furniture and increasingly accessible. But the unforeseen consequence of the photocopier was that it made everyone potentially a publisher and a designer.

Though conventional design history registers the impact of desktop publishing systems, the photocopier created a secret revolution. Fanzine editors were free to grab from anywhere, and unlike the 1960s magazine outsiders, they did not have printers worrying about the obscene publications squad. The photocopier removed a layer of human intervention – the printer – in publishing.

Remarkably, fanzine publications like *Sniffin' Glue* and *Ripped and Torn* were actually the visual precursors to music sampling. The

David Pelham, *Sirius* by Olaf Stapledon, book cover, Penguin, 1973. Illustration: Pelham

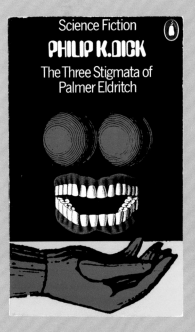

David Pelham, *The Three Stigmata of Palmer Eldritch* by Philip K. Dick, book cover, Penguin, 1973. Illustration: Pelham

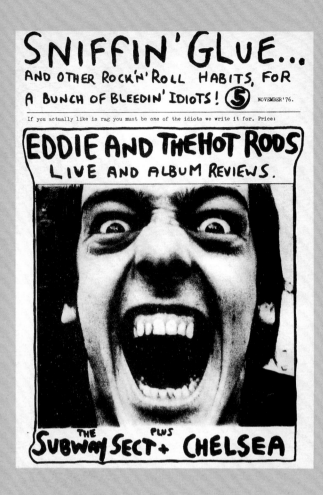

SNIFFIN' GLUE...
AND OTHER ROCK'N'ROLL HABITS, FOR
A BUNCH OF BLEEDIN' IDIOTS! (5) NOVEMBER '76.

If you actually like is rag you must be one of the idiots we write it for. Price:

EDDIE AND THE HOT RODS
LIVE AND ALBUM REVIEWS.

THE PLUS
SUBWAY SECT + CHELSEA

Mark P and others,
Sniffin' Glue no. 5,
punk fanzine cover,
November 1976

creators of these magazines, like the later samplers, were self-taught. All they had was a photocopier and what radio DJ John Peel called 'cheerful amateurism'. These graphic autodidacts were the visual counterparts of journalists like Julie Burchill and Paul Morley, freelance theorists whose originality and freshness were a consequence of having to invent a new journalistic voice. This is why even though Dada is often cited as a precursor to punk, the true reference point for early punk, especially the widespread fanzine culture, is Henri Rousseau and the Sunday painters, artists without formal training, whose work was essentially out of its time. What this wave of self-publishing brought to the table of graphic design was an untutored eye, which would begin to shake up more mainstream graphic culture.

GRAPHIC TURMOIL
The raw graphics of the self-published fanzines had their counter-part in the sleeve art of Malcolm Garrett and Jamie Reid. The slashes and cuts of *Orgasm Addict* by the Buzzcocks and *God Save the Queen* by the Sex Pistols were signs of a reality ripped, a nation on the verge of a civil war: striking miners, CND, Greenham Common, inner-city riots. But these signs of graphic distress also signified an increasing sense of the surface of things, of pleasure in the skin of things.

You could see it in *i-D* magazine, in which fashion and style became a different way of documenting everyday life. The cut-and-paste edits and the overprinting communicated a new era in which reality was layered and built and dizzyingly fragile. Editor Terry Jones's achievement was not just providing an alternative fashion voice to *Vogue* by focusing on 'street', but making 'street' appear on the page as if it might come apart at the seams. Nor was this simply a distressed aesthetic, or style for style's sake. It communicated the fracturing society of the UK in the late 1970s and early 1980s.

While 'deconstruction' would become the philosophy buzzword of the 1980s and 1990s, the process had already slipped into news-stand media such as *i-D*, because everything was *already* coded-up, created as a sign or constructed representation. Graphic designers were laying bare – with absolute literalness in the case of Hipgnosis's cover for XTC's *Go 2* – how images and formats are coded and built.

It was precisely because the social fabric was becoming unglued that the graphic designer became the unwitting narrator of the story of Britain in the 1980s. The emergence and prominence of graphic design in the UK in the early 1980s was a symptom of the fact that the familiar conventions and symbols of status, of belonging and

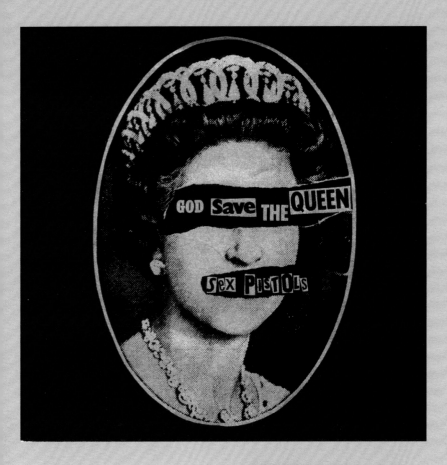

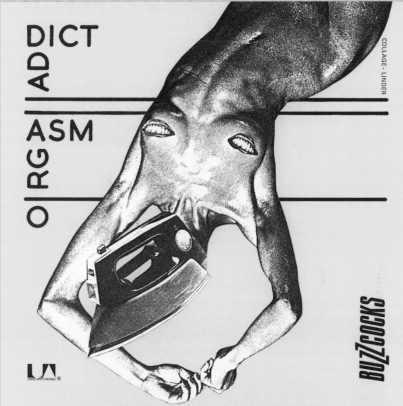

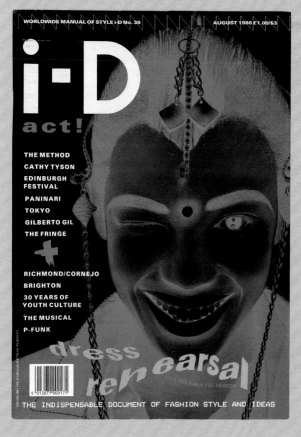

Top: **Jamie Reid**,
God Save the Queen by
the Sex Pistols,
7-inch single cover,
Virgin, 1977

Malcolm Garrett,
Orgasm Addict by the
Buzzcocks, 7-inch single
cover, United Artists,
1977. Montage: Linder

Moira Bogue,
i-D no. 39, magazine
cover, August 1986.
Art director: Terry
Jones. Photograph:
Robert Erdmann

This is a RECORD COVER. This writing is the DESIGN upon the record cover. The DESIGN is to help SELL the record. We hope to draw your attention to it and encourage you to pick it up. When you have done that maybe you'll be persuaded to listen to the music - in this case XTC's Go 2 album. Then we want you to BUY it. The idea being that the more of you that buy this record the more money Virgin Records, the manager Ian Reid and XTC themselves will make. To the aforementioned this is known as PLEASURE. A good cover DESIGN is one that attracts more buyers and gives more pleasure. This writing is trying to pull you in much like an eye-catching picture. It is designed to get you to READ IT. This is called luring the VICTIM, and you are the VICTIM. But if you have a free mind you should STOP READING NOW! because all we are attempting to do is to get you to read on. Yet this is a DOUBLE BIND because if you indeed stop you'll be doing what we tell you, and if you read on you'll be doing what we've wanted all along. And the more you read on the more you're falling for this simple device of telling you exactly how a good commercial design works. They're TRICKS and this is the worst TRICK of all since it's describing the TRICK whilst trying to TRICK you, and if you've read this far then you're TRICKED but you wouldn't have known this unless you'd read this far. At least we're telling you directly instead of seducing you with a beautiful or haunting visual that may never tell you. We're letting you know that you ought to buy this record because in essence it's a PRODUCT and PRODUCTS are to be consumed and you are a consumer and this is a good PRODUCT. We could have written the band's name in special lettering so that it stood out and you'd see it before you'd read any of this writing and possibly have bought it anyway. What we are really suggesting is that you are FOOLISH to buy or not buy an album merely as a consequence of the design on its cover. This is a con because if you agree then you'll probably like this writing - which is the cover design - and hence the album inside. But we've just warned you against that. The con is a con. A good cover design could be considered as one that gets you to buy the record, but that never actually happens to YOU because YOU know it's just a design for the cover. And this is the RECORD COVER.

Hipgnosis, *Go 2* by
XTC, album cover,
Virgin, 1978

place, were breaking down. The Conservative government's economic policies wrought a social revolution. The self-image of the nation was dismantled and recast, and just as graphic design entered this fractured space, the nation began its 'design decade'.

In a curious way, punk and post-punk graphics could be seen as experiments in how big business would brand itself. It is an old story, the idea that insider commerce makes money out of outsider art by adopting its attitudes and postures in advertising. As musician Jah Wobble reflected on the design of Pil's *Metal Box*, 'We wanted it to be stern, monolithic and scary, beyond language and – the implication was – beyond thought. The logo presaged that 1980s corporate thing, which pisses me off now I think about it.'[7] The sleeve art of Heaven 17 (*Penthouse and Pavement*) and Scritti Politti (*Asylums In Jerusalem*) also played with the graphic language of corporate and consumer culture that would soon occupy the visual space of the nation. Neville Brody would complain about his work being ripped off for corporate purposes while on the other hand Malcolm Garrett spoke with apparent approval about the idea of corporate identity, explaining how he had applied this to pop groups such as Duran Duran. Even so, Garrett's late 1980s neo-punk sleeve for Boy George's *Sold* album stamps the commercial message like a cattle brand across the pop star's chest.

INFLATION AND DEPRESSION IN GRAPHIC DESIGN

The point is that graphic designers are always at the frontline of social and cultural change, providing the visual vocabulary that makes sense of things. And crucially it is their relationship with the music industry that keeps the latter at the forefront of social change. As Jacques Attali, businessman, academic and former president of the European Bank of Reconstruction and Development, wrote in *Noise: The Political Economy of Music*: 'Music is prophecy. Its styles and economic organization are ahead of the rest of society because it explores, much faster than material reality can, the entire range of possibilities in a given code. It makes audible the world that will gradually become visible, that will impose itself and regulate the order of things; it is not only the image of things, but the transcending of the everyday, the herald of the future.'[8]

At the beginning of the 1980s, graphic design and pop culture fused with the future in all its forms, as pure commerce, as a way to get a glimpse of the future, of new forms of social identities and economic organization. You can see the history of the UK in the 1980s through Neville Brody's designs for magazines *The Face* and *Arena*. The layouts with multiple points of entry for the reader in

Top: **B.E.F.**, *Penthouse and Pavement* by Heaven 17, album cover, Virgin, 1981. Cover painting: Ray Smith

Malcolm Garrett, Assorted Images, *Sold* by Boy George, album cover, Virgin, 1987

early issues of *The Face* are very much post-punk – spiky and also dynamic. You can see it in some of the contents pages, where the typeface begins to disintegrate and deconstruct itself. If *The Face* was documenting a culture, it did so within its internal magazine architecture. Like the nation itself, in search of a new narrative, it sought out a new way of telling stories. (By the time Brody's quieter designs for *Arena* appeared, lifestyle culture had been bedded down in the nation's narrative of itself.)

The logo for Channel 4 by Robinson Lambie-Nairn (1982) communicated similar emotions of dizzy excitement with its floating shapes and colours that dispersed on the screen, only to be sucked back into the form of a number '4'. This use of monumental typography as an anchor for imagery that shot off the surface can also be seen in Brody's album work (*Red Mecca* and the 12-inch single *James Brown* by Cabaret Voltaire).

THE TYRANNY OF STYLE

It was no surprise that the music press (the 'inkies') reacted badly to the increasing prominence of design in pop music and pop culture at large. Sleeves designed by Brody for bands like Cabaret Voltaire and 23 Skidoo are emotionally evocative, but often abstract, while rock press journalism, as much as the teenage pop magazines, tends to be personality-based. Such interest in style, in the surface and texture of things, was often perceived as a sign of shallowness.

In the 1980s, a whole range of artists, from Richard Prince to Cindy Sherman, created art around styles and surfaces, and there is no question that graphic designers were as much stylists as designers in many ad campaigns, such as those for British Airways, Nike and Apple. Deep-seated cultural prejudices started to emerge, which equated design with a lack of substance, along with a yearning for something useful, for something meaningful. Designers in the 1980s occupied a deeply ambivalent social space, where their work was both admired and treated with suspicion. Design and graphic design became synonymous with self-consciously 'stylish' packaging; with upmarket Italian products such as olive oil and ground coffee. Ironically the 'simple' design of such food labelling flattered the consumer with the idea that 'substance', or content, was important. (Of course, there is no such thing as 'simple' design. The honest, the sincere, the 'non-designed' is in reality as highly designed as the most artificial-looking piece of work.)

All the criticisms of the 1980s as the 'design decade' or 'style decade' ultimately landed at the feet of designers. To retro-fit a 1990s term, graphic design was simply regarded as visual 'spin'. From

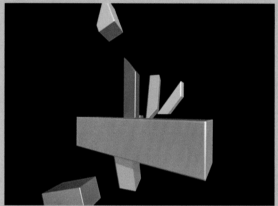

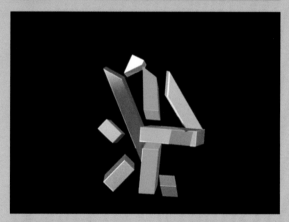

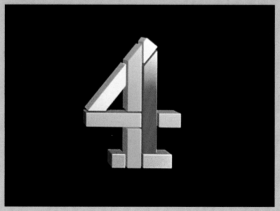

Martin Lambie-Nairn, Robinson Lambie-Nairn, logo for Channel 4, 1982. Computer animation: Tony Pritchett and III

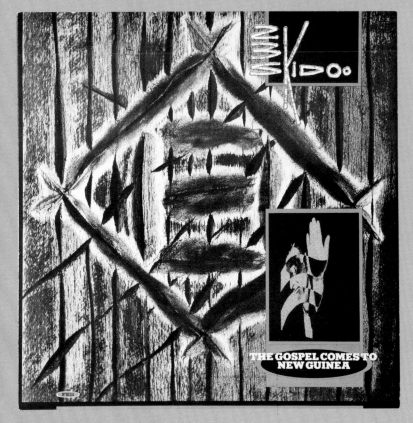

Top: **Neville Brody**,
The Face no. 59, March
1985. Photograph:
Christopher Makos

Neville Brody,
*The Gospel Comes to
New Guinea* by 23
Skidoo, album cover,
Fetish, 1981

power dressing and a fetish for black and chrome furnishings, to shell suits and conspicuous consumption, the growing reputation of graphic design in the 1980s became tarnished by its association with the vulgar and spiritually impoverished trappings of the times.

As Jon Savage wrote in *The Face*, 'Style culture's biggest *canard* now appears to be the idea of unfettered mass media access, where it's enough to enter and to skate across the surface of the media, without worrying about what it is you have to say and what effect it has on the people who consume it.'[9] While it is true that graphic design itself has often been a matter of applying style for style's sake, the fact is that, deep down, the suspicion of design is sometimes shared by designers themselves who often would like to be seen as artists and are uncomfortable with design's commercial imperative.

DESIGN VERSUS ART

The whole study of graphic design is built around the perceived distinction between the 'higher calling' of fine art and the more pragmatic, 'second-rate' pursuit of applied art. Applied art is seen as a conduit, a vehicle for something else. Fine art is all about purity of expression: the uniqueness and aura of the work itself.

This distinction was at the heart of the work of early 20th-century writer Walter Benjamin, one of the heroes of sociologists and cultural studies lecturers in the 1980s. 'That which withers in the age of mechanical reproduction is the aura of the work of art. This is a symptomatic process whose significance points beyond the realm of art. One might generalize by saying: the technique of repro-duction detaches the reproduced object from the domain of tradition. By making many reproductions it substitutes a plurality of copies for a unique existence.'[10]

This neatly defines the difference between the graphic designer and the artist (unless you are Andy Warhol). Benjamin's essay, a canonical piece for cultural critics in the 1980s, is both a celebration of the new technology of cinema and photography and a nostalgic paean to the aura of a work of fine art, now largely lost. Such an aura is the consequence of a work being hand-crafted, unique and part of history. Like Benjamin, graphic designers were excited by the possibilities of a newly popular art form, but also somewhat melancholic about where this art form stood in the cultural lineage.[11] You can recognize this in the sentiments expressed by Peter Saville who admitted in 2004: 'Now in the last ten years or so, I was more concerned with the meaning of things, not with the look of things. While in the Eighties, I was one of the founders of the commodification of culture.'[12]

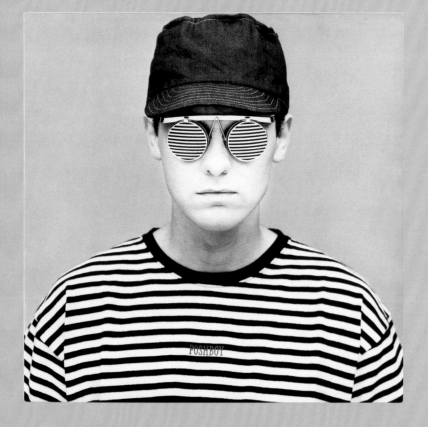

Top: **Paul Elliman**, *The Wire*, no. 49, magazine spread, March 1988. Photograph: Simon Durrant

Nigel Grierson and Vaughan Oliver, 23 Envelope, *Echoes in a Shallow Bay* by Cocteau Twins, 12-inch EP cover, 4AD, 1985. Image construction and photography: Grierson. Typography: Oliver

Mark Farrow and Pet Shop Boys, *Suburbia* by Pet Shop Boys, 12-inch single cover, EMI, 1986. Photograph: Eric Watson

A kind of melancholia is played out in some of the most exciting and apparently vibrant work of the 1980s: Neville Brody's nostalgia for the formal austerity of early 20th-century Russian Contructivism; Paul Elliman's design of *The Wire* magazine with its extensive use of white space (often the sign of cooling things down, pacifying the visual stimuli); Vaughan Oliver's blissed-out, 'spent' artworks for record label 4AD, which visualized the sound of what rock writer Simon Reynolds called 'the cult of oblivion' in bands such as the Pixies and the Cocteau Twins.

Equally fascinating is the psychological polarity between Brody and Oliver, which is articulated in design terms as each responds to the politics of the times. Brody's work is ultimately about demystification, drawing the reader's attention to the materiality of the magazine format with its random full-colour bleeds; forsaking conventional legibility for legibility of the code of magazine construction; creating eccentric points of entry for the reader.[13] Oliver's work for bands like the Cocteau Twins and the Pixies is all about remystification: illegibility, the elemental, getting lost in the synaesthesia where colour turns to texture.[14]

These works are about surfaces and visual structures; about ways of seeing and the pleasure of seeing. The inescapable fact for graphic designers and society at large is that great design is firstly about looking – about visual thinking – and only secondarily about 'meaning'. Bad design offers up its meaning immediately, literally, obviously. This is why perhaps one of the most insightful analyses of the 'design decade' and its symptoms comes from within graphic design itself, from Mark Farrow's *Suburbia* sleeve for the Pet Shop Boys. A conventional star portrait is stylized to the point where the image can no longer reflect back the desire of the fan. It is without depth. It is pure style. It is where the look begins to devour itself.

Later, Scott King delivered a similar commentary on the triumph of style, again working with the purely visual and iconic, in his 'Militant Pop' cover for *Sleazenation* magazine, where Marxist revolutionary Che Guevara morphs into the pop singer Cher. In King's cover for an Earl Brutus album, *Tonight You Are the Special One*, an SUV and BMW are parked side by side, feeding exhaust fumes to one another via a hose, in what King described as a 'yuppie suicide pact'.

SOCIOLOGY OF THE SURFACE
Good design, innovative design is a sociology of the surface, of the image. You can grasp the deep trends of the UK in the 1990s purely through design. There was *Wallpaper*★ magazine flying the flag

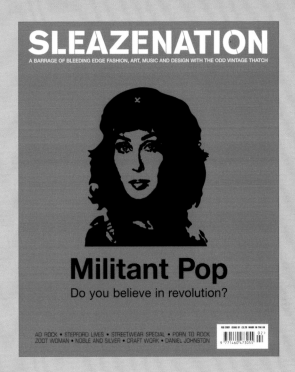

Top: **Scott King**, *Sleazenation* vol. 4 no. 1, magazine cover with 'Cher Guevara' image by King, February 2001

Scott King, *Tonight You Are the Special One* by Earl Brutus, CD cover, Fruition/Island, 1998. Photograph: Jack Daniels

for mid-1990s minimalism.[15] Its use of illustration and fashion-shoot narratives gave it a frothy, camp flavour, making cool minimalism palatable for more self-conscious British tastes. Or men's magazine *Loaded*, with its brash noisy layouts expressing the lurid, postmodern patchwork of 1990s 'blokespace'. Or the popular *Trainspotting* poster where Stylorouge effectively opened up the design architecture of the poster itself with its grids and blocks and panels, showing the growing appeal of design motifs to an intuitively aware public. Or (and whatever you say about 1980s vaingloriousness, no one had the bravado or nerve to take on God) there was the Bible redesigned by Angus Hyland for Canongate, stripping out colour, playing with scale and the shape of light, using *chiaroscuro* in a silent-movie effect, as if to say that design at the cusp of the 21st century ultimately knew its place and would not interrupt the word of God. Or Julian House's *Xtrmntr* sleeve for Primal Scream, an uncanny graphic prophecy of texting.

Strangely enough in the 1990s, graphic design was popularized for the cultural guardians through the back door. In the 1980s, applied art begin to take centre stage in the art world, epitomized by the American artist Jeff Koons in his Nike ads and in his assumption of the role of art director rather than art-maker. But in the 1990s the triumph of BritArt – Damien Hirst's drug cabinets, Simon Patterson's *The Great Bear*, based on the London Underground map, Marcus Harvey's *Myra*, a media icon of evil created out of handprints – represented in many instances the triumph of graphic design in disguise. The appeal of BritArt was only made possible by a public that had been trained in conceptual thinking through advertising and graphic design.

ACADEMIC INVISIBILITY

So while graphic design is everywhere and has become part of the perceptual vernacular of the mainstream, when it comes to being recognized as a significant discipline and cultural form it is still firmly B-list.

In academic life, subject areas like cultural studies are still wedded to theories of interpretation based around 'reading texts'. Graphic design is as much based around line, colour, shape, texture and format. It is 'dream thinking' that perhaps lends itself more to psychoanalysis than to semiology.

In any case, an understanding of semiotics has already passed into every level of the design business, from the client to the account manager to the art directors and designers themselves, who do a wealth of research and analysis. Conventional cultural studies

Mark Blamire and Rob O'Connor, Stylorouge, *Trainspotting*, film poster for Polygram, 1995. Photographs: Lorenzo Agius

analysis can only repeat what is obviously already there, and lacks the critical tools to unpack the issues of colour and format and font constructed by the designer.

Graphic design is a discipline that works on the leading edge of the economy; it creates identities, uses the latest technologies and materials, exploits art, music, literature, cinema and fashion to its own end, is consumed everywhere and is being created by vastly increasing numbers of people in areas from websites to PowerPoint presentations. One of the consequences of being a discipline on the move, constantly adapting to change and shaping change, is that graphic design is almost too quick for the traditional academy.

We need a whole new discipline to capture what graphic design does and what it means for our world. It would be a discipline that offers technology skills, technology analysis, art, sociology, business, marketing, psychology and political philosophy. Because these are what graphic designers engage with everyday. We need fewer Supermen and more Lex Luthors.

Design is everything.

Angus Hyland, *Revelation*, book cover for Pocket Canons, Canongate, 1998. Picture research: Jeremy Hall. Photograph: Rene Burri/Magnum Photos

Angus Hyland, Pentagram, *Jonah*, book cover for Pocket Canons second series, Canongate, 1999. Photograph: Minden/ Robert Harding Picture Library

Angus Hyland, Pentagram, *Hebrews*, book cover for Pocket Canons second series, Canongate, 1999. Photograph: Images Colour Library

Angus Hyland, *Job*, book cover for Pocket Canons, Canongate, 1998. Picture research: Jeremy Hall. Photograph: P. McDonough/ Photonica

Endnotes

Spirit of independence

1 Herbert Spencer, *Design in Business Printing*, London: Sylvan Press, 1952.

2 John Lewis and John Brinkley, *Graphic Design with Special Reference to Lettering, Typography and Illustration*, London: Routledge & Kegan Paul, 1954.

3 See Pat Schleger, *Zero: Hans Schleger – A Life of Design*, Aldershot: Lund Humphries, 2001; and *Abram Games Graphic Designer: Maximum Meaning, Minimum Means*, Aldershot: Lund Humphries, 2003.

4 Christopher Booker, *The Neophiliacs: The Revolution in English Life in the Fifties and Sixties*, London: Pimlico, 1992 (first published 1969), p. 42.

5 Daniel J. Boorstin, *The Image: A Guide to Pseudo-Events in America*, New York: Vintage Books, 1992 (first published 1961), pp. 186–87.

6 Booker, *The Neophiliacs*, p. 43.

7 George Daulby, personal statement in leaflet for 'Graphic Design: London' exhibition, 1960.

8 John Commander, personal statement in leaflet for 'Graphic Design: London' exhibition, 1960.

9 David Usborne, 'What's wrong with British graphic design?', *Motif*, no. 7, summer 1961, p. 81.

10 F.H.K. Henrion, 'Whither graphic design?' in Allan Delafons (ed.), *The Penrose Annual*, vol. 56, London: Lund Humphries, 1962, p. 7.

11 Ken Garland, 'Structure and substance' in Allan Delafons (ed.), *The Penrose Annual*, vol. 54, London: Lund Humphries, 1960, p. 9.

12 Ken Garland, 'Typophoto', *Typographica*, new series no. 3, June 1961.

13 See Robin Kinross (ed.), *Anthony Froshaug: Typography & Texts* and *Anthony Froshaug: Documents of a Life* (2 vols.), London: Hyphen Press, 2000; Edward Wright, *Graphic Work & Painting*, London: Arts Council, 1985; and Rick Poynor, *Typographica*, London: Laurence King Publishing, 2001.

14 Alan Fletcher, 'Letter from America', *Ark*, no. 19, spring 1957, pp. 36–39.

15 Henrion, 'Whither graphic design?', p. 5.

16 Garland, 'Structure and substance', p. 9.

17 Alan Fletcher, Colin Forbes and Bob Gill, *Graphic Design: Visual Comparisons*, London: Studio Books, 1963, p. 5.

18 *Fletcher/Forbes/Gill 1962/3*, London: self-published, 1963. The team's statement about visual problem-solving in *Graphic Design: Visual Comparisons* is repeated almost word for word.

19 *Graphics RCA: Fifteen Years' Work of the School of Graphic Design, Royal College of Art*, London: Lion and Unicorn Press, 1963.

20 The exhibition was shown at the offices of Lund Humphries in Bedford Square, London from 1 to 15 May. See Herbert Spencer's introduction, 'Typography in Britain', *Typographica*, new series no. 7, pp. 2, 19–20.

21 John Commander, foreword in *17 Graphic Designers London*, London: Balding & Mansell, 1963, no page number.

22 John Commander, 'Design & Art Direction '63',

Graphis, no. 109 vol. 19, 1963, p. 366.

23 Review by 'D.C.' (Dennis Cheetham?), *Design*, no. 178, October 1963, p. 68.

24 Anthony Wedgwood Benn, 'First things first', *The Guardian*, 24 January 1964.

25 Ken Garland et al., 'First Things First', London: self-published, 1964. Reprinted in Michael Bierut et al., *Looking Closer 3: Classic Writings on Graphic Design*, New York: Allworth Press, 1999, pp. 154–55.

26 Herbert Spencer, 'The responsibilities of the design profession' in Herbert Spencer (ed.), *The Penrose Annual*, vol. 57, 1964, p. 21.

27 Brian Grimbly and Dennis Cheetham, 'Once more – with feeling', *Design*, no. 199, July 1965, p. 40.

28 Ibid.

29 Richard Negus, 'Informing, persuading and deceiving', *SIA Journal*, no. 134, April 1964, p. 10.

30 See Jonathon Green, *All Dressed Up: The Sixties and the Counterculture*, London: Pimlico, 1999. For an oral history of the period, see Jonathon Green, *Days in the Life: Voices from the English Underground 1961–1971*, London: Minerva, 1989. See also Robert Hewison, *Too Much: Art and Society in the Sixties 1960–1975*, London: Methuen, 1986.

31 Originally published in *The Observer* in 1967 and reprinted in George Melly, *Revolt into Style: The Pop Arts*, Oxford: Oxford University Press, 1989 (first published 1970), p. 153.

32 Ibid.

33 Editorial, *Print*, XXIII:II, March/April 1969, p. 21.

34 Edward Booth-Clibborn, 'Design today: the new professionals', *Print*, March/April 1969, p. 28.

35 Ibid., p. 34.

36 Gerald Woods, Philip Thompson and John Williams (eds.), *Art without Boundaries: 1950–70*, London: Thames & Hudson, 1972, p. 9.

37 Designers' statement in *Pentagram: The Work of Five Designers*, London: Lund Humphries, 1972, no page number. See also Peter Gorb (ed.), *Living by Design*, London: Lund Humphries, 1978 and David Gibbs (ed.), *The Compendium*, London: Phaidon, 1993.

38 See Aubrey Powell, Peter Christopherson and Storm Thorgerson (eds.), *Hipgnosis: 'Walk Away René'*, Limpsfield: Paper Tiger, 1978.

39 The best account is Jon Savage, *England's Dreaming: Sex Pistols and Punk Rock*, London: Faber & Faber, 1991. See also Dick Hebdige, *Subculture: The Meaning of Style*, London: Methuen, 1979. For an account of design's new wave, see Catherine McDermott, *Street Style: British Design in the 80s*, London: Design Council, 1987.

40 Quoted in Dave Fudger, 'Barney Bubbles', *The Face*, no. 19, November 1981, p. 35.

41 See Rick Poynor, 'Malcolm, Peter . . . and Keith', *Eye*, no. 49 vol. 13, autumn 2003, pp. 38–49.

42 For a full account, see Rick Poynor, *Vaughan Oliver: Visceral Pleasures*, London: Booth-Clibborn Editions, 2001.

43 Herbert Spencer, *Pioneers of Modern Typography*, London: Lund Humphries, 1969 (revised edition 2004).

44 Quoted in Jon Wozencroft, *The Graphic Language of Neville Brody*, London: Thames & Hudson, p. 5.

45 Ibid., p. 10.

46 Peter York, 'Chic graphique' in *Modern Times*, London: William Heinemann, 1984, p. 29.

47 Chris Smith, *Creative Britain*, London: Faber & Faber, 1998. Source of figures: Design Council. Smith was then Secretary of State for Culture, Media and Sport.

48 See Fudger, 'Barney Bubbles', pp. 32–35; Steve Taylor, 'Industrial manoeuvres in the art' (on Saville), *The Face*, no. 10, February 1981, pp. 50–53; Jessamy Calkin, 'Image maker' (on Garrett), *The Face*, no. 23, March 1982, pp. 44–45; Jon Savage, 'Guerilla graphics' (on Reid), *The Face*, no. 42, October 1983, pp. 26–31.

49 Ken Garland, 'Graphic design in Britain today and tomorrow', *Idea*, special issue: 'British visual communication design 1900–1985', 1985, p. 6.

50 See Rick Poynor, *No More Rules: Graphic Design and Postmodernism*, London: Laurence King Publishing, 2003.

51 Quoted in Colin Maughan, 'Ranged against the centre', *Blueprint*, no. 30, September 1986, p. 48.

52 Robin Kinross, 'Technics and ethics: the work of Anthony Froshaug', *Octavo*, no. 1, 1986, pp. 4–9.

53 *Octavo*, no. 1, 1986, p. 1.

54 *The Late Show*, BBC2, March 1990.

55 See *Why Not?*, London: Booth-Clibborn Editions, 1998.

56 Henrion, 'Whither graphic design?', p. 1.

57 Ken Garland, 'Stop footling around', *Design*, no. 527, December 1992, p. 11.

58 Bridget Wilkins, 'Type and image', *Octavo*, no. 7, 1990, no page number.

59 Ibid.

60 Robin Kinross, *Fellow Readers: Notes on Multiplied Language*, London: Hyphen Press, p. 31.

61 Quoted in Jane Lamacraft, 'Siobhan Keaney', *Direction*, December 1991/January 1992, p. 21.

62 A measure of this was the entire issue of *Emigre* devoted to TDR: no. 29, winter 1994. See also *Idea vs The Designers Republic*, Tokyo: Seibundo Sinkosha Publishing, 2002.

63 Lucienne Roberts and Julia Thrift, *The Designer and the Grid*, Hove: RotoVision, 2002; Quentin Newark, *What is Graphic Design?*, Hove: RotoVision, 2002; Michael Johnson, *Problem Solved*, London: Phaidon, 2002; David Crow, *The Visible Sign*, Crans-près-Céligny, Switzerland: Ava, 2003.

64 See Michael Rock, 'The designer as author', *Eye*, no. 20 vol. 5, spring 1996, pp. 44–53 and Poynor, 'Authorship' in *No More Rules*, pp. 118–47. See also John O'Reilly, *No Brief: Graphic Designers' Personal Projects*, Hove: RotoVision, 2002.

65 See Tomato, *Process; A Tomato Project*, London: Thames & Hudson, 1996; Tomato, *Bareback. A Tomato Project*, London: Laurence King Publishing, 1999; Fuel, *Pure Fuel*, London: Booth-Clibborn Editions, 1996; Fuel, *Fuel Three Thousand*, London: Laurence King Publishing, 2000.

66 Claire Catterall, 'New graphic realism', *Blueprint*, no. 155, November 1998, p. 34.

'Stealing Beauty: British Design Now', Institute of Contemporary Arts, London, 3 April to 23 May 1999. Graphic designers featured in the exhibition included Alex Rich, Rebecca Brown and Mike Heath, Bump and British Creative Decay.

67 Quoted in an interview with Stuart Bailey in Bailey (ed.), *Foundation 33*, London: self-published, 2003.

68 See John Morgan, 'An account of the making of *Common Worship: Services and Prayers for the Church of England*', *Typography Papers*, no. 5, 2003, pp. 33–64. For the Dogme95 manifesto, see Richard Kelly, *The Name of this Book is Dogme95*, London: Faber & Faber, 2000, pp. 226–28.

69 John Morgan, 'The Vow of Chastity', *Dot Dot Dot*, no. 3, summer 2001, p. 33.

Design magazines and design culture

1 Editorial in *Blueprint*, no. 2, November 1983, p. 3.

2 Rick Poynor, *Typographica*, London: Laurence King Publishing, 2001, p. 11.

3 See Alex Seago, *Burning the Box of Beautiful Things: The Development of a Post-modern Sensibility*, Oxford and New York: Oxford University Press, 1995.

4 An assertion that formed the basis of Daniel J. Boorstin's *The Image. A Guide to Pseudo-Events in America*, New York: Vintage Books, 1992 (first published 1961).

5 See Corin Hughes-Stanton, 'What comes after Carnaby Street?', *Design*, no. 230, February 1968, pp. 42–43; Christopher Cornford, 'Cold rice pudding and revisionism', *Design*, no. 231, March 1968, pp. 46–48.

6 See Gillian Naylor, 'The designer v. Jack the paintbrush', *Design*, June 1966, pp. 40–9.

7 Corin Hughes-Stanton 'Leader: One-dimensional man?', *Design*, no. 240, December 1968, p. 21.

8 Jonathan M. Woodham, *Twentieth-Century Design*, Oxford and New York: Oxford University Press, 1997, p. 171.

9 Patrick Wallis Burke, 'The education of "graphic designers"', *Icographic*, no. 4, 1972, p. 1.

10 Shyram S. Agrawal, Mei-Ling Hsu, Aaron Marcus, Yukio Ota and Ebrahim Rashidpour, 'New ways to see world problems', *Icographic*, no. 14/15, 1979, p. 23.

11 Germano Facetti, 'Penguin paperbacks', *Icographic*, no. 3, 1972, p. 12.

12 See *Baseline*, no. 6, 1985 and no. 7, 1986 (both edited and designed by Erik Spiekermann).

13 Richard Addis, 'Pitch doctors', *Creative Review*, August 1984, pp. 36–37.

14 Simon Rocker, 'Marketing by design', *Creative Review*, October 1984, p. 46.

15 Edward Booth-Clibborn in conversation with Marina Vaizey, 'The art of illustration', *Creative Review*, April 1983, pp. 28–29.

16 See Neville Brody in conversation with Simon Esterson in *Blueprint*, no. 46, April 1988, pp. 50–53.

17 Cynthia Kent, 'A lively Arena for Brody', *DesignWeek*, 14 November 1986, p. 10.

18 See Laurence Rees, *Selling Politics: We Have Ways of Making You Think*, London: BBC Publishing, 1992.

19 Andrew Wernick, *Promotional Culture*.

Advertising, ideology and symbolic exchange, London: Sage, 1991.

20 By the end of the 1980s Britain spent the second highest proportion of GNP on advertising in the world. This figure was boosted by the sums spent on promotion by the then Conservative government.

21 *DesignWeek*, vol. 5 no. 34, 31 August 1990, p. 3.

22 See, for instance, 'The green stuff', *DesignWeek*, 10 February 1989, pp. 14–15.

23 Gerard Forde, 'The designer unmasked', *Eye*, no. 2 vol. 1, winter 1991, pp. 57–68.

24 Steven Heller, 'Advertising: mother of graphic design', *Eye*, no. 17 vol. 5, summer 1995, pp. 26–37.

25 Rick Poynor, 'Design is advertising' (part 1 and part 2), *Eye*, no. 29 vol. 8, autumn 1998, pp. 46–51 and *Eye*, no. 30 vol. 8, winter 1998, pp. 36–43.

26 Rick Poynor and Michael Rock, 'What is this thing called design criticism?', *Eye*, no. 16 vol. 4, spring 1995, p. 57.

27 Paul Stiff, 'Stop sitting around and start reading', *Eye*, no. 11 vol. 3, 1993, pp. 4–5.

28 Rick Poynor, 'An eye on graphic design', *Blueprint*, October 1990, p. 36.

29 Philip Meggs, *A History of Graphic Design*, New York: Van Nostrand Reinhold Co., 1983.

30 Keith Robertson, 'Spot the difference', *Eye*, no. 15 vol. 4, winter 1994, pp. 36–43.

31 *Sexymachinery* is published by Åbäke and Architectural Association graduates Shumon Basar, Dominik Kremerskothen and Dagmar Radmacher.

32 See Michael Rock, 'The Designer as Author', *Eye*, no. 20 vol. 5, spring 1996, pp. 44–53.

British web design: a brief history

1 Boo.com was a victim more of poor performance than poor design. As the site launch date loomed, it was decided that it would be quicker to add site functionality on the client side. The upshot was that pages downloaded more slowly but, more importantly, processing the page code slowed the client browser considerably, and its complexity generated more errors than HTML.

2 Jakob Nielsen, 'Boo's Demise', *AlertBox*, May 2000.

3 Interaction design addresses the means by which users input changes to an IT system – including the web – and feedback is supplied by the system to the user. Interface design considers this challenge in the context of software and in the presentation of the user's working space. For background on interaction design see the UK Design Council resource 'About: Interaction Design', http://www.designcouncil.info/interactiondesign

4 Hypertext Markup Language describes the codes for formatting documents to be displayed by a web browser, and the structure documents need to follow. Many applications allow HTML documents to be authored more easily using visual interfaces, though from an engineering perspective the code produced may need work to optimize.

5 A blipvert is the equivalent of the interstitial advertising 'stings' used in television to bumper between a programme and the

adverts. They tend to be animated and to appear briefly; they may include audio. As with television, on the web a user is required to see the blipvert before moving onto their intended destination, unlike banner ads, which they can choose whether or not to select.

6 For more on this period in the UK, and the trend for self-initiated projects, see 'How to untangle the Web Blueprint' Nico Macdonald, *Blueprint*, December 1996, www.spy.co.uk/Articles/Blueprint/UntanglingTheWeb See also the transcripts of the Design Agenda–Central Saint Martins MA Communication Design conference 'Designing the Internet: When Digital Design Demands Analogue Thinking', London, 1996.

7 The Association for Computing Machinery (ACM) Special Interest Group on Computer-Human Interaction (SIGCHI) conferences began in the early 1980s.

8 A plug-in is a third-party addition to a browser that can be installed independently and adds functionality; for instance, when accessing data in the Flash file format. Vector-based graphics can be described most efficiently in terms of straight lines and curves, colour, tone and gradation.

9 For an overview of digital art projects see *New Media Art: Practice and Context in the UK 1994–2004*, London: Arts Council of England and Cornerhouse, 2004.

10 Studios created by Deepend alumni include Re-collective, Poke, De-construct and Playerthree.

11 For more on the fall-out for design from the end of the boom see Nico Macdonald, 'After the fall', *AIGA Gain*, vol. 1 no. 2, 2001. www.spy.co.uk/Articles/Gain/AfterTheFall

12 Ibid.

13 Ibid.

14 While this is an important cultural difference, it is rooted in the differing balance of UK and US economies. The US is the home of corporations, many of which are dominant in the UK. The US is still manufacturing-based and focuses on product innovation and price, while the UK is more focused on packaging and the retailing experience.

15 Vector-based graphics started with Adobe Illustrator and have been quite influential for years. This has been accentuated by Flash, as its movies are distributed online for all to see.

16 Already graphical user interface design and web design are merging. Much user interface design draws on web interaction models – hypertext links and single clicks – and interfaces to products such as Macromedia Dreamweaver. Many Microsoft products are rendered in HTML.

Note The following people contributed to research for this essay: Patricia Austin, Ranzie Anthony, Andrew Boag, Kieran Evans, Darryl Feldman, Gonzalo Garcia-Perate, Robin Grant, Jonathan Hirsch, Martyn Perks and Jack Schulze.

Notes and references related to this essay can be found at writing.spy.co.uk/Books/Communicate

Thinking with images

1 Thomas Hine, *The Total Package*, New York: Little Brown and Company, 1995, p. 202.

2 *Newsnight*, BBC2, 8 December 2001. Chris Ware, *Jimmy Corrigan*, London: Jonathan Cape, 2003.

3 *DesignWeek*, 23 January 2003, p. 6.

4 Peter Matthews, managing director of Nucleus, *Marketing*, 26 June 2003.

5 A black stripe on a yellow background.

6 Marshall McLuhan and Quentin Fiore, *The Medium is the Message*, Harmondsworth: Penguin Books, 1967, p. 125. As McLuhan also points out, 'the few seconds sandwiched between the hours of viewing – the "commercials" – reflect a truer understanding of the medium.' McLuhan's point here is that one of the problems of evaluating art, cinema, advertising and graphic design using the traditional tools of literature is that the narrative form created by new technologies is completely different to the continuous narrative of the novel form.

7 'The 100 best record covers of all time', *Q* magazine (collector's special edition), 2001, p. 198.

8 Jacques Attali, *Noise: The Political Economy of Music*, Minneapolis: University of Minnesota Press, 1985, p. 11.

9 Jon Savage, 'The Toytown Nihilists', *Time Travel: Pop, Media and Sexuality 1976–96*, London: Chatto & Windus, 1996, pp. 182–83 (originally published in *The Face*, December 1985).

10 Walter Benjamin, 'The work of art in the age of mechanical reproduction', *Illuminations*, London: Fontana, 1982, p. 223.

11 Melancholy is a symptom at one level of there being too much stuff in the world, too much happening for an individual. People can no longer make sense of these experiences. Melancholy is a way of holding things together, a belief – more than a belief, a longing – for paradise lost, for a world in which things once again make sense. In the early 1980s, the UK economy was in recession. The country was in a state of depression with catastrophic unemployment, inner-city riots and communities based on traditional manufacturing becoming, as the Specials' song put it, 'A Ghost Town'.

12 *Form*, no. 193/194, January/February 2004, p. 83.

13 See Jon Wozencroft, *The Graphic Language of Neville Brody*, London: Thames & Hudson, 1988, pp. 104 and 108.

14 In fact, so seamless was the photography (by Nigel Grierson and others) and design in Oliver's work, and so heavily treated, that it almost falls outside the category of graphic design and becomes illustration.

15 The magazine was aimed at 'urban modernists', but even the asterisk beside the title highlighted the fact that this version of modernism was a little frou-frou.

Bibliography

Alison, Jane and Liz Farrelly (eds.), *Jam: Style + Music + Media*, London: Booth-Clibborn Editions/Barbican Art Gallery, 1996

Bardonnet, Blandine (ed.), *Créations Graphiques en Grande-Bretagne*, Villeurbanne: Maison du Livre, de L'Image et du Son, 1993

Barley, Nick (ed.) *et al.*, *Lost and Found: Critical Voices in New British Design*, London: Birkhäuser/British Council, 1999

Birdsall, Derek, *Notes on Book Design*, New Haven and London: Yale University Press, 2004

Booth-Clibborn, Edward and Daniele Baroni, *The Language of Graphics*, London: Thames & Hudson, 1980

Burgoyne, Patrick, *GB: Graphic Britain*, London: Laurence King, 2002

Catterall, Claire, *Stealing Beauty: British Design Now*, London: Institute of Contemporary Arts, 1999

Commander, John, *17 Graphic Designers London*, London: Balding & Mansell, 1963

Crowley, David, *Magazine Covers*, London: Mitchell Beazley, 2003

De Ville, Nick, *Album: Style and Image in Sleeve Design*, London: Mitchell Beazley, 2003

Fletcher, Alan, Colin Forbes and Bob Gill, *Graphic Design: Visual Comparisons*, London: Studio Books, 1963

Games, Naomi, Catherine Moriarty and June Rose, *Abram Games Graphic Designer: Maximum Meaning, Minimum Means*, Aldershot: Lund Humphries, 2003

Garland, Ken, *A Word in Your Eye*, Reading: University of Reading, 1996

David Gibbs (ed.), *The Compendium*, London: Phaidon, 1993

Gorb, Peter (ed.), *Living by Design*, London: Lund Humphries, 1978

Hillman, David, Harri Peccinotti and David Gibbs (ed.), *Nova: 1965–1975*, London: Pavilion Books, 1993

Hollis, Richard, *Graphic Design: A Concise History*, London: Thames & Hudson, 1994 (revised edition 2001)

Horsham, Michael, *Work from London: Graphics, Visual Languages and Culture* (exhibition poster/leaflet), London: British Council, 1997

Huygen, Frederique, *British Design: Image & Identity*, London: Thames & Hudson, 1989

Ishihara, Yoshihisa, *British Visual Communication Design 1900–1985*, special issue of *Idea*, Tokyo, 1985

Jobling, Paul and David Crowley, *Graphic Design: Reproduction and Representation since 1800*, Manchester: Manchester University Press, 1996

King, Emily (ed.), *Designed by Peter Saville*, London: Frieze, 2003

Kinross, Robin, 'From Commercial Art to Plain Commercial', *Blueprint* no. 46, April 1988, pp. 29–36.

——— (ed.), *Anthony Froshaug: Typography & Texts* and *Anthony Froshaug: Documents of a Life* (2 vols.), London: Hyphen Press, 2000

———, *Unjustified Texts: Perspectives on Typography*, London: Hyphen Press, 2002

Küsters, Christian and King, Emily (eds.), *Restart: New Systems in Graphic Design*, London: Thames & Hudson, 2001

Lewis, John and John Brinkley, *Graphic Design with Special Reference to Lettering, Typography and Illustration*, London: Routledge & Kegan Paul, 1954

Lloyd Jones, Linda *et al.*, *Fifty Penguin Years*, London: Penguin Books, 1985

Macdonald, Nico, *What is Web Design?*, Hove: RotoVision, 2003

McQuiston, Liz, *Graphic Agitation: Social and Political Graphics since the Sixties*, London: Phaidon, 1993

Mellor, David, *The Sixties Art Scene in London*, London: Phaidon/Barbican Art Gallery, 1993

Merritt, Douglas, *Television Graphics: From Pencil to Pixel*, London: Trefoil, 1987

McDermott, Catherine, *Street Style: British

Design in the 80s*, London: Design Council, 1987

McLean, Ruari, *Magazine Design*, London: Oxford University Press, 1969

Murgatroyd, Keith, *Modern Graphics*, London: Studio Vista, 1969

Myerson, Jeremy, *Beware Wet Paint: Designs by Alan Fletcher*, London: Phaidon, 1996

Myerson, Jeremy and Graham Vickers, *Rewind: Forty Years of Design & Advertising*, London and New York: Phaidon, 2002

Olins, Wally, *The Corporate Personality: An Inquiry into the Nature of Corporate Identity*, London: Design Council, 1978

O'Reilly, John, *No Brief: Graphic Designers' Personal Projects*, Hove: RotoVision, 2002

Owen, Ted with Denise Dickson, *High Art: A History of the Psychedelic Poster*, London: Sanctuary, 1999

Owen, William, *Magazine Design*, London: Laurence King, 1991

Powers, Alan, *Front Cover: Great Book Jacket and Cover Design*, London: Mitchell Beazley, 2001

Poynor, Rick, *Vaughan Oliver: Visceral Pleasures*, London: Booth-Clibborn Editions, 2000

———, *Typographica*, London: Laurence King, 2001

———, *No More Rules: Graphic Design and Postmodernism*, London: Laurence King, 2003

Reid, Jamie and Jon Savage, *Up They Rise: The Incomplete Works of Jamie Reid*, London: Faber & Faber, 1987

Rose, Cynthia, *Design after Dark: The Story of Dancefloor Style*, London: Thames & Hudson, 1991

Seago, Alex, *Burning the Box of Beautiful Things: The Development of a Postmodern Sensibility*, Oxford: Oxford University Press, 1995

Schleger, Pat, *Zero: Hans Schleger – A Life of Design*, Aldershot: Lund Humphries, 2001

Spencer, Herbert, *Pioneers of Modern Typography*, London: Lund Humphries, 1969 (revised edition 2004)

Spinoza, Andy (ed.), *Sublime: Manchester Music and Design*, Manchester: Cornerhouse, 1992

Walker, John A., *Cross-Overs: Art into Pop/Pop into Art*, London and New York: Methuen, 1987

Whiteley, Nigel, *Pop Design: Modernism to Mod*, London: British Council, 1987

Woods, Gerald, Philip Thompson and John Williams, *Art Without Boundaries: 1950–70*, London: Thames & Hudson, 1972

Wozencroft, Jon, *The Graphic Language of Neville Brody*, London: Thames & Hudson, 1988

———, *The Graphic Language of Neville Brody 2*, London: Thames & Hudson, 1994

Wright, Edward, *Graphic Work & Painting*, London: Arts Council, 1985

Contributors' biographies

David Crowley is deputy head of the Department of Design History and senior tutor in the Department of Historical and Critical Studies at the Royal College of Art, London. His articles have appeared in *Creative Review*, *Design*, *Blueprint*, *Journal of Design History* and *The Economist*. He has written several books, including *Graphic Design: Reproduction and Representation since 1800* (as co-author, 1996) and *Magazine Covers* (2003).

Jane Lamacraft is a former editor of design and advertising magazine *Direction*, and was a contributing editor of *Blueprint*. She now combines writing and editing, often in the field of design, for the Commission for Architecture and the Built Environment, Camberwell College of Arts and other clients.

Nico Macdonald has been speaking and writing about web design since 1995; his work has appeared in *Eye*, *Blueprint*, *Design Week*, *AIGA Gain* and other publications. In the mid-1990s, he co-programmed the 'Designing the Internet' conference and in 2000 co-programmed the 'Design for Usability' conference. He founded and programmes the London events of the AIGA Experience Design community. He is author of *What is Web Design?* (2003).

John O'Reilly is a writer and editor working at Getty Images and Intro design in London. After completing a doctorate in philosophy, he was an editor at *Colors* and *The Modern Review* and a regular contributor on pop music, art and media for *The Guardian*, *Independent* and *Observer* newspapers. He is a contributor to *Eye* and author of *No Brief: Graphic Designers' Personal Projects* (2002).

Alona Pardo completed an MA in contemporary curating at Goldsmiths College before joining the Barbican Art Gallery, London as an assistant curator. Her other projects include co-curating 'About Belief' at the South London Gallery; co-editing and co-curating 'Leftover' as part of the Deptford X Festival in 2002; and curating a video programme for the first International Biennale of Video Art in Tel Aviv in 2002.

Rick Poynor founded *Eye* magazine in 1990 and edited it for seven years. He is a columnist for *Print* magazine in New York and has written about design, media and visual culture for *Blueprint*, *Frieze*, *Domus*, *I.D.*, *Metropolis*, *Harvard Design Magazine*, *Adbusters*, *The Guardian* and *The Financial Times*. His books include *Design Without Boundaries* (1998), *Typographica* (2001), *Obey the Giant: Life in the Image World* (2001) and *No More Rules* (2003). He is a former visiting professor at the Royal College of Art and he lectures on visual communication in Europe, the US and Australia.

Designers' biographies

Åbäke is an international graphic design collective based in London, consisting of Patrick Lacey (b. 1973), Benjamin Reichen (b. 1975, France), Kajsa Stahl (b. 1974, Sweden) and Maki Suzuki (b. 1972, France). Collaboration is fundamental to the group's approach, and this openness is reflected in its diverse choice of media, which includes illustration, photography, film and typography, and in its playful approach to the printing process (offset, silkscreening and letterpress). *Sexymachinery*, a collaboration with two architects and one textile designer with whom Åbäke co-edit and design this 'architectural production', has taken the form of magazines, an exhibition and a lecture. Other clients have included the bands Air, Daftpunk and Basement Jaxx, as well as the Royal Institute of British Architects, the Design Museum, Book Works, Channel 4 television and the Royal College of Art.

Aboud Sodano is a London-based design agency known for its long-standing relationship with British fashion designer Paul Smith. Alan Aboud (b. 1966, Ireland) and Sandro Sodano (b. 1966) met while studying graphic design at Central Saint Martins College of Art and Design and in 1989 set up a collaborative practice, with an emphasis on art direction and a minimalist graphic vernacular. The degree of trust and under-standing built up between client and designers since inception has resulted in an unusually large and imaginative body of work that has shaped the Paul Smith identity.

Aboud and Sodano (who concentrates on photography) have won numerous awards, including the New York Art Directors Club silver cube award and the Art Directors Club of Europe gold award, both in 2002.

Dennis Bailey (b. 1931) studied at Worthing Art School and the Royal College of Art (1950–53). He spent 1956 in Zurich as assistant editor of *Graphis*. As a freelance designer, he worked for publisher Jonathan Cape, the Council of Industrial Design and Time-Life. In the early 1960s, Bailey collaborated on film projects and lived for a time in Paris. From 1964 to 1966, he was art director of *Town*. His other clients as an independent designer and illustrator included *The Economist*, *Nova*, the Royal Institute of British Architects, the British Council, the Arts Council, Westerham Press and *BMJ* (British Medical Journal). He taught at Chelsea School of Art from 1971 to 1980.

Stuart Bailey (b. 1973) studied graphic design at the University of Reading. After working as a freelance designer in London with Richard Hollis, he moved to the Netherlands. From 1998 to 2000, he was part of the first group of participants at the Werkplaats Typografie in Arnhem. In 2000, with co-editor Peter Bilak, he launched *Dot Dot Dot*, a graphic design and visual culture magazine. Since 2001, Bailey has worked independently in Amsterdam, London and Warsaw, often on self-initiated projects. He teaches at the Rietveld Akademie.

Jonathan Barnbrook (b. 1966) studied graphic design at Saint

Martin's School of Art and the Royal College of Art. Since 1990, his London-based studio, Barnbrook Design, has produced work that combines typographic inventiveness, politics and irony. Barnbrook created typefaces such as Mason and Exocet for Emigre and released others through his own font foundry, Virus. He has collaborated with a number of artists, including Damien Hirst on the monograph *I Want to Spend the Rest of My Life Everywhere, with Everyone, One to One, Always, Forever, Now* (1997). The studio, which Barnbrook prefers to stay small, has been preoccupied with projects that question the role of graphic design in society. This led to commissions from Adbusters and other opportunities for graphic authorship. Barnbrook works regularly in Japan and in 2002 he designed the corporate identity for the new Mori Art Museum.

Nick Bell (b. 1965) studied graphic design at the London College of Printing. His London-based studio was known as Nick Bell Design until 1998 when it became associated with Una in Amsterdam and was renamed Una (London) Designers. Bell has been art director of *Eye* since 1998. His experience on *Eye* enabled him to develop a more curatorial method of editorial design. He has also designed CD covers and a corporate identity for Virgin Classics, books for Phaidon, Taschen and Tate Publishing, stamps for the Royal Mail, and exhibitions for the Barbican Centre, the British Council, Tate Britain and the Imperial War Museum. His animated typographic displays for the Science Museum's BNFL

visitor's centre won two D&AD silver awards in 2003. His work was featured in the touring exhibition 'Lost and Found: Critical Voices in New British Design' (British Council, 1999). He was a visiting lecturer at the London College of Printing from 1990 to 2000 and has lectured widely in Europe and the US. Bell was a selector for the graphic design survey *Area* (2003).

Derek Birdsall (b. 1934) has worked as a freelance graphic designer since 1957 when he completed his national service. He studied at the Wakefield College of Art, 1949–52, and at the Central School of Arts and Crafts, 1952–55. In 1960, Birdsall was a founding member of the design group BDMW in London. His many projects have included the first Pirelli calendar in 1964, sales literature for Lotus cars and numerous book covers for Penguin. He was art director of *Nova*, *Town, Twen* and *Connoisseur* magazines and, in 1988, he was appointed consultant of the *Independent Magazine*, where his clear typography and use of strong photography, often in black and white, revived the established virtues of the weekend supplement. In 1978, he was a founder partner of Omnific Studios, which redesigned the Church of England's *Common Worship* prayer book in 2000. Birdsall was a visiting professor of graphic arts and design at the Royal College of Art from 1987 to 1988, and he has also taught at the London School of Printing and Central Saint Martins College of Art and Design. Books that he has authored and designed include *A Book of Chess* (1974)

and *The Technology of Man* (1978).

Neville Brody (b. 1957) studied graphic design at the London College of Printing. After designing record covers for the independent labels Stiff and Fetish, he became designer, then art director, of *The Face*. Between 1983 and 1990, he provided art direction for several other magazines, including *City Limits*, *Arena*, *Per Lui* and *Lei* (Italy) and *Actuel* (France). In 1987, Brody founded his own London-based design studio, which worked on projects for Nike, the Dutch postal service, the German TV channel Premiere, the Austrian TV channel ORF and other clients. The company became Research Studios in 1994. Brody has designed several typefaces, including Arcadia, Industria, Insignia, Blur, Pop, Gothic and Harlem. He was a partner of FontShop International in Berlin and FontWorks in London, and was founder of the digital type publication *Fuse*. Brody was one of the most influential graphic designers to emerge in the 1980s and quickly achieved an international reputation. In 1988, the Victoria & Albert Museum put on a major retrospective of his work. His designs and ideas are documented in two books, *The Graphic Language of Neville Brody* (1988) and *The Graphic Language of Neville Brody 2* (1994).

Robert Brownjohn (1925–70) studied with László Moholy-Nagy and Serge Chermayeff at the Chicago Institute of Design. In 1957, he founded Brownjohn, Chermayeff & Geismar (BCG) in New York with Ivan Chermayeff and Tom Geismar. His projects included the 'Streetscape' display for the American pavilion at the World Exhibition in Brussels. In 1960, Brownjohn left BCG and moved to London to become art director first at J. Walter Thompson, then at McCann Erickson. He designed the title sequence for the James Bond film *From Russia with Love* (1963), now regarded as a classic, and joined David Cammell and Hugh Hudson's film production company, where he designed the titles for *Goldfinger* (1964). Two commercials for the Midland Bank, involving moving type, were equally innovative. For Pirelli, the company created *The Tortoise and the Hare*, a promotional film.

Barney Bubbles (1942–83) attended Twickenham College of Art. In 1965, he joined the Conran Design Group still using his original name, Colin Fulcher, but left after two years. In his new guise as Barney Bubbles, located in Portobello Road, London, at the heart of the counter-culture, he worked on *Friends* and *Oz* magazine. For the rock band Hawkwind, he devised every aspect of their visual identity, from drum kit paintings to record sleeves. In the late 1970s, Bubbles worked as a full-time freelance designer for Stiff Records, founded by Jake Riviera, creating highly inventive and influential 'new wave' cover designs for Nick Lowe, The Damned, and Ian Dury and the Blockheads, as well as T-shirts, ads for the music press and back-stage passes. A prolific designer of work that he was often reluctant to sign, Bubbles also produced sleeves for Dr Feelgood, Billy Bragg, and Elvis Costello and the Attractions.

Anthony Burrill (b. 1966) studied graphic design at Leeds Polytechnic from 1986 to 1989 before completing his MA at the Royal College of Art. He has worked as a freelance designer since 1991, producing print, moving image and interactive design based on direct communication in which humour often plays a central role. His projects have included poster campaigns for the London Underground and Hans Brinker Budget Hotel in Amsterdam. Burrill and Kip Parker set up Friendchip in 1997. Their first job was a website for the German band Kraftwerk and subsequent commissions came mainly from the music industry. Clients have included Scanner, Björk, Sigur Ros, 13AMP and Air.

Margaret Calvert (b. 1936, South Africa) completed her National Diploma in Design, specializing in illustration, at Chelsea School of Art in 1957 under the tutelage of Brian Robb and Jock Kinneir (1917–94). Kinneir invited her to join him as assistant designer, working initially on exhibitions for Shell and lettering and signs for Gatwick Airport. In 1964, they became Kinneir Calvert Associates. Their most significant projects were the design of lettering and sign systems for the UK's roads and motorways, railways, airports, hospitals and armed services. Commercial clients included the fishmongers Burkett/Rudman and office suppliers Ryman. In 1980, Kinneir and Calvert designed signs for the Tyne & Weir Metro in Newcastle. Calvert taught graphic design at the Royal College of Art for 35 years and was head of graphic design at the college from 1987 to 1991. She is a member of the Alliance Graphique Internationale.

Stephen Coates (b. 1962) began his career in editorial design in 1984, working alongside Simon Esterson at *Blueprint*. The pair won a D&AD award in 1989. Coates went on to become art director of *Eye* (1990–98) and set up a studio working in partnership with Tony Arefin on catalogues and posters for arts institutions such as the ICA and the Serpentine Gallery. *Eye* won a D&AD award in 1993. Coates was also art director of *Tate* magazine (1996–2002) and the film magazine *Sight and Sound* (from 1998). He left *Eye* to launch August, a publishing imprint and design consultancy, with Nick Barley. August's output includes books and catalogues about design, architecture and fine arts. Coates completed the redesign of *New Scientist* in 2002 and *Music Week* in 2003.

Keith Cunningham (b. 1929, Australia) left Sydney for London in 1949. On arrival, he enrolled at the Central School of Arts and Crafts, and went on to complete an MA in fine art at the Royal College of Art in 1956. He was a part-time lecturer at the London College of Printing and became a consultant art director for the John Collins advertising agency, where he worked on a series of ads for El Al airlines. In 1964, he began a long association with publisher Peter Owen, designing book covers. He used boldly restrained, often black-and-white graphic elements to achieve a high degree of impact. Cunningham was also an

accomplished exhibition designer, working with the Australian designer Gordon Andrews on the Festival of Britain exhibit at the Science Museum, as well as designing stands with Barry Warner for various clients.

Mike Dempsey (b. 1944) studied calligraphy and typography at evening classes. In the late 1960s, he worked as art director for two of Britain's leading publishing houses, William Heinemann and William Collins & Sons. In 1979, with fellow designer Ken Carroll (b. 1946), he founded the London design consultancy Carroll & Dempsey. With the arrival of Nicholas Thirkell (b. 1942), they became Carroll, Dempsey & Thirkell. CDT specialized in the creation of brand, corporate and environmental identities. The company's projects have included stamps for the Royal Mail; film title sequences for Louis Malle, Dennis Potter, David Hare and Bruce Beresford; identities for English National Opera and the South Bank Centre; and signing programmes for the Royal National Theatre and the Royal Opera House. Dempsey has received ten silver D&AD awards and the D&AD gold award. He is a regular contributor to *Design Week* and has written for *The Times* and many other publications on design issues.

The Designers Republic (TDR) was founded in Sheffield in 1986 by Ian Anderson (b. 1961), a philosophy graduate with no formal design education, and Nick Philips. Anderson had gained experience designing record sleeves for Person to Person, a band he managed during the

1980s. TDR's record sleeve for Age of Chance's cover version of the Prince track 'Kiss' was well received, and Anderson went on to establish TDR in the 1990s as a leading producer of contemporary imagery for the music business, club scene and entertainment sector. Their clients have included Warp Records, Issey Miyake, Sony, MTV, Powergen and Swatch. Some of TDR's best-known sleeves, for the band Pop Will Eat Itself, present a series of identities built from found images and bastardized versions of corporate logos. This kind of ironic image sampling became a mainstay of their exhilaratingly overloaded digital design aesthetic. The approach was further developed in self-initiated banners about consumerism, fast food and religion produced for exhibitions such as 'Customised Terror', shown at Artists Space, New York (1995).

8vo was founded in 1984 by Mark Holt (b. 1958) and Simon Johnston (b. 1959), who were joined in 1985 by Hamish Muir (b. 1957). Holt studied at Newcastle Polytechnic; Johnston at Bath and the Kunstgewerbeschule, Basel; and Muir at Bath Academy and the Kunstgewerbeschule. Michael Burke was an associate member. Much of 8vo's layered, experimental typography, fuelled by the technological possibilities of typesetting and page make-up systems, preceded the widespread use of the Macintosh computer. Their self-published journal of typography, *Octavo*, was a reaction to the idea- and image-based design prevalent in 1980s Britain. The exceptional

purity and rigour of their modernist-informed typography exerted great influence on the course of British graphic design in the 1990s. 8vo's clients included Factory Records, Zanders, the Boymans-van Beuningen Museum, Rotterdam, for which they designed a series of catalogues and posters, and American Express. The studio was disbanded in 2001.

Paul Elliman (b. 1961), a self-taught graphic designer, was a member of the *City Limits* collective, then design director of the music magazine *Wire* (1986–88), before becoming a freelance designer. In 1991, his electronic journal *Box Space*, distributed by fax, earned him a gold D&AD award. In 1995, Elliman began work on his Bits typeface, constructed from roadside detritus scanned into the computer to create readymade, irregular letterforms. He has taught at Central Saint Martins College of Art and Design, the University of East London and the University of Texas at Austin. He has been a project tutor at the Jan van Eyck Academie in the Netherlands since 1996 and assistant professor at Yale School of Art since 1998. His work has featured in exhibitions internationally, including 'Lost and Found: Critical Voices in New British Design' (British Council, 1999) and 'Century City' (Tate Modern, 2001). Elliman has a regular column in *Idea* magazine and contributes to *Eye* and *Dot Dot Dot*.

Michael English (b. 1941) studied fine art at the Ealing School of Art from 1963 to 1966.

His involvement in poster design began in 1967 when he met Nigel Waymouth. Using the name Hapshash and the Coloured Coat, the two designed a series of psychedelic posters for music and counter-cultural events, influenced by Mucha, Beardsley and Arthur Rackham, that became emblems of their era. English went on to combine work as a freelance designer with fine art. The publisher Booth-Clibborn Editions commissioned a series of limited edition posters. Other significant projects have included the redesign of SwissAir's identity in 1996 and posters for British Airways. In 2000, the Royal Mail commissioned him to design a series of stamps about British buses.

Simon Esterson (b 1958) began his career as a self-taught designer in the late 1970s at *The Architects' Journal*. In 1983, he was one of the founders of *Blueprint* magazine, where he applied classic principles of clear, bold editorial design and made dramatic use of commissioned photography. The magazine won D&AD silver awards in 1986 and 1989. In 1988, Esterson was a co-founder of the London-based studio Ellis, Esterson Lackersteen (which became Esterson Lackersteen). In 1991, he redesigned the film magazine *Sight and Sound*. He was consulting art director for *The Guardian* (1996–2000) and creative director of *Domus* (2000–03) He has undertaken consultancy work for *The Times*, *The Observer* and *The Sunday Telegraph* and has designed books and catalogues for the Hayward Gallery, the Royal Academy of Arts and Tate

Publishing. In 2003, the studio was renamed Esterson Associates. He is a Royal Designer for Industry and a member of the Alliance Graphique Internationale.

Mark Farrow (b. 1960) studied briefly at Tameside Polytechnic, near Manchester, before beginning his career designing sleeves and flyers for Factory Records. In 1985, he moved to London to work at XL Design. In 1986, he formed 3 Associates, which became 3a, then Farrow. A new incarnation, Farrow Design, was founded in 1995. Farrow's sleeves for the Pet Shop Boys made an immediate impact with their extreme minimalism. He went on to design restrained, modernist covers for Spiritualized, Manic Street Preachers and Orbital, as well as the Cream nightclub. Farrow Design's clients have included Tate Modern, Levi's, Museum für Gegenwartkunst, the Science Museum, Harvey Nichols, MTV and Oliver Peyton's restaurants. Farrow received his first D&AD award for a record sleeve in 1987 and further awards in 1995, 1996, 1997 and 1998.

Robin Fior (b. 1935) studied English at Oxford University. His involvement in left-wing political causes led him to print. In 1955, he attended Edward Wright's typography evening classes at the Central School of Arts and Crafts, but he is a largely self-taught designer. In 1960, he went to Switzerland to acquaint himself with Swiss design, and he applied this modernist typography to forceful posters for the Campaign for Nuclear Disarmament's Committee of 100. He designed

the weekly *Peace News*, became art editor at Pluto Press and was a signatory, in 1964, of Ken Garland's *First Things First* manifesto. In 1972, Fior moved to Lisbon, where he joined Praxis, a design cooperative. After an army coup ended Portugal's dictatorship, he produced political propaganda during the period leading to the first elections in 1975. He was a founding member of the Portuguese Association of Designers, and helped with the establishment of the Centro de Arte e Comunicação Visual, where he taught for many years.

Alan Fletcher (b. 1931) studied at the Central School of Arts and Crafts, the Royal College of Art and Yale University School of Art. After freelancing in the US in the late 1950s, he returned to London and, in 1962, co-founded Fletcher/Forbes/Gill. Clients included Pirelli, Cunard, Penguin, BP and Olivetti. Fletcher co-founded Pentagram in 1972 and created design programmes for Reuters, the Victoria & Albert Museum, Lloyd's of London, Daimler Benz, Arthur Andersen and ABB. In 1992, he left to set up his own studio, working for *Domus* magazine, London Transport, Shell, Toyota and Phaidon. In 1973, he was president of the Designers & Art Directors Association (D&AD) and, from 1982 to 1985, president of the Alliance Graphique Internationale. He is a Royal Designer for Industry, a fellow of the Chartered Society of Designers, senior fellow of the Royal College of Art and of the London Institute, and he has an honorary doctorate from Kingston University. He is co-author of *Graphic Design: Visual*

Comparisons (1963), *A Sign Systems Manual* (1970) and *Identity Kits* (1971) and author of *The Art of Looking Sideways* (2001). In 1996, he designed *Beware Wet Paint*, a monograph about his career. Fletcher has received gold and silver awards from D&AD and the One Show in New York. In 1977, he shared the D&AD president's award for outstanding contributions to design with Pentagram partner Colin Forbes. In 1982, the Society of Industrial Artists and Designers awarded him its annual medal for outstanding achievement in design. In 1993, he received the Prince Philip designer of the year prize. In 1994, he was inducted into the Hall of Fame of the American Art Directors Club.

Colin Forbes (b. 1928) studied at the Central School of Arts and Crafts (1948–51) before beginning his career as an assistant to Herbert Spencer. From 1958 to 1961, he was head of the graphic design department at the Central School. In 1962, he co-founded Fletcher/Forbes/Gill with Alan Fletcher and Bob Gill. Their clients included Pirelli, Cunard, Penguin, BP and Olivetti. In 1972, with additional partners, they renamed themselves Pentagram, and Forbes played a key role in the development of the company's innovative structure. He moved to New York in 1978 to open a Pentagram office. In 1977, he shared the D&AD president's award for outstanding contributions to design with Fletcher.

Foundation 33 was set up in London in 2000 by graphic designer Daniel Eatock (b. 1975) and American architect Sam

Solhaug (b. 1965). Eatock completed his MA in communication design at the Royal College of Art in 1998, then worked as a designer for a year at the Walker Art Center in Minneapolis. Foundation 33 applies a conceptually motivated design method to projects for Channel 4 television, Endemol/Initial, Universal-Island Records and the Department of Trade and Industry.

Vince Frost (b. 1964) studied graphic design at the West Sussex College of Design before joining Pentagram in 1989, where he worked primarily on projects for Polaroid. In 1994, he left to form his own consultancy, Frost Design. Frost attracted attention for his bold use of photographic images and his striking typography, which he applied to projects for Magnum, 4th Estate, Royal Mail, television advertising for British Telecom and a corporate identity and promotional programme for the Photonica picture library. His work on *Big* magazine confirmed his reputation as an editorial designer. In 1995, he was commissioned to redesign *The Independent*'s magazine and a year-long appointment as art director followed. Frost has received a gold award from the Society of Publication Designers in New York, silvers from D&AD and other accolades from the New York and Tokyo Art Directors Clubs. He is a member of the CSD, D&AD, ISTD, and Alliance Graphique Internationale.

Fuel was founded in 1991 by Peter Miles (b. 1966), Damon Murray (b. 1967) and Stephen Sorrell (b. 1967) while they were

students at the Royal College of Art, where they published the first issues of their magazine, *Fuel*. Issues such as 'Girl', 'Cash' and 'Hype' were uncompromising in both content and brutally direct graphic style. Fuel's commercial clients have included Marc Jacobs, Levi's, MTV and Microsoft XBOX. They received a gold award for their Sci-Fi Channel idents at Promax Europe 2002. They have designed ads and catalogues for the White Cube Gallery and have worked on a number of projects with artist Tracey Emin. They designed both the book and graphics for artist Sam Taylor-Wood's exhibition at the Hayward Gallery, a series of books and exhibitions for photographer Juergen Teller and the art survey *Cream 3* (2003) for Phaidon. In 1998, the trio made a series of short experimental films under the title *Original Copies*, which was shown at international film festivals and broadcast on Channel 4 television. They have published the self-authored book projects *Pure Fuel* (1996) and *Fuel 3000* (2000). In 2003, they designed the title sequence for the film *Lost in Translation*.

Ken Garland (b. 1929) studied design at the Central School of Arts and Crafts in London in the early 1950s. He was art editor of *Design* magazine, published by the Council of Industrial Design, from 1956 to 1962. He left to set up his own company, Ken Garland & Associates, and the same year began an association with the Campaign for Nuclear Disarmament. In 1964, he published his *First Things First* manifesto, which questioned the emphasis on commercial promotion in design and argued for more socially useful forms of practice. Garland designed corporate identity programmes for toy maker James Galt, Race Furniture, the Butterley Brick Company and Barbour Index. The studio became involved in children's game design, and the card game Connect (1968) became a notable success. Later work included a series of posters and catalogues for the Arts Council. Garland has been influential as an educator and examiner and he has been a frequent lecturer at design colleges throughout Britain. He is the author of *Graphics Handbook* (1966), *Illustrated Graphics Glossary* (1980), *Graphics, Design and Printing Terms* (1989), *Mr Beck's Underground Map* (1995) and *A Word in Your Eye* (1996), a volume of his collected writings.

Malcolm Garrett (b. 1956) began designing record sleeves for bands such as the Buzzcocks while completing his BA in graphic design at Manchester Polytechnic. In 1978, he founded Assorted Images, which produced a stream of influential new wave record cover designs for Magazine, Simple Minds, Duran Duran, Culture Club and Peter Gabriel. Garrett was one of the first British designers to apply ideas derived from corporate identity to music graphics. He also showed an early interest in the graphic potential of computers. In 1994, he set up AMX, an interactive media design company whose clients included Barclays, Guinness, British Telecom, Carlton, The Woolwich, Trinity College Dublin and the Science Museum. In 2002, he left AMX and became an independent design consultant, specializing in design for interactive media, as well as an associate designer at the newly formed Applied Information Group in London. In 2000, Garrett was appointed visiting professor of interaction design at the Royal College of Art and he was also a visiting professor at Central Saint Martins College of Art and Design. In 2000, he was made a Royal Designer for Industry by the Royal Society of Arts.

James Goggin (b. 1975, Australia) graduated from the Royal College of Art in 1999 and went on to found Practise, which attempts to combine design, teaching and writing as equal components of a graphic design studio. Goggin works predominantly on print-based projects with curators, museums, cultural institutions, galleries, multinational corporations, publishers, record labels, performing arts organizations, photographers, artists, writers, fashion designers, industrial and furniture designers, film directors and architects. His clients have included Tate, Booth-Clibborn Editions, Routledge, Vintage and Random House, and the Anthony d'Offay Gallery.

Jon Goodchild (1941–99), a former mod and model, was a designer of the underground magazine *Oz*, in which he introduced a psychedelic approach to page layout, making inspired use of spot colouring, complex overlays and hand-inked colour separations. Words mutated into pattern and patterns became pictures. He left England in 1970 to work on *Rolling Stone* in San Francisco, and later ran his own design company in San Rafael, California.

Graphic Thought Facility's founders, Paul Neale (b. 1966), Andy Stevens (b. 1966) and Nigel Robinson (b. 1964), met in 1988 on the MA graphic design course at the Royal College of Art. In 1991, with funding from the Government's Enterprise Allowance scheme, they formed Graphic Thought Facility (GTF). Robinson departed in 1993 and Neale and Stevens slowly developed GTF into a five-person practice notable for its emphasis on a well-established but still contemporary-looking approach to graphic problem-solving, often making use of a variety of unexpected materials. GTF's clients have included Habitat, the Science Museum, the Royal College of Art, Shakespeare's Globe Theatre, record company One Little Indian, Tate and Booth-Clibborn Editions. The company has designed fashion catalogues for Antoni and Alison and identities for fine art retailers Counter Editions and the publishers Little-i. *Bits World*, a survey of their output designed by GTF, was published in 2001.

Raymond Hawkey (b. 1930) graduated from the Royal College of Art in 1953. He won a *Vogue* talent contest and joined Condé Nast, first as art director of its promotion department and then as art director of *Vogue* affiliated magazines. From 1959 to 1964, Hawkey was design director of the *Daily Express*, where he introduced illustrated graphic panels into the news pages to announce editorial features. Other newspapers rapidly adopted these techniques. Hawkey's innovative

book jacket for Len Deighton's novel *The Ipcress File* (1962), which employed a photographic still life to suggest narrative, was also influential. Other book covers for Deighton followed. In 1964, Hawkey became presentation director of *The Observer*. His first novel, *Wild Card*, was published in 1974. Since then, he has worked as a graphic designer, consultant art director and author.

Katy Hepburn (b. 1947) graduated from the Central School of Art and Design before completing her MA at the Royal College of Art in 1972. As a freelance designer, she worked with director Terry Gilliam on animations for *Monty Python's Flying Circus*, a landmark in the history of television comedy. Hepburn went on to become designer and art director of the first two Monty Python books and other Python-related projects. She expressed the team's anarchic humour in parodies achieved with great typographic precision. Hepburn was simultaneously designer at *Spare Rib*, Britain's first feminist magazine, for which she designed the logo. Her other projects included a D&AD award-winning poster for French musician Jean-Michel Jarre's concert in China.

David Hillman (b. 1943) was educated at the London School of Printing and, from 1966 to 1968, worked as a designer on the *Sunday Times Magazine*. In 1968, he joined *Nova* as art director and went on to become the magazine's deputy editor. In 1975, he set up his own design practice with a commission to design a new French daily newspaper, *Le Matin de Paris*.

Since he became a Pentagram partner in 1978, Hillman has continued to work on editorial design, identity, signage and packaging projects. In 1988, Peter Preston, then editor of *The Guardian*, commissioned him to undertake a redesign that would give the paper a more 'European' appearance. Hillman has won numerous awards and his work has been exhibited worldwide. He is a fellow of the Chartered Society of Designers and a member of the Alliance Graphique Internationale (AGI). In 1997, he was made a Royal Designer for Industry and in 2001 was elected president of the AGI.

Tom Hingston (b. 1973) graduated from Central Saint Martins College of Art and Design in 1994. In 1997, after working with Neville Brody for three years, he set up Tom Hingston Studio in London. The team works across the fields of music, fashion, publishing, film titles, video and web design. Clients have included Massive Attack, Robbie Williams, the Rolling Stones, Mandarina Duck and Dior. In 2002, the studio collaborated with *Dazed & Confused* on the book *Porn?*

Hipgnosis was formed in 1968 by Storm Thorgerson (b. 1944) and Aubrey Powell (b. 1946). Thorgerson gained a degree in English and philosophy from Leicester University and an MA in film and television from the Royal College of Art. Powell was educated at the London School of Film Technique. Hipgnosis designed photographically inventive album covers for Pink Floyd, Led Zeppelin, 10cc, Genesis, Peter Gabriel, Black Sabbath, Paul McCartney and

many other musicians. They published the *Album Cover Album* series of books about music graphics, and Hipgnosis: '*Walk Away René*' (1978) and *The Goodbye Look* (1982) about their own work. From 1983 to 1985, as Green Black Films, they produced videos for Paul Young, Nik Kershaw, Robert Plant and Yes. Thorgerson continued to design album covers for Ian Dury, the Cranberries, Catherine Wheel, Alan Parsons, Ween and Pink Floyd. Powell is author of *Classic Album Covers of the 1970s* (1994) and Thorgerson is author of *Eye of the Storm* (1999). Together they compiled *100 Best Album Covers* (1999).

Hi-Res!, a digital media design company, was founded in London in 1999 by artistic directors Florian Schmitt (b. 1971, Germany) and Alexandra Jugovic (b. 1968, Germany). They met at the Hochschule für Gestaltung Offenbach in Germany, where Schmitt was studying product design and Jugovic fine art. Taking full advantage of developing web technologies, they have applied their interactive story-telling approach to ambitious and quirky projects for Mitsubishi, NTT Data, Sony PlayStation2 and Lexus, for which they produced the BAFTA award-winning 'Minority Report Experience' website. They have also designed enigmatically oblique promotional sites for Darren Aronofsky's film *Requiem for a Dream* (2000) and Richard Kelly's *Donnie Darko* (2001).

Richard Hollis (b. 1934) studied art and typography at Chelsea School of Art, Wimbledon School of Art and the Central School of Arts and Crafts. From 1958, he

taught lithography and design at the London College of Printing and Chelsea School of Art. In the early 1960s, he worked in Paris. From 1964 to 1966, Hollis was head of graphic design at the West of England College of Art, Bristol and was for six years a senior lecturer at the Central School of Art and Design. From 1966 to 1968, he was art editor of the weekly *New Society* and in the 1960s and 1970s he designed books for Pluto Press. For 40 years, from 1963, he was designer for the quarterly journal *Modern Poetry in Translation*. In two phases, Hollis produced publicity material and catalogues for the Whitechapel Art Gallery (1970–72 and 1978–83). His graphic approach is characterized by the integration of text and image, as in his design for John Berger's *Ways of Seeing* (1972). He is author of *Graphic Design: A Concise History* (1994).

Angus Hyland (b. 1963) studied graphic design at the London College of Printing and the Royal College of Art. After gaining an MA in 1988, he ran his own studio in Soho, London for ten years, working on a variety of projects including book publishing, identities, fashion campaigns, commercials, record sleeves and information design. In 1998, he was invited to become a partner in Pentagram's London office. Hyland has won numerous awards for his work, including a D&AD silver award and two Big Critics awards in 1999. In 2000, he was awarded the grand prix at the Scottish Design Awards. In 2002, he featured in the *Independent on Sunday*'s 'Top Ten Graphic Designers in the UK'. He has held

the position of visiting tutor at the London College of Printing, at the Royal College of Art and at the Domus Academy in Milan. He is a member of the Alliance Graphique Internationale and, in 2002, he received an honorary MA from the Surrey Institute of Art and Design.

Intro was established in London in 1988 by Adrian Shaughnessy (b. 1953), a self-taught designer with experience of working for UK record labels, and business partner Katy Richardson, whose background is in film and TV production. As creative director, Shaughnessy oversaw the company's design output, recruiting Julian House (b. 1967) and other designers to join the team. Intro's clients have included Penguin, Sony, Ministry of Sound and the British Council. House's album and CD covers for Primal Scream, Stereolab and Broadcast fuse carefully researched, often arcane retro images with rough computer edits and a collage aesthetic. He has acted as art director on video promos for Doves and Radiohead. Shaughnessy and House collaborated on the books *Sampler* (1999), *Sampler 2* (2000) and *Sampler 3* (2003), surveys of radical design in the music industry. *Display Copy Only*, a collection of Intro designs, was published in 2001. In 2003, Shaughnessy left Intro to concentrate on consultancy, lecturing and writing for the design and music press.

Jannuzzi Smith was founded in London in 1993 by Michele Jannuzzi (b. 1967, Switzerland) and Richard Smith (b. 1967). They met while completing MAs in communication design at the

Royal College of Art. Their client list has included Central Saint Martins College of Art and Design, for which they designed printed and online course information, the Royal Mail, Sainsbury's, the Royal Institute of British Architects and Sotheby's. *Informal*, designed in collaboration with the engineer Cecil Balmond, the book's subject, was awarded a silver medal by the New York Art Directors Club in 2003. Jannuzzi and Smith are co-authors of *Dotlinepixel: Thoughts on Cross-Media Design* (2000).

Michael Johnson (b. 1964) studied design and marketing at Lancaster University. He founded Johnson Banks in 1992, after eight years' experience working in advertising and design in London, Sydney, Melbourne, Tokyo and New York. The studio's clients have included the British government, the Design Council, Angel Drug Services, and the Parc de la Villette, Paris. Its work emphasizes strong graphic ideas and clear communication. Johnson was a member of the D&AD executive committee for five years and served as its president from 2003 to 2004. In 2002, he co-curated the exhibition 'Rewind' at the Victoria & Albert Museum, which highlighted D&AD's achievements since 1962, and he designed the accompanying book. Johnson teaches at Kingston University, Central Saint Martins College of Art and Design and the Glasgow School of Art. He is author of *Problem Solved* (2002).

Terry Jones (b. 1945) studied graphics at the West of England College of Art, Bristol under

Richard Hollis. His first job was as Ivan Dodd's assistant and in 1972, following stints at *Good Housekeeping* and *Vanity Fair* magazines, he became art director at British *Vogue*. In 1980, Jones launched *i-D*. Starting as a home-produced, stapled-together fanzine with a rough-and-ready approach, the magazine has evolved, through many changes of style informed by Jones' concept of 'instant design', into a successful glossy. On the way, it has acted as a training ground for journalists, photographers and designers, including Moira Bogue and Stephen Male. In 1996, after several years spent concentrating on advertising art direction, Jones decided to take a more hands-on approach to *i-D*, and has steered the monthly back towards fashion, while retaining a punkish treatment of design and content. Jones' work has been documented in *Instant Design: A Manual of Graphic Techniques* (1990) and *Catching the Moment* (1997).

Siobhan Keaney (b. 1959) graduated from the London College of Printing in 1982. In the 1980s, she worked briefly at Smith & Milton, Robinson Lambie-Nairn and David Davies Associates before setting up her own studio. Her European-influenced graphic methods and independent, even maverick stance – seen in projects for Apicorp and The Mill, a television post-production company – soon attracted attention. Two Apicorp annual reports won D&AD awards. In 1995, Keaney designed a set of four science fiction stamps for Royal Mail. Her work has been recognized

overseas and she has been invited to exhibit and lecture in the US, Sweden, Germany, Canada, the Netherlands, Israel, Thailand, France and Turkey. Keaney teaches at the University of Brighton and has been a visiting lecturer at the Royal College of Art and external assessor at Central Saint Martins College of Art and Design, Manchester Metropolitan University, Leeds Metropolitan University and Bath Spa University College.

Kerr Noble was founded in 1997 by Frith Kerr (b. 1973) and Amelia Noble (b. 1973) while they were studying graphic design at the Royal College of Art. Their studio, based in Clerkenwell, London has carried out projects for Liberty, the Design Council, the Architecture Foundation, the Victoria & Albert Museum, Laurence King Publishing and Channel 4 television. They have collaborated with film-maker Tony Kaye on typographic and moving-image commissions. '400:4:1' was a web project about eclipses written and designed for the Natural History Museum, London. They designed the publicity material and website for 'The Allure of the Digital' conference at Tate Britain (1999), and publicity material for the 'User_Mode' conference at Tate Modern (2003).

David King (b. 1943) is a designer, photographer, editor, researcher and author. He studied graphic design at the London School of Printing under Robin Fior. As art editor of *The Sunday Times Magazine* from 1965 to 1975, he collaborated with art director Michael Rand to

create the new cinematic language of the colour supplement. In the mid-1970s, he began designing posters for organizations such as Apartheid in Practice and the National Union of Journalists. His graphic style, a mix of explosive sanserif typography, solid planes of vivid colour and emphatic rules, reworked the graphic language of the Russian Constructivists for the British New Left. King's collection of Soviet photographs consists of more than a quarter of a million pictures, and he has drawn on it extensively for the visual histories he has authored and designed. These include his first pictorial biography, with Francis Wyndham, *Trotsky: A Documentary* (1972); *The Great Purges* (1984); *The Commissar Vanishes* (1997); and *Ordinary Citizens* (2003).

Scott King (b. 1969) studied graphic design at Hull University. He was art director of *i-D* magazine in the mid-1990s and went on to become creative director of *Sleazenation*, where he produced a string of provocative covers that challenged the idea of a 'style magazine'. The 'Che Guevara' cover won a Total Publishing award. King's other clients have included Earl Brutus, Malcolm McLaren, the Pet Shop Boys, Suicide, Morrissey and The Michael Clark Dance Company. He is a member, with Matthew Worley, of the art duo *Crash!*, which has initiated a series of publishing projects. In 1999, 'Crash!'was staged at the ICA, London. Since leaving *Sleazenation*, King has created personal work for gallery display and exhibited widely in London and European galleries.

Alan Kitching (b. 1940) began a six-year apprenticeship as a compositor at a Darlington print works after leaving school. Here, and at evening classes, he learnt the craft of letterpress typography and printmaking. In 1964, he was appointed typography instructor at Watford School of Art under the influential typographer and teacher Anthony Froshaug and began the transition to teacher and designer. In 1989, after a period working in corporate graphic design, including directorship of Omnific Studios with Derek Birdsall, Kitching established the Typography Workshop in Clerkenwell, London. In the same year, he was appointed visiting lecturer in typography at the Royal College of Art and, in 1992, began his letterpress workshop for students. He is internationally renowned for his expressive use of wood and metal letterforms to create typographic images for advertising, publishing and self-initiated work.

Martin Lambie-Nairn (b. 1945) studied at Canterbury College of Art and Design. In 1970, after early experience in the BBC graphic design department, at Rediffusion Television and at Conran Associates, he joined London Weekend Television as a designer. In 1976, he formed the partnership Robinson Lambie-Nairn in London; the company was later renamed Lambie-Nairn. The studio's computer-animated logo for Channel 4 (1982) made a national impact as an emblem of the new television station's innovative output. In the 1990s, Lambie-Nairn's playful idents for BBC2 transformed public perceptions of the channel.

Other clients included BBC1, BBC's Nine O'Clock News, S4C, and Disney Channel UK. In 1987, Lambie-Nairn was appointed a Royal Designer for Industry. The company received the Queen's Award for Export in 1995.

Romek Marber (b. 1925, Poland) arrived in London in 1946. He studied at Saint Martin's School of Art (1950–53) and the Royal College of Art (1953–56). From 1959 to 1967, he designed covers for *The Economist*. As a consultant designer for Penguin, he devised the grid for the crime series, which was applied, with modifications, to Penguin's fiction and Pelican titles. Marber designed more than two hundred Penguin covers. In 1964, he was involved in the launch of *The Observer*'s colour magazine and he went on to act as its design consultant. Other clients included Balding & Mansell, Consumer Association, BP, the BBC, Nicholson Publications, Hodder & Stoughton, the London Planetarium and the magazines *New Society*, *Queen* and *Town*. He taught at Saint Martin's School of Art, London College of Printing and the Royal College of Art, and was an examiner at many colleges. He was head of the design department at Hornsey College of Art (1967–73) and head of communication design at Middlesex Polytechnic (1973–90).

George Mayhew (1921–74) began his career in a silkscreen print workshop at the age of fourteen. After seven years with Stuart's Advertising Agency he set up his own studio. In 1960, he co-founded BDMW Associates with Derek Birdsall, George

Daulby and Peter Wildbur. He was a design consultant for the Paris Pullman cinema, Joan Littlewood's Theatre Workshop and the *Daily Telegraph*, and a graphic designer for BBC1's *Panorama* and for BBC2. His posters for the Royal Shakespeare Company were models of clear but expressive communication. Mayhew taught at the Central School of Arts and Crafts, Watford Technical College and Chelsea School of Art.

John McConnell (b. 1939) studied at the Maidstone College of Art, Kent and began his career in visual communication in the advertising industry. Between 1963 and 1974, he ran his own graphic design practice. His clients included Biba, one of the most fashionable and era-defining 1960s retailers. In 1967, McConnell co-founded Face Photosetting and, in 1974, he joined Pentagram as a partner. He has been a design consultant to Clarkes Shoes, Faber & Faber and the pharmaceutical company Boots, where he was a member of the board, giving him a high level of influence on design policy. He has won numerous design awards, including two D&AD golds, nine D&AD silvers and the president's award for outstanding contributions to design. He served as president of D&AD in 1986 and is a Royal Designer for Industry and a member of the Alliance Graphique Internationale.

Michael McInnerney (b. 1944) studied graphic design at the London College of Printing. Leaving early, he took up an offer to art edit the alternative newspaper *International Times*.

He participated in counter-culture events on the London scene, creating posters for the UFO club and the Big O Poster Company. He formed Omtentacle with Dudley Edwards to produce murals, posters and alternative wallpaper before moving into mainstream graphics, in 1969, with the album cover for *Tommy* by the Who. His later clients included *The Sunday Times*, *Nova*, *New Scientist*, Rod Stewart and the Faces, and Allen Ginsberg. He helped to set up an illustration course at the Hochschule für Gestaltung und Kunst in Lucerne, Switzerland.

Me Company was founded by Paul White (b. 1959), who studied illustration and graphic design at West Sussex College of Art. In the early 1980s, as a freelance, he designed record sleeves for Some Bizarre Records. In 1985, White helped to set up the One Little Indian record label. Me Company, which dates from this time, designed sleeves and CD covers for the Heart Throbs, the Popinjays, the Shamen, Erasure, Carl Cox and the Icelandic singer Björk. In the mid-1990s, the studio pushed digital technology to the limit to create complex three-dimensional graphic spaces, and Björk's image was subjected to a series of startling transformations.

Morag Myerscough (b. 1963) completed an MA at the Royal College of Art in 1988. She set up Studio Myerscough in 1993, after working at Lamb & Shirley and freelancing for Conran Design Partnership and Studio de Lucchi in Milan. In 1995, Chris Merrick joined Myerscough, followed later by Simon Pickford and Sally

Cowell. The studio has wide experience of exhibition design and building collaborations, as well as two-dimensional graphics. Clients have included the Royal Institute of British Architects, the Design Council, the Design Museum, the Arts Council and the Commission for Architecture and the Built Environment. The team collaborates regularly with architects Allford Hall Monaghan Morris, and has carried out projects for the Barbican Centre, Sadlers Wells and the Science Museum.

Quentin Newark graduated from Brighton Art School in 1982. His first job was with publishers Faber & Faber. He then went on to work for Alan Fletcher at Pentagram, designing the logo for ABB and the signs for Stanstead Airport. He co-founded Atelier Works in London in 1991 with John Powner. Their clients include Volkswagen UK and the Labour Party. Among his other design projects are the rebranding of the Royal Institute of British Architects and the Landmark Trust. He has designed various materials for the Design Council and numerous books for Phaidon and Laurence King Publishing. He contributes to *Design Week*, *Creative Review*, *Print* and *Domus*. He is the author of *What is Graphic Design*? (2002).

North was founded in 1995 by Royal College of Art graduate Sean Perkins (b. 1963) and Simon Browning (b. 1958). The two had previously worked together at Cartlidge Levene. The London-based team specializes in corporate identities, brand strategy, annual reports and other corporate literature,

and exhibitions and events. The studio is unusual for the degree of aestheticism, inspired by European modernism, that it brings to typography, design and print quality in a sector not often noted for progressive design values. North's unexpectedly futuristic redesign of the Royal Automobile Club (RAC) brand identity in 1996–97 exerted a wide influence. The team has completed design programmes for a range of national and international clients, including Andersen Consulting, Selfridges, Samas Roneo, Syn Production (Tokyo), Ikepod Watch, The Mill, Hugo Boss, the Photographers' Gallery, the Serpentine Gallery and Birmingham Repertory Theatre. Browning left North in 2003.

Vaughan Oliver (b. 1957) studied graphic design at Newcastle Polytechnic, where he began collaborating on projects with Nigel Grierson. In 1980, Oliver moved to London and took a job at Benchmark, a packaging company, before joining Michael Peters & Partners. He began designing sleeves for 4AD Records and, in 1983, he became the label's full-time designer. With Grierson, he formed the partnership 23 Envelope; Grierson took photo-graphs and Oliver did the design. Their lavishly conceived, intensely emotive sleeves for the Cocteau Twins, This Mortal Coil and other bands won an international following. In the late 1980s, still based at 4AD, and now called v23, Oliver began working with other photographers on sleeves for the Pixies, Lush, His Name is Alive and other artists. He also took on commissions for publishers,

theatre companies and fashion designers. His work was shown at one-man exhibitions in Paris, Tokyo and Los Angeles and in the books *Exhibition/Exposition* (1990), *This Rimy River* (1994) and *Vaughan Oliver: Visceral Pleasures* (2000).

Harri Peccinotti (b. 1935) worked in London in the 1950s as a commercial artist, musician and then advertising art director. Increasingly, he combined photography with design. He was art director of *Flair* and *Vanity Fair* before becoming in 1965 the first art director of *Nova*, one of the most influential magazines of the time. Peccinotti continued to photograph for *Nova* and other magazines such as *Vogue*, *Elle* and *Marie Claire* into the 1970s. He moved to Paris, where he worked for *Le Nouvel Observateur*, *Le Matin*, *Rolling Stone* and the French ecology journal *Grand Air*.

Mark Porter (b. 1960) studied modern languages at Oxford University. He has been art director of *Campaign*, *Direction*, *ES* magazine, *Wired* (UK) and *Colors*, and has worked on newspaper and magazine projects in Belgium, Italy, Spain and Switzerland. In 1996, Porter moved to *The Guardian*, where in 2001 he became the paper's creative director, responsible for the design of its many sections and supplements.

Rebecca and Mike is a London-based partnership founded by Rebecca Brown (b. 1972) and Mike Heath (b. 1972), who graduated from Central Saint Martins College of Art and Design

in 1995. They describe their approach as 'applied thinking'. They analyse complex information and work out how best to communicate it, a process that leads to unexpected, albeit logical, results. Their projects include a commission from *Tate* magazine to devise a system to analyse data relating to the Turner Prize from its inception in 1984, and a brochure for Diesel that mapped consumers' eye movements when looking at the retailer's clothes.

Jamie Reid (b. 1947) attended Wimbledon College of Art and studied painting at Croydon School of Art from 1964 to 1968. In 1970, he co-founded *Suburban Press*, a local newssheet littered with Situationist slogans and agitprop. In 1976, Malcolm McLaren, who studied with Reid in Croydon, enlisted his visual talents to help promote the Sex Pistols punk rock band. Reid designed album covers, posters, T-shirts and other publicity material that included anarchy flags subverting the Union flag, images of the Queen lifted from postage stamps with swastikas replacing the eyes, ransom note lettering and safety pins. These controversial images rapidly became icons of the anti-establishment punk movement. Jon Savage documented Reid's exploits in the book *Up They Rise: The Incomplete Works of Jamie Reid* (1987).

Alex Rich (b. 1975) graduated from Ravensbourne College of Design and Communication in 1997. In 1998, he was appointed as a visiting lecturer at Camberwell College of Art and Design. He has participated in many exhibitions, including 'Stealing Beauty' (1999) at the Institute of Contemporary Arts, London. His clients include Camden Arts Centre and August/Birkhäuser. He lives and works in Tokyo.

Sans+Baum was set up in 1989 by Lucienne Roberts (b. 1962). Roberts graduated from the Central School of Art and Design in 1986, then worked as a designer for the Women's Press. Sans+Baum is notable for its commitment to design for social causes. Its clients have included the ICA, Sadlers Wells, Phaidon, the Arts Council, the British Council and Breakthrough Breast Cancer. In 1997, Roberts was joined by her associate Bob Wilkinson (b. 1970). After graduating from Central Saint Martins College of Art and Design in 1993, Wilkinson worked at Neville Brody's Research Studios on projects for Zumtobel Lighting and software packaging for Macromedia. Both Roberts and Wilkinson lecture at London colleges and are signatories of the *First Things First 2000* manifesto. Roberts contributes to *Eye* and other magazines and is co-author of *The Designer and the Grid* (2002) and *In Sight: A Guide to Design with Low Vision in Mind* (2004).

Peter Saville (b. 1955) studied graphic design at Manchester Polytechnic. A meeting with Tony Wilson, who was about to open a club, led him to become involved in design for Wilson's Factory Records. After moving to London in 1979, Saville became art director of the Virgin offshoot Din Disc. During this period, he created covers for Joy Division, New Order, Orchestral Manoeuvres in the Dark, Ultravox and Roxy Music that were notable for their formal precision and conceptual control. In 1982, he formed Peter Saville Associates with Canadian designer Brett Wickens. Their clients included the Whitechapel Art Gallery, the Pompidou Centre, and fashion designers Yohji Yamamoto, Martin Sitbon and Jill Sander. The studio closed in 1990 and Saville joined Pentagram as a partner. In 1993, Saville and Wickens left Pentagram and moved to Frankfurt Balkind's office in Los Angeles as creative directors. This also failed to work out and Saville returned to London. He completed projects for Mandarina Duck, Pulp and Suede, consolidating his place as one of British graphic design's most influential figures. In 2003, his work was exhibited at the Design Museum, London and explored in the book *Designed by Peter Saville*.

John Sewell (1926–81) studied painting at the Hornsey School of Art and graphic design at the Royal College of Art. In 1954, he became the first full-time, art school-trained graphic designer at BBC television. From 1957, he worked as a freelance designer, producing book covers for Calderbooks and Penguin, and posters, paper bags, wrapping paper and other promotional materials for Better Books, the City Bookshop, Bumpus and the Book Society. In the late 1950s and early 1960s, Sewell used bright colours as well as bold and sometimes whimsical decorative elements with an expressive freedom that was then unusual in British graphic design. His other clients included *Design* magazine and Shell Chemicals. In 1960, he wrote and directed the short film *Everybody's Nobody*, starring the artist Bruce Lacey.

Herbert Spencer (1924–2002), designer, editor, writer and photographer, founded *Typographica* magazine in 1949, which he edited and designed until its final issue in 1967. In 1946, Spencer joined London Typographical Designers before becoming a freelance designer in 1948. He built up a thriving practice, consulting and designing for clients such as Lund Humphries, British Railways, the Post Office, the Tate Gallery, the University of Leeds, the University of East Anglia, Shell and stationery retailer WH Smith. In 1965, he was made a Royal Designer for Industry. Spencer's first book, *Design in Business Printing* (1952), advocating asymmetrical modernist typography, became a bible for students. In the 1950s, he taught typography at the Central School of Arts and Crafts. He consolidated his considerable influence by editing the prestigious *The Penrose Annual* for Lund Humphries (1964–73). In 1966, Spencer was appointed senior research fellow at the Royal College of Art (RCA), where, with *The Visible Word* (1968), he made a significant contribution to legibility studies. He was professor of graphic arts at the RCA from 1978 to 1985. *Pioneers Of Modern Typography* (1969) was the first illustrated survey of its kind. His photographs were published in *Traces of Man* (1967).

Spin was established in 1992 by Tony Brook (b. 1962) and

Patricia Finegan (b. 1965). From the outset, the London-based studio worked in a variety of media including print, moving graphics and web design. Its style is influenced by the European modernist tradition of graphic design, with a strong preference for clear communication. Spin's clients have included Diesel, Levi's, Nike UK and Europe, Deutsche Bank art department, Channel 4 television and the Whitechapel Art Gallery. In 2002, the company helped to re-brand Channel 5, which was renamed Five, by making it the first British television channel to use purely typographical promos on a regular basis.

State was founded in 1997 by Mark Hough (b. 1971) and Philip O'Dwyer (b. 1974). The company, based in London, works across all graphic media and has completed projects in the fields of motion graphics, interactive media and print. State has designed seven title sequences for Onedotzero, the digital film festival. Other moving image commissions have included a promotional video for the European launch of PlayStation 2 and a corporate identity animation for Hitachi. Interactive projects have included the launch site for the Sega Dreamcast in Europe, I-mode designs for MTV Japan, brand and interface development for a next generation mobile phone for O2 and an online film festival website for *Dazed & Confused* magazine.

Kate Stephens (b. 1956) studied graphic design at Brighton College of Art and Design. In 1979, she joined Wolf Olins, where she was involved in the groundbreaking corporate identity for 3i. In 1986, she became an independent designer, working primarily for artists and galleries. Her clients have included the Arts Council, the Serpentine Gallery, Tate, Royal Academy and the South Bank Centre. Stephens' work is notable for a monumental approach to typography and layout that produces page settings of great purity and spaciousness for the art depicted. In 1990, the British Council commissioned her to design a catalogue for the artist Anish Kapoor at the Venice Biennale. From 1989 to 2001, she worked for the Whitechapel Art Gallery designing catalogues, books and posters and in 1997 she implemented a new gallery identity.

Stylorouge was founded in 1981 by Rob O'Connor (b. 1955), who studied graphic design in Coventry and Brighton. O'Connor began his design career in Brighton, then moved to Polydor Records in London. Stylorouge has designed sleeves for Siouxsie and the Banshees, Tears for Fears, Squeeze, Simple Minds, George Michael, Maxi Priest and Blur. The studio has also completed film, fashion, retail, corporate identity, publishing and exhibition projects. O'Connor was a founding member of an organization that became the Association of Music Industry Designers (AMID). He has been a visiting lecturer and external assessor at Chelsea, Brighton and Camberwell Schools of Art. In 1997, he studied film direction with director Jim Pasternak and computer graphics at UCLA in Los Angeles. Stylorouge's work was collected in *Delicious: The Design and Art Direction of Stylorouge* (2001).

Tomato was formed in London in 1991 by Steve Baker, Dirk van Dooren, Karl Hyde, Rick Smith, Simon Taylor, John Warwicker and Graham Wood. Jason Kedgley joined in 1994, Michael Horsham in 1996. The members had a range of backgrounds: van Dooren began his career as an illustrator, Hyde and Smith were members of the group Underworld, and Horsham was a writer. Graphic designer John Warwicker (b. 1955), a graduate of Camberwell School of Art, had previous experience working as a designer for the music business at da Gama, A&M Records and Vivid. Wood (b. 1965) was a graduate of Central Saint Martins College of Art and Design. Tomato refused to be pigeonholed as 'graphic designers' and produced work of great expressive intensity that challenged distinctions between art and design. They rapidly built up an international reputation. Members of the team were involved in moving-image projects for pop promos, advertising and television. Their clients have included *The Guardian*, Nike, Philips, Nescafé, Aspesi, TV Asahi in Japan and the BBC. The team has authored three book projects: *Mmm . . . Skyscraper, I Love You* (1994), *Process* (1996) and *Bareback* (1999). Wood is author of a work of fiction, *Tycho's Nova* (2001).

Trickett & Webb was founded in 1971 by graphic designers Lynn Trickett (b. 1945) and Brian Webb (b. 1945). Trickett studied at Chelsea School of Art (1962–66), Webb at Canterbury College of Art, Kent (1963–67). Their London-based company specialized in graphic design, packaging and exhibition design, and undertook architectural collaborations with Trickett Associates. Trickett & Webb designs united elegant, well-crafted, even traditional typography with images commissioned from illustrators and photographers. Their long-running series of self-initiated annual calendars showed their art direction of illustration at its most sophisticated. They won D&AD silver awards for direct mail, corporate identity and book design. Trickett & Webb closed in 2003 and Brian Webb opened the design studio Webb & Webb.

Klaus Voorman studied commercial art at the Meisterschule für Grafik und Buchgewerbe and completed his design education at the Meisterschule für Gestaltung, Hamburg. During his studies, he worked as a freelance designer for fashion magazines and advertising agencies. He met The Beatles in Hamburg and moved to London, where he set up home with George Harrison and Ringo Starr, before becoming a professional musician. In 1966, The Beatles invited him to design the cover of *Revolver*, for which he won a Grammy award.

Nigel Waymouth (b. 1941) studied economics and history at University College, London and the London School of Economics, before opening in 1965 London's first psychedelic boutique, Granny Takes a Trip, on the King's Road. In 1967, as a member of Hapshash and the Coloured Coat, with Michael English, Waymouth began designing music posters and record covers that became icons of the 1960s counter-culture.

William Webb (b. 1962) studied graphic design and illustration at Newcastle Polytechnic, before working as a freelance graphic designer for 4th Estate, Verso, Routledge, Virgin Classics, Bloomsbury and John Murray publishers. He has been design director at Bloomsbury since 1996, working on hundreds of book covers annually. His cover designs have won numerous awards, including the design and production award for *The Tulip* by Anna Pavord in 2000 from the British Book Awards.

Why Not Associates was founded in 1987 by Andy Altmann (b. 1962), David Ellis (b. 1962) and Howard Greenhalgh (b. 1963), after the three completed MAs in communication design at the Royal College of Art. In 1993, Greenhalgh went on to manage Why Not Films, leaving Altmann and Ellis to develop Why Not's playful, rule-breaking typographic approach, which proved to be highly influential. This was one of the first London design studios to embrace multimedia design. Its eclectic output won the studio many clients, including Next, Smirnoff, Royal Mail, the Royal Academy, *Time* magazine and the Barbican Centre. They colla-borated regularly on exhibition and publishing projects with British architect Nigel Coates. Environ-mental commissions included *A Flock of Words*, a 300-metre typographic path in Morecambe, England in collaboration with artist Gordon Young. Their work is documented in the books *Why Not?* (1998) and *Why Not? 2* (2004).

Thomas Wolsey (b. 1924, Germany) studied at Leeds College of Art and the Central School of Arts and Crafts. He began his career at the W. S. Crawford advertising agency, where he worked with Ashley Havinden. In 1960, he joined Cornmarket Press, becoming art director of *Man About Town* (later *Town*). Wolsey's pages set a new standard for forceful, expressive British magazine design. He was also art director of *Topic*. He undertook freelance art direction for Jaeger and was a consultant to El Al Airlines and the Contemporary Art Society. Later, he moved to New York.

Index

Acknowledgements

The editor would like to thank the following people for their invaluable assistance with the exhibition and book: Steven Bateman (Pentagram), Eliza Brownjohn, Stephen Coates, Len Deighton, Mike Dempsey, Ted Dicks, EGA Printers (Brighton), Alan Fletcher, Peter Golding, Raymond Hawkey, Richard Hollis, Bruce Lacey, Anthony Pritchard, Sally Waterman (Pentagram) as well as all the designers and contributors who made this book and exhibition possible.

The Barbican Art Gallery would also like to extend thanks to David English (EMI), Liz Farrelly, Emily King, Anne Odling-Smee, Keith Ormondroyd (Warner Music UK), Penguin Books (UK), Caryl Stephen (Azman Associates) and all those who helped with the exhibition and book.

Photographic acknowledgements

The publishers have made every effort to trace and contact the copyright holders of the photographs reproduced in this book. However, they would be pleased, if informed, to correct any errors or omissions in subsequent editions of this publication.

T = Top; B = Below; L = Left; R = Right; C = Centre; TR = Top Right; TL = Top Left; TLC: Top Left Centre; BR = Below Right; BL = Below Left: BRC: Below Right Centre: BLC: Below Left Centre

p. 18: © Design & Art Direction (D&AD), UK; p. 23: © David King Collection, UK; p. 24: © Peter Golding, Inspirational Times Collection; p. 25: © V&A Images/V&A Museum, London, UK; p. 27: © Images Appears Courtesy of Apple Corps Ltd; p. 30: T © Courtesy The Beat Goes On and EMI Records Ltd; p. 31: T: © Courtesy Polydor; p. 31: B: © Courtesy Ace Records; p. 32: T: Licensed courtesy of London Records 90 Limited. © 1979 Factory Communications Limited; p. 32: B: © Fetish Records; p. 38: © Arts Council, England; p. 42: © London Chamber Orchestra; p. 53: TL, TR, BL: Pentagram, London; p. 53: BR: (Pelican 1972) Copyright © John Berger, 1972; p. 54: All images courtesy of Penguin Books, 1971; p. 54: B © Penguin Books. p. 63:TL, BL: © David King Collection, UK; p. 65: BL, BLC, BRC: Images appear courtesy of Faber & Faber; p. 65: TR, BR: Images appear courtesy of Minerva; p. 66: L: © Independent Newspapers; p. 67: All images appear courtesy of Independent Newspapers; p. 68: R: © *The Guardian*; p. 69: TR: © *The Guardian*; p. 70: T, B: © *The Guardian*; p. 71: All images © *The Guardian*; p. 72: TL © Dazed & Confused; p. 72: BL, BLC, BR: © Bloomsbury Publishing; p. 72: TRC: Copyright © Leonard Cohen, 2001, Reproduced by permission of Penguin Books Ltd; p. 72: TR: Copyright © Leonard Cohen, 2001, Reproduced by permission of Penguin Books Ltd; p. 72: CR: Copyright © Hunter S. Thompson 1999, Reproduced by permission of Penguin Books Ltd; p. 73: All images appear courtesy of Sleaze, Swinstead Publishing; p. 74: TL, TR, BL: © Phaidon; p. 75: TL, TR: © Prestel Publishing; p. 84: L © British Film Institute, HSBC and Eliza Brownjohn; p. 85: © Pentagram, London; p. 88: L © BBC Two; p. 90: All images appear courtesy of RAC plc; p. 93: All images appear courtesy of Channel Five; p. 94: Images appear courtesy of Channel 4; p. 99: R © Institute of Contemporary Arts, London; p. 100: R © Pentagram, London; pp. 102 & 103: T, B & L © Images appear courtesy of Whitechapel Art Gallery, London; p. 104: TL © Pentagram, London & © Arts Council, England; p. 104: TR, BR © Arts Council, England; p. 106: TL, TR © Royal Institute of British Architects (RIBA); p. 106: BL, BC © Serpentine Gallery; p. 106: BR © British Council; p. 107: TL © Serpentine Gallery; p. 107: TR © Institute of Contemporary Arts, London; p. 107: BL © British Council; p. 108: L, R © English National Opera; p. 110: L, R © Royal Academy of Arts, London; p. 111: BL © Booth-Clibborn Editions & Damien Hirst; p. 111: TR © British Council, London; p. 114: L © Shakespeare's Globe Theatre and Nigel Shafran; p. 114: R © British Council, London; p. 115: L © Tate Britain; p. 119: TR © Design & Art Direction (D&AD), UK; p. 122: R © Artwork used by permission of EMI Records Ltd & Peter Golding, Inspirational Times Collection; p. 123: L © Peter Golding, Inspirational Times Collection; p. 123: R © V&A Images/V&A Museum, London, UK; p. 124: TL, BL © Decca / Universal; p. 124: BR © Charisma / Virgin Records. Appears courtesy of Virgin Records; p. 125: BR © Artwork used by permission of EMI Records Ltd; p. 126: TL, TR, BL © 1977 Sex Pistols Residuals/Virgin Records Limited. Appears courtesy of Virgin Records; p. 126: BR © Bright Music Ltd.; p. 127: TL, TR, BR © Demon Records; p. 128: © Artwork used by permission of EMI Records Ltd; p. 129: T, B © Artwork used by permission of EMI Records Ltd; p. 130: BL © 1980 Virgin Records Ltd. Appears courtesy of Virgin Records; p. 130: BR © The Factory; p. 131: T © 1984 Virgin Records Ltd. Appears courtesy of Virgin Records; p. 132: TL © 4AD / Beggars Banquet; p. 133: TR © Licensed courtesy of London Records 90 Limited. © 1985 CentreDate Co. Limited; p. 133: BR © EMI Records Ltd; p. 134: TL © Licensed courtesy of London Records 90 Limited. © 1983 Factory Communications Limited; p. 134: BL Licensed courtesy of London Records 90 Limited. © 1993 CentreDate Co. Limited; p. 134: BR © Artwork used by permission of EMI Records Ltd; p. 135: TL, TC, BL © Courtesy EMI Records Ltd / Virgin Classics; p. 135: TR, BR © Courtesy One Little Indian; p. 136: T, B © Junior Boys Own / V2; p. 137: TR © Junior Boys Own / V2; p. 139: T, B © Creation Records / Sony Music UK; p. 140: T, B © Sony Music UK; p. 141: T © Duophonic; p. 141: TR © BMG; p. 141: BL © Warp Records; p. 141: BR © BMG; p. 142: TL, TR © (C) 1998 Virgin Records Ltd. Appears courtesy of Virgin Records; p. 142: B © Warp Records ; p. 143: TR © 2000 Virgin Records Ltd. Appears courtesy of Virgin Records; p. 143: BR © Artwork used by permission of EMI Records Ltd; 152: L, © V&A Images/ V&A Museum, London, UK; p. 154: L, R © David King Collection, UK; p. 155: T, B © David King Collection, UK; p. 165: © Bruce Lacey & East Anglian Film Archive; p. 168: BL, BCL, BCR, BR © Pentagram, London; p. 203: T © Agency.com; p. 203: B © Virgin Records. Photography: Bettina Walter; p. 204: C © 2004 Warp Records Limited; p. 205: B © Virgin Records; p. 212: B © Hyphen Press; p. 214: © Virgin Records; p. 217 & 218 C: © Sony PlayStation, UK; p. 223: T © 1977 Sex Pistols Residuals/Virgin Records Limited. Appears courtesy of Virgin Records; p. 223: B © Artwork used by permission of EMI Records Ltd; p. 225: B © 1987 Virgin Records Limited. Appears courtesy of Virgin Records; p. 226: © Channel 4; p. 227: B © 1981 Fetish Records; p. 228: BL © 4AD / Beggars Banquet; p. 228: BR © Artwork used by permission of EMI Records Ltd; p. 229: B © 1998 Island Records; p. 230-231: © Universal Studios, USA

Photography © Anthony Oliver: p. 17: T, B; p. 19: T; p. 23: TR; p. 26: T, R; p. 34: C; p. 35: B; p. 38: B; p. 39: B © Courtesy 4AD / Beggars Banquet; p. 40: B; p. 41: TR; p. 43: TR; p. 56: TL: p. 59: T, C, B; p. 60: T, C, B; p. 61: TL: p. 63 BR; p. 64 TR, BR; p. 68: TL, BL: © *The Guardian*; p. 69: TL, BL, BR: © *The Guardian*; p. 88: TC, TR, C, BR; p. 89: T, B © Habitat; p. 99: L © Arts Council, England; p. 107: BR © Serpentine Gallery; p. 109: BL, BR; p. 122: L © Apple Corps Ltd.; p. 124: TR © Artwork used by permission of EMI Records Ltd; p. 125: TL, TR © Warner Music. Appears courtesy of Led Zepplin; p. 130: TL © 1981 Virgin Records Ltd. Appears courtesy of Virgin Records; p. 131: B © 4AD / Beggars Banquet; p. 132: TR, BR © 4AD / Beggars Banquet; p. 133: L; p. 134: TR: Licensed courtesy of London Records 90 Limited. © 1992 Factory Communications Limited; p. 138: T, C © Universal; p. 138: B © A&M / Universal; p. 143: L; p. 144: L, R; p. 147: C; p. 151: C; p. 156: B; p. 157: C, B; p. 173: C; p. 186: T; p. 187: T, B; p. 188: B; p. 189: T, B; p. 195: B; p. 196: B; p. 220: TL, TR, BR © *The Sunday Times Magazine*; p. 224: © 1978 Virgin Records Limited. Appears courtesy of Virgin Records; p. 225: T © 1981 Virgin Records Limited. Appears courtesy of Virgin Records; p. 227: T; p. 228: TL; p. 231: BL, BCL, BCR, BR © Canongate Books.

Photography © Yorgos Yerardos: p. 13: L; p. 14: T; p. 16: C; p. 19: B; p. 20: C; p. 21: TL, TR; p. 22: T, B; p. 28: BL © (Penguin Books 1951) Copyright 1934 by Evelyn Waugh; p. 28: BR © (Penguin Books 1937) Copyright 1937 by Evelyn Waugh; p. 33: B; p. 36: C; p. 37: TR / Licensed courtesy of London Records 90 Limited. © 1986 Factory Communications Limited; p. 43: TL © Infectious Records Ltd., 1993; p. 44: B; p. 45: C; p. 46: T; p. 50: TL © (Penguin Books 1962) Copyright © Kingsley Amis et al, 1962; p. 50: TR © (Penguin Books 1962) Copyright © George Barker et al, 1962; p. 50: BL © (Penguin Books 1961) Copyright © Bruce Buckingham, 1961; p. 50: BLC © (Penguin Books 1959) Copyright © Erle Stanley Gardner, 1959; p. 50: BRC © (Penguin Books 1959) Copyright © G.K. Chesterton, 1959; p. 50: BR © (Penguin Books 1962) Copyright © Dorothy L. Sayers, 1962; p. 51: L; p. 51: TRC, TR, BLC, BL: Images appear courtesy of Peter Owen Publishers; p. 52: TL, TR, BL, BR; p. 53: TR, BL, BR; p. 57: BL; p. 61: BL; p. 63: TR; p. 64: TL, BL; p. 65: TL; p. 66: TL: (King Penguin 1984) Copyright © Milan Kundera, 1984. Translation copyright Peter Kussi 1984; p. 66: BL: (King Penguin 1983) Copyright © Milan Kundera, 1983. Translation copyright Michael Henry Heim 1983; p. 74: BR; p. 83: TR, BR; p. 84: R © Eliza Brownjohn; p. 98: L, R © Royal Shakespeare Company, Stratford-upon-Avon; p. 100: L; p. 149: T; p. 150: C; p. 153: R; p. 158: 6; p. 157: T; p. 164: T, B; p. 170: BL, BR; p. 172: C; p. 174: C; p. 177: TL, TR; p. 178: C; p. 185: TR; p. 186: B; p. 188: T; p. 190: TL, TR, BL, BR; p. 191: T, B; p. 192: B; p. 193: B © 1999 Eidos Interactive Ltd; p. 198: T, B; p. 199: T, B; p. 221: BL (Penguin Books 1964) © Olaf Stapledon 1964; p. 221: BR (Penguin Books 1973) © Philip K. Dick 1973; p. 223: BR.

Photography © Nigel Jackson
p. 183: L; p. 184: B.